The Good and Simple Life

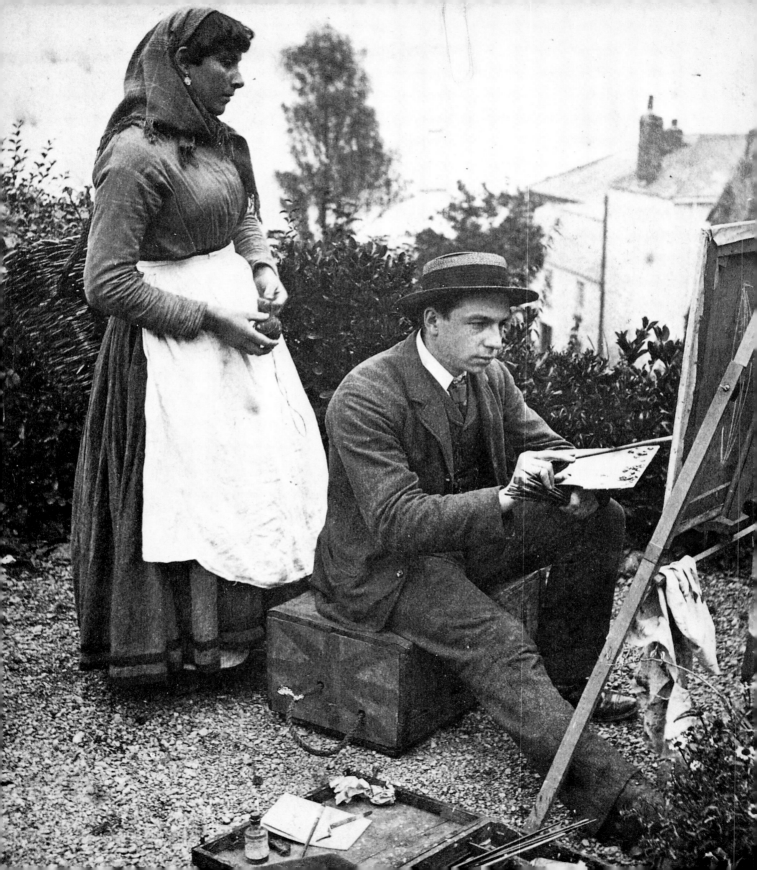

The Good and Simple Life

ARTIST COLONIES IN EUROPE AND AMERICA

Michael Jacobs

Phaidon · Oxford

For Jackie

Phaidon Press Limited, Littlegate House, St. Ebbe's Street,
Oxford, OX1 1SQ

First published 1985
© Phaidon Press Limited 1985

British Library Cataloguing in Publication Data

Jacobs, Michael
 The good and simple life: artist colonies in Europe and
 America
 1. Artist colonies—History—19th century 2. Painters
 I. Title
 759.05 N6465.A7/

 ISBN 0-7148-2315-5

Designed by Sarah Tyzack, Oxford

Typeset, printed and bound in Great Britain by Butler &
Tanner Ltd., Frome and London

FRONTISPIECE: Percy Craft painting at Bellevue, Newlyn,
*c.*1886

Contents

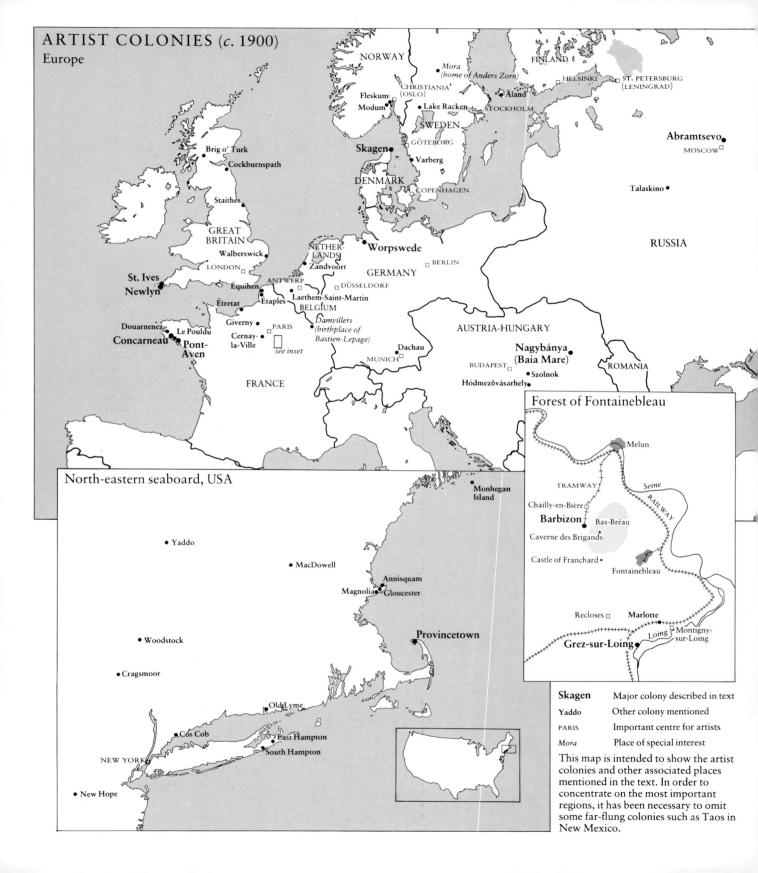

ARTIST COLONIES (*c.* 1900)
Europe

NORWAY
Mora
(home of Anders Zorn)
FINLAND
□ HELSINKI
● ST. PETERSBURG
(LENINGRAD)
Fleskum ●
CHRISTIANIA
(OSLO)
● Åland
Modum ●
● Lake Racken
STOCKHOLM
SWEDEN
GÖTEBORG
● Abramtsevo
MOSCOW □
Skagen ●
● Varberg
Brig o' Turk ●
Cockburnspath ●
DENMARK
□ COPENHAGEN
Talaskino ●
Staithes ●
GREAT
BRITAIN
RUSSIA
Worpswede ●
Walberswick ●
NETHER-
LANDS
□ BERLIN
LONDON □
Zandvoort ●
GERMANY
St. Ives
Newlyn
ANTWERP
□ DÜSSELDORF
Équihen ●
Laethem-Saint-Martin ●
Étretat ●
Étaples ●
BELGIUM
AUSTRIA-HUNGARY
Giverny ●
Damvillers
(birthplace of
Bastien-Lepage)
Douarnenez ●
● PARIS
Le Pouldu ●
Nagybánya
(Baia Mare) ●
Concarneau
Pont-
Aven
Cernay-
la-Ville ●
see inset
● Dachau
BUDAPEST □
ROMANIA
MUNICH □
● Szolnok
Hódmezővásárhely ●
FRANCE

North-eastern seaboard, USA

● Monhegan
Island

Forest of Fontainebleau

● Melun
TRAMWAY
Seine
Chailly-en-Bière ●
RAILWAY
Barbizon ●
Bas-Bréau ●
Caverne des Brigands
Castle of Franchard
Fontainebleau
● Yaddo
● MacDowell
Annisquam ●
Magnolia ●
● Gloucester
Recloses □
Marlotte ●
Provincetown ●
Montigny-
Loing
sur-Loing
● Woodstock
Grez-sur-Loing
● Cragsmoor
Old Lyme ●
● Cos Cob
East Hampton ●
NEW YORK
South Hampton ●
● New Hope

Skagen	Major colony described in text
Yaddo	Other colony mentioned
PARIS	Important centre for artists
Mora	Place of special interest

This map is intended to show the artist colonies and other associated places mentioned in the text. In order to concentrate on the most important regions, it has been necessary to omit some far-flung colonies such as Taos in New Mexico.

Preface

THIS BOOK deals with a major yet little-studied phenomenon of the late nineteenth century—the formation of artist communities in country districts throughout Europe and America. These places were formed to meet a growing interest in open-air painting and the portrayal of rural life. They can also be seen as part of a widespread back-to-nature movement that developed at a time of rapid urban and industrial expansion.

I have made no attempt to write a comprehensive history of this phenomenon, but have concentrated instead on a number of individual colonies. The ones which I have chosen to study in this way are from virtually all the major countries where such places took root and are those which were regarded as among the most important in their time. Such a choice is of course also and inevitably affected by purely subjective factors. There are notable omissions (in particular Laethem-Saint-Martin in Belgium, which has already been the subject of three books), and at least one questionable inclusion. This is Abramtsevo in Russia, which was really more of an Arts and Crafts community than an artist colony. I have none the less included it for the sake of variety and also because it illustrates another facet of the nineteenth-century obsession with peasant life, which is so central to the book as a whole. At other times I have been swayed in my choice of places by the amount or interest of the available material relating to them. I have also tried to follow the careers of certain artists from one colony to another, and thus to give a tentative narrative continuity to the book.

My task in writing this book would have been much easier had I decided to limit myself to a discussion of the works produced in the artist colonies, and of the ideas that led to the formation of these places. However, to me the particular attraction of the subject lay in the opportunity which it gave to delve into the minutiae of artist life. Much of the material which I have included would be dismissed by many art historians because it has no direct relevance to art, and by others because it is too ephemeral and anecdotal. I feel none the less that the type of history which discusses simply objects, ideas, or sociological patterns, can be a limited one. The circumstances surrounding the creation of a work of art invariably make for more interesting reading than an analysis of a work's style; what an individual says or professes to believe in frequently bears little relation to what he actually does; and any attempt to reduce the past to simple patterns has necessarily to ignore the quirks of human behaviour that make history so much easier to relate to one's own everyday experiences.

The research for this book has been carried out in eleven countries and involved the participation of an especially large number of people. Some have openly shared their recollections of a particular colony or artist, others have made freely available their scholarship. Many have contributed in other no less important ways, ranging from offering generous hospitality during my research trips to assisting with translations.

A grant from the British Academy made possible much of my travelling in France, the USA, Scandinavia, Germany, and Britain. The British Council has also been an invaluable support, and has sponsored my visits to the Soviet Union, Hungary, and Romania in collaboration with the governments of these countries.

In France I was helped by Anne Merle d'Aubigné,

André Cariou of the Musée des Beaux-Arts at Quimper, Yann Daniel, M. Queinec of the Collège de Benaros at Pont-Aven, and Patrick Ramade of the Musée des Beaux-Arts at Rennes. Corinne Colomb talked to me about her grandparents, Frank Chadwick and Emma Löwstadt, and was also kind enough to give me photographs from her family album. Duncan and Nancy Caldwell were wonderful hosts in Paris, while David and Ruby Turner took me all over the Fontainebleau forest. Much of the book was conceived and written while lecturing at the Cleveland Institute of Art at Lacoste in the Vaucluse. I am very grateful to the director of studies there, Bernard Pfriem, for his advice and kindness (both in Lacoste and in New York) and to the students of his institute, on whom were tried many of my ideas for the book.

The USA turned out to be an exceptionally fruitful centre for my research. The efficiently organized Archives of American Art provided me with my main source of unpublished material: I would like to thank the staff of their offices in New York, Boston, and Washington, and in particular Bill McNaught and Bob Brown. The following were also of great assistance: Doreen Bolger Burke of the Metropolitan Museum of Art in New York; Eleanor Crowley of the Ipswich Public Library, Ipswich, Massachusetts; the staff of the Hirschl and Adler Gallery, New York; Ronald McKnight Melvin, director of the Terra Museum of Art, Evanston, Illinois; and Joseph Amarotico and Kathy Stover both at the Pennsylvania Academy of the Fine Arts, Philadelphia. I am particularly indebted to David and Anne Sellin, who have helped the book in numerous ways, not least by directing me to important American archival sources. I have talked to many people about their personal memories of Provincetown, including Emily Dickinson, Stanley Kunitz, Chris Magreel, Myron Stout, the late Jack Tworkoff, Brita Walker, Hazel Hawthorne Werner, and Tessim Zorach. Bruce McKain not only supplied me with colourful anecdotes about his teacher, Charles Hawthorne, but also introduced me to Provincetown's Beachcomber's Club. Reggie Cabral, proprietor of the infamous A-House bar at Provincetown, brought the town vividly to life for me through his recollections, and offered me a privileged glimpse of his unsurpassed collection of literature, paintings, and memorabilia relating to the colony; with remarkable generosity he also gave me a copy of the exceedingly rare *Lorelei* magazine, which includes the map reproduced on p. 179. However, my greatest debt in Provincetown must be to Susan Slocum, for-

merly director of the Fine Arts Work Center there: with her great energy and what she termed 'civic duty' she saw to it that all my time in the town was usefully and pleasantly employed, and even provided me with a beautiful old house by the sea. Among the many others who have been hospitable to me in the USA, I would like specifically to mention Laurel Bradley, Mary Dean, Ben Grossof, Anne Lobe, Paul Resika, Patrick and Anna Maria O'Riley, Alan Solomon, Cathy and David Silver, Caroline Simon, and Ian Wardropper.

Everywhere I went in Scandinavia I met with an extraordinary willingness to help, which encouraged me to expand my researches. Invaluable scholarly assistance was given by Marianne Brøns of the Statens Museum for Kunst, Copenhagen; Hans Brummer of the Zorn Museum, Mora; Jan af Búren and Dr Gorgel Cavalli-Björkman of the Nationalmuseum, Stockholm; Björn Fredlund, director of the Göteborgs Konstmuseum, Göteborg; Ulwa Neergaard, director of the Larsson Museum, Sundborn; Dr Aimo Reitala, director of the Art History Institute of Helsinki University; Annette Stabel of the Hirschsprungske Samling, Copenhagen; Oscar Thue of the Nasjonalgalleriet, Oslo; Dr Henri Usselmann of the Art History department of Göteborg University; and Knud Voss, director of the Skagens Museum, Skagen. Hans Nielsen of the Skagen Library was a great help in securing photographs and tracking down little-known articles on the Skagen artists. A delayed train from Göteborg to Oslo had the fortunate consequence of my striking up a conversation with Dr Steinar Gjessing, director of the Kunstnerns Hus in Oslo. Thereafter Dr Gjessing acted as an excellent host and guide in Oslo, and tirelessly provided me with information on late nineteenth-century Norwegian art. Dr Leena Ahtola-Moorhouse of the Ateneum in Helsinki also devoted a great amount of time to helping me: much of my knowledge of and enthusiasm for Finnish art is due to her. Jan Böstrom, Kenneth Johnson, and Endre Nemes all looked after me well in Stockholm, and Tuukka and Anja Talvio saw to my well-being in Helsinki. John Lind both put me up in Copenhagen, and kindly read through a draft of my chapter on Skagen.

Most of my research in Germany was done in and around Bremen, where I enjoyed the company and help of Jutta Schönrock and Andreas Wesdholz. Gunther Busch, director of the Kunsthalle in Bremen put me right on a number of points about the Worpswede artists. Hans Rief of the Haus im Schluh in

Worpswede acted as my guide to the archives there, and Peter Else of the Worpswede Verlag gave me access to his remarkable collection of old photographs.

My stay in the Soviet Union was organized by the Ministry of Culture, two of whose employees, Mikhail Mikleev and Tatiana Antonova, spent time with me in Moscow and Leningrad. Tatiana Litvinova and Tatiana Matvejeva were my interpreters, and also helped me to cope with the complexities of the Lenin Library in Moscow. I had discussions on Russian art with Nina Aleksandrovna, director of the Viktor Vasnetzov Museum in Moscow; V. M. Volodarski of the Tretyakov Gallery, Moscow; Helen Kirillina, director of the Repin Museum, Repino; Nikolai Novanspensky of the Russian State Museum, Leningrad; E. Pastóne of the Abramtsevo Museum; and Apollinary Vasnetzov. Terry Sandell, the British assistant cultural attaché in Moscow, made a number of useful suggestions for my research.

In Hungary, where I was also a guest of the local Ministry of Culture, I benefited enormously from the hospitality and scholarship of Dr László Barlé-Szabo of the Institute for Art History in Budapest; Dr Éva Bodnár of the Hungarian National Gallery; Marie Csernitzky of the Janus Pannonius Múzeum in Pécs; and Maria Égri of the Damjanich János Múzeum in Szolnok. The staff of the Hungarian National Gallery were particularly keen to ensure that my visit to the country was a success: above all I must thank Judith Pálosi, who did much to encourage my interest in the Nagybánya artists. It was also through her that I was able to meet Elizabeth Ferenczy, who talked to me at length about her husband, Béni, and her childhood in Nagybánya. Lia Radocsy, István Szabo, and Lajos and Sophie Svaby were among the many others who made me feel so greatly welcome in Hungary. Árpád Szabados and Íldikó Varnagy were especially kind to me; and their daughter, Réka, gave me my first lessons in the Hungarian language. Special mention must also be made of my interpreter, Judith Polgar, who in addition to being remarkable in her job, did more than anybody else to increase my awareness of Hungarian history and culture.

In Romania I was the guest of the Union of Artists, whose president is Ion Gheorghiu. It would be impossible to list all the artists to whom I was introduced in Bucharest, Baia Mare (Nagybánya), and Cluj. I shall remember in particular the friendship and hospitality of Mircea and Doina Bochis, Ilie Cămănsăn, Doina and Victor Ciato, Gusztav Cseh, Nicolae

Maniu, Jutta Pallos, Alex Seinelic, and Mircea Toca. Antónia Csikós, Aurel Ciupe, Sándor Móhy, and Albert Nagy all talked to me about their experiences in Baia Mare in the early years of this century. Jenő Murádin, Negoitā Lāptoiu of the Art Gallery in Cluj, and Georghe Vida of the Art History Institute in Bucharest, all gave valuable scholarly advice. Most useful of all the academic contacts I made in Romania was Raoul Sorban, with whom I discussed on several occasions the artistic history of Baia Mare. The British Council staff in Bucharest were all unfailingly helpful: in particular I must thank the assistant cultural attaché, Theresa Kassel, who accompanied me and my excellent interpreter, Lydia Ionescu, on my trip to Baia Mare.

I was greatly helped in my chapter on the colonies at Newlyn and St. Ives by Michael Canney, formerly director of the Newlyn Art Gallery; Francis Greenacre of the Bristol City Museum and Art Gallery; Anna Gruetzner of the Art History department of Reading University; John Halkes and his staff at the Newlyn Art Gallery; and Roy Ray of the St. Ives School of Art. I have incurred numerous other debts in Britain. I would like to thank the following for their various kindnesses: the late Sir John Betjeman, the late Professor Anthony Blunt, Jill Craye, Fintan Cullen, Erica Davies, Joe Earle, Nick Green, Jennifer Johnson, Dilwyn Knox, Amanda Lillie, Claudia Nabr, Gillian Perry, Paul Stirton, Donald Watson, and Adam Yamey. Jytte and Roger Hardistie made excellent companions on a visit to Skagen, and Jytte gave an enormous amount of help with Danish texts. Others were no less generous in the time they spent translating books and articles for me. Alexander Elkin and Elena Schapiro assisted with Russian texts, and Karen Bamborough and Peter Herring with Norwegian and Finnish ones respectively. Without the help of Helen Tarnoy for Hungarian texts, and of Antonia Böstrom and Christine Stevenson for Danish and Swedish ones, this book would scarcely have been possible.

Many others of my friends and family have given me encouragement at every stage of the book, and have had to put up with countless stories connected with it. I am grateful to all of them, but especially to my parents, David and Mariagrazia Jacobs, and to Liz Burrett, Richard Cowan, and Ian and Jackie Rae. Finally, I would like to thank the staff at Phaidon Press for having faithfully borne with me throughout my wanderings. My thanks in particular to Peg Katritzky, David Morgenstern, and Jean-Claude Peissel.

M.J.

1
The Academy of Nature

INTRODUCTION

THE FASHION for belonging to an artist colony in the country was essentially one of youth, and can only fully be understood with a knowledge of changes in the training of young artists.

Until well into the nineteenth century, an artist's education was not considered complete until he had spent a time in Rome. The artists who went there from all over Europe and America, finding themselves in an exciting but alien environment, and often not speaking Italian, naturally tended to mix with artists from their own countries. These foreign communities began to be associated with specific parts of the city and also with individual restaurants or bars. At the beginning of the nineteenth century a group of German artists, later to be called the Nazarenes, went one step further and moved to a disused monastery on the outskirts of Rome, where they grew their hair long and wore archaic robes.

In the course of the nineteenth century other European cities developed as international art centres, most notably Düsseldorf, Munich, Antwerp, and, above all, Paris, which by the 1870s had come to supersede Rome as the artistic capital of the Western world. Alongside this shift away from Rome was a dissatisfaction with conventional academic training, which insisted on the supremacy of historical and mythological painting, and forced the artist to copy from the antique and work indoors, often in artificial light. The consequent desire to paint naturalistic subjects in the open air constituted initially almost an act of rebellion among the young. At first the open-air, or 'plein-air', painters devoted themselves mainly to the execution of modestly sized landscapes, but by the 1880s they had also taken on the less practical task of painting outdoors life-sized figure scenes.

The earliest large concentration of open-air painters was in the forest of Fontainebleau, about forty miles to the south of Paris. It was here, at the hamlet of Barbizon, that there grew up the most famous of all the rural artist colonies. Today Barbizon is remembered almost exclusively for a handful of French painters who came here, at a relatively late stage in their careers, in the first half of the nineteenth century. These painters are the ones generally referred to as the Barbizon School. Yet Barbizon's importance as a colony dates really from the time when open-air painting had come to be a widely accepted part of the art student's life in France. From the 1850s onwards the great majority of the artists who worked in the hamlet and its surroundings comprised a transitory crowd of art students from Paris. Moreover among

1 Ditlev Conrad Blunck, *Danish Artists at the Osteria La Gensola in Rome* (seated on the right is the distinguished neoclassical sculptor Bertel Thorvaldsen; Blunck himself is seated third from the right), 1837. Thorvaldsen Museum, Copenhagen

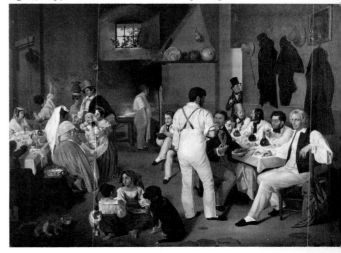

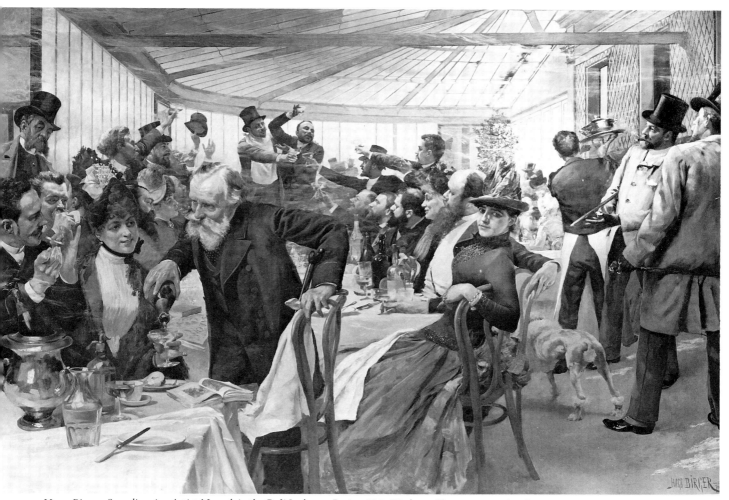

2 Hugo Birger, *Scandinavian Artists' Lunch in the Café Ledoyen, Paris*, 1886. Göteborgs Konstmuseum, Sweden

these was an ever-growing number of foreigners. As in Rome, the foreign artists in Paris tended to group together according to their nationalities, and it was only natural that they should continue to do so when they moved out into the country. By the mid-1870s there were probably more foreign artists in Barbizon than French ones. These foreigners also began to dominate—sometimes completely—the many artist colonies that by now were being set up elsewhere in rural France. In many cases colonies were formed simply because a cluster of foreign artists decided to put up at a particular village or small town. This is for instance what happened at Pont-Aven, which came to rank with Barbizon as the most famous of the French colonies.

With the increasing popularity of open-air painting in France in the second half of the nineteenth century, many artists started spending sometimes over half their year working in the countryside. The exodus from Paris took place early in the summer, following the closure not only of the art schools but also of the annual government-sponsored exhibitions, known as the Salons. The American painter Howard Russell Butler wrote to his sister on 3 July 1885: 'The Salon is over. The medals have been given. A new art fiscal year has begun. Paris has no longer any attractions for the artist—in a week's time they will nearly all be gone.' Once in the country, many of the artists, after an initial period of acclimatizing themselves to their new surroundings, would embark on the major picture

that they intended to submit to next year's Salon. Generally they would begin by making a series of oil sketches, and would not get round to working on the large canvas until early in the autumn. By the winter most of the artists would be back in Paris, where they would put the finishing touches to their picture; some, however, stayed on in the country right up to the opening of the Salon in the spring. Artists at the very beginning of their careers were usually advised not to attempt any ambitious canvas until they had spent at least one season in the country doing nothing but outdoor sketching. Some of them would defer the moment of transition from mere daubing to doing truly serious work almost indefinitely, and eventually have to accept that they were artistic failures. Most of them, however, could hardly wait to begin on their Salon piece. A success at the Salon meant invariably that one was fully established as an artist, and in consequence could enjoy financial independence, buy a house, marry, and, in the case of foreign artists, return home to what they hoped would be a hero's welcome.

For young artists there were innumerable advantages to working in the country in colonies rather than on their own. Quite apart from being with a group of people with whom they could freely socialize, it was often beneficial, especially for those who were very unsure of themselves, to have artists always on hand to criticize their work and offer suggestions. Furthermore these colonies were always exceptionally cheap. In fact the usual reason for artists choosing to popularize a particular place was the presence there of an inn whose landlord or landlady was sympathetic to their needs, and realized the ultimate advantage of keeping prices low and offering extended credit. Finally it was much easier for an artist to obtain models in a place where the locals had become used to seeing artists at work and had overcome some of their initial suspicions about them.

The development of open-air painting in the nineteenth century is generally seen as part of a movement in the arts towards realism and away from romanticism. This is misleading. The naturalistic concerns of the open-air painters hid an attitude towards the rural environment and its people which was inherently romantic and bound by conventions no less rigid than those which in earlier periods had led artists in search of sun-drenched landscapes corresponding to visions of antiquity, or wild mountainous regions fulfilling notions of the sublime.

In almost all the places where colonies were established, the artists fancifully saw their surroundings in terms of a primitive world far removed from modern civilization. These places were in fact hardly remote; indeed, they developed as colonies largely as a result of the spread of the railway network. However, they were to be found in rural areas that previously had not been considered especially beautiful and had certainly been little visited by tourists. As the English painter Stanhope Forbes wrote of Cancale in Brittany: ''tis well enough but by no means interesting except to us painters'. All the colonies that were set up in France in the nineteenth century were in the north and north-west of the country. The Alps and the Mediterranean coast had little appeal to this generation of painters. Instead they loved relatively flat and often bleak countryside lit by grey skies. And it was essential that such areas should be populated by old-fashioned peasant and fishing communities.

'One of the notable features of our century is the interest shown by artists, literary and pictorial, in the lower classes . . .' So began an article entitled 'A Painter of Peasants' in the *Magazine of Art* for 1885. The obsession with traditional rural life was indeed central to late nineteenth-century culture. A legend grew up around the peasant comparable to that of the 'noble savage' in the eighteenth century. He was regarded as a figure of great moral worth, someone uncorrupted by the sophistications and materialism of the modern world. Tolstoy was perhaps the most famous writer of this period to discuss at length the virtues of the peasantry. For him these people were not simply among the worthiest subjects for artists and writers to portray. They also had attitudes themselves towards life and art that he thought offered a solution to contemporary ills. He found that most of the art of his time was a reflection of the decadence of the wealthy classes and that it had 'sunk to the transmission of the feelings of pride, discontent with life, and above all—sexual desire'. In contrast, according to his English friend and translator, Aylmer Maude, he learnt that 'in the souls of primitive folk dwells a susceptibility to the infection of art—a susceptibility often atrophied in sophisticated people interested in the technicalities of art but whose feelings are sterilized'. Once, Tolstoy returned home from a long walk feeling very depressed, and was immediately cheered up by the singing 'of a large choir of peasant women'; later in the day he attended a Beethoven concert which left him completely unmoved.

The belief that modern civilization had been corrupted by losing contact with the soil led to the

formation in the late nineteenth century of innumerable experimental communities. Tolstoy himself, who took to the wearing of peasant costume, started up on his estate at Yasnaya Polyana a community run on the principles of self-sufficiency and the simple life. His example was emulated all over Europe and America. One of the most famous of these Tolstoyan communities was at the village of Whiteway in the English Cotswolds. Here people of many different nationalities joined in the hay- and bread-making, lived in crude mud-filled buildings, shared underwear, and dabbled in anarchism, communism, nudism, and free love. Less extreme were the various Arts and Crafts communities that were formed at this time, mainly under the inspiration of the English writer and craftsman William Morris. One such place was at Chipping Campden near Whiteway. This was founded by the architect C. R. Ashbee, and was organized as a medieval guild. Apart from advocating the virtues of the hand-made as opposed to the mass-produced craft object, its members made their own clothes and beer, and extolled the pleasures of traditional English cheese. In common with most experimental communities, Ashbee's eventually fell apart as a result of financial pressures, sexual tensions, and the onset of middle age among its members.

The English painter and critic R. A. M. Stevenson, in an essay on the artist colony at Grez-sur-Loing, referred to the French colonies as places 'where more than half the ideals of the nineteenth century have been hatched'. The artists who associated with these places enjoyed communal activities, the Bohemian life-style, wearing peasant costume, and, perhaps to a lesser extent, the simple country existence. They also felt at times a superiority to the conventional middle-class town-dweller. In all this they can be seen to have formed part of that same idealistic, anti-materialistic movement to which the experimental communities belonged. Yet for the most part these artists could hardly be called radical in their beliefs. Moreover they were largely apolitical, as is illustrated in their attitude towards the downtrodden country folk whom they so liked to paint. They considered these people as little more than quaint components of the rural scene; their social conscience was as little stirred by them as was that of seventeenth-century artists by pipe-playing goatherds in the Roman Campagna. They almost seemed to condone poverty and backwardness because it was picturesque, and at heart resented any material improvement in these people's condition because this meant that attractive old costumes and traditions would disappear.

No less than others of their generation, the painters of the French colonies had a belief in the peasant or fisherman as a noble being. Yet they had more experience than most of dealing with them, not simply through living in the same places, but also through having to use them constantly as models. Getting to know them on a personal level like this, they often began to dislike them, and often for the same reasons that they found them picturesque: namely, that they were dirty, foul-smelling, bigoted, and ignorant. What meanwhile did the country folk think of having an invasion of artists in their villages? Their reactions were very much as one would have expected. They were often initially suspicious, bewildered, amused, and sometimes even antagonistic. However, they were also sensible enough to realize the financial advantages to be gained from having large numbers of artists around: easy money could be had from providing food, accommodation, and studio space,

3 Eduard Vogeler, brother of the painter Heinrich, dressed as a peasant woman, Worpswede, c.1900

posing for the artists, and even charging them (often illegally) for painting on their land. Moreover, in places where photographers hardly came, it flattered their vanity to have likenesses made of themselves.

Tolstoy listed as the great writers of his age Victor Hugo, Dostoevsky, and Charles Dickens. The painters whose names he ranked alongside theirs were all specialists in peasant subject-matter: Jean François Millet, Jules Bastien-Lepage, Léon L'Hermitte, and Jules Breton. Others of Tolstoy's generation might perhaps have questioned his assessment of the last two, but almost all would have agreed with him about Millet and Bastien-Lepage, who acquired an almost legendary stature in their lifetimes. Their reputations were certainly helped by their both having had peasant upbringings, albeit extremely privileged ones. The fact of their peasant birth was given great prominence in all the early writings on them, which also emphasized their complete dedication to work, their moral purity, and the happiness of their childhoods. Bastien-Lepage's background was compared extremely favourably with that of his companion, Marie Bashkirtseff, who was, in the words of Bastien-Lepage's biographer, Theuriet, 'the offspring of Tartar nobles . . . descended from owners of land and serfs'. Theuriet continues: 'Just as Marie's parents lived apart in painful disunion, those of Bastien-Lepage were united by the tenderest family affection . . . Country life, with its primitive simplicity and its regular succession of daily tasks, sank deeply if unconsciously into the little fellow's mind.'

Millet, who lived for most of his life in Barbizon, was the first major painter to devote himself to the portrayal of the rural poor. His approach to such subject-matter was rarely sentimental or anecdotal. Instead he did away with expression and excessive detail, and aimed to capture in his work what he thought to be the timeless, biblical qualities of the peasant. In contrast to Millet, Bastien-Lepage has suffered a great decline in reputation this century. In many ways he was the more influential of the two and was certainly regarded as the more proficient technician. Although he worked only very briefly in an artist colony, he rose to fame in the late 1870s and early 1880s, when the fashion for artist colonies was at its height, and he can be seen almost as the hero of the whole movement. Technically he was praised for tackling large figure scenes out of doors (he was one of the first to do so), alternating broadly handled areas of paint with meticulously detailed ones, and for the subtlety of his overall grey tonalities. In addition, his work had a strong sentimental appeal, as well as an occasional element of symbolism (as, for instance, in his *Père Jacques*; plate 1), which seemed to confirm his profundity as an artist. Butler saw a retrospective of his work in Paris in 1885, and wrote about it to his family: 'Lepage was a revelation to me . . . some parts of his pictures are carried very far so that they could stand inspection with a microscope. Other parts are barely suggested with large washes of colour. But Lepage is more than a good painter . . . every picture of Lepage's attracts you because of something which has to do with sentiment and human nature and all that, but which though I feel it, I cannot define.'

Today there is a tendency to think of late nineteenth-century art in terms primarily of a stylistic process leading from the open-air practices of the so-called Barbizon School, through to the spontaneous and colourful brushstrokes of the group of painters known as the Impressionists, and finally to the supposed rationalization of the latter's techniques by the tenuously defined Post-Impressionists. Such an approach to the art of this period leaves little room for a discussion of the grey works of Bastien-Lepage and

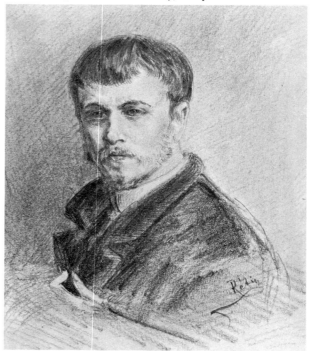

4 István Réti, *Copy of Self-Portrait by Bastien-Lepage*, early 1890s. Hungarian National Gallery, Budapest

5 Jules Bastien-Lepage, *The Beggar*, 1880. Ny Carlsberg
Glyptotek, Copenhagen

his countless followers all over the world. These artists
had a far greater importance in their time than their
contemporaries, the Impressionists. The latter were
not widely known or fully understood until as late as
the 1890s: if they were admired before that time, it was
often on account of their being realists and not for the
technical advances for which they are best known
today. To present-day tastes the purely visual qualities
of a work of art seem often more worthy of attention
than the subject-matter. Yet by bringing such biases to
the study of late nineteenth-century art, one is likely to
underestimate what must surely be one of the most
significant characteristics of the art of this period—the
obsessive interest shown by artists in subjects of
traditional rural life.

Just before his death, Bastien-Lepage told a young
painter, Louis de Fourcault, that an artist who had no
roots could not be a proper artist, and that it was much
better to paint the countryside in which one was
brought up than to work in alien surroundings.
Bastien-Lepage himself had executed almost all his
greatest paintings in and around his native village of

Damvillers near Verdun. His words to Fourcault,
which were printed in the *Gazette des Beaux-Arts* in
February 1885, seem to have echoed the feelings of the
innumerable foreign artists who had settled in France
but who had come to long to return to their home
countries. In the course of the 1880s many of these
artists did in fact return home, although invariably
they found themselves in an artistic environment
which seemed to them very conservative in com-
parison to that which they had recently been used to.
They began to feel nostalgic for their days in France;
those among them who had been associated with an
artist colony there, frequently came to join or found
other such communities. The growth of these places,
however, was not an expression simply of Franco-
philia, but also of the nationalistic sentiments that had
brought so many of the artists home in the first place.
By associating themselves with parts of the country
where rural and folklore traditions had been well
preserved, the artists liked often to feel that they were
sowing the seeds of a revival of national culture.

Many of the artists who came to work in the
colonies outside France were no longer young, and
they frequently intended their stays in these places to
be permanent rather than just a transitory stage in
their artistic development. Many of them lived to see
their artistic principles severely challenged, their own
ideals fade, and the spirit of camaraderie that had once
infused their communities destroyed by personal
tensions. But by the latter years of the nineteenth
century the character of artist colonies everywhere
was changing radically. As a result of press interest
they had come to attract a growing number of amateur
artists—mainly women—and, above all, tourists. As
the painter Henry Bacon wrote: 'Follow artists and
journalists and you will find something worth finding.'
The fascination of the colonies for tourists derived
from both a belief that a place greatly favoured by
artists must be interesting, and a curiosity about the
artists themselves, who were usually imagined to be
strange creatures; when a group of tourists once
visited the colony at Old Lyme in Massachusetts and
asked where the artists were, the latter understandably
responded by dropping to the ground on all fours and
making barking noises. Yet it was not these crowds of
amateurs and tourists that led, in the early years of this
century, to the declining interest shown in colonies by
serious artists. It was simply that by now the practice
of open-air painting and the portrayal of rural life had
ceased to be vital artistic concerns. A number of
artistic colonies continued to thrive well into the

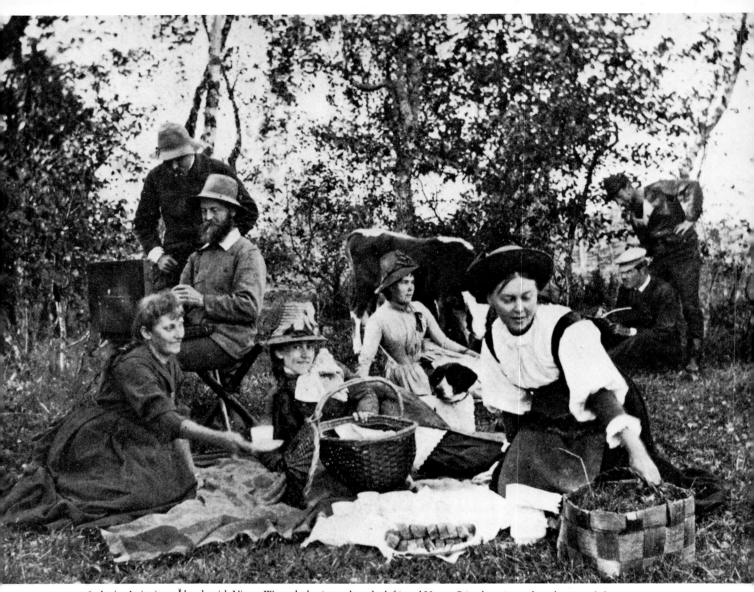

6 Artists' picnic at Åland, with Victor Westerholm (seated on the left) and Hanna Rönnberg (seated on the grass, left)

twentieth century, some even up to the present day. However, in their later years they lived largely off their reputation for being enclaves of Bohemia and can certainly not be seen to form part of any major artistic movement.

The Irish painter Henry Jones Thaddeus, reflecting on his days spent at the colonies at Pont-Aven and Concarneau, wrote: 'The life in the open air, together with the absorbing occupation of painting from nature, followed by the pleasant reunions in the evenings, constituted an ideal existence to which I know no parallel.' Other artists did not share his

enthusiasm. Albert Besnus, for instance, found that 'artists like canvases are best seen at a distance'. Perhaps the most accurate characterization of the colonies was given by R. A. M. Stevenson, who once said: 'Any writer could tell you that they found those colonies more suited for the study of the human heart than for that of trees or rocks. You saw the very bones and muscles of the passions laid bare.' Ultimately the study of artist colonies has a relevance beyond that to art history. It enables one to see in almost comic close-up the conflict between human ideals and behaviour.

2
The Bethlehem of Modern Painting

BARBIZON AND GREZ-SUR-LOING (FRANCE)

THE AMERICAN writer James Fenimore Cooper visited the forest of Fontainebleau in 1827 and is said to have found the place 'exceeding in savage variety' anything that he had seen in his native country. This rather extravagant description was echoed by innumerable visitors to the region in the nineteenth century, many of whom even liked to imagine that the forest was inhabited by Druids. When the English painter and critic Henry Naegely came here in the 1850s he found his surroundings so primitive that he felt as if he were 'hundreds of miles from Paris'.

This place, supposedly so wild and evocative of a primeval past, was in fact in the sixteenth century associated with one of the most sophisticated court cultures of the Renaissance. In what is now the town of Fontainebleau, right in the heart of the forest, the French king Francis I decided to build a palace incorporating the most advanced features of contemporary Italian art and architecture. The presiding spirit here was the goddess Diana, who featured prominently in the palace's painted and sculpted decorations, and was constantly alluded to in the poetry and music of the court. Her pre-eminence was intended partly as flattery of the King's mistress, Diane de Poitiers, and partly because of her role as goddess of hunting, which was one of the main recreations of the court. The forest itself must certainly have been seen by many of the courtiers in terms of the sylvan Arcadia inhabited by Diana and her maidens and as described by classical authors such as Ovid; indeed, in the work of the group of court poets known as the Pléiade, the real world of Fontainebleau and the world of classical mythology were curiously intermingled. After the death of the King, the palace declined in importance, and was to survive only in its more prosaic capacity as a hunting-lodge. It was to assist hunting that in the time of Louis XIV the surrounding forest was tamed by the construction of a network of straight avenues.

At the very beginning of the nineteenth century, visitors other than hunters once again began to explore the forest. One of these was a reclusive writer called Étienne Pivert de Sénancour, whose largely autobiographical book *Obermann* (1804) contains long descriptions of the place. For de Sénancour the forest had a mysterious beauty and was ideally suited for solitary contemplation. Yet he admitted that it lacked the spectacular and sublime qualities admired by his romantic contemporaries, and that without its trees it would simply be 'a monotonous surface . . . a frivolous and meaningless assemblage of little healthy plains, of small ravines and meagre rocks handsomely consorted'.

By 1820 the forest had already become popular with landscape painters. Many of them stayed at the village of Chailly on the north-eastern edge of the forest. Barbizon, about two miles to the south of this, was 'discovered' in the early 1820s, supposedly by two minor followers of the landscape painter Camille Corot, d'Alibert and Caruelle d'Aligny. Up to the 1850s Barbizon was a hamlet of modest thatch-roofed houses, often overgrown with large patches of green moss; there were no shops, school, or church. Situated between the forest and flat agricultural plain to the west, the place was populated by both foresters and peasants. A number of people at Barbizon made a living by such menial activities as collecting dead wood from the forest (competitions among the more

elderly of these so-called faggot gatherers as to who could carry the largest pile of wood resulted in death on at last one occasion) and gleaning what was left over from the harvest. Millet's friend and biographer Alfred Sensier described Barbizon at this time as being inhabited by an 'almost primitive people who built their thatched houses under the trees and next to meagre pastures, and who seemed to retain memories of Druidical rites in their veneration of St. Martin'.

The extent to which Barbizon was a poor and primitive place is debatable. A contemporary of Sensier, the American painter George Wheelwright, even described the hamlet as being a 'prosperous place' and with 'no real poverty'. At all events many of Barbizon's inhabitants profited from the growing number of artists who came here in the wake of d'Aligny and d'Alibert. One such local was François Ganne, a tailor whose wife ran a grocery store in Chailly. Ganne owned two houses in Barbizon, the smaller of which—where he and his family originally lived—he let to d'Aligny at the beginning of the 1820s. Ganne subsequently moved into the larger house, and in 1824 decided to turn this into an inn. It was largely through the success of this inn that Barbizon was to develop into such an important artist resort.

Among the early artist visitors to Barbizon was Corot himself, who was first introduced to the forest in the 1820s by d'Aligny and d'Alibert, and who became an *habitué* of Ganne's inn from 1832 onwards. He in turn encouraged one of the most successful of his followers, Louis Français, to join him in Barbizon; these two artists were among those who initiated the series of painted decorations which were originally intended just for the dining-room of Ganne's inn, but which gradually began to spread to every corner of the house. Another important arrival at Barbizon during this early period was Théodore Rousseau, who began painting in the forest in 1827–8 and was installed in Barbizon from 1836. Whereas Corot attempted to convey with the simplest of means the shimmering tonalities of the forest, Rousseau, taking his inspiration from the seventeenth-century Dutch landscapist Jacob Ruisdael, was more interested in the drama of the forest, and loved isolating and dramatically lighting motifs such as gnarled oaks, which he imbued with almost symbolical significance. A one-legged painter of Spanish origin whom Rousseau met in 1836, Narcisse Diaz de la Peña, came to work with him at Barbizon that year, and assisted in the decoration of the dining-room at Ganne's; Diaz was greatly influenced by Rousseau's approach to landscape, but developed a more striking freedom of brushstroke. A lesser disciple of Rousseau's was Jules Dupré who also came to Barbizon at about this time. With the exception of Daubigny and above all Millet, the nucleus of painters later referred to as the 'Barbizon School' had been formed.

Just at the time when Barbizon was becoming rapidly established as an artist resort, the exploitation of the forest by those anxious to make a quick profit through the felling of trees and the quarrying of stone had begun in earnest. As early as October 1835 an article in a local newspaper included the following warning: 'Barbizon, you will soon became widowed of artists; soon the doyenne of innkeepers' wives, old Mother Ganne, will unlock her stewing-pot . . . for the woodcutter's destructive axe is threatening the old oaks.' In 1839 an equal if less obvious threat to the forest was posed by the publication of a book entitled *Guide du voyageur dans la forêt de Fontainebleau*. Its author, Dennecourt, knew the forest intimately, and had devised a way in which the whole area could be seen by the tourist in just five walks of about six hours each (or two walks of two hours each for those who had less time on their hands). Dennecourt frankly admitted in his introduction to the guide that as he had not the imagination of the poet or the painter to convey any of the special atmosphere of the forest, he simply hoped to offer practical assistance to the tourist. He devoted the rest of his life to this task. However, he did not simply limit his endeavours to the printed page, but blazed a series of well-marked trails throughout the forest, built look-out towers, and gave names to certain rocks, trees, and hills (such as the Crying Rock, the Eagle's Nest, Druid's Tree, and Mount Peleus) to which he directed the tourist by putting up large unsightly signs, and which he tried to make more interesting by creating spurious stories pertaining to them. In the choice of these sites he had been influenced by the number of artists whom he had seen working beside them. Naturally enough, the artists themselves, who had given Dennecourt such unconscious assistance, were the most indignant about his activities. To them Dennecourt was the man who more than anybody else had 'vulgarized' the forest.

By 1840 the railway line south of Paris had come as far as Corbeil, from where it was just an hour's journey by carriage to the town of Fontainebleau. Artists and tourists now started coming to Barbizon in greater numbers than ever before. Charles Daubigny, a friend and disciple of Corot, first came here in 1843

7 Charles Émile Jacque, *The Sheepfold*, 1857. The Metropolitan Museum of Art, New York

and put up at Ganne's. The growing fame of this inn was celebrated in a twenty-five verse poem known as the 'Plainte de Barbizon', in which much play was made of the word 'bison' (generally in reference to the hirsute appearance of the artists). Although Ganne's was to remain the main artists' meeting-place in Barbizon until the 1870s, many of the artists who came to the village from the 1840s onwards preferred to rent or even buy property rather than to stay at the inn. Rousseau himself began renting what Sensier described as a 'cold, and low-ceilinged woodcutter's house', and lived there initially on his own. In 1848 he was joined by Eliza Gros, a woman with whom he was to live for the rest of his life. From that year dates also his official success as an artist.

In 1849 the railway line was extended from Corbeil to Fontainebleau. According to the journalist Pigeory this had the effect of making the 'ancient town' of Fontainebleau seem little more than a suburb of Paris, and bringing (much to the regret of the many artists in the neighbourhood) vast crowds of day-trippers to the place at the weekends. One of the many new arrivals to Fontainebleau in 1849 was Jean François Millet. He came here in June from Paris accompanied by the woman with whom he lived, Catherine Lemaire, their three children, and the painter Charles Émile Jacque, who was later to be best remembered for his portrayal of sheep. Leaving his family at Fontainebleau for the day, Millet, together with Jacque, went on to look at Barbizon, which had been recommended to them by Jacque's friend Diaz. Their reactions were enthusiastic, and Millet later wrote to Sensier to say that he had decided to stay there for 'some time'. He was to remain there for the next twenty-seven years, until his

death in 1875; of all the well-known 'Barbizon School' painters, Millet was the only one to settle there permanently. At first he and his entourage put up at Ganne's, where they were encouraged to undergo a sort of initiation ceremony. Diaz used to keep a well-seasoned pipe over the mantelpiece of the dining-room; every newcomer to the inn was encouraged to take a few puffs at it, and according to the colour of the smoke a jury had to decide whether the person in question was to be placed among the 'classicists' or the 'colourists'. Jacque was proclaimed a 'colourist', but Millet characteristically refused to take part in the ceremony. Towards the end of the month both Jacque and Millet had found houses to rent in the village.

As the American painter Will Hicock Low tersely noted, a legend grew up in the nineteenth century that Millet was a 'half-starved peasant'. It is true that Millet experienced financial problems in his early years at Barbizon, but his income even at this stage of his life was none the less generally sufficient to enable him, in the words of Low, to 'support his family in a comfort unknown to his neighbours'. Neither should too much be made of the fact that Millet lived in Barbizon in a simple peasant house, and wore peasant-style clothes, including a smock and wooden clogs. His house was sparsely furnished and had unpapered walls, yet it also contained casts from the Parthenon frieze and the column of Trajan, as well as a growing number of books. As for the clothes that he wore, these were apparently common to many of the long-term Barbizon residents. The smock was probably liked for its being very comfortable, while the clogs were ideally suited for walking on damp, muddy ground.

Neither Millet nor any of his Barbizon colleagues were regarded by any of the peasants in the village as being other than 'Parisian' and bourgeois. Although Millet never inspired the enmity among the locals that Jacque managed to do (local children used to scrawl *Jacque est bête* on the latter's door), he was not fully accepted by them until he had achieved the world-wide renown of his later years. Apart from using the peasants as models, he had in fact very little contact with them, and on several occasions spoke to Wheelwright of their 'utter want of appreciation of the charms of nature . . . of their often discontented and repining spirit, their low aims, their sordid views, their petty jealousies'. Today it is fashionable to think of Millet as a political radical who was actively involved in trying to better the lot of the French peasantry. There is no evidence of this. Furthermore,

Wheelwright wrote: 'In all his conversations with me he never, so far as I remember, touched upon political questions; nor do I think he ever proposed to himself, of set purpose, the task of benefiting the laboring classes; least of all by means of any arbitrary change in their outward condition.'

Before coming to Barbizon Millet had made his name largely as a painter of mythologies and nudes. Now he concentrated instead on the portrayal of the local country folk. He was one of the first of the Barbizon painters to take an interest in the representation of people rather than of landscape. He loved the forest, and found that the long walks which he took there helped to soothe the migraines from which he constantly suffered. But he never felt any strong desire to paint it; he never, as one contemporary put it, 'made one of the almost innumerable company of artists who, during the summer months, spread themselves over the forest, dotting the sylvan shade with their white umbrellas'. Indeed he rarely worked out of doors at all. More unusual for the time was the interest he took in the featureless plain to the

8 William Morris Hunt, *The Belated Kid*, 1857. The Corcoran Gallery of Art, Washington, DC

west of Barbizon: it was the life of the plain rather than that of the forest which provided him with the subjects of most of his greatest works, including the *Sower* (1852), the *Angelus* (1855–7), and the *Gleaners* (1857; fig. 9).

By the mid-1850s Barbizon's fame as an artist resort had spread outside France. Already a number of foreign artists had settled in the village, including the Swiss painter Karl Bodmer, who was to remain until his death in 1893 and to have a tree named after him in the Bas-Bréau, and the Belgian painter Xavier de Cock, who on his return to Belgium in the 1860s became the first of the many artists associated with the village of Laethem-Saint-Martin. Of much greater significance was the interest taken in Barbizon by Americans. The Americans were always fascinated by the forest of Fontainebleau. As the Goncourts were later to point out, their interest was perhaps ironical in view of their coming from the 'land of the virgin forest'; however, no such place in America had so strong a sense of history attached to it. But the main attraction which drew them initially to Barbizon was the presence there of Millet, whose representation of the peasantry had an especial appeal to a people who were only too conscious of the lack in their own country of a class which represented such an unbroken link with the past.

In 1847 a young Boston painter called William Babcock, then studying in Paris in the studio of Thomas Couture, made friends with Millet. When in the following year the latter moved to Barbizon, Babcock decided shortly afterwards to follow him there; he was to remain until 1892. A difficult, reclusive man, Babcock painted little but gathered with slender means a remarkable collection of works of art which was later to include paintings by such controversial artists as Pissarro, van Gogh, and Cézanne. But his particular obsession was Millet, both as a man and as an artist. The American painter Edward Simmons related how Millet would throw away the drawings with which he was dissatisfied into a box behind his stove, and how Babcock would rush to pick them out, Millet yelling at him all the time: 'Nothing daunted he would retreat like a dog with a bone. Even the garbage can is not sacred to some people.'

Through Babcock's friendship with Millet, many Americans who came to Barbizon would approach Babcock with a view to obtaining an introduction to the great man. One such person was another pupil of Couture, William Morris Hunt, who came to Barbizon in 1852 after having been inspired by the sight of

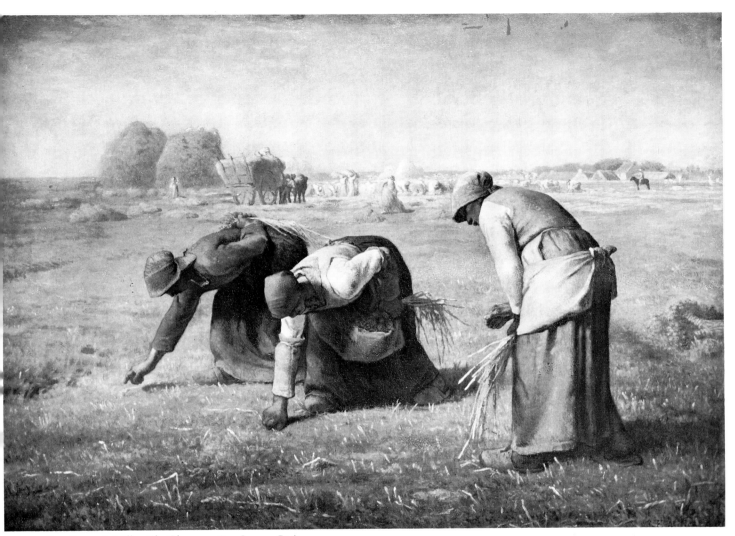

9 Jean François Millet, *The Gleaners*, 1857. Louvre, Paris

Millet's *Sower* in the Salon of that year. Much to Couture's disgust, Hunt stayed on in Barbizon for two years, during which time he became a very close friend and disciple of Millet. Unlike Babcock, Hunt was a very ambitious and, in later life, successful painter. The wealthy son of a Vermont congressman, he always dressed in peasant garb when he was with Millet in Barbizon so that, according to his biographer Helen Knowlton, 'he might be more in sympathy with the new master whom he had found'. He was apparently very popular in the village on account of his wit, and scored a particular success with his imitation of the squeaking cry of his landlord, a rabbit-seller called

Jean Gabelier. According to W. H. Low, another of Hunt's jokes was to attach his pair of fine horses to a fashionable cart piled high with canvases and painter's paraphernalia, and then enter 'the village at a smart trot to the astonishment of all its inhabitants, unused to anything more rapid than the patient donkey'.

Hunt was a great help in securing Millet's prodigious reputation in America. He was responsible for buying an early version of the *Sower*, and in so doing became the first American to buy an important painting by a Barbizon artist. In 1881 the ageing Walt Whitman was to see this work in Boston, and to find in it 'that last impalpable ethic purpose' which, to his

mind, was also the primary purpose of a truly American literature. It was a friend of Hunt's, a rather volatile painter called Thomas Appleton, who on visiting Barbizon in 1857 commissioned what was to become the most reproduced and influential of all Millet's canvases, the *Angelus*. Appleton never returned to collect the painting, which was later owned for a time by the American Art Association of New York, who had it exhibited with triumphant success in several American cities.

From the 1850s onwards, one is able to form a much clearer picture of what artist life was like in Barbizon: the earliest important newspaper and magazine articles date from the early years of this decade, and, in addition, many of the painters who came here during this period were in later life to record their impressions of the Barbizon which they had first known. In the course of the 1850s the spirit of high jinks and camaraderie that characterized the art student's life in Paris increasingly came to infect Barbizon itself, leading in 1858 to the village fête being changed from the winter to the summer so that all the artists could join in the festivities.

However, at the same time a barrier developed between the so-called Barbizon School of painters and the new generation of artists who came to the village. The former appear to have kept very much to themselves and to have led a relatively sedate social life. Millet and Rousseau were both particularly reserved, and certainly considered their work to be the most important aspect of their lives. By way of entertainment, they would play chess, dominoes, or a game called 'Fox and Geese', at which Millet would show uncharacteristic animosity, even inspiring Rousseau to write that 'Millet's vanity has become insupportable, as this game has revealed a strength of an intelligence which painting had failed to discover. I mean to play him a trick, and introduce whist next time, a new game!' But generally their evening gatherings, held mainly on Saturdays and to which only their closest circle of friends would be invited, were intensely serious affairs; Diaz, one of the most sociable of this group, would sometimes bang his wooden leg on the table and protest that the company should spend so much of its time talking about art and literature. The main difference between the old and new generations of Barbizon artists was summed up by one of the young artists who settled here in the 1850s, A. Dubuisson: 'the period of intense fervour in front of nature was a thing of the past. The new generation saw no more need for leading that austere

life completely dedicated to art which had been that of their predecessors.'

The most spirited account of the lighter side to Barbizon life during the 1850s was provided by a painter called Jean-George Gassies, who arrived in 1852 and settled initially at Ganne's. The people who lived for long periods in this inn were referred to as the 'Peint-à-Ganne' and tended to be looked down upon by the artists who had acquired houses of their own in the village. Living conditions in this inn were cramped and certainly unsuitable for serious work or any deep meditations on art. With many beds placed within a single room during the crowded season, the place must have resembled the sleeping quarters of a boarding school, with all the high jinks associated with such places. A constant series of practical jokes was played on tourists and pretentious artists; rowdy midnight trips were made to the supposedly haunted ruined castle of Franchard, and there was endless drinking and music-making. Gassies concluded that 'to judge from all these frivolous activities one would think that these young artists . . . had only come to Barbizon to have a good laugh and enjoy themselves in the fresh air'.

Appropriately, the famous chronicler of Bohemian life, Henri Murger, spent much of the 1850s in the village of Marlotte near Barbizon; his move there in either 1850 or 1851 was made possible by the enormous critical and financial success of his *Scènes de la vie de Bohême* of 1848. Largely under Murger's influence, Marlotte was one of several villages in the Fontainebleau area which from the 1850s onwards became popular with artists and writers as an alternative to the already overcrowded Barbizon. There were two inns there, Saccault's and Père Anthony's, the former of which was slightly the better of the two. Murger decided initially to stay here but later moved to Père Anthony's on account of the picturesque character of the owner, a man who spent almost all his day in bed in a drunken stupor and let his guests fend for themselves. Murger found the life in Marlotte an idyllic one, and tried to encourage as many of his Parisian friends and acquaintances as possible to come here. He became an enthusiastic hunter who none the less, and much to the amusement of the villagers, never managed to catch a single animal. It was while staying in Marlotte in 1858 that Murger was told that he had received the Légion d'honneur, thus satisfying the life-long ambition of the man who had always lived on his reputation as a Bohemian to achieve bourgeois respectability;

unfortunately the news came too late, as he was already dying from a grotesque wasting disease.

Among the various distinguished visitors to Marlotte during Murger's time was one of Millet's most successful French followers, Jules Breton, and the Goncourt brothers. The former first discovered here the pleasures of living and working with a group of artists: after painting all alone and in the darkest heart of the forest he felt sometimes 'seized with a sort of spleen', and was relieved to get back to Père Anthony's, where agreeable company was waiting for him, along with appetizing dishes such as sautéd rabbit and carp dressed with wine; at other times his companions would join him in painting out of doors, an activity punctuated by a 'thousand exclamations of wild gaiety and sparkling sallies of wit'. A different picture of communal life at Marlotte was given by the Goncourts: 'We live a kind of family life . . . The sound of love-making can be heard through the walls. We borrow soap from one another and throw ourselves upon meagre meals with giant appetites . . . Everybody pays his share good-humouredly. The women get their shoes wet without grumbling.'

The Goncourts returned to the forest in the 1860s, most notably in 1865, when they were researching

10 Jules Breton, *The Song of the Lark*, 1884. The Art Institute of Chicago

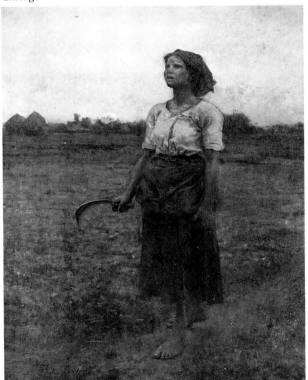

their novel of artist life, *Manette Salamon*. This time they stayed at Ganne's in Barbizon, and gave what was perhaps the first negative account of the place: 'We who have poor health must be really courageous and love our work to stay here in this dreadful, uncomfortable inn which only painters could put up with, in these bedrooms without fires, at this table where gruyère cheese is gobbled up at the end of the meals; over these rooms hovers the immense sadness of dried fruits, sitting there, mingling with the sinister melancholy of all the diseases that have arranged to meet here.' What attracted them to the area was the mysterious, primeval beauty of the forest, in particular of the Bas-Bréau, a place 'where it seems as if Druids are going to be seen passing by'.

Yet even to the most imaginative of minds it must have been increasingly difficult to sustain illusions about the primeval mysteriousness of an environment which was deteriorating in an even more dramatic manner. The thatched roofs of Barbizon, which had contributed so much to the primitive character of the place, had become fire hazards and were gradually being replaced by slates; Rousseau's house was one of the many which suffered such a fate during the course of the 1850s. Any such changes were despised by most of the artists; the threatened modernization of the cemetery at Chailly prompted Millet to write to Sensier in 1873 that 'nothing stands in the way of the rage for embellishment that takes hold of people'. The artist most actively involved in the fight to conserve the forest itself was Rousseau. His concern dated back to at least 1847, when an article by the critic Théophile Thoré dealing in part with the artist's indignation with the commercial exploitation of the forest had appeared in the journal *Le Constitutionnel*. In 1853 Rousseau wrote a petition to the Emperor outlining his fears for the forest and succeeded in having the place declared a '*réserve artistique*'. Despite this, however, the Emperor continued to let Dennecourt, on whom Rousseau had put much of the blame for the destruction of the forest, continue his activities unchecked, and allowed the Empress Eugenie to have a network of asphalt paths laid out so that her feet would not get wet when she was hunting. Fires, whether or not set off by carelessness, continued to destroy many of the picturesque old oaks, which were subsequently replaced by what one artist described as the 'ugliest of trees', the pine; the planting of these trees always aroused the anger of many of the artists, who made frequent attempts to remove the seedlings. But nature herself, in the winter of 1879–80, was to be

responsible for the final indignity, when the intense cold killed off many of the oaks in what must have seemed the most timeless and indestructible part of the forest, the Bas-Bréau.

The changes to the forest did little to stop the flow of artists coming into Barbizon in the second half of the century. However, from the mid-1850s up to the 1870s few important artists and writers settled in the place for any significant length of time. The group of artists later to be known as the Impressionists apparently avoided the place altogether: Monet, Sisley, and Bazille all spent short periods in the forest, staying in Chailly and Marlotte, but seem to have been unsympathetic both to the idea of an artist colony and to the 'back-to-nature' ideals of many of the more permanent artist residents of the forest. One of the few important artists to settle in Barbizon in this period

11 Nicolae Grigorescu, *Andreescu at Barbizon*, c.1881. The Art Museum of the Socialist Republic of Romania, Bucharest

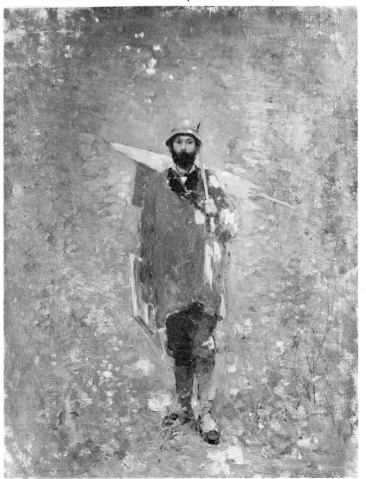

was the Romanian painter Nicolae Grigorescu, who came in 1862 and worked here intermittently until 1868. Of peasant birth, Grigorescu had a great admiration for Millet, and later came to be known for his representations of the Romanian peasantry. His lyrical and suggestive style of painting was to have a great impact on his younger compatriot, Andreescu, who settled in Barbizon from 1879 to 1881 and painted the village and the forest in a series of freely handled canvases. Together, Grigorescu and Andreescu, both of whom achieved maturity in Barbizon, laid the foundations of modern Romanian art, much of which, even up to the present day, harks back to their work.

The greatest artists working in Barbizon in the 1860s remained Rousseau and Millet. The former lived on until 1868, experiencing a certain amount of sadness in his last years. In 1862 a close Barbizon friend of his, the painter Vallardi, committed suicide in a particularly gruesome way, repeatedly stabbing himself in the area of the heart with a blunt pair of scissors; his despair had been caused by his unmarried state and the fear of dying in poverty. Although, unlike Vallardi, Rousseau was a renowned painter and could command high prices for his work, he was incapable of saving his money and was virtually penniless by the time he died. From the mid-1860s he began to suffer from worsening attacks of paralysis, and his doctor suggested that he should separate from his common-law wife, who was gradually lapsing into insanity and was said to be destroying the painter's spirit through her constant screaming and hysteria—Rousseau refused to leave her. In July 1868 he received the Légion d'honneur, but, as with Murger, was in too advanced a state of illness fully to appreciate this award. He died in December, with Millet in attendance.

In that same year Millet himself was awarded the Légion d'honneur. The once controversial artist had thus become a much respected figure of the establishment; moreover, with his sentimental *Shepherdess and Her Flock* of 1865, a painting which features a young and pretty peasant girl, the artist had at last achieved popular as well as critical success. Yet the mind of the increasingly reclusive artist was wandering away from Barbizon and back to the Normandy of his childhood. With the outbreak of the Franco-Prussian War in 1870, Millet and his family took refuge in the Norman town of Cherbourg; although he stayed there for just under a year, and returned for good to Barbizon in 1871, the work of the last years of his life was full of memories of the Norman countryside.

The Barbizon of the 1870s was certainly a very different place to the Barbizon Millet had known when he had first arrived. No longer a hamlet, it had become more of a recognizable village, with a *bureau be tabac* and more than one inn where artists and tourists could stay. Both Père Ganne and his wife were now dead, and their establishment taken over by their son-in-law, who decided at the beginning of the decade to move house and set up the hotel nearer the forest. He brought with him all the inn's painted decorations, which were then so celebrated that an English aristocrat had made at least two unsuccessful offers of enormous sums of money to buy them. This new hotel, called the Villa des Artistes, attracted a much richer clientele than did the previous establishment. The true Bohemian home of Barbizon became the newly opened Hôtel Siron, which was situated at the end of the village's main street, near to where the Bas-Bréau opened up. For the nostalgic Gassies, Siron's 'was as lively as Ganne's had once been, but it was no longer the same generation, nor was there indeed the same intimacy; there was a billiards table where endless games were played, and the "cloc" of the billiards rather spoilt the conversations and discussions on art.'

Millet, who lived opposite Siron's, was known never to have set foot in the place. Respected by the young artists in the village as one of the greatest masters of his time, he was also regarded by them as 'somewhat of a bear'. However, he had not long to live. In September of 1874, there occurred an incident which the already very sick artist considered, apart from anything else, a terrible omen. Millet had always been an outspoken opponent of all the hunting that went on in the forest. He was thus particularly disturbed when one day he heard the wails of a terrified hunted stag which had collapsed in his garden; innumerable artists and villagers rushed to the scene, and the animal was eventually taken to die in the courtyard of Siron's. Millet himself died just over two weeks later. At his deathbed were Babcock and Gassies, who was asked to photograph the occasion, but who in his emotion dropped the photographic plate.

The death of Millet and the radical transformation of Barbizon in the 1870s signified the end of an era, but by no means the end of the important artistic life of the Fontainebleau area. After the short lull caused by the Franco-Prussian War, a new chapter began in the history of the forest, which although much less well known than the previous one was in many ways to be

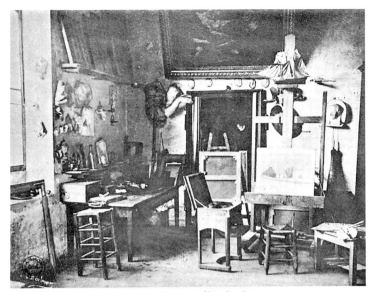

12 Millet's studio, Barbizon, at the time of his death in 1875

of far greater significance for the development of the major artist colonies of the late nineteenth century. It was at about this time that Barbizon came to be invaded by a vast international crowd of artists. One of these was the American Will Hicock Low, who was later to become the main chronicler of this new, exciting period in the history of Barbizon and the forest.

Low arrived in Paris from Philadelphia in 1873 and like so many of his compatriots entered the academy of Gérôme. In the summer of this year, he decided to be different from his American colleagues and, instead of going to some colony such as Barbizon, strike out on his own. He chose an undistinguished village called Recloses, where he began to feel very homesick and frustrated at not being able to speak French. He soon ended up in Barbizon with his compatriots, and felt very much better for it. Shortly after coming here, he rented a house and studio in the village, together with an American friend from the Gérôme academy, Wyatt Eaton. This first summer at Barbizon they largely devoted to work, and spent relatively little time at Siron's, where all the lively artistic life of the village was now centred. Having their own house in the village and thus liking to feel that they had much in common with the villagers, they treated the semi-permanent residents of Siron's, whom they labelled

the 'hotel crowd', with the same contempt in which the 'Peint-à-Ganne' had been held in the 1850s and 1860s. Through Babcock they managed to get an introduction to Millet, despite the fact that an imagined affront had led Babcock temporarily to break his friendship with the great man. Millet was kindly disposed towards the two young Americans, and became on intimate terms with Eaton, who developed into a fervent disciple of his; it was eventually Eaton and Low who effected the reconciliation between Millet and Babcock.

Another artist whom Low got to know this summer was the newly arrived Hungarian, Mihály Munkácsy, a painter of large bitumen-black and bleakly expressive history paintings, then well on his way to achieving his later outstanding success in the Paris art world. Before Munkácsy's arrival, Low had been asked by an eccentric countess to vacate his own studio for the benefit of the Hungarian whom she had described as a '*très grand peintre*'. The arrogant and impetuous Munkácsy later took a liking to one of Low's canvases, and suggested that Low, who was then wondering whether he should stay on in Gérôme's academy, should abandon formal training altogether and follow his natural inclinations; this suggestion appalled the traditionally minded Millet, but it was to lead to Low's transference to the Académie Duran on his return to Paris in the winter.

Low came back to Barbizon the following summer, and this time associated to a much greater extent with Siron's. The 'hotel crowd' this year was a particularly interesting one. There was the German Max Liebermann, who was described by Low as having a 'blue-black beard and a marvellous facility for painting in two or three styles'; he was later to become one of the leading German painters of the late nineteenth century. Munkácsy was staying here this year, as was the eccentric Swedish painter Carl Hill, who had first come to Barbizon in 1873. Hill's exceptional originality as an artist was recognized by all the guests at Siron's, to whom he kept saying that '*il faut faire de la beindure nouvelle*'. He was to continue painting in the forest until 1878, when he was struck down with madness. The rest of his life was spent in a mental home in Sweden, where he executed (like his compatriot Ernst Josephson) bizarre psychotic drawings which completely transcend their time.

The young American painter Julian Alden Weir stopped off at Siron's in 1874 on his way to Pont-Aven in Brittany. He was given a most friendly welcome here, and, in a letter to his mother, referred to all the

13 Carl Hill, *The Quarry, Fontainebleau*, 1876. Malmo Museum, Sweden

artists as the 'family'; he also noted how peasant costume was worn by the permanent artist residents in the village, among whom he included Millet and the Hungarian painter László Paál (whom he mistakenly identified as Norwegian). The latter, who complimented Weir on one of his sketches, was a good friend of Munkácsy's and a regular at Siron's. He had first settled in Barbizon in the previous year, and had won a great reputation for his sombre and broadly executed pictures of the forest, a place which reminded him of the wooded area of Odvos in Transylvania where he had spent much of his childhood. However, his talent was to be cut tragically short in 1877 when, on getting up from table in his Barbizon home, he struck his head violently against a gas pipe and suffered permanent brain damage, leading to his death the following year in the mental hospital at Charenton. Of the considerably outnumbered French contingent associated with Siron's, the most dominant personality was that of the landscape painter Olivier de Penne. In fact de Penne resided at Marlotte, where he held a position in the artist colony similar to that which Murger had held in the 1850s; but at least once a week he would come over to Siron's. Here he would invariably become hopelessly drunk and viciously offend someone, often for no better reason than the person in question had a nose which displeased him. In his rare moments of

sobriety, he was apparently delightful company, lively, witty, and with a great facility for repartee.

Towards the end of the summer of 1874 another such brilliant conversationalist joined the company of Siron's, and was soon to bring to the place an unprecedented degree of animation. The man was R. A. M. Stevenson, the cousin of Robert Louis Stevenson. Generally known as 'Bob', he was the archetypal Bohemian, impetuous, eccentric in appearance, and with a total disrespect for convention; he had played a great part in shaping the imagination of the young Louis, and was considered by the latter's puritanical parents, who had wanted to try and separate him from their son, as a dangerous and unhealthy influence. He was clearly in his element in Barbizon, where he used to dress up in large striped socks, and sport a wide-brimmed hat, which seen in combination with his swarthy features and large black moustache gave him the appearance of a 'Mexican vaquero'. Earlier in 1874 he had begun his studies as an art student in Antwerp, and later in Paris, where he had registered at the Académie Duran. At Barbizon he was immediately and universally felt to be a genius, but no one at that stage knew exactly where his real talents lay. Hill praised his work as being '*beindure nouvelle*'; but for the American painter Birge Harrison, voicing the feelings of most other members of the community, he was simply 'endeavouring to demonstrate to himself and to others his right to be ranked seriously as a landscape painter, and wasting considerable quantities of perfectly good pigment in the effort'.

14 The Barbizon–Melun carriage, known locally as La Patache or the 'boneshaker', in regular service during the 1870s and 1880s

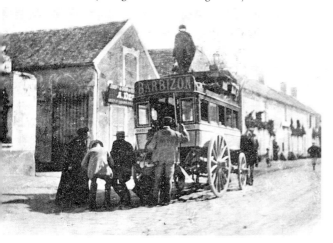

Low had only had a passing acquaintance with Bob at the Académie Duran, and it was not until Bob had been settled for several weeks at Siron's that the two men began seeing much of each other; by the end of the summer of 1874, they were intimate friends. Much of their time together that summer was spent talking about art. In one of these conversations Bob maintained that in the age in which they lived science had come to be held in much higher esteem than art, and that there were no painters of the day equal in stature to the great masters of the past. Low's protests led to a discussion of the relative merits of fashionable contemporary painters such as the muralist Baudy. Eventually Low took Bob to see Millet: when confronted with the great French painter ('this figure with the heavy shoulders and slow tread') Bob was apparently very moved and, according to Low, became convinced that he was in the 'presence of one who, here in our time, was close kin to the mighty dead'. Afterwards, outside in the village street, Bob turned to Low and said, 'Do you consider it fair play, in a conversation between gentlemen concerning minor poets, to spring Shakespeare on your opponents?'

Back in Paris in the winter of 1874, Bob acquired a studio just across the courtyard from Low's, at 81 Boulevard Montparnasse. This and the adjoining studio, which belonged to a friend of theirs and fellow pupil at the Académie Duran, the English painter Henry Enfield, immediately became a well-known meeting-place for the Duran circle. Confined here for a long period with the mumps shortly after coming back from Barbizon, Bob found himself sufficiently unwell to do any serious work, but in perfectly adequate health to receive all the many devotees of his unruly life-style that he had made at the art school. Among these was the American painter Theodore Robinson: a timid and very ugly man, with an enormous head attached to a frail slouching body, he none the less had a wonderful sense of humour, and was even said by his friends to radiate a 'spiritual beauty'. Another member of the circle was the Irishman Frank O'Meara, tall, debonair, handsome, and prone to wild extremes of hilarity and violence. Into this circle came Robert Louis Stevenson, then on his way back from Menton where he had been advised to go to by his Scottish doctor on account of his frail health. This was to be Louis's first glimpse of Bohemia, and it was to leave an indelible impression.

With the return of the summer the Stevensons, Low, and a number of their art school friends, including Robinson and O'Meara, all found themselves at

Barbizon, and thus helped boost the ranks of what Low described as the 'first considerable contingent of English-speaking students at the village'. For Low and many others, these British and American painters all came to be known as the 'Anglo-Saxons'; for the remaining French painters in the village, they were all 'Anglais'. The Stevensons became the acknowledged leaders of this group. Louis had all the infectious vivacity and conversational brilliance of his cousin, but was not as flamboyant in appearance or behaviour; although not afraid to display strong emotions, and indeed liable to burst on occasion into uncontrollable tears, he was a much shyer person than Bob, and with a much kindlier and more quietly charming manner. For Louis, as for so many of his English and American friends, the experience of living in Barbizon represented a new found freedom, an escape from the repressive influence of his upbringing. It was also at Barbizon that he began to find himself more fully as a writer. When he first arrived at Barbizon, he announced himself to the painters as a 'writer chap' or at least that he was hoping to be one. He soon settled down to what Low described as a life of 'idle industriousness', taking a very active part in all the festivities and other sociable activities of the community, and at the same time finding in all the drama of life lived so intensely and in such close surroundings an enormous fund of potential material for future work. While living with painters, and watching them in their daily endeavours—endlessly sketching from nature, and gradually building up to the masterpiece which they hoped would finally make their careers— he was also able to develop his strong belief that writing was no less of a craft than painting, and that it demanded equal hard work and preliminary experimentation.

Stevenson and Low described the life led by the *habitués* of Siron's in terms of an Arcadian and Bohemian idyll. When not going on long walks in the forest or else trying out the various inns in the village, the days would be spent painting out of doors. Generally speaking the artists would devote their energies to small-scale oil sketches, although some would embark on enormous canvases which had to be attached firmly to the ground and for convenience left outside, sometimes for weeks on end. When his companions were all painting, Louis would find some quiet part of the forest where he could read or write. However, even in the remotest part of the forest, it was virtually impossible to get away from all the painters with their white umbrellas. On one occasion, when sitting in the Bas-Bréau and engaged on an article later to be entitled 'Forest Notes' and published in the *Cornhill Magazine*, Louis was surprised by Low who asked if he could do an oil sketch of him writing. Louis agreed on condition that he could smoke the pipe which he rarely put down. In the finished painting which was to develop from his sketch Low added a female muse standing above the writer; such an allegorical touch became typical of much of Low's later work after his return to the USA, where he became a successful muralist.

On returning to the inn in the evening, 'vermouth and friendly criticism' awaited the painters. There was a custom that all the work done during the day was laid out in the courtyard and subjected to an 'impromptu critical gathering'. As Low said, this was often the moment when one painfully realized that the covering of the canvas surface 'had effectually deprived the world of the potential masterpiece, with which every blank canvas may, perchance, be pregnant'. The vermouth followed afterwards. Indoors the social life would revolve round the billiards room and the dining-room. The former had walls covered with silhouettes made by the artists of themselves by copying the shadow projected by a candle. The dining-room, which was panelled with oil sketches left by the artists, had an out-of-tune piano and an enormous drinks cabinet. The guests of the inn would often help themselves to drinks at whatever time of day or night they felt like it; early in the morning Siron would judge how much of the various bottles had been drunk and divide the cost between those whom he reckoned had spent much of their time in the dining-room the day before. Naturally this was a system which was very open to corruption.

The drinking, heated discussion, and billiards and piano playing which would follow the evening's criticism session would suddenly be interrupted by the arrival of Siron bearing a huge smoking soup-tureen and shouting, '*À table, Messieurs, à table*'. Afterwards the former activities would resume. Sometimes the painters would go and see friends in the village. At other times, if the moon was shining, one of them would suggest that they all go on some midnight outing. A popular place to go at this hour was a cave inexplicably named by Dennecourt the 'Caverne des Brigands': by day this was a popular tourist site and even had an old man stationed outside it selling lukewarm beer, but by night the painters had it to themselves, and would entertain themselves by singing songs and drinking punch.

Forêt de Fontainebleau
La Caverne des Brigands

15 Postcard of La Caverne des Brigands in the Forest of Fontainebleau, *c.* 1900

Siron's, as Louis observed, was not so much a hotel as an exclusive club. Although the society here must have seemed to newcomers and outsiders a lawless one, it was in fact governed by its own unwritten code of behaviour. The penalties for being a philistine or 'cad', or in any way offending this unwritten code, were exclusion from the society. On one occasion Siron's was visited by a dapper little Englishman who was soon discovered to be a 'cad', a fact which had initially been concealed by the man's general inconspicuousness. Shortly after this discovery the man was witness to some chair vaulting and other such feats of agility in the courtyard of the hotel and decided to join in the fun by pushing off Bob's wide-brimmed hat. After having been angrily instructed to pick it up and dust it, he was told by Bob: 'Perhaps some time—though not here, I trust—you will learn that where the greatest latitude prevails the utmost nicety of conduct must be observed. You can do things in church, at home, that you can't do in Barbizon.' The man was then snubbed by everyone, prevented from accompanying them on a trip to the Caverne des Brigands, and eventually told to go away. Not surprisingly, he considered everyone at Siron's to be a very 'rum lot'.

The greatest danger for those who stayed regularly at Siron's was laziness. There were those who spent their days looking for motifs and rarely getting down to sketching, let alone embarking on a major canvas. For these people, who were dubbed 'snoozers' by their colleagues, it was very difficult to leave Barbizon, the life there being so cheap and congenial. Many people

whittled away their lives at such a place as Siron's, realizing only too late how little they had achieved, and becoming very embittered as a result. In his essay entitled 'Fontainebleau: Village Communities of Painters', Louis wrote that 'snoozing' was the great disease of the artist village. Its only treatment, according to him, was 'continual returns to the city, the society of men further advanced, the study of great works, a sense of humour or, if such a thing is to be had, a little religion or philosophy.'

Amidst all the different nationalities present at Siron's, the Anglo-Saxons distinguished themselves by making little attempt to speak French. At dinner they would all sit together at one end of the table and, in the words of Low, conduct themselves 'with a freedom unattainable to them in their native land'. The Scandinavians, Hungarians, and other nationalities, who would sit at the opposite end of the table and speak to each other in French, would sometimes be envious of the high spirits of the Anglo-Saxon community and insist that some witticism or story be translated; in translation these often provoked rather less hilarity than their authors had expected. Perhaps the most significant contribution of the Anglo-Saxons to the life at Siron's was the introduction of sporting activities. These activities, or 'health-seeking Anglo-Saxon pleasures' as Low termed them, and which included leap-frog, scaling garden walls, and wrestling bouts, encountered considerable distaste and incomprehension from the other nationalities. They were also to be, as Low admitted, 'at the root of the undoing of Barbizon, and its dethronement'.

What Barbizon most obviously lacked as a place of entertainment was the presence of any water. A number of the artists were enthusiastic swimmers, and others, including Bob, who had acquired a passion for this sport while at Cambridge, were devoted canoeists. One day Henry Enfield spoke out: 'Why does a man come to Barbizon where there is nothing to do, only to mess with a lot of sticky colour? No self-respecting countryside is without water, and here you can hardly get a tub.' There was no other solution but to find another village where there was a nearby lake or river. Someone suggested Grez-sur-Loing, a village on the banks of the Loing, a few miles to the south of Marlotte. It had been a place which had attracted artists since the 1830s, although few had remained for more than a few days at a time. A handful of painters had settled there in the 1850s and 1860s, but by the mid-1870s they had become 'inveterate snoozers',

people who, as Bob was later to describe, 'tinkered at little pictures from Nature, neither studying their impressions sincerely nor making art boldly, but falling between two stools with a certain old-fashioned grace.'

On a late August day in 1875, following a long period of continuous rain when no painting had been done at Barbizon, the Stevensons, accompanied by Low, Henry Enfield, O'Meara, and a wealthy young man who had recently joined their circle, Sir Walter Simpson, hired a carriage from the local firm of Lejosne and went over to Grez to see what the place was like. They were pleased with the local inn, the Pension Chevillon, which they found picturesque, with good food and a most friendly proprietress. Unfortunately the rain which had been the immediate cause of their departure from Barbizon continued without a break for the three days which they spent there, and they could do little of their intended outdoor activities. Louis, relating their visit in a letter to his mother, described the village as 'pretty and very melancholy', and that there was 'about it all such an atmosphere of sadness and slackness, one could do nothing but get into the boat and out of it again and yawn for bedtime.' Yet despite this disappointing first visit, they were all back again at Grez shortly afterwards to give the place a 'serious trial', and seem also to have encouraged a large number of Anglo-Saxons to follow in their footsteps. By the autumn of 1875, the place had livened up considerably as an artist resort, and, as Bob put it, the casseroles of the Pension Chevillon had begun to 'clink to the tune of a new life'.

Of all the places in the Fontainebleau area that were once popular with artists, Grez is perhaps the only one which still retains something of its original character: it has resisted to a greater extent than the others the onslaught of the antique shop and the fashionable villa, and remains almost as quiet and little visited as when the Anglo-Saxons first went there. Bob described the village as looking 'as if it had crept down from the forest upland, drawing a long trail of tall poplars after it across a mile or two of rolling plain till it finally settled in a hollow by the sluggish stream that drains the Gâtinais.' Its most beautiful features are the series of gardens rolling down to the reed- and lily-filled river, its medieval church and castle ruins, and above all its ancient bridge. The latter, now heavily restored and shorn of the sedge which once choked its pointed arches, was by far the most popular motif for the artists who once worked at Grez; Low was to be one of several painters who were proudly to claim the distinction of being the only one not to have painted it. The overriding characteristic of the village, and the one largely responsible for creating the atmosphere of sadness that not only the Stevenson party but also many other visitors to the place initially felt, is its greyness. Grey stone combines with grey tiles, and both are heightened by the silverish grey tones of the river. The pun on 'Grez' and 'grey' was to be made on at least one occasion, by Sir John Lavery, who called one of his paintings *A Grey Summer's Day—Grez*. The greyness was at any rate to be very influential in determining the distinctive style of painting which emerged from the village.

In the autumn of 1875 Low became the first of his close circle to marry. Contrary to his fears, this deed did not cut him off from all the camaraderie which he had so enjoyed in his early days in Paris and Barbizon. None the less it did mean that he felt obliged to find a proper home for himself and his wife. After wintering in Paris, he came back to the Fontainebleau area early in the spring of 1876 and after some searching eventually found such a home at a small town popular with French painters called Montigny, which was on the Loing a few miles upstream from Grez. The journey between the two places made a pleasant evening's walk for Low, who spent much of the spring and summer of 1876 with his friends in the village. At Grez this year he found that 'the Anglo-Saxon was in full possession of Chevillon's inn, to a much greater degree than Barbizon ever knew'. Apart from the 'discoverers' of the place in the previous year, there were others who 'brought to the quiet inn the clamour of our English tongue, and a freedom of manners and customs that escapes geographical definition'. The village had become so overrun by English and Americans that 'when, as rarely occurred, a chance visitor of Gallic strain happened there, he rubbed his eyes, wondered if he was still in France, and soon departed'. Such had been the impact of the Anglo-Saxons that the village children had begun to pick up some of their language, and could even be heard singing in the village streets such tunes as 'John Brown's body lies a-mouldering in the grave'. Equally novel to the villagers was the sight of men walking to the *bureau de tabac* in just a pair of bathing trunks, sandals, and a straw hat. One also wonders what the villagers made of the more self-consciously rebellious artists (most of whom were frequently provided with ample allowances from their parents) who took great delight in shocking everyone by wearing outrageous costumes, such as an old frock-coat and a fez.

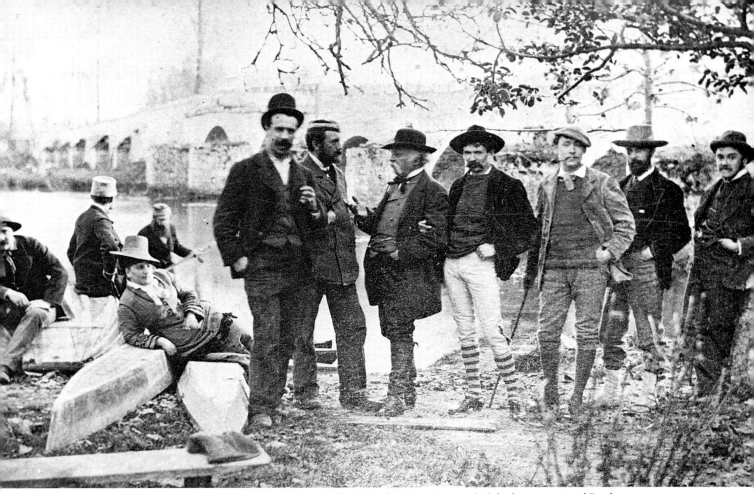

16 Artists at Grez, late 1870s, with R. A. M. Stevenson (in the striped socks), Chevalier Palizzi (on the left of Stevenson), and Frank O'Meara (on the right of Stevenson)

Apart from the Stevensons' close circle of friends, the artists who came to Grez in 1876 included the English painter Weldon Hawkins, the American Birge Harrison, who was later to write an account of his days at Grez, and another American called Bloomer, who amused Louis by saying of this ancient village that 'these parts don't seem much settled, hey'. Taking an enthusiastic part in the new artistic life of the village was an elderly painter called the Chevalier Palizzi. He was one of the 'snoozers' who had been settled in the village long before the coming of the Anglo-Saxons, and had innumerable stories to tell of the Fontainebleau forest in its earlier days. Bob said of him: 'Though a great talker, his conversation was not what is called stimulating. We hear of talk that effervesces like champagne, or warms like Burgundy. His rather spouted perennially, like clear spring water—a

sparkling and refreshing draught that never excites but rarely cloys.' An ultimately more significant addition to the colony was a Californian woman called Fanny Osbourne, who came to Grez in the spring of this year, accompanied by her very attractive sixteen-year-old daughter, Isobel, and eight-year-old son, Lloyd.

Fanny had first come to Europe in November 1875, leaving behind her husband, with whom she was experiencing increasing difficulties, but taking all her children. Boldly she had decided to take up painting and had begun studying art at Antwerp and shortly afterwards at Paris. However, her already poor financial situation had rapidly deteriorated, and she and her family had been forced to live in considerable poverty. After her youngest son, Hervey, had died of scrofulous tuberculosis, she had been advised by an

American sculptor friend to spend some time recuperating in the country. This friend had suggested Grez, although he had warned her that the village attracted a group of Bohemians who might resent the intrusion of a woman and her family. Not surprisingly, Fanny arrived in Grez in a state of extreme emotional vulnerability. Up till that time the colony had been, in the words of Low 'an Eve-less Paradise', and there were many who wanted to keep it that way. Writing to Louis in 1874, Bob had resentfully noted that in Barbizon 'everyone keeps a woman now. I begin to see the intrusion of Latin Quarter life.' Fanny and her family were welcomed almost immediately into the Grez colony, although it was to be several weeks before they were to meet the two Stevensons, who were known as the 'ringleaders' of the colony, and the ones who would be the most difficult to please. Bob was the first to arrive, and he took an instant liking to them, a liking perhaps not entirely unconnected with his being greatly attracted to Isobel. Louis came later on in the summer, on the way back from the canoe trip which was to be the subject of his *Inland Voyage;* he entered Fanny's life in a literally dramatic manner by jumping through the window of the inn and landing next to the dining-table around which the members of the colony were seated.

The rest of that summer survives now in the idyllic descriptions not only of Low but also of Lloyd and Isobel. Much of the fun centred round the river, where there were constant canoe battles, and equally dangerous tub races; Henry Enfield, the acknowledged tub-racing champion, always managed to retain his monocle even after repeated duckings in the water. Other devised sports on the river included the one described by Isobel as 'a sort of "shoot the chutes"', in which everyone got into a huge old boat and persuaded passing peasants to push it off. These 'amphibious activities', as Low admitted, 'wreaked havoc to the arts'. Then there were the 'old hall-dances', performances by strolling players, and, once, a masquerade in which the guests of the inn dressed up as gods and goddesses in sheets and wreaths. The extent to which this fantasy world took hold of everyone's imagination is illustrated by Bob's quixotic plan to have a barge constructed, in which various members of the colony would live while drifting around France. People were invited to take part in this scheme, including Low, who refused, despite the offer of a marital suite with a painted decoration in the manner of Watteau's *Embarkation for Cythera.* Against all odds the scheme nearly succeeded: the boat

was built, nicknamed the 11,000 *Virgins of Cologne,* but then for some reason abandoned in her moorings on the Loing, eventually to rot and be disposed of.

The love intrigues that inevitably resulted from the desecration of the Eve-less Paradise had their equally absurd side. The twenty-six-year-old Louis fell in love with the much older Fanny, who was at first more attracted to Bob, who was chasing after Isobel, who was more interested in O'Meara. Eventually Fanny, encouraged by Bob in the course of a long walk which the two had taken together in the forest and which had itself been the source of much gossip in the inn, became close to Louis. Isobel meanwhile had finally nothing to do with either Bob or O'Meara, and was in later life to marry an American painter with whom she went to live in Tahiti.

After having been forewarned by Low of the arrival of Fanny and her entourage at Grez in 1876, Louis had said: 'It's the beginning of the end.' And in a sense he was to be proved right. The year of 1877 saw their circle beginning to break up, Low becoming increasingly encased in Montigny, Enfield devoting himself to yacht-building in Rouen, and Louis, after a brief return to the forest, pursuing his affair with Fanny in Paris. Bob was to continue spending time at Grez until 1879, reporting on the doings of those of their circle who had remained, such as for instance the occasion when O'Meara had threatened serious injury to an artist with a beer bottle, and had only been dissuaded from carrying out this threat after having drunk his weapon's contents. Finally Bob, who by now had become, by Low's account, a 'restless spirit', became fed up with Grez, finding it a changed place and with too many people there for his liking. In that same year he was briefly at Cernay-la-Ville, where he had already spent a short period with Louis in the summer of 1877. Cernay, together with Marlotte, was the colony near Paris most favoured by French artists; the leading spirit of the place was the now little-known landscape artist Léon-Germain Pelouse. While staying here Bob was sketched by a young Danish painter, Peder Severin Krøyer, then engaged on a painting featuring all the Cernay artists gathered round the dining-room table of the local inn. After the summer of 1879, Bob returned for good to England, where he was to marry, lead an insecure career as an art critic, and die young from a paralytic stroke.

Despite the absence of the Stevensons, Low, and others, Grez continued to exert a fascination for Anglo-Saxon artists for much of the 1880s. Of the original group who remained in the place for some of

this period, the most important were O'Meara, Weldon Hawkins, and Birge Harrison. There were also a number of important additions. William Stott (Stott of Oldham) came to stay between 1879 and 1882, and was followed in 1883 by the Glasgow School painter Sir John Lavery, who later described the two years which he was to spend here as being his 'happiest days in France'. Lavery's Glasgow School colleague Sir James Guthrie was also in Grez in the 1880s, as were the influential Scottish dealer and patron of van Gogh, Alexander Reid, and the future friend and follower of Gauguin at Pont-Aven, Roderic O'Conor. Birge Harrison's brother, Alexander, then regarded as the greatest American artist working in France, was yet another distinguished visitor to the colony during this decade, and created here—as he did at Concarneau—a considerable stir by having nude models pose out-of-doors.

By the beginning of the 1880s all the artists at Grez had begun to paint in a similar style. It was a style almost wholly dependent on that of Bastien-Lepage, who had suddenly acquired an enormous reputation following the exhibition of his *Harvest* in the Paris Salon of 1878. The Grez artists, unlike so many of their predecessors who had worked in the Fontainebleau area, rarely painted a landscape without including some figurative element, in particular some scene of peasant life; they found almost all the subjects for their work within the village itself and the immediate surroundings. The special greyness of the village encouraged them to develop further the subtle grey tonalities evident in Bastien-Lepage's art. The sun is rarely seen to shine in their paintings, the season seems to be perpetually autumn ('October' being a favourite title), the peasants depicted are invariably gloomy, and there is often much symbolism, particularly in O'Meara's work, suggesting the passing of time and the inevitability of death. Perhaps the most influential and talked-about work painted in Grez at the beginning of the 1880s was a painting by Hawkins originally entitled *Young Lovers*. At a party given at Grez on the eve of the work's departure for the 1881 Paris Salon, an eccentric American painter, who was best known in the colony for his falsetto singing, suggested to Hawkins that as the features of the two protagonists were so gloomy the title should be changed to *The Orphans*. With this title the work scored an immediate success at the Salon, and was purchased by the French State, receiving praise from all the critics for the remarkable pathos and dignity with which the artist had treated the subject. Unfortunately Hawkins was

17 Alexander Harrison, *In Arcadia*, 1885. Louvre, Paris

not able to repeat such a success, and his subsequent declining finances and talent led him to desperate measures, such as dressing up in expensive clothes and visiting the leading Paris dealers in the guise of a wealthy patron anxious to buy the latest of Hawkins's works.

In the spring of 1882, the course of Grez's history took a curious turn. The village began to attract an enormous crowd of Scandinavian artists, including almost all the leading Norwegian and Swedish painters of the late nineteenth century, as well as Sweden's greatest writer. These artists were for the most part to perpetuate the 'Grez style' that had been evolved by the Anglo-Saxons, and were even to point specifically to Hawkins's *Orphans* as a considerable influence on their work. The earliest important Scandinavian artists to arrive at Grez in 1882 were the Norwegians Christian Skredsvig and Christian Krohg, and the Swedes Richard Bergh, Nils Kreuger, Karl Nordström, and Carl Larsson. The first three were to have only a fleeting association with Grez, while the others were to spend much of the next three years here, a period which was to be the greatest in the history of the Scandinavian colony. Of this last group, Nordström had probably the most progressive outlook on art. In later life he strongly objected to the way his early work came to be bracketed with that of the Grez school: the only Grez influence which he was then to admit was the drawing style of the now forgotten American artist, Frank Myers Boggs. Nordström had certainly a much greater interest in colour than his

Grez colleagues. Together with his close friend Krohg, he was also much more aware of the art of the Impressionists; Krohg's *contre-jour* portrait of Nordström in his hotel room at Grez, in the spring of 1882 (fig. 18), was apparently executed under the influence of an Impressionist exhibition which the two artists had recently seen together in Paris. On his return to Scandinavia, Nordström was to join forces with Kreuger and Bergh to help form an artist colony at Varberg on the north coast of Sweden; here he executed a series of bleakly simplified landscapes, which could hardly form a greater contrast to the busy, prettily coloured garden views that he mainly painted at Grez.

Undoubtedly the Scandinavian artist whose life and work is most closely associated with Grez is Carl Larsson. He was the first of the Scandinavian group to achieve success here. Shortly after his arrival in the village in April 1882 he had abandoned working in oils and taken up watercolour; he had become so involved with this medium that while most of his colleagues

18 Christian Krohg, *Karl Nordström at Grez*, 1882. Nasjonalgalleriet, Oslo

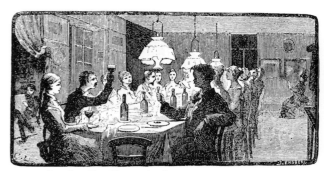

19, 20 Pension Chevillon and a dinner party at Grez, from drawings by Carl Larsson, 1884

spent the winter of that year in Paris he remained in Grez to continue working. His efforts were rewarded in the spring of the following year when he was told by O'Meara that a group of his watercolours had been awarded a medal in the Paris Salon. This success won him enormous respect among the Scandinavian artists within the colony as well as the nickname 'rich Larsson'; from then onwards he was also to have an unchequered career leading to his becoming the most popular of all Sweden's artists.

It was through Larsson that Strindberg and his wife, Siri von Essen, came to Grez in the summer of 1883. Strindberg had first met Larsson in the early 1870s in Stockholm, when he had paid an unexpected visit on the painter to ask for his advice as to which publisher he should approach for his novel on Bohemian life,

The Little Red Room; Larsson had suggested Bonnier, and Strindberg had reacted by taking the manuscript to Bonnier's rival Selgmann instead. Although Strindberg and Larsson were to remain friends for some time, each always harboured misgivings about the other, and in later life they became sworn enemies and even exchanged insults in public. However, Strindberg's visit to Grez in 1883 was greatly welcomed by both Larsson and the other members of the colony, and the writer was to return to the village in the following summer. Of the other Scandinavians in Grez in the early 1880s, it is interesting to note the large presence of women artists, among whom were the Swedes Julia Beck, Karin Bergöö, Emma Löwstadt, Caroline Benedicks, and Tekla Lindeström. These were all talented artists (in particular Löwstadt who was to win a medal in the Salon of 1887) but they were never able fully to develop their talents, perhaps largely as a result of marrying other members of the colony.

All the latest developments in the colony at Grez were closely followed by the Swedish press. Not only did Strindberg keep them posted, but there was at least one prominent journalist in their midst, J. Janzon (who wrote under the pseudonym of 'Spada'). In addition, there were various artists and writers, most notably Georg Pauli and Siri von Essen, who had close connections with the press. Writing in 1884 on Carl Larsson for the magazine *Svea*, Strindberg noted that about twenty articles had already appeared on Grez in Sweden. Through such writings a minutely detailed picture emerges of what Grez was like in the 1880s. By this period another hotel had opened up in the village to meet the greatly increased demand for rooms: the Hôtel Beauséjour, generally referred to as Laurent's. In 1883 Spada divided the Scandinavian colony into the 'Laurentare' and the 'Chevillonare', although the choosing of which hotel to stay in did not imply, as it did in other artist villages, any particular artistic allegiance; in fact many of the artists within the colony would alternate between the two.

Both Chevillon's and Laurent's were attractively situated with large formal gardens leading down to the river. Larsson and Nordström did much of their painting within these gardens, remaining for most of their time fixed on one particular spot, and just swivelling their chairs round when they wanted to start a new picture. The Chevillon garden, with its terraces and goldfish pool, was regarded as slightly more beautiful than Laurent's. Its lush vegetation was described in great detail by Strindberg: there were

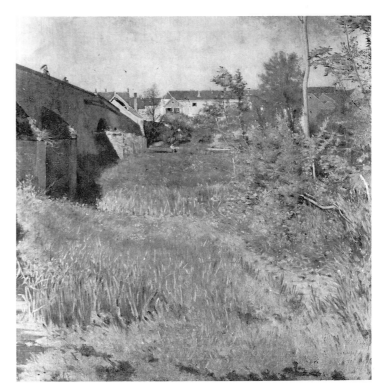

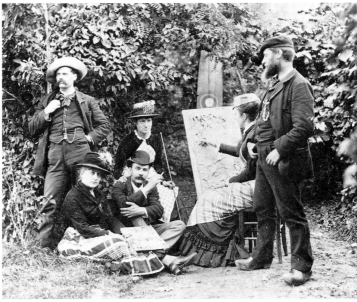

TOP: **21** Karl Nordström, *The Old Garden, Grez*, 1882. Waldemarsudde, Stockholm
BOTTOM: **22** Caroline Benedicks working at Grez, 1880s

23 The former Pension Laurent, Grez, 1953

vines, peaches, and a fig bush (of which 'better examples could be seen in middle Sweden'), in addition to a large vegetable garden, which included carrots, green and white beans, asparagus, artichoke, cauliflower, and 'four sorts of lettuce'. The whole was shaded by poplars. There were also a number of dead apple trees, which had not been cut down both out of respect for the artists' wish to paint them and because they served as supports for washing-lines.

Inside both hotels large piles of artists' materials were left lying around everywhere; in Chevillon's the billiards room doubled as a studio in times of bad weather. The dining-rooms of both places had paintings of generally humorous subject-matter in wooden frames. According to Strindberg, Chevillon's dining-room had racks for magazines, as well as a sideboard where the hotel guests could keep their bottles of eau-de-vie and tins of anchovy. Dogs and cats overran both establishments. A particular favourite was a dog called Thuls, who had been saved from drowning in the river. Of the two hotels, Laurent's had apparently both the more comfortable rooms and the best views (the view from Nordström's room can be seen in Krohg's portrait of him; fig. 18). However, it had by far the worse food, which was extremely repetitious, and invariably included vermicelli soup washed down by sour wine. Many complaints were made by the guests about this food, particularly after a period in 1883 when they had to eat red currants twice a day for five weeks: it was the bright colour of the berries which they found especially offensive.

For Strindberg the special quality of life in Grez was the way in which people could behave just as they liked. There was a freedom from the normal social duties, politenesses, and conventions; all this, he considered, must have had a deep effect on such a person as Larsson who had come from a strict and conventional background. As in Stevenson's day many people, mainly Americans, went around in strange costumes: Strindberg saw some artists in knee-breeches and a Basque beret, others in clogs and a nightshirt, and one even with a sailing rope tied round his waist and a Japanese hat; he also noted that it was quite acceptable to walk round the hotel in a bathing-costume and to appear at table in slippers. There were no rules about times of eating, and at table no one bothered about 'whether one's neighbour was a lady or a man'. The Americans apparently remained unconcerned when at the beginning of a meal the Scandinavians would follow their national custom of celebrating a saint's day with a toast and a song; likewise the Scandinavians would pay no attention to the Americans when during the course of the meal the latter started eating raw tomatoes and drinking cognac.

The playfulness which had been such a feature of the colony in its earlier days continued into Strindberg's time, although by all accounts the Scandinavians were not as wild as their Anglo-Saxon predecessors. A favourite evening activity of theirs was singing, in which they were often accompanied by a guitar, cornet, and flute, but rarely fuelled, according to Strindberg, by too much drink. Strindberg also observed how a remarkable harmony existed between the various Scandinavian nationalities when they were all together like this: they would sing their national songs without any enmity being caused, and they never talked politics; in fact they were all rather amused at the way in which the Scots and the Irish were always picking on the English. The Scandinavians, despite their greater reserve, none the less welcomed any opportunity such as a birthday, saint's day, or arrival or departure of a friend, for some form of festivity or celebration. Dancing played an important part in these occasions, and Spada noticed that a great variety of dances were practised, including six or seven types of polka. Then there were masked balls, for which no one was allowed to hire costumes, but had to make them from various household objects; the Swedish painter Janzon once appeared looking like a Chinese mandarin, with caricatures of all the Grez artists painted on his costume. A cabaret was also once set up, for which Strindberg contributed sketches with a leading part for his wife. But the

greatest of the Scandinavian community's festivities were those held in the Christmas of 1884, which, according to Spada, who enthusiastically recorded the occasion for a Stockholm newspaper, were like those of a 'Swedish peasant wedding'. Over thirty Scandinavian guests were invited from Paris, including the renowned Ernst Josephson, who proposed the royal toast. For decorations Larsson and Janzon had executed ten-metre-long cartoons of the Grez artists in funny costumes and situations. There was much singing, dancing, and drinking of stout ale, and also a large

Christmas table of Swedish food. Spada tersely added in the midst of his description of the event: 'Everyone is in love with Miss Bjorkegren.'

Whereas Strindberg was struck by the unconventional nature of life at Grez in the 1880s, Pauli found it less Bohemian than Barbizon or other French colonies which he had known. His reason for this was that there was more of a family element in Grez: there were fewer bachelors, and more children and elderly people, among whom were women who spent their time quietly reading or engaged in needlework. In at

24 Masked ball at Grez, 1880s

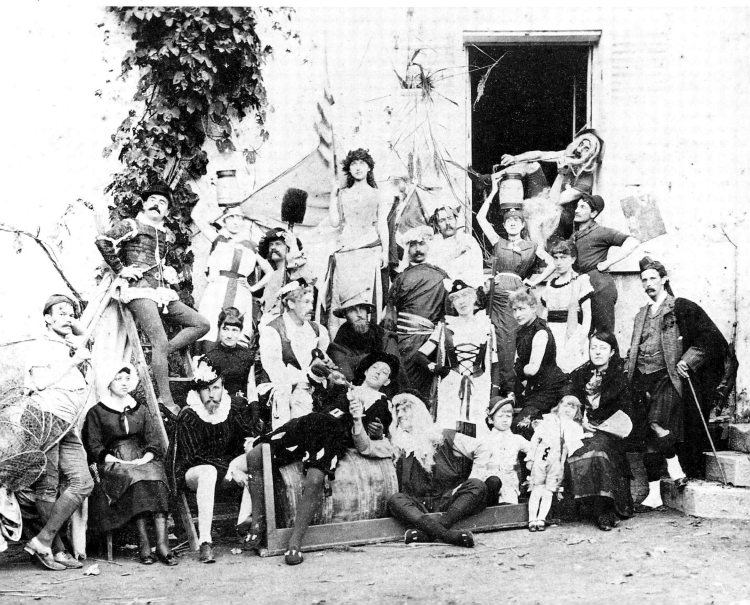

least one respect the colony at Grez in the 1880s can be seen as a colony going through as it were a conventional post-adolescent form of development: many of its members had reached a stage when they wanted to marry. A considerable number of these found their husbands or wives within the colony itself. Among such marriages were those of Nordström and the lithographer Tekla Lindeström, Emma Löwstadt and the rich American painter Frank Chadwick, and Caroline Benedicks and the Canadian artist William Blair Bruce. But perhaps the most famous of the Grez romances was that between Carl Larsson and Karin Bergöö. Larsson's modestly titled autobiography *I (Jag)* enables one to follow closely its development from the time of his first meeting her in the summer of 1882, through his subsequent period of elation despite persistent liver trouble, to the proposal on the bridge at Grez, and finally to marriage with his beloved 'cow eyes', as he used to call her, in June of 1883. Soon after the marriage they took up residence in a small house in the garden of the Pension Chevillon, and in August 1884, Karin gave birth to their first child, Suzanne. Larsson recorded his new-found domestic happiness in his *Studio Idyll* (fig. 25), which he painted when the baby was a few months old. The pleasures of domestic life were also to be the subject of much of Larsson's later work, when he and his ever-growing family set up their extraordinarily pretty and now much visited home in the village of Sundborn in central Sweden.

Of course not all the amorous intrigues which went on in Grez in the 1880s met with such a happy ending. One such unsatisfactory affair involved yet again the ill-fated O'Meara. For a twilight painting of a blonde girl by the river, O'Meara had used as a model one Florence Lewis, who subsequently fell in love with him. She in turn was loved by a Scottish painter called Donald Smith. As the latter had more money than O'Meara, Florence's mother thought he was a more suitable partner for her daughter. An opportunity came for the two men to prove themselves when a boating accident resulted in both mother and daughter falling into the river. Smith immediately jumped into the water and rescued the mother; O'Meara calmly waited on the bank and simply extended a helping hand to the daughter as she swam near him. Despite his bravery and favour with the mother, Smith did not win Florence's heart, but neither, it seems, did she win O'Meara's.

More serious emotional difficulties were experienced by Strindberg on his second visit to Grez in 1884. At this time there arrived in the village two Danish girls, the elder of whom, Sofie Holfen, was both a painter and a journalist. Strindberg suggested to her that she should cycle with him around the country so that he could write articles about French peasants and nature, which she could illustrate. Meanwhile the other girl, Marie David, who thought herself to be a daughter of the famous advocate for sexual reform, Georg Brandes, and who was herself an ardent believer in sexual equality, developed a close friendship with Strindberg's wife, Siri, and persuaded her to try and succeed more in her career. Strindberg became convinced that his wife was bisexual and having an affair with Marie. Their marriage, which had earlier benefited from their being with congenial company at Grez, was never to recover.

With the departure of Larsson, Nordström, Kreuger, Strindberg, and others after 1885, the Scandinavian colony at Grez became a much quieter and less publicized community. Larsson returned briefly in 1887, and this time found himself in the

25 Carl Larsson, *A Studio Idyll: the Artist's Wife and Daughter Suzanne*, 1885. Nationalmuseum, Stockholm

company of Sweden's most famous animal painter, Bruno Liljefors, who was then on his honeymoon. Larsson painted Bruno's wife Anna peering out of the Chevillon boat house, her red dress adding the principal colour note to a sombre watercolour. Towards the end of the 1880s Caroline Benedicks and William Blair Bruce took over Larsson's former house in the Chevillon garden, and for a few years led a life of self-sufficiency and lawn tournaments before moving to Sweden and an idyllic home rather similar to that of Larsson at Sundborn. Emma Löwstadt and Frank Chadwick spent part of the second half of the 1880s in the colonies of Pont-Aven and St. Ives, while always maintaining a base in Grez. This they were to do for the rest of their lives, living at first in a large house owned by the eccentric Marquis de Cazeaux, and later buying the Pension Laurent when it fell into disuse; their granddaughter still lives in the village. Of the leading Anglo-Saxon artists, O'Meara alone stayed almost uninterruptedly at Grez. He remained here until 1888, when he contracted malaria while painting out of doors and was taken back to Dublin to die. He was only thirty-six. It was no wonder that Low, when writing his *Chronicle of Friendships*, was sometimes to feel that he was compiling a mortuary list, noting that all the friends who feature prominently in the book had died under the age of sixty. They were all, to use Low's words, 'loved of the Gods'.

Although by the 1890s Grez had ceased to be an important artist colony, its lingering attraction for artists was indirectly responsible for bringing to the village in 1896 the composer Frederick Delius. In Paris in the 1890s Delius used to associate with a largely Scandinavian circle of artists who gathered at the home of William Mollard, an amateur Norwegian composer, and his wife, Ida Ericsonn, a Swedish sculptress; other associates of this circle included Strindberg, Munch, Gauguin (who was married to a Dane), and the Irish painter and friend of Gauguin from Pont-Aven days, Roderick O'Conor. It was here, in 1896, that Delius met a German painter called Jelka Rosen. Jelka had for a few years been living in Grez, renting in fact the house belonging to the Marquis de Cazeaux where Emma Löwstadt and Frank Chadwick had lived; Jelka had already attracted local attention by using her garden, which was overlooked by the presbytery, as an outdoor studio for nude models to pose in, thus turning it, in the words of Lavery, 'into a small and very select nudist camp which would have been a great success had it not been for the mosquitoes'. Delius came to visit her here shortly after

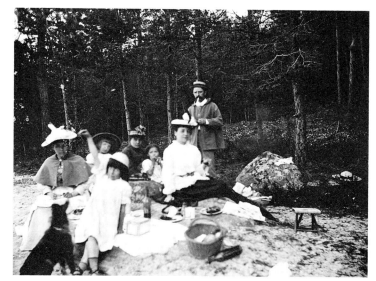

TOP: **26** Frank Chadwick and Emma Löwstadt picnicking in the forest of Fontainebleau, early 1890s
BOTTOM: **27** Pension Chevillon, Grez, as it is today

they had met, but the following year went back to his orange plantations in America. During this period, Jelka bought the house, began to live here with a painter friend called Ida Gerhardi, and determined that the house should be a sort of women's sanctuary where men would not be allowed. Her plans were thwarted by the unexpected return later in 1897 of Delius. He was to live here until his death in 1934, marrying Jelka in 1903. Always preferring the com-

pany of artists to musicians, Delius invited to Grez such painter friends as Munch, Roderick O'Conor, and the English Expressionist Matthew Smith. However the last years of Delius's life saw the composer going gradually blind and becoming ever more reclusive.

Delius's presence in Grez certainly did little to prevent the village from sinking back into its former obscurity. At about the turn of the century Low, who had then settled in America, came back to Grez and went to see Madame Chevillon: 'the good old woman took me to her capacious bosom, crying with joy as at the return of a prodigal son, and with sorrow that I alone came of the gay company . . .'. Shortly afterwards her establishment was to follow the example of Laurent's and close down. Today nothing remains, not even, it would seem, the memory of the villagers, to attest to the former importance of Grez as an artist colony.

Barbizon's decline manifested itself in a different way; it also set in much earlier, indeed from the time when the nucleus of the Anglo-Saxon community had transferred its allegiance to Grez. A visiting American journalist to Barbizon in 1881 wrote of the place: 'It is fast becoming like one of the cities of the Miracle of Italy or South America: every house in it is more or less of a shrine. Even Siron's eating house . . . has now that semi-sacred character, and in a few years it may become something of a profanation to eat there at all . . .'

28 Barbizon, c.1900, after the tramway had replaced the horse-drawn carriage

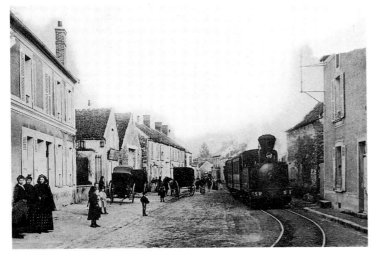

The American painter Edward Simmons stayed briefly in Barbizon in the mid-1880s and wrote that at Siron's at this time 'there were always dozens of artists gathered together, hoping to pick up one of Millet's paper collars'. The enormous crowds of tourists who came to the place gave Simmons and his painter friends a new daytime activity: they would place one of their sketches against a tree, retire to a hiding-place, and observe the reaction of the passing tourists. A points system was worked out on the basis of whether the sketch was noticed, examined carefully, or taken away; if the latter happened then the sketch was considered 'one hundred per cent perfect', and the artist in question had to buy his colleagues a bottle of wine. Of the original Barbizon colony still left in Simmons's time, there was just Jacque and Babcock. The latter, according to Simmons and others, had become an embittered hypochondriac, who was also so terrified of people that the only times he emerged from his house were either from the back door or else in the middle of the night. He also seemed completely unaware of the passing of time, as Low found out on a brief return visit to Barbizon in 1886: after having knocked at Babcock's door for the first time in at least eight years, the latter, without showing the slightest surprise, simply said: 'Oh it's you, Mr Low, come right up to the studio.' Low's visit to Barbizon in that year was to be his last. But once, in later life, he found himself on a train coming back from Italy, and, passing through Melun, saw out of his window a trolley-car with 'Barbizon–Chailly' written on it in large letters: 'Profanation of profanations! This mechanical contrivance replaces the old yellow omnibus, which for so many years carried the hopes, ambitions, and the persons of generations of artists to the village.'

Yet it seems that every succeeding generation of Barbizon artists came to have regrets similar to those of the preceding one. Gassies's nostalgia for Barbizon in the 1850s was no less than Low's for the village in the 1870s. And the French poet André Billy, who lived to see the site of Millet's *Angelus* be marked by a petrol station, looked back to the village he had first known in the 1890s as an idyllic haven. Today Siron's has been enlarged into a luxury hotel, whose guests have included the Shah of Iran, Rockefeller, Fernandel, Jean-Paul Belmondo, and Ingrid Bergman. Numerous other hotels and guest houses have opened up, including the Hôtel Angelus. An attempt has been made to restore Ganne's inn to its former state, and some of the original painted decorations have been brought back

29 Hôtel Ganne, Barbizon, as it is today

30 Hôtel Siron, Barbizon, as it is today

here; the place now acts as a shop for the Association des Peintres de Barbizon, and the visitor is encouraged to buy indifferent prints of local views. One need not mention the countless shops selling expensive antiques, pottery, and other such objects: these are the usual attributes of a place once favoured by artists. Thanks to the Autoroute du Soleil, which passes a few miles from Barbizon across the plain of Chailly, the village can now be reached by car from Paris in about half an hour. The only consolation one can offer Low is that the Melun–Barbizon trolley-car has stopped running. Doubtless there are many people in the village who deeply regret that loss too.

A considerable imagination is now required to picture Barbizon as a primitive hamlet; but one must remember that even as far back as de Sénancour's and Fenimore Cooper's time the primitive qualities of the whole Fontainebleau area existed more in the imagination than in reality. Many of the innumerable visitors to the forest in the nineteenth century were particularly susceptible to the idea of a place as some sort of magical domain where one could suddenly be lifted from the realities of the present. They were young, sometimes new to France, or else experiencing for the first time the life of a close-knit community of Bohemians. Of course once their imagination had been stirred in this way, the more restless among them felt a need for wider horizons. Birge Harrison wistfully reflected that the consequences of Robert Louis Stevenson's going to Grez were indirectly to lead him as 'an "Amateur Immigrant" to California . . . start him on that year-long cruise of the Pacific, and waft him at last, like a piece of driftwood, to far off Samoa'. Although few of the Fontainebleau artists were to have quite the same spirit of adventure as Stevenson, many of them were encouraged by their experiences of living in the area to seek other places where the primitive and Bohemian idyll could be recreated. The legend of Barbizon and its forest soon spread all over Europe and America. Yet just as the place had begun to capture such a widespread hold on the imagination, another area of France, remoter and more obviously primitive, began to attract artists in their hundreds. This was Brittany.

3
A Second Arcadia

PONT-AVEN AND
CONCARNEAU (FRANCE)

'Quaint, curious and mysterious region of lower Brittany, out of the beaten track of tourists and at the time at which I write seldom visited and hardly known to the world at large. Here I lived so long that its primitive oddities and absurdities ceased to surprise and became a component part of everyday life—and now the years of my sojourn there live in my memory as a background of a sombrely tinted tapestry whereon, in their fantastic setting of scenes not to be found elsewhere, move the strangely costumed personages as shadowy figures move and speak in a dream.'

With these words the American painter Clement Nye Swift began one of a group of short stories based on his life in the Breton town of Pont-Aven in the 1870s. Almost all the visitors to Brittany in the nineteenth century viewed the region in a similar way; and to many the experience of coming here was like travelling back to the Middle Ages, or even further back in time, to a primeval era. This fanciful image of Brittany had an obvious appeal to the growing number of artists who in the second half of the nineteenth century—to appropriate a phrase by the Symbolist painter Émile Bernard—isolated themselves more and more from their own period, whose preoccupations with industrialization disgusted them. By the late 1870s Brittany had come to be referred to as the 'land of the painter', and indeed to attract more artists than any other region of France. Significantly, of the countless painters who worked in the region during this period, hardly any were Bretons. Instead the artists who came to the region were determined that it should live up to its reputation for being backward and remote; as one traveller to Brittany put it, they

were people who 'resent all change in costume and dwelling in order that villages should remain "picturesque", who look upon their brother living in a hovel as they do upon an old door-knocker or china plate.'

By the time these artists started coming in large numbers to Brittany, the region had in fact become much less backward and remote than it had been in the first half of the century. Through the reclamation of wastelands and the improvement of farming methods, agriculture had begun to prosper. Moreover, railway lines had been built, as well as a series of modern roads which were the pride of France and considered by one American artist as far superior to those in the vicinity of Ipswich, Massachusetts. In only one important respect had Brittany changed little since the beginning of the century: it had remained largely untouched by the industrial revolution. As a result many Bretons were forced to look outside their region for employment. The new railway facilitated their emigration, while at the same time it helped Brittany to develop as a tourist centre.

In 1878 the English writer Henry Blackburn summarized the charms of Brittany for the artist in a very popular book called *Breton Folk*: 'Rougher and wilder than Normandy, more thinly populated and less visited by the tourists, Brittany offers better opportunity for outdoor study, and more suggestive scenes for the painter.' It is certainly true that the bleak character of much of the region had a particular appeal to a generation of artists who had come to appreciate landscape not so much for its spectacular or lusciously pretty qualities, but rather for the way in which it seemed to express the bleak, monotonous

reality of everyday rural life. To an extent perhaps greater than anywhere else in France, Brittany is characterized by its greyness. Granite is a favourite material for building and sculpting, rocky outcrops punctuate otherwise featureless moorlands, and the coastline comprises for much of its length a series of massive boulders leading to a perpetually grey sea.

Whereas the visitor to the forest of Fontainebleau could only dream of Druids, the visitor to Brittany could actually find many examples of Druid culture scattered in the landscape. These took the form of menhirs (upright stones) and dolmens (massive stone slabs set up in the form of cists or tables). The influence of Druid religion persisted with the advent of Christianity; a compromise was reached and many menhirs were consecrated and inscribed with crosses. The nineteenth-century tourists liked to imagine that the peasants still venerated these and other such lumps of stone, and one American derived sacrilegious pleasure from whistling 'Yankee Doodle' underneath a large dolmen off the road between Pont-Aven and Concarneau. In fact the tourists were probably more hoodwinked by these objects than were the peasants, to judge by the amount of interest which they took in the tales of mystery and folklore attached to them. Just outside Pont-Aven, again in the Concarneau direction, is the Mendogan Stone. This is a rocking stone—a block of granite poised on a second slab half buried in the ground—which supposedly can be pushed by wives who have been faithful to their husbands. In Blackburn's day the many groups of tourists who came here were met by little boys who offered to show the stone in action for just a few *sous*.

Native Breton art and architecture is perhaps cruder than that of any other French region. It was only in the nineteenth century that the expressive qualities inherent in Brittany's old churches and sculptures came fully to be appreciated by a sophisticated public. Particularly distinctive to Brittany were sculpted free-standing Calvaries which were placed outside a church or chapel; sometimes these powerful granite works dominated a so-called parish enclosure, or group of ecclesiastical structures including a church, ossuary, and gatehouse. The most famous of these enclosures, which are also special to the region, all date from the sixteenth and early seventeenth centuries. The ossuaries contained on open display the remains of all the bodies which were accidentally thrown up in the course of digging graves (a common occurrence this, as the Bretons used to mark their graves with small wooden crosses which quickly decayed). The sight of enormous piles of bones and skulls, which were sometimes even placed outside at the foot of the Calvary, undoubtedly contributed to the stark power of the setting.

It was not only the Breton environment which so fascinated artists, but also the people themselves. There was something very exotic about them. First, they were not French, but Celts who had come over to France from England to escape the Anglo-Saxon invasion. They have maintained a spirit of independence up to the present day. At the time of the French Revolution they joined in the Vendean wars against the Paris government, and also formed their own uprising under Jean Chouan: they were not seeking separation from the rest of France, but were rather attacking the notion of an inflexible dictatorship. They were punished terribly afterwards. The Breton language, which has oriental roots, continued to be spoken throughout the nineteenth century, despite attempts by the French government to suppress it by not allowing it to be taught in schools. The American painter Benjamin Champney, writing about Pont-Aven in 1866, claimed that the 'moment we got outside the market-place . . . no one spoke French, or if they knew it would condescend to speak it'. The idea of a small oppressed race fighting to keep its national identity had undoubtedly a romantic appeal to artists and tourists alike, especially at a time when a spirit of

31 Chapel of Trémalo, Pont-Aven, with a rough-hewn granite cross in the foreground, *c.*1900

romantic nationalism was spreading all over Europe. Linked to this was a growing fascination with the forms of early Celtic art and literature which was to lead to the Celtic Revival at the end of the century.

There were other aspects of the Bretons which interested foreign observers, such as their strong folk-lore tradition and intense Catholicism. The latter was especially manifest in their numerous quaint religious festivals held throughout the year. Most notable of these were the *Pardons,* which lasted up to three or four days, combining the religious with the secular: church ceremonies were followed by wrestling bouts, dancing, and other such fairground activities. But above all there was the Breton costume. In the nineteenth century Brittany was the principal French region to retain its national costume; and even today it is still worn by the more elderly Bretons. The costume varied according to a person's age, status, village, and, in the case of a woman, whether or not she was still a virgin. The principal component of a woman's costume was the head-dress or *coiffe*: this could be very short and closely fitting (usually an indication of virginity), tall and narrow, or wide and butterfly-like, and was made of lace or cotton; it was invariably white, and always concealed every strand of hair. The very long hair which women tended to have, yet which was rarely exposed, was often cut off in times of hardship and sold for wigs. The men also wore their hair long, but their full traditional costume was much less often worn than the women's and was becoming something of a rarity in the late nineteenth century. It consisted of a wide-brimmed black hat, short loose jacket, woollen double-breasted waistcoat, and breeches cut wide at the hips and buttoned at the knee. Both men and women wore wooden shoes or sabots, which differed from those of other parts of France by being slightly pointed and turned up at the toes; the wealthier Bretons wore these with long thick woollen socks, but the poorer simply stuffed straw into them.

The Breton peasant in his costume, whether working in the fields, walking in the streets, praying at church, or taking part in some festivity, provided these nineteenth-century artists with their principal source of inspiration. Yet many of them found such people on a personal level unattractive, and often for the same reasons that they found them quaint as models. Everyone was agreed that they were all lazy and stupidly credulous, and that they rarely washed and spent much of their time drinking or indulging in crude gossip. An American painter, Elmer Boyd Smith, claimed that he had never seen so much drunkenness

as in Pont-Aven; he also considered the Breton character to be rather similar to what he imagined to be that of the Irish, except that the former was too lazy and complacent to have the latter's belligerent streak. Another American, Julian Alden Weir, wrote that 'the peasants here in Brittany are the most ignorant set of beings I ever met, few of them read or write, and are kept in perfect control by the priests.' The English painter Stanhope Forbes described the Breton as 'a very dirty, uninteresting, drunken sort of creature' and complained about 'the dearth of beautiful maidens in these parts'; according to Forbes, if a woman had an attractive figure, it was not apparent because she was always wearing heavy clothing. Forbes's opinions on this matter were shared by the American Howard Russell Butler, who thought the Bretons 'ungraceful and exceedingly homely'. 'But,' Butler added, 'nowadays there is a rage for homely faces and this gives the Bretons a chance.'

The English and Americans were the two most prominent nationalities among the artist visitors to Brittany in the nineteenth century. For the former there was of course the advantage of geographical proximity; they were, moreover, sentimental about the strong Celtic connections between their own country and Brittany. However, it was the Americans who were the greatest Breton enthusiasts, and it is really to them that the main credit must be given for encouraging the appreciation of this region. Champney wrote that 'Brittany and its people make a

32 Pascal Dagnan-Bouveret, *Breton Women at a Pardon,* 1887. Calouste Gulbenkian Foundation Museum, Lisbon

very strong impression upon an American visitor'; and by Blackburn's day it was commonly said that Brittany was 'the only spot in Europe where Americans are content to live all the year round'. Coming from such a new country themselves, the Americans were obviously fascinated by a region which to them seemed to live so much in the past. At the same time they also found strong similarities between the Breton coast and the east coast of America, and also derived pleasure from knowing that only the Atlantic divided Brittany from their own country. During the first weeks of her stay in Concarneau, the portraitist Cecilia Beaux was constantly reminded of the Massachusetts seaport of Gloucester, and in homesick moments would stare out across the sea.

Artist colonies were set up all over Brittany in the nineteenth century; but the most important were to be found in the south-west, in the region then known as Finistère but which had originally been called 'La Cornouaille'. The earliest were Douarnenez and Pont-Aven. The latter was founded in 1866 by a largely American group of artists, and came shortly to rank with Barbizon as the largest and most famous artist colony in Europe.

Despite improved transport in the second half of the nineteenth century, the journey from Paris to Pont-Aven was a relatively long one. The overnight train from Paris arrived in Quimper at about noon the following day. The traveller had to finish his journey in a mail coach drawn by four horses, which in 1890 did not leave Quimper until 6.24 in the evening. After crossing the outskirts of Quimperlé, Baye, and Riec for an hour and a half, the coach went up and down a series of rugged hills for fourteen kilometres and eventually, about two hours later and after descending the very steep Touliffo hill, would arrive at the main square of Pont-Aven.

Pont-Aven is a conventionally pretty place which owes much of its charm to being built around a fast-flowing river, the Aven, full of rocks and cascades, and bordered by mills and quaintly asymmetrical houses. The valley in which the small town is nestled is very different from what it used to be, being now much more wooded; this change is due largely to householders abandoning firewood in favour of other sources of energy, as well as to the owners of the first villas in the region planting trees both to protect themselves from the wind and to create parks. In the nineteenth century the only wooded area in the immediate vicinity of Pont-Aven was the much

33 The river Aven at Pont-Aven, c.1900

painted Bois d'Amour, which lies along the Aven on the northernmost edge of the town. On the other side of the town the Aven widens to form a small port, where in the last century the ships taking part in the profitable export of potatoes to England were loaded. From here a beautiful walk can be made to the sea, an excursion which was once very popular with artists.

As far back as 1798 the Breton writer, Louis Chambry, wrote that 'the neighbourhood of Pont-Aven, and the village itself, offers a hundred picturesque subjects for the painter who wishes to make studies.' The story of Pont-Aven's development as an artist colony, however, does not begin until 1863. In this year a twenty-five-year-old artist called Robert Wylie came over to Paris from America. Wylie had been born in the Isle of Man, but had settled in Philadelphia when still a child, and, just before coming to France, had studied at the Pennsylvania Academy of Art. As a temporary measure on his arrival in Paris, Wylie enrolled at the casually run and not very prestigious Académie Suisse. His intention was to move on to the École des Beaux-Arts, where he wanted to study sculpture. However, he found himself too old to be a student here, as in 1863 there was an age limit of twenty-five; at any rate in the following year this school was to be temporarily closed to all foreigners. During this frustrating period, Wylie became friendly with a nervous young art student called Charles Way,

the son of a Boston millionaire. Way in turn introduced Wylie to the American genre painter Henry Bacon, who spoke highly of a trip he had just made to Brittany. In the summer of 1865 Wylie and Way visited the region themselves.

In the following year two other Philadelphians arrived in Paris, Earl Shinn and Howard Roberts. They put down their names for the École des Beaux-Arts, but as the ban against foreigners was still operating they were unable to enter the school until 1867. In the meantime they met up with Wylie, who had recently returned from Brittany and was intending to go back again with Way early in the summer of 1866, and stay in Pont-Aven. Wylie's enthusiastic tales of Brittany clearly caught their imagination, and Shinn began eagerly collecting a number of books on the region. In June they followed Wylie to Pont-Aven, but, much to Shinn's annoyance, forgot to bring all these books. They were shortly joined in Brittany by the Bostonian painter Benjamin Champney, who had recently come to France from Italy and had also encountered Wylie earlier in the year in Paris. In August this circle at Pont-Aven was enlarged by the arrival of an eighteen-year-old from Alabama, Frederick Bridgman, who had come to Paris in the spring, and, like Wylie, had enrolled at the Académie Suisse while at the same time making an application for the École des Beaux-Arts. Other arrivals at Pont-Aven this summer included a Bostonian painter called Moses Wight, and two obscure English artists, Martin Lewis and Garraway. Shinn soon referred to these early artist visitors to Pont-Aven as the 'seven original sinners'; in fact there were probably about twelve artists staying in the town that summer.

The dominant personality in this group was certainly Robert Wylie, who was also probably the oldest. All his colleagues considered him as a Christ-like figure, quiet, modest, and self-effacing, and yet always commanding an immense authority. According to Shinn, Wylie's compassionate manner encouraged people to yield to him almost on first acquaintance 'a part of that confidence we all save up for the confidential spirit we all expect to meet some day'. Wylie also appears to have won the immediate respect of the villagers of Pont-Aven. Champney wrote that 'he understood their characteristics well ... and was always dignified and polite with them, and gained their confidence, more so than any stranger could have done.' Following his thwarted attempt to become a sculpture student at the École des Beaux-Arts, Wylie devoted himself to painting. In this he

36 Robert Wylie, *A Breton Fortune-Teller*, 1871–2. The Corcoran Gallery of Art, Washington, DC

earned himself an enormous reputation. Although only a few of his works survive, a certain amount is known about his art from contemporary descriptions. His speciality was scenes of Breton life, in particular scenes with an element of mystery, such as a group of peasants gathered around a fortune-teller. These works were admired for the artist's use of pure colour; he was known to attach a rose to his canvas to help him to achieve a vivid red, and Shinn wrote that he was the only artist he had encountered who used cerulean blue in his shadows. He painted largely with a sable brush and palette knife, and his extensive use of the latter was regarded as very novel at the time. From his Rembrandtesque *Breton Fortune-Teller* (fig. 36), his major surviving work, it is difficult for one now to appreciate why he was so highly esteemed. Yet all his contemporaries insisted that it was through him, through his fame both as a man and a painter, that Pont-Aven developed into what Shinn was to describe as a 'university town for artists'.

Of the others in Pont-Aven in the summer of 1866, only Frederick Bridgman was to achieve a comparable reputation as a painter. However, at this time he was only at the very beginning of his career, and to his friends simply 'a shy, industrious, blay-eyed youth'. Roberts was to become a well-known sculptor in his native Philadelphia, but like Bridgman had then not even had a proper art school training. Lewis and Garraway were clearly not very special, as nothing

37 Pont-Aven, view from the bridge, with the Pension Gloanec on the right, c.1880

was ever written about their work; Wight was a conventional portraitist; Way was simply a wealthy amateur. As for Champney and Shinn, they are best remembered today not for their art, but for their writings on the artist life of this period. Champney was Shinn's favourite personality among the Pont-Aven crowd of 1866 (Wylie, for Shinn, had more presence, but was also apt to be dogmatic): 'He has the art of getting on with others, which I think a very interesting study. The race of artists, whose profession obliges them to go through the world with their nerves bare, are not famous for harmony among themselves. Champney is a model of balance, philosophy, and good humor.' As a painter he was rather less striking: he was a conventional landscapist, brought up in the classical landscape tradition and later drawn to the art of Barbizon School painters such as Corot, Rousseau, and Daubigny. One is none the less indebted to Champney for his memoirs, which include a vivid chapter on Pont-Aven at this time. Shinn had likewise little gift as a painter, and indeed was to change profession after 1868, but he was a lively writer and observer of the world around him. In Pont-Aven he spent much time writing a regular series of letters to the *Philadelphia Evening Bulletin*, which were published under the pseudonym 'L'Enfant Perdu' and entitled 'Rash Steps'.

The mail coach from Quimper to Pont-Aven deposited travellers at the north-east corner of the central square, just outside the Hôtel des Voyageurs, which was the mail stop of the town. There were in the

1860s two other hotels to which the traveller could go: the Hôtel du Lion d'Or, which was further down the square on the same side, and the Pension Gloanec, which was just past the bottom of the square in between the covered market (no longer existing) and the main bridge across the Aven. Nothing is known about what the latter establishment was like at this time. However, Shinn wrote that the Lion d'Or was then run by 'three lionesses' who were always keeping an eye on the proprietress of the Voyageurs and trying to get her into trouble for selling a glass of cider after nine o'clock or for sending off a carriage party without a permit from the gendarmerie.

All the artists who came to Pont-Aven in 1866 went straight to the Voyageurs. This was then owned by Madame Feutray, who, according to Shinn, 'made pets of her transatlantic family'. She organized feasts for them on Twelfth Nights and saints' days to 'show them the customs of the country', and even surprised the town's inhabitants on fair days 'with a totally new line of purchasers of Breton costumes'. Her husband apparently did little all day but sleep in a small pantry which served as their bedroom. This made him of course an excellent model. In fact Madame Feutray became quite jealous that the artists should spend so much time painting and sketching her lazy husband, while never attempting to achieve a likeness of her. One day she challenged Champney about this, and with great presence of mind he replied that the husband was an oddity, and she was handsome. Madame Feutray's mother, Madame Hochet, also lived in the hotel. Always referred to for some reason as 'Dam'roch', she was then probably in her eighties, but, according to Champney, 'sprightly and gay as a girl'. One day she invited Champney and Wylie to come and dine with two old friends of hers who lived in a nearby village. It turned out that these friends had a young nephew of 'roving disposition' who had gone to seek his fortune in America and had not been heard of since; they wondered if he was known to the two painters. Dam'roch was loved by all the artists, and intrigued them by her involvement as a child in a tragic incident in the Vendean wars: she had been taken with her mother and many other women in carts to be thrown into water and drowned, but, whether through luck or pity, had been saved at the last moment.

As with all hotels popularized by artists, the interior of the Voyageurs soon came to be covered with paintings. In later years there was to be more discretion exercised as to who was allowed to decorate

the place, but in 1866 everyone was given a free hand. Thus a sunlit view of the Bay of Naples by Champney hung near a sombre Breton scene featuring peasants, oxen, a Druid column, and ominous clouds; also nearby was a portrait of a graceful Breton girl cheerfully sifting grain as if she was playing a tambourine. Amidst this assorted company could at one time be found hanging a real dead duck which served as a model to the artists on rainy days and was eventually to be eaten before the paint had dried on their canvases.

The hotel then was a very small place, and the unexpected invasion of artists in 1866 had already put Madame Feutray, in Shinn's words, 'to strange devices to feed and bed us'. Fortunately there was an obliging notary called Tanguy who lived almost next door and offered to help by putting up guests in his own house. This is where Shinn stayed, while, like Tanguy's other guests, always taking his meals at the Voyageurs. Shinn was very enthusiastic about his room here and compared it favourably to the room in a Quaker farm outside Philadelphia which his sister was then visiting: 'in the latter,' he wrote to her, 'you are afraid to sit down except at right angles. Here I find the freedom which you think anarchy . . .' Tanguy himself made a delightful companion, young, lively, informed, and with a great sympathy for artists; he also had a pretty wife with 'Indian hair and Spanish eyes'.

It was through Tanguy that the artists came to have the use of an abandoned manor-house called Lezaven, located just outside the town off the Concarneau road. Tanguy had the keys to this place, and one day decided to take his artist friends there. Their first reaction was to ask if it was haunted, but Tanguy reassured them that there had only been a murder there. It was a large rambling unkempt place, half manor, half farmhouse, with walls hung with decaying Watteauesque canvases, and a garden gone to seed; Shinn described entering the kitchen as 'like turning up an engraving after Ostade in a portfolio'. One very large room, with a wide open fireplace and a high square window, was immediately seen to have excellent potential as a studio. With Tanguy's permission, the artists soon started coming to work here every day. In free moments they would pitch quoits in the gardens or else explore every recess of the house, discovering on one occasion numerous mementoes of the revolutionary period such as coins and assignats. The house was gradually transformed. The rooms came to be filled with a growing collection of Breton bric-à-brac such as embroideries, spinning-wheels, crucifixions,

and knee-breeches; the Watteauesque canvases were replaced by the artists' own works which, in the words of Shinn, 'gave a modern air to the old manor-house.' The place became a veritable museum, and attracted many passing tourists, as well as countless beggars who congregated outside the studio as if it were a church.

A usual day for the artists began around half-past six when they would get up and assemble to have coffee. At this point attempts were made with great difficulty to rouse one of the maids, Francine. She played a very important part in their daily life as it was she who was responsible for calling and then looking after the day's models. At about half-past seven everyone gathered at Lezaven. If it was sunny the model would pose out of doors: this seems to have been quite an unusual practice for the time, and was not to be widely adopted until the advent of Bastien-Lepage. (Millet, it must be remembered, had always worked with the model in the studio.) However, as it rained for much of the summer of 1866—Shinn described the season as 'more like a winter in Patagonia than a summer in France'—the artists were forced to work in the studio of the house. Here the model was illuminated by a single shaft of light coming from the high square window: this was a more typically academic method of working, and often gave a Rembrandt-like quality to the paintings produced. Whether outside or in, Francine would always be there, quietly knitting an endless stocking, occasionally exchanging words in Breton with the model, and sometimes being called upon to sing by the assembled company.

Thanks to the trust which artists such as Wylie inspired in the villagers, there was no difficulty in procuring models. The villagers liked to pose not only for the money, but also for the pleasure of having a picture of themselves; photographers hardly ever came to the town during this period. The driver of the mail coach, then reputedly the handsomest young man in Pont-Aven, who that summer had made many a local girl cry by becoming engaged, was once sketched surreptitiously by Shinn; having subsequently been given the sketch, he spent the rest of his day showing it to everyone he met and then asked Shinn if he could be portrayed in Breton costume. Shinn also relates that the prettiest girls in Pont-Aven would sit for them without hesitation, and that the artists' 'popularity with the Celts' reached such a point that they even managed to persuade both the peasants and the local gendarmerie to pose for them bare-headed. Favourite models included Marie Mower, who had a very pale

complexion and a fine red overcoat; an old bedraggled man with waist-long hair and no apparent family or Christian name; and an angelic-looking boy called Grégoire Canivet, whom Bridgman had 'discovered' kneeling at prayer at the *Pardon* at Scaer. To judge from the usual Breton picture of this time it would seem likely that the models employed were all asked, as Grégoire was once, to assume a sad expression. The long-suffering Grégoire was also reluctantly made to wear a pair of his father's baggy breeches; to him this picturesque item of clothing was not only unattractive but also out of fashion.

The artists would spend the morning at Lezaven copying from the model, and then would go back to the hotel for lunch. After spending about an hour and a half at the table they would return to the studio at around two o'clock. A new model would then be waiting for them, and they would work until about six. Occasionally, if the weather was hot, they would go off earlier and have a swim in the Aven. Back in the inn, if there was any free time before supper, Bridgman

38 Frederick Bridgman, *Study of a Young Girl, Pont-Aven* (a rare glimpse of a Breton girl without a *coiffe*, a state considered provocative and indecent), 1869. National Museum of American Art, Smithsonian Institution, Washington, DC

would perhaps play for a while on his violin in the privacy of his small room. Supper was always at about half-past six and was an even more protracted affair than lunch, there being about five courses (soup was never served in the middle of the day). Everybody sat around a long, largely bare table, which Shinn thought would have made an excellent billiards table except for the presence in the centre of an enormous mound of butter weighing about five or six pounds and which looked like the Colosseum. Gathered round this table the artists made a strange sight: 'Each man,' wrote Shinn, was a 'long-bearded solitary, like an Enoch Arden, after six months' abstinence from barber shops. They were heavily browned upon the face, hands and back of the neck. There was something outlandish in their dress. Brown men with long hair have a lonely look even when they go in bands.' Wylie always sat at the head of the table and was responsible for all the carving; in this task he amazed Champney by being so unselfish as never to keep back 'a tit-bit' for himself. After each course the table was always cleared, and all the plates and cutlery washed. This last was Dam'roch's job. The artists were waited on by a maid called Yvonne, who always stood behind the table with a completely inflexible expression, and soon acquired the nickname of '*le sphinx*'. This always puzzled her, and she kept asking, '*Qu'est ce que c'est que le sphinx?*'

Opinions were divided about the quality of the food, but at least the servings were generous. One much liked speciality was Madame Feutray's *gâteau du roi*. Then there was the celebrated *omelette au rhum*. Bringing this in was 'le sphinx's' moment of glory. After emerging from the kitchen and closing the dining-room door behind her for fear of a draught, she solemnly walked towards the table bearing in one hand what looked like a flat white rock covered in flames. This was not a time for trifling with her. The flames lit up her perfectly rounded and immobile features, and in the strange light her Breton *coiffe* was transformed into an Egyptian cap. When she began to ladle portions of the flaming omelette into the bowls, she became, in the words of Shinn, like a 'priestess of Isis, busied with mysterious rites'.

Shinn gave an imitation of the sort of talk that use to accompany these dinners.

Yes, the effect was the most stunning I've hit upon yet. You know the first curve in the river? Well, there's a huge face of rock there, a little bigger than Couture's *Decadence*, it's a mass of gray lichen,

39 Ruins of the castle of Rustéphan, Pont-Aven, c. 1900

very pure Courbet colour, plenty of silvers along the gray, with some faint malachite reflexions from the trees, and a good bit of burnt umber where they had had a fire against it. Now a pig, that had been out crabbing in the mud at low water, where I passed, had just gone to rub itself—a monstrous animal. Well, you know the gray on a pig's back is the heavenliest colour, well it just carried off the gray of the rock, slick as lard; then the flesh-tint beginning to move through the bristles down the sides of the animal took the eye safely down into the mud, which showed some warm radiations from a gamboge cloud that hung handy; it was the hottest mud I've fallen upon yet—remarkable for softness and feeling: quite juicy, you know and singularly clean. Altogether I was enchanted. I made a sketch on the spot: I'm thinking of a Flight into Egypt.

For lighter relief Tanguy provided the latest sporting news, Dam'roch gave a few more reminiscences about the Vendean war, and, occasionally, wandering sailors joined the company and contributed their own

tales. By early in the summer, everyone had got to know each other's pet jokes and stories by heart. Shinn summarized the evenings as 'festal, but not bacchanalian'. The conversation was always brought to an abrupt end with the ringing of the village church bell at eleven o'clock and the reappearance of 'le sphinx' quietly telling everyone to go to bed.

If the moon was shining brightly, the artists, like those at Barbizon, would sometimes go on nocturnal outings. The usual place of pilgrimage at this hour was to the ruined castle of Rustéphan, which had a strange tale attached to it and a reputation for being haunted. The lord of the castle in medieval times had a beautiful daughter called Guinevere, who was in love with a peasant by name of Ivanic. To break up the match, the lord had Ivanic dispatched to a monastery to study for the priesthood. One day Guinevere attended Mass at a neighbouring village to find her beloved officiating at the service. The shock was too great for her, and she collapsed and died shortly afterwards. What subsequently happened to Ivanic is not known, but after he died his face was often seen to gaze from a tower in the castle every time a dance was held in the great hall. This apparition naturally did little to enliven these occasions, which soon had to be stopped. The Bretons continued to believe in this ghost story, and even made occasional sightings of Guinevere herself, standing on the parapet and dressed in green with a golden fleur-de-lis. The old well of the castle supposedly contained hidden treasure, but no Breton was brave enough to go and dig for it. The artists of course all treated this as one big joke, and on their moonlit excursions would sing, laugh, and have an altogether jolly time. This apparently deeply offended the peasants, who thought such behaviour unseemly for a place which they considered filled with evil spirits. Later generations of artists at Pont-Aven were to continue to visit the castle by moonlight. On one such later visit, in 1885, when the tale of the ghosts was being told, one of the artists threw a small stone up the ivy of the walls, and it came rattling down with a noise which made everyone present shiver. By this later date there was also a very real danger in the form of an immense bloodhound, and visitors to the castle were advised to bring with them sticks and stones in case of an attack.

By the end of the summer of 1866 the artists began to disperse. Champney went back to America by way of Liverpool. Travelling through England, he found the landscape 'soft and lovely . . . but a little monotonous . . . and wanting in character after the rough, rocky hillsides of Pont-Aven'; he longed to sit down

again before a 'fine gray rock'. On board ship crossing the Atlantic, an intense nostalgia set in for the face of Yvonne and the 'provoking dimples of Francine'; not even the ship's cooking could console him by being any better than that at Madame Feutray's.

Roberts was one of the next to leave. On the evening of his departure from Pont-Aven, three others of the remaining group, Wylie, Bridgman, and Shinn, went to what the latter described as one of 'those dreary French fêtes which the natives can stand to any extent, looking in each others' faces and singing songs without end, but which perforate Americans badly'. Roberts arrived in Paris to find that the École des Beaux-Arts was still closed to foreigners. Luckily for him and for other Americans, there was also in Paris at this time a fellow Philadelphian, Thomas Eakins, who through sheer persistence and such ruses as pretending to be deaf or not to speak French when he was challenged by some lowly official (in fact he spoke French much better than most of his compatriots) eventually managed to get an interview with the usually unapproachable Count Nieuwerkerke, and to persuade him to sign passes for all the Americans who wanted to get into the École des Beaux-Arts. Thus Roberts was finally able to enter this prestigious art school and take up lessons under the renowned Gérôme. He was joined there by Shinn, who had returned from Pont-Aven shortly after him, and later, in February 1867, by Bridgman, who had probably remained in Brittany until that time.

Only Wylie continued to stay in Pont-Aven, and indeed, apart from the odd visit to Paris, was to do so for the rest of his life. In August 1867 he came briefly to Paris and called on Shinn, who had just returned from a trip to Italy. Shinn found that his old friend had picked up a considerable amount of Breton during his year's residence in Pont-Aven and would now have made 'the most eligible of companions around the courts of Arthur, and the battlefields of the Table Round'. Wylie suggested that he came on a month's trekking with him around Brittany. This they did, and met up with a number of beggars and serving-girls whom they had known in the previous year in Pont-Aven, as well as some French artists who told them about the Hôtel de Bretagne in Douarnenez. Wylie and Shinn went there and found the landlady, to whom they had been given a letter of introduction by the French artists, to be a most beautiful and generous person, and the food which she served in her establishment to be some of best they had had in Brittany. They also found her dining-room covered with pic-

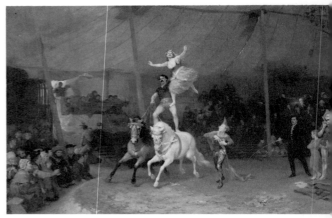

40 Frederick Bridgman, *The American Circus in Brittany*, 1869–70. Collection of Nelson Holbrook White

tures in a Jules Breton style. It turned out that in the previous summer, just as they and their American friends had begun to settle into Pont-Aven, Jules Breton and a number of his followers had been establishing a colony at Douarnenez.

Early in the autumn of 1867 Wylie and Shinn finally arrived back in Pont-Aven. One or two of their friends of the previous year had returned, including Garraway. There were also a number of other Americans. This was the year of a major international exhibition in Paris; back in the USA Champney had told all his colleagues intending to come to France for this exhibition about the marvels of Pont-Aven, and doubtless had encouraged them to go and see the place for themselves. Shinn felt rather disappointed on arriving back: 'whenever we get back to an old horizon how we find the landmarks changed.' One of the saddest of these changes concerned his old friend and landlord Tanguy: his business had declined and had been sold out, and his small son Felix, who had been sketched by Shinn in the previous year, had since been sketched in the coffin by Garraway. Meanwhile, Shinn lamented, 'marriage had made almost equal slaughter among the names of my different pretty girls at Pont-Aven.'

Shinn returned for another season at the École des Beaux-Arts. In 1868 he ran into severe financial difficulties and decided to go back to Philadelphia. Back home he was to abandon painting altogether and devote himself to a financially unrewarding career as an art critic, always writing under a pseudonym so as not to offend his fellow Quakers, who thought writing

about art a frivolous activity. Bridgman, who had also stayed on for a second season at the Beaux-Arts, likewise experienced financial problems at about the same time. His solution was to go and settle in Pont-Aven, where life was cheap and friendly, and models and extensive credit were easily obtainable. Shortly after returning here in 1868 a chance occurrence enabled this shy young man to develop a close friendship with the family of the Marquis de Montier, an elderly amateur painter who spent much of his time at Pont-Aven. The Marquis had two daughters, who in 1866 had already aroused the interest of the Americans, but who had then, in Shinn's words, 'avoided our acquaintance with the usual French delicacy'. This year Bridgman was finally able to get to know them after having jumped into the Bay of Biscay, at great risk to himself, to save one of them from drowning. From that moment on he and his violin were always welcome at the Marquis's house. He was also soon to make his breakthrough as a painter. In the winter of 1869–70 he began visiting a circus in a town near to Pont-Aven with the intention of making studies for a large canvas; at the same time in Pont-Aven itself he made an imitation circus tent and track with the aid of earth and an old sail. The end result of all this was a picture entitled *The American Circus in Brittany* (fig. 40), a work which for all its rustic characters and setting is remarkably similar to many of his teacher Gérôme's celebrated pictures of the Circus and Colosseum in ancient Rome; however, it was to win for the artist recognition in France, and, in 1870, celebrity in America.

The outbreak of the Franco-Prussian War in the summer of 1870 made life in Paris especially difficult for foreign artists, who found themselves suspected by the French as Prussian agents and by the Prussians as French provocateurs. Most of them decided to leave, either to go back to their own countries or else to take refuge in some suitable place in the country. Barbizon was too near, and, as has been seen, was itself greatly affected by the war. Brittany, however, was sufficiently remote, and Pont-Aven, with its growing reputation as an artist colony favoured by Americans, seemed the obvious choice for the American artists in Paris. One of the very few Americans who bravely decided to remain in Paris, the sculptor Olin Warner, mentioned in a letter to his parents how a large contingent of his compatriots had moved out of the city in November, two months after the beginning of the siege; he himself, however, had thought it better to stay on for the new season at the École des Beaux-Arts,

and wanted to reassure his mother that there was no danger for him in doing so. By the spring of the following year he would be writing home to say that 'it is a little disagreeable remaining here now and listening to the roaring of cannon and the cracking of musketry day and night.' Six weeks after this he was morbidly to note: 'it is not with a feeling of pity a person looks upon a pile of corpses covered with blood, it is with disgust.'

Shortly after Warner had opted to brave the siege, his compatriots who had gone to Brittany were indulging in some unexpected sporting activity. The winter of 1870 was an exceptionally cold one, and for apparently the first time in living memory the part of the Aven which flows alongside the Bois d'Amour froze over. Immediately the artists commandeered the local blacksmith to make skates for them, and, according to one observer, 'astonished the peasants with their manoeuvres on the ice'.

By this date only Wylie and Bridgman were left of the 'seven original sinners'. However, after the war ended in the summer of 1871, Bridgman returned to Paris, and from then onwards was only to visit Pont-Aven intermittently, becoming renowned as a specialist in oriental rather than Breton scenes. Wylie remained the father figure of the Pont-Aven colony. In 1872 he became the first American artist to be awarded an important medal in the Paris Salon, and thus helped to increase Pont-Aven's fame as an artist resort.

One of the group of American artists who had found themselves in Pont-Aven as a result of the Franco-Prussian War, Clement Nye Swift, was to stay here for the next ten years. He had come with little money, and was obliged at first to sell paintings to tourists. He told his parents, who were urging him to come home, that lack of success had made him 'taciturn, morose, caustic and sarcastic'; but none the less he was very keen to stay on in Pont-Aven, and attributed his feelings of failure not to want of dedication (far from it, for some of his colleagues referred to him as the 'serious Swift') but to the fact that he was rather slow at doing things: 'I think slowly, speak slowly, act slowly and write slowly . . .' Success of sorts came to him in 1872 when one of his paintings was accepted in the Paris Salon and 'hung on the line'; thereafter he was to be a regular exhibitor at the Salon. He had also ambitions as a writer, although the Breton short stories which he was to write in later life, and from which the opening lines of this chapter were taken, were never published. These stories are thinly disguised autobiographical pieces, and many of

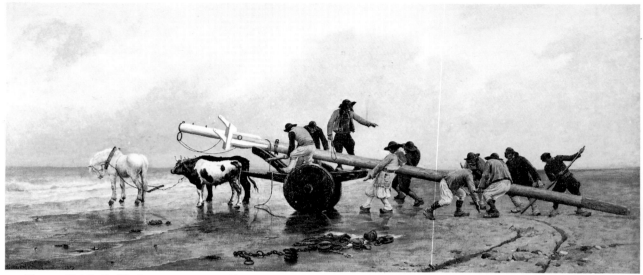

41 Clement Nye Swift, *The Spar*, 1879. New Bedford Free Public Library, Massachusetts

the mysterious incidents which he describes in his high-flown prose can actually be verified from other sources. One of the stories is entitled 'The City of the Chouette', and is about the Breton superstition that every time an owl is heard shrieking a sudden death is about to occur. The narrator tells how one afternoon, when 'the indescribable melancholy of the brooding heart of autumn was over everything', the streets of Pont-Aven suddenly echoed with the cry of an owl. The tragic event which this presaged was based on a real incident which took place in the Hôtel des Voyageurs in the autumn of 1873, and which he, a resident in the hotel at this time, related in a letter to his parents.

By 1873 Madame Feutray's husband was dead and she herself had gone into something of a decline. She had become filthy in her habits and slept in the pantry amidst a growing accumulation of rubbish and without ever opening the window. At this point there enters the story someone whom Swift described as a 'remarkable tall and large girl with a very good and pleasant character as well'. Julia Guillou, as she was called, was the daughter of a local woman whose business was to make *crêpes*, the thin pancakes which are a speciality of Brittany. For several years she had been a maid at the Hôtel Laurens in Concarneau, but had aroused the jealousy of Madame Laurens by her superior managing abilities. Eventually she had been told to leave; in addition Madame Laurens had circulated reports to her discredit, which no one fortunately had believed. Arriving back in her home

town, Julia was taken on as a maid by Madame Feutray. Soon, however, Julia succeeded in making her jealous too. A very tidy and efficient person, Julia was appalled by how disordered the hotel had become, and even intervened in the cooking, which was then done (badly) by Madame Feutray's son. The son got angry and insulted her. She went to complain to his mother who, however, took the son's side, threatened to dismiss her, and thereafter continually pestered her with the most petty grievances. To make matters worse Julia was made to sleep in Madame Feutray's squalid room and in the same bed; this arrangement was so insupportable to her that in hot weather she preferred to sleep in a chair in the kitchen or on the staircase. The only reason why Julia remained in the hotel was for the sake of some of the women staying there who were very friendly to her, and always stood up for her. Eventually these women went in a group to complain to Madame Feutray about the way Julia was treated. Her response was to say that she and Julia could not go on living together under the same roof. One of the women, who was going on to Nantes, offered to take the girl with her and to find her a position there. This Julia accepted, but returned to Pont-Aven in the summer of 1873. By this date Madame Feutray had become so incapable of managing the hotel on her own that she pleaded with Julia to buy the place without telling anyone. Julia, however, would have either fair and open dealing or none at all. The end result was that after various legal complications, Julia started to rent the hotel, and sold

off all the furniture and everything belonging to the house to pay for all Madame Feutray's debts. The humiliation was so great for the old woman that one rainy and misty night, when Swift was tossing and turning in his bed 'with horribly undefined visions', she hanged herself from a tree in the garden.

As soon as Julia took over the running of the hotel, a reign of order and tidyness set in, and the place began to prosper. The locals wondered how a mere village girl could achieve such a transformation, and came to suspect that the Americans had secretly bought the place and were forcing Julia to look after the establishment according to their wishes. They also began to feel that the place was haunted, and marvelled at how anyone could be brave enough to stay there. Swift himself admitted to his parents that stoical as he was he always shuddered when he thought of that night when the old lady had killed herself. However, he also said that in Brittany people could never turn down the chance for a ghost story, and that in reality there was now only one apparition in the hotel, and this was 'cleanliness, which stalks continually through the house, armed with a dustpan and broom'. In his story, 'The Cry of the Chouette', he wrote: 'The death of the landlady caused the inn to fall into much more competent hands. It became more orderly and modernized and almost incongruous with the wild region around us, where the dogs were yet wearing iron collars to protect them from the wolves.'

Julia was soon to become one of the legendary hotel proprietresses of Europe. She took such a motherly interest in the artists who stayed with her that she came later to be known as *la mère des artistes* (and is commemorated as such today by a plaque which marks the original site of the hotel). Soon respected by everyone in the town, she acquired a reputation for silencing the most disorderly, drunken, and feared of her customers; in certain cases she would even make use of her extraordinary strength and quite literally throw people out of the door. She also started to amass a remarkable collection of traditional Breton wood-carving, pottery, and other craftware, which in itself came to be a reason for people to visit Pont-Aven. Every traveller to the town mentioned her friendliness and hospitality, and the comforts of her hotel. In 1927 she was even to be the subject of a book. Apart from her initial struggles, there appears to have been one discordant note in her life: she was rumoured to have fallen in love with Wylie. Both were always to remain unmarried, and it is unlikely that Wylie reciprocated her feelings, yet she was a very great support to him up

to and, as shall be seen, after his death.

In August 1874 Julian Alden Weir arrived at Pont-Aven, by way of Barbizon and the Breton town of Portrieux. At Portrieux he had had his first experience of being in a place entirely surrounded by French, and had found it 'queer not to find anyone speaking one's own language'. He felt much happier in Pont-Aven, where there was less danger of his being swindled, and the prices were much cheaper: he could hardly believe that the highest daily charge here for a model was, in American money, about forty cents (women were thirty cents, and children about one cent); in Paris it would have been about two dollars, and he did not dare to think what it would have been in the USA. He took rooms of his own in the town, but always ate at the Hôtel des Voyageurs, where he had 'as good food as one could wish for and plenty of it, with wine, cider and beer, and coffee in the morning'. For both food and accommodation, including the servicing of his rooms and the blacking of his shoes, he paid only twenty-seven dollars a month.

Among those staying at Pont-Aven, there was a Scottish painter called Colin Hunter, with whom Weir became friendly. Weir found Hunter's accent intriguing and his conversation amusing. According to Weir, Hunter was then engaged on a large picture showing a church interior with peasants at High Mass. Weir also met up with a number of fellow students from the École des Beaux-Arts. But the great excitement for Weir was meeting Wylie, whom he described as 'one of the best of our American painters'. He was also deeply impressed by Wylie's character: 'He is a quiet, gentlemanly man and a strict Presbyterian, a man of excellent principles, and a strict observer of Sunday.' On his first Sunday in Pont-Aven, Weir happily set off to go painting, but on his way to the motif was interrupted by an American friend, Edgar Ward. Ward inquired what his friend was up to, and then Weir guiltily realized that it was a Sunday, and that he would have to abandon the idea of working that day. Instead, he decided to visit Wylie's studio at Lezaven. Wylie had now moved into the old kitchen, which he had converted into a studio by cutting a large window into it. Weir noted scattered round the place the artist's 'costumes and bits which he has collected for his pictures'; on the wall was hanging an original study for the central figure in Couture's celebrated canvas *The Romans of the Decadence*. On his easel stood a large picture representing a scene from the Vendean Wars: in it a wounded man was shown having just been brought into an old church, where

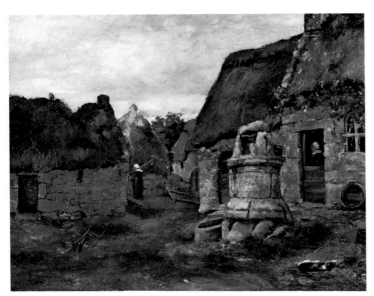

42 Julian Alden Weir, *Breton Farm*, 1874. Collection of Helen
E. Peixotto

peasants crowd around him and a priest in disguise is
about to administer the last sacrament. The wide-
spread interest among artists in the heroic exploits of
the Bretons in the Vendean wars had recently been
given fresh impetus by the discovery in the hollow
trunk of an old apple tree near Pont-Aven of a skeleton
still clutching a musket.

Weir does not seem to have shared Wylie's interest
in historical subject-matter, but none the less, during
his stay in Pont-Aven, he received much encourage-
ment and technical advice from Wylie. On Weir's
birthday, Wylie treated him to a glimpse of the second-
class medal which he had received in the 1872 Salon.
This medal must have been a great object of pride to
the Americans in Pont-Aven; it almost symbolized for
them their hope that their country would shortly have
a great artistic tradition of its own. In Portrieux, Weir
had been encouraged in this hope by a French sculp-
tor, Frédéric-Auguste Bartholdi, who was later to
achieve fame as the sculptor of the Statue of Liberty.
And in Pont-Aven he was to find himself in the
company of those who spent much of their time dis-
cussing the important part which artists could play in
the coming American Centennial. There was even talk
of an English boat being hired to take all the American
artists from Pont-Aven back home for the occasion.

Weir described Pont-Aven as 'a one horse town' and
was always commenting on its picturesquely old-
fashioned and backward character. He seems amazed
that there was a church 'over three hundred years old',
and noted with interest that all the town's streets were
paved with cobblestones, and throughout the day you
could hear the click of wooden shoes. He found the
peasants so ignorant that not only were they kept
under perfect control by the priests, but also they
believed in ghosts and sorcerers. During his two
month stay here he spent much of his time making
landscape and figure studies for a large canvas of
peasants threshing wheat; he ordered the canvas from
Paris, but does not seem to have made much progress
on it by the time that he had to go back to the Beaux-
Arts. When not working during the day, he occupied
himself with such activities as going for long walks,
visiting Rustéphan with Swift, taking a rowing-boat
with Wylie down to the sea, and going to at least two
Pardons. The first of these *Pardons* was at the church
of the Bonnes Nouvelles about ten miles from Pont-
Aven. It was a beautiful late August day. Weir went
accompanied by Bridgman, Ward and Hunter. At the
church they chanced upon at least three or four of their
models from Pont-Aven, including the local 'belle',
Susanne, who said that she had made a special prayer
for Weir. 'Hoop!' was his reaction. Outside the church
Weir's attention was also distracted by 'some of the
most horrible beggars I ever saw'. Later all the artists
started walking back, and were passed on the road by
'waggon loads' of returning peasants, who asked them
if they wanted a ride. Bridgman and Ward accepted,
but Weir and Hunter 'preferred to walk as the after-
noon was so lovely and the people in the carts were
singing at the top of their voices, the horses galloping,
and they all seemed tight.' Back at the Voyageurs in
the evenings, the conversation tended to revolve
around 'art and adventures'. Then there were the
traditional nocturnal walks with the promise of real
adventures resulting from chance encounters with
dogs or bellicose drunkards.

Weir's descriptions of his stay in Pont-Aven, which
are all contained in his letters home, are full of the
beauties of the locality. He was especially struck by the
abundance of fruit: everywhere there were peaches,
pears, apples, and plums to be had; the plums more-
over were so large that you could 'hardly get your
fingers round them'. His major causes of complaint
were the cold (even in August he found that he was
obliged to wear his 'winter things') and above all the
fleas; in one of his letters he wrote: 'I have been
interrupted several times in this note by fleas; they are

here in millions, they forced me to strip twice today and I caught two dozen. I am almost crazy with them.' By the end of the first week in September the character of the landscape was changing rapidly: 'Fall is fast advancing; here the trees are already beginning to drop their leaves, there is none of the richness of our bright colours, everything is sombre.' The advent of the wet weather in this month forced him to buy a pair of wooden shoes. He was very pleased with this purchase: he found them very well made and good for keeping out the rain, and admired the scroll-work on the top. But he did not have long to use them; by the end of the month he was already back at art school in Paris.

In the summer of the following year, 1875, Ward tried to persuade Weir to come back with him to Pont-Aven. However, Weir refused, 'as everybody is going down there to paint Breton subjects this year, and I know I will learn more and be serious if I remain with the Frenchmen.' He went instead to Cernay-la-

43 Thomas Hovenden painting in the Bois d'Amour, c. 1880; this view, looking towards the Moulin David, was that chosen by Sérusier for *The Talisman* (1888)

Ville. Those who returned to Pont-Aven with Ward included the American painter Milne Ramsey, together with his wife Annie Ruff, three-year-old daughter Ethel, and a close friend, Helen Corson, who had recently been disowned by her respectable Philadelphian family for becoming an artist. Ramsey had first come to Pont-Aven during the Franco-Prussian War, but had returned shortly afterwards to America; he had come back married in the summer of 1874. The summer of 1875 at Pont-Aven was to be especially memorable for him, because his wife was to give birth to a son, Frederick, in the Hôtel des Voyageurs; in the absence of the local doctor, a vet officiated at the birth. Ramsey and his family were to spend the remaining summers of the 1870s in Pont-Aven, their children being looked after by a local nurse, and Fred's birthright being a source of pride to the peasants. Ethel, the daughter, was later to record her impressions of life as a child in Pont-Aven during this period. Among her most vivid memories was the sight of women bathing in the part of the Aven which went through the beautiful garden of the Hôtel des Voyageurs: the women used to undress in the thicket, and instead of putting on the elaborate bathing costumes of the day, wrapped themselves up in sheets so that they 'floated in the shallow stream with a horrid Ophelia-like effect'; for Ethel this spectacle was made 'further repulsive by the fact that on coming out, it was necessary to look for leeches—which [were] removed with shrieks of horror.'

Another American arrival in Pont-Aven in the summer of 1875 was the painter Thomas Hovenden, who was to stay for five years. Irish by birth, Hovenden had served a seven-year apprenticeship to a carver-gilder in Cork before moving to America in 1864; there he had lived at first in New York, then in Baltimore, supporting himself as a painter by tinting photographs, framing, and making portaits. He had come to Paris in 1874, where he had entered the École des Beaux-Arts after having pretended to be four years younger than he actually was. In his background Hovenden had much in common with Wylie (both for instance were orphans), and was only two years younger. In Pont-Aven they became great friends. While Wylie was completing his canvas of the *Dying Chouan*, Hovenden commenced what was to be his first important painting, *In Hoc Signo Vinces* (fig. 44), which also portrays a scene from the Vendean wars, in this case the moment when a Breton peasant woman presents a consecrated medal to her son prior to his going to fight. Hovenden's working methods both in

Pont-Aven and later life seem to have been similar to Wylie's: for his historical canvases, he used to gather together in his studio all the appropriate furniture, costumes, and other accessories, and then, with the aid of models, create a *tableau vivant*. Back in America in 1881, Hovenden was to marry Helen Corson, and their house just outside Philadelphia became a regular meeting-place for their Paris and Pont-Aven friends. He was to gain an enormous reputation for his sentimental historical genre scenes, in particular for his *Last Moments of John Brown*. He died in 1895 in a heroic manner, worthy of one of his paintings, run over by a passing freight train while making a futile attempt to save a ten-year-old girl.

The summer of 1876 saw the American contingent in Pont-Aven further enlarged by the arrival, among others, of two Baltimore friends of Hovenden, the brothers Bolton and Frank Jones, and a young Bostonian, William Lamb Picknell. Yet by this date the artist colony in the town was by no means wholly dominated by Americans. Quite apart from various British artists, there were more and more artists from France and elsewhere, including the Dutch genre painter van den Anker, who had settled in the town in about 1872, and a now forgotten French artist called Défau, who was attracting a large crowd of admirers by his ability to paint at the rate of two canvases a day.

Other changes were also occurring. In 1876 a shop was set up, selling not only such items as tobacco, hats, casseroles, and chamber pots, but also artists' colours and materials. The artist population of the town in full season had now grown from the original dozen or so to about fifty or sixty; and it was to keep on growing, reaching well over a hundred by the middle of the following decade. This population, which included a growing number of women painters, was now almost equally divided between the town's three hotels. The Lion d'Or attracted mainly French artists, while the Hôtel des Voyageurs continued to be patronized by a largely American and British crowd. The latter was still extremely cheap, but was none the less the most expensive and sophisticated hotel in the town. The

44 Thomas Hovenden, *In Hoc Signo Vinces*, 1880. Detroit Institute of Arts

45 William Lamb Picknell, *Pont-Aven Harbour*, 1879. Phoenix Art Museum, Arizona

Swiss painter Édouard Girardet stayed here in about 1876. In a letter to his brother, Paul, he described the dining-room as comprising two tables, the larger of which was occupied by English painters emanating '*dignity bocoup*' (*sic*), as well as two '*barons amateurs*' and a '*Prix de Rome Manqué*'; the other table was much livelier, but '*tous Anglais ou Americains*'. For Girardet one of the special features of the hotel was its billiard table, which fully made up for the slightly higher price of board and lodging: Girardet styled himself the 'Défau of the billiard table', beating on one occasion first an Englishman, then an American, and finally a Dutchman. His son, Henri, who was in Pont-Aven at the same time, stayed at the third and cheapest of the hotels, the Pension Gloanec. This was where Défau held court. Girardet also described it as the rowdiest place in town, and it maintained this reputation into the next decade, which was to be the most famous in its history.

The Jones brothers stayed at Gloanec's with their friend Hovenden, while Picknell put up at the Hôtel des Voyageurs, which still included among its guests, the Ramsey entourage, Swift and Wylie. Like all new American arrivals at Pont-Aven, the Joneses and Picknell immediately fell under the spell of Wylie, yet it was Picknell who was to benefit the most from his influence. Picknell had come over to France in 1874. He had been given an allowance of 1,000 dollars by his uncle, but had been told that once this was spent he would be given no more. After two years at the École des Beaux-Arts, he had arrived virtually penniless at Pont-Aven. Here he began to devote himself exclusively to landscape painting. Wylie's interests of course lay elsewhere, but he was able to help the younger artist in the development of his technique. Influenced by Wylie, Picknell started working largely with a palette knife, and using colour directly from the tube. Wylie was a hard taskmaster, making his disciple

46 William Lamb Picknell, *The Road to Concarneau*, 1880. The Corcoran Gallery of Art, Washington, DC

paint a tree what seemed like a hundred times over until he would allow him to sign the picture. Picknell was also deeply affected by the character of Wylie. His memories of the man would continue to haunt him throughout his later life; on his deathbed in 1895, he told his sister, 'Do you know I rarely think of Christ without thinking of Wylie? There was a serenity and purity about him that was unique in my experience of men.'

Picknell could only have known Wylie for a few months, for this Christ-like figure was to die in February 1877. Swift described Wylie's death in the same short story which features that of Madame Feutray. A more sober account of the incident is provided in a letter from Hovenden to his dealer in Paris. On the twelfth of the month Wylie had gone to the neighbouring town of Lorient, and had returned about noon the next day, apparently in excellent health and spirits. In the afternoon he went rowing, and in the evening dined with an American family staying in the town, returning to the Hôtel des Voyageurs around ten o'clock; after pleasantly talking with those whom he met here, he retired to bed. At about three in the morning he pulled the bell cord in his room to summon the maid, who arrived to find blood flowing from his mouth and nose. Julia was immediately called, and when she arrived, Wylie asked her to dip her finger into the blood and spread it on the side of his chamber pot so that he could see the colour. As soon as he saw the colour he realized that he was going to die, and muttered his mother's name a few times. (In Swift's account of the incident this moment of realization comes when he hears an owl screeching on the balcony outside his room.) Soon a number of people gathered in the room, including a doctor. However, it was too late, and, after speaking a few words to Julia, Wylie lapsed into unconsciousness, dying at about four in the morning. Because of his strict Presbyterian beliefs Wylie had not endeared himself to the Breton clergy, and at first they considered burying him in the field which they reserved for those who committed suicide. Julia intervened, and managed to have him buried in her own family plot in the little cemetery on the hill; it was later to be rumoured that her decision never to marry resulted from Wylie's death. At the time of his death Wylie was intending to send his large canvas of the *Dying Chouan* to the Paris Salon. It would have been his first work to have been exhibited there since his success of 1872.

In the summer of 1877 a French painter whose reputation was comparable to that of Wylie, the land-

scape artist Léon-Germain Pelouse, came to Pont-Aven; he was to return in the summers of 1878 and 1879. Although more closely associated with the colony at Cernay-la-Ville, his presence at Pont-Aven was to attract a large number of his pupils, and, as one visiting American journalist put it, make up in quality what the French artist contingent here lacked in quantity. One of the American artists who held his work in high esteem was Picknell, then greatly in need of a mentor following the death of Wylie.

In the summer of 1878 Pelouse suggested that it was time that Picknell began an 'important picture'. There was an additional incentive for Picknell to produce such a work: Bridgman had come back to Pont-Aven that summer and stood as a shining example to all Americans of what could be achieved by extreme dedication. He had just been awarded, at the exceptionally early age of thirty-eight, the coveted Légion d'honneur, a decoration which his more jealous colleagues said he had embroidered on his underwear. Picknell was further excited that year by what he referred to, in a letter to a Paris painter friend, D. Maitland Armstrong, as a 'glorious addition to our little colony'. This was an English general's family, which included two daughters aged twenty-one and twenty-three whom Picknell described as 'charming, beautiful and talented'. 'You,' he wrote to Armstrong, 'knowing the old chick, can imagine the feelings of his innermost heart.' In the same letter he gives an indication of the lengths to which he had gone to carry out the 'important picture' which Pelouse had been urging him to produce.

Now when you read the following awe-inspiring confession do not exclaim, 'What a fool!' Your humble servant has builded him a house out on ye lande, and yesterday did begin to rub charcoal in a most wonderful manner on to ye canvas. Eight feet by 5½, how's that for size? for cheek? for future headaches? and sleepless nights? Pelouse told me to paint an important picture this year. So thought the best way to get out of the scrape was to make it important in size. Walked about one thousand miles before finding subject, wore out two pairs of shoes, ten pairs of good nature! Subject once found, got permission to build on ye peasant's land. Had said peasant to dinner, gave him good wine, good cigars, and about ten p.m. he went staggering home, a happy if not wiser man. Result of dinner, jolly good friends with peasant. He laughs at my jokes in French—very appreciative fellow. Two

cartloads of colors sent to château yesterday, 800 doz. brushes, 4 shovels, and small cannon, American flag expected tomorrow, cider bottle hid in one corner. All creation thinking of working in my part of the world, the hut appearing to be a good place to leave pictures in. Shall have newspapers, etc., and charge regular London club prices.

Such elaborate preparations for a picture would have involved a financial outlay which a struggling artist such as Picknell would have been unable to provide on his own. Fortunately Julia was convinced of Picknell's talent and advanced him a sum of money for the picture, as well as providing him every day without charge a boy and a horse and cart to take him to the motif. Picknell's dedication and Julia's investment were finally to pay off in 1880, when the work, entitled *The Road to Concarneau* (fig. 46), won an honourable mention in the Paris Salon. With this success behind him, Picknell returned to the USA where the picture was heralded as one of the greatest American landscape paintings of the day.

In his short story 'Kroas An Laer Krow', Swift wrote that 'Once "discovered", much of the charm which belongs to quaint, unsophisticated localities was gone.' Swift, while pleased that the kind Julia was profiting from the ever-growing popularity of Pont-Aven, moaned that his 'little rustic paradise' had been destroyed by the 'aimless bustle of summer tourists'. He consoled himself with the thought that all these and other idlers would some day suddenly stop coming and take themselves elsewhere. This was certainly wishful thinking. In 1878 the English writer Henry Blackburn came to Pont-Aven accompanied by his compatriot, the illustrator Randolph Caldecott. Two years later the two published a book together, *Breton Folk*, which was to increase yet further the number of artists and tourists coming to the place. Up to that date there had been relatively few Britons in Pont-Aven in comparison with the Americans. (It must be remembered that non-English-speaking artists such as Girardet would often confuse the two nationalities and refer to them both as *Anglais*.) But with the publication of *Breton Folk*, they began to swarm here. Blackburn, who wrote the text of the book, enthused over the beauties of Pont-Aven, and made the mistake of writing that, apart from being well known to artists, Pont-Aven was a '*terra incognita* for the majority of travellers in Brittany'. Nothing is more guaranteed to spoil a place than to

describe it as unspoilt. Blackburn wrote that for artists the place could offer both unlimited motifs and cheap and willing models; and that for everyone there were the attractions of the town's hospitable, clean, and remarkably cheap hotels. He spoke at length of the Hôtel des Voyageurs, which he described as 'principally supported by Americans'. He warned prospective guests not to be surprised to find that the main subject of conversation at table was the Paris Salon, that bedrooms were converted into studios, or that there was a pervading smell of oil paint. But the living here, he wrote, was 'as good and plentiful as can be desired'. He also attributed much of the success of this hotel to its 'portly young hostess, Mademoiselle Julia Guillou', whom he praised for her kind face and the motherly care which she took of her clients. He reserved further superlatives for his description of the Pension Gloanec, which he referred to as the 'true Bohemian home at Pont-Aven'; he found it difficult to believe that this place could manage to be even cheaper than the Hôtel des Voyageurs while still being so comfortable and providing such plentiful food. All in all he hoped that his account of Pont-Aven would dispel the popularly held notion that 'creature comforts . . . are unknown in Brittany'.

The close of the 1870s marked a turning-point in the history of Pont-Aven as an artist colony. With the death of Wylie and the imminent departure of Swift, Hovenden, and Picknell, an era was at an end. The Americans continued to maintain a strong hold on the town, but the artists now coming here had different ideals and different heroes. This was of course a time when everyone had begun to speak about Bastien-Lepage. In 1880 two American admirers of this master, the brothers Birge and Alexander Harrison, arrived in Pont-Aven, after having spent the previous summer at Grez-sur-Loing. While staying in Pont-Aven, Alexander painted outdoors, with the aid of imported sand and studies made from the nearby coast, a large canvas of a pretty boy lying dreamily on a beach. The title was *Castles in Spain*. The ambitious and still unrecognized twenty-nine-year-old artist considered this work to express his own feelings at the time. Whatever castles he may have been dreaming of they were none the less to turn out to be very real ones. When exhibited in the Paris Salon of 1883, the work received enormous praise for its *plein air* realism, subtle grey tonalities, and pathos in the rendering of the subject. It also attracted the attention of Bastien-Lepage himself, who subsequently became a good friend of Harrison. Harrison, who was to spend much of his time in Brittany in the 1880s and 1890s, soon assumed a position in relation to the artistic life of the region similar to that which Wylie had enjoyed in the previous two decades. And at first he was to be virtually unchallenged.

Along with a different set of protagonists came new settings against which the artistic history of Brittany would unfold. Pont-Aven continued to be the scene of much of the action, as did the Hôtel des Voyageurs. But soon a new colony in the nearby fishing town of Concarneau would come to rival that of Pont-Aven, and in Pont-Aven itself the Pension Gloanec would play the central role in what was to be one of the most heated periods in the town's artistic history. The Harrisons in their stay in Pont-Aven in 1880 put up at Gloanec's. In the following year an Irish painter, Henry Jones Thaddeus, was also a guest at this inn. Both Birge Harrison and Thaddeus gave a most vivid and detailed description of the appearance and character of the place only a few years before it joined the ranks of Ganne's, Siron's, and Julia's as one of the most celebrated artist inns in Europe.

In 1842 Joseph Gloanec had bought a house in Pont-Aven with the intention of using it as a wine and spirit shop. On the death of Joseph in 1855, the place had been taken over by his widow Marie-Jeanne, who by 1863 had it licensed as an inn. It was a very small establishment with few beds, and with the growing number of artist customers in the 1870s Madame Gloanec was obliged to find rooms for some of her guests in neighbouring houses. Outside the inn were a series of tables and benches, where people drank

47 Artists in front of the Pension Gloanec, Pont-Aven, an illustration by Randolph Caldecott from *Breton Folk* (1880)

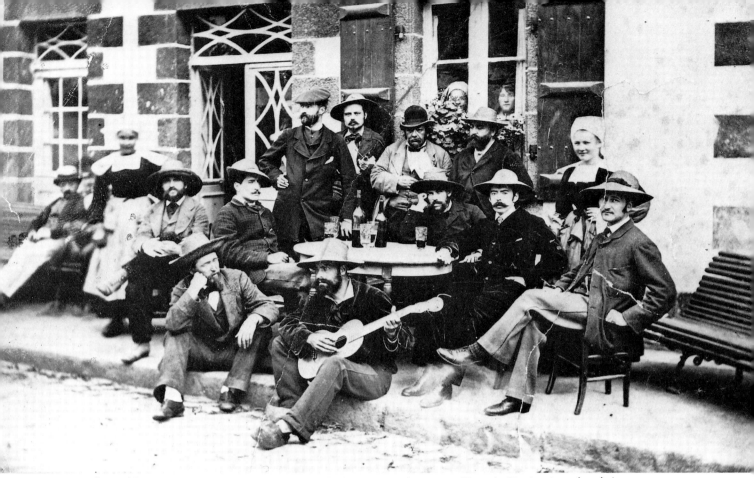

48 Artists in front of the Pension Gloanec, Pont-Aven, *c.*1880, with Thomas Hovenden, Birge or Alexander Harrison (seated on chairs, left), the Mayor of Pont-Aven (wearing a bowler hat), William Lamb Picknell (seated in front of the Mayor), and van den Anker (standing on the right of the Mayor)

during the day and took coffee after supper. As soon as one entered the building one found oneself in a room which served both as a kitchen and dining-room. It had red-tiled flooring and was encircled by massive oak tables, black with age. Above a cavernous fire-place hung a beautifully polished *batterie de cuisine*, and underneath, above the log fire, was suspended an iron pot full of soup which was constantly replenished and kept simmering. The only other room on the ground floor was completely pannelled in wood and also used as a dining-room. Both rooms, predictably, came to be covered in paintings and sketches. All the bedrooms were on the first floor and in the attic, and were apparently modestly furnished and spotlessly clean.

Marie-Jeanne Gloanec—'dear, wizened old Marie-Jeanne', as Birge Harrison once referred to her—acquired a popularity among the artists in Pont-Aven almost equal to that of Julia. Like Julia she became a sort of adopted mother to them all, greatly enjoyed their company, and was quite exceptionally generous in extending credit. One artist staying in the inn in Thaddeus's time, an 'ancien' who always took the head of the table at meals, had come to the town ten years previously and had apparently not paid a penny for board and lodging throughout this period. He was reputedly talented but incorrigibly lazy, and when he had arrived at Pont-Aven had begun a canvas which was still not finished. Eventually he was to inherit some money, settle arrears, but find himself unable to leave the place, and stay there until his death. Needless to say, he never completed his canvas. Marie-Jeanne could afford having such people around. As with all the proprietresses of the famous artist inns in France, her apparently casual approach to business had brought her in a considerable amount of money. She

49 View from the ferry point in the *Ville Close*, Concarneau, *c.*1880

was further able to profit by keeping the running of the establishment within her family. By Thaddeus's day she had acquired a nearby farm, which was looked after by her sons and which provided much of the food for the inn. Her three daughters meanwhile acted as maids and serving-girls.

The high point of the inn's day was the evening meal. Amidst uproar, hilarity, and drinking of cider, the three daughters—known as Nannie, Jeannie, and Soisie—would bring the steaming dishes to the tables. This was a hazardous task, as the girls would often have to contend with amorous advances, the repulsing of which would sometimes result in an innocent diner having the contents of a dish accidentally poured on his head. The 'more amply proportioned mother', as Thaddeus described her, would throughout this time stand by the fireplace and supervise the cooking. Occasionally she would turn round to inquire of the success of some special delicacy, or at other times join in the general merriment herself. 'Every meal,' concluded Thaddeus, 'was a feast of reason, alive with merriment and good feeling, whilst afterwards, when we took our coffee outside, the village rang with our hearty laughter.'

When in the summer of 1881 Thaddeus and a group of artists had set off from Paris to Brittany they had intended simply to pass through Pont-Aven. Their real destination was Concarneau, where they arrived later in the summer. Concarneau was soon to be the haunt of the Harrisons and numerous other Americans. One of the first artists to have worked there was a native of

the town, Alfred Guillou, who had studied in Paris at the Académie Suisse and the Beaux-Arts in the late 1860s and had returned home early in the following decade with his brother-in-law Théophile Deyrolle. By the end of the 1870s, Concarneau had become an international artist colony absorbing many of those who had found Pont-Aven overcrowded and all its motifs appropriated. P. S. Krøyer, the Danish artist who had sketched R. A. M. Stevenson at Cernay-la-Ville in June 1879, had come here in August of that same year, following a brief stay at Pont-Aven. In 1894 Birge Harrison was to write that 'Concarneau is an offshoot of Pont-Aven, but an offshoot that has grown into a formidable rival.'

The coastal town of Concarneau is a much larger place than Pont-Aven. Its most picturesque feature is the so-called *Ville Close,* the walled medieval part of the town. This stands on an island guarding a deep harbour and connected to the main square of the new town by a now stationary drawbridge. Inside the walls are narrow streets lined with small houses. In the last century most of the poor families of Concarneau were concentrated here; today the whole area has become like a museum. At the far end of the *Ville Close* is a ferry point from which passengers are taken across the harbour; in the nineteenth century one could also take a boat from here to Pont-Aven. Much of today's new town has been recently rebuilt, but even in the last century this once rambling old-fashioned area had begun to be tidied up and occupied by middle-class families. This was where the town's three hotels could

be found: the one most popular with artists was the Hôtel des Voyageurs, which survives today, on the main square overlooking the harbour. With one exception, all the artists' studios were located in the new town. These were mainly converted lofts, and were sometimes lived in by the artists. A group of studios was also constructed in one of the new town's numerous sardine factories.

In the nineteenth century Concarneau's principal industry was connected with sardines. The activities associated with the catching of the fish were, according to at least one artist, the American Edward Simmons, beautiful to watch. Myriads of small boats with sails originally dyed in brilliant colours but, in Simmons's words, 'always faded to lovely tones of rose, gray and tan', set out from the harbour in the early hours of the morning. At the fishing grounds the nets would be lowered, and the captain of each boat would throw in the imported cods' roe which was used as bait. His action in doing so was to Simmons 'more beautifully Greek than anything in all Europe', and made the artist wonder if Christ had not performed the Miracle of the Fishes in a similar manner. If the day had been successful the boats would return with their decks full to brimming with what to Simmons seemed like 'fifty cent pieces in a flutter'. To then eat some of these freshly caught sardines cooked in beef dripping and served with a boiled potato was Simmons's idea of the perfect gastronomic experience. Others were less enthusiastic than Simmons at the return of the heavily laden boats. For this meant that the curing and packaging of the sardines could now begin in earnest,

50 P. S. Krøyer, *Sardine Cannery at Concarneau*, 1879. Statens Museum for Kunst, Copenhagen

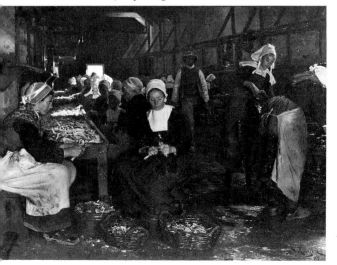

a task which employed most of the town's womenfolk not engaged as models. The process of curing the fish resulted in the whole town smelling so bad that many of the artists had to take themselves elsewhere. The odours lingered throughout the year and led to Alexander Harrison's dubbing Concarneau 'Sardineopolis'.

Thaddeus put up at the Hôtel des Voyageurs, which he found 'crammed with a crowd of cosmopolitan painters similar to that at Pont-Aven'. It was a modern and quite luxurious hotel, and though cheap by normal French standards was much more expensive than Gloanec's. A great boon for Thaddeus was that wine was always served here at meals rather than the cider which was the principal drink available at Gloanec's; he thought cider a pleasant enough drink, but when consumed in too great quantities had 'disastrous results'. The hotel also had a billiards table, a commodity which in Pont-Aven had of course only been available in the Hôtel des Voyageurs. A regular at this table was the town's *Commissaire de Police*, who invariably beat 'the less accomplished paintbrush brigade'. There was, Thaddeus admitted, little else for this man to do in the day, save to intervene in the occasional drunken quarrel which was generally started by one of the town's massively built fishwives. However, the artists themselves were sometimes the cause of trouble.

During the day all the artists generally worked, but in the evenings, said Thaddeus, 'the spirit of mischief was let loose and all kinds of pranks were indulged in'. One such prank involved a Swede who suffered from some disease of the digestive system which always made him fall into a deep sleep after eating. One evening the artists decided to carry him in this state to a local circus show: the man woke up to see lions in front of him, and ran away screaming, causing the whole audience to follow his example. On another occasion the artists thought it time to repay the hospitality of some of their artist acquaintances in Pont-Aven. They invited them to the funeral of a 'dear friend', who, they assured them, came from a very wealthy family, and had left them all an 'appetizing legacy'. Their Pont-Aven chums entered the spirit of the prank and arrived at Concarneau in the most fantastical funereal garb, some of them even blackening their faces to simulate the most dreadful grief. They then all followed the coffin in a procession through the town; for Thaddeus this was a 'sight never to be forgotten'. The *Commissaire de Police* naturally suspected a hoax and had the coffin opened to find

that there was a pig inside. He was furious, but apparently calmed down under the influence of a few glasses of vermouth.

Thaddeus's summer at Concarneau ended in a genuinely tragic manner, with many real coffins passing through the streets. It was an exceptionally hot summer, and the normal odours of the sardines mingled with those of fetid mud and unflushed drains. Circumstances were right for the outbreak of smallpox. The mayor of Concarneau had given Thaddeus the use of a medieval chapel in the *Ville Close* as a studio (this attractive building with stained-glass windows was afterwards to be regularly used by the town's artists). One day Thaddeus had two boys posing there, one of whom asked in the middle of the session if he could take a rest. Soon afterwards the boy became suspiciously quiet, and Thaddeus realized that he had died. The smallpox epidemic killed off a high proportion of the child population of Concarneau, particularly those from the poor families in the *Ville Close*; they mainly died within an hour and a half of

51 Edward Simmons, *Awaiting his Return*, 1884. Private Collection

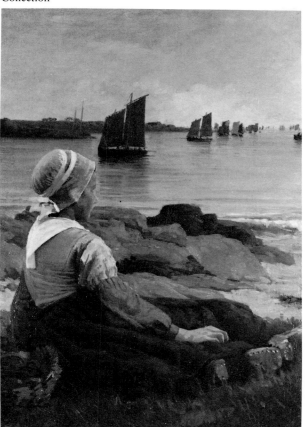

catching the disease. Thaddeus does not seem to have been aware of the full significance of the epidemic, being too much absorbed in his painting. 'It was,' he confessed, 'somewhat dispiriting at first to look up from your plate at lunch and see a priest heading a procession of five, ten, or even twenty coffins on its way to the cemetery . . . but one soon got used to it.' Thaddeus left Concarneau at the end of the summer, thereafter becoming a successful portraitist, receiving even a portrait commission from the Pope, and ending up as artist to a German princely family. He was to style his memoirs *Recollections of a Court Painter*.

Edward Simmons came to Concarneau in the same year that Thaddeus did. He was at the centre of the American community of artists who came to dominate the artistic life of the town in the 1880s. A Harvard graduate and student of the Boston Museum school, Simmons had led an adventurous life in the American West before ending up in Paris in 1879. Like many of his generation of American painters he had decided to go to the newly opened and very fashionable Académie Julian rather than the Beaux-Arts. Here with great confidence he had immediately begun working in paint rather than going through the normal procedure of spending a long period meticulously drawing from the model; one of his teachers had told him that if he were to continue like this he would be better off going home and making shoes. Hard work had eventually led to acceptance in the Salon of 1881, after which he came to Concarneau with the intention of painting figure studies in the open air. He stayed at the Voyageurs while using a nearby wheat loft as a studio. One of the more ambitious works he undertook soon after arriving in Concarneau was of a pretty local girl washing clothes. This painting, *La Blancheuse*, was successfully exhibited in the Salon of 1882, and later in America. But both Simmons and the girl he painted were shortly to achieve far greater celebrity.

Working in the Simmons's wheat loft at the same time as he was engaged on *La Blancheuse* was an American writer called Blanche Willis Howard. How she came to be working there is not known, but it is possible that she had got to know Simmons in her home town of Bangor, Maine, where Simmons had once had a brief spell as a school teacher. Clearly absorbed by the artist colony at Concarneau, she began to write a novel about it. This book, *Guenn: A Wave on the Breton Coast,* was to be published in 1883 and enjoy instant popularity. Howard had disguised Concarneau under the name Plouvenec, but the place

was immediately recognizable, as were the characters who inhabited it. Many of the significantly larger number of artists and tourists coming to Concarneau from 1883 onwards were to take great delight in trying to recognize the sites and people which feature in the book. As late as 1909 the Baedeker guide to northern France was to state that 'Concarneau is supposed to be the "Plouvenec" of Miss Howard's charming and pathetic story of *Guenn*.'

The principal theme of this book—if one can discuss what is little more than a lightweight romance in such terms—is the conflict between the world of the primitive peasants and fishermen and that of the artists who come to paint them. Neither world is shown to understand the other; and Howard's awkward attempts to render the speech and behaviour of the 'natives' offers further if unintended illustration of this theme. The artists of Plouvenec are portrayed as people who, though liking to flirt with the local women, are interested principally in the 'natives' as pictorial objects. They are mainly at the start of their careers, ambitious, and have little else to think about other than what they are going to send in to the next Salon. They are happy with the lively, congenial life at the Hôtel des Voyageurs, find their surroundings incredibly picturesque, and are fascinated by quaint local traditions such as *Pardons*. All in all, they appear to be having the time of their lives. For the 'natives' of Plouvenec, all these artists, even those from other parts of France, will always remain strangers. They fail to understand why the artists should spend so much of their time painting grey walls and not the new, brightly painted Plouvenec church. They are asked to make a light, simple packing-case to help transport an artist's pictures to Paris, and are afterwards surprised at the artist's displeasure on finding that they have followed the tradition of their ancestors and constructed a beautifully crafted oak chest, 'as firm as a dolmen'. They feel insulted: 'Shall I allow a foreign *gars* to explain to me the properties of a box? Shall a man who spends his days in daubing paint on good sail-cloth dictate to me about dimensions, wood and nails? *Je m'en moque bien!*' Yet the presence of so many artists in their town obliges the 'natives' to tolerate them, and to adopt the attitude that as long as the artists keep as much as possible to themselves and do not interfere with their own private doings they are welcome 'to make telescopes of their hands and stare in rapture at the sky, to exhibit their familiar brown corduroys on every crag and beach, to put a girdle of camp stools and easels round Plouvenec and all the

52, 53 Illustrations from Blanche Willis Howard's *Guenn* (1883); see also p. 181

adjacent hamlets.' Besides, the 'natives', and in particular the shopkeepers, appreciate how much the artists have done to liven up trade in the town.

The hero of the novel is called Hamor and is based on Simmons, with the principal difference, according to Birge Harrison, that Simmons lacked Hamor's 'all-pervading selfishness'. Hamor is a young, handsome and outwardly charming American painter who has come to Plouvenec by way of Paris. In Paris his talents had been immediately recognized, and he had even had works in the salons. However, this 'American Raphael' had still remained unknown to the world at large. In this position he had found it 'expedient, after a summer in the lovely Fontainebleau woods, to retire to a remote Breton fishing village for a season of inexpensive living, improvement in colour, and inward growth.' At Plouvenec he beautifully converts an old wheat loft into a studio, and shares this with two other painters, Douglas, a Scot, and Staunton, an Englishman whose claims to distant Welsh ancestry make him feel well equipped to understand the Bretons. The story of the novel concerns Hamor's

54 Alexander Harrison, *The Wave*, 1884–5. Pennsylvania Academy of the Fine Arts, Philadelphia

obsession with a beautiful and initially strong-minded Breton girl called Guenn. Her physical appearance is supposedly modelled on that of *La Blancheuse* by Simmons; yet Simmons thought that Howard exaggerated the girl's attractions, 'as all the Breton peasants I ever saw washed below their chin only twice in their lives—once when they were born and once when they were married'. Hamor is determined that Guenn should pose for him. At first she obstinately refuses to do so, but then gives in, and finally falls passionately in love with him. It then turns out that Hamor, a determined bachelor, is only interested in her as a subject for a painting which he hopes will bring him enormous success at the Paris Salon. When this success occurs, he leaves Plouvenec without even saying goodbye to Guenn. Guenn in her despair rows out to sea in a storm and is drowned.

The real Simmons remained in Concarneau, as did his pretty model. Either in 1882 or 1883 Alexander Harrison came to spend the first of many summers in Concarneau. If he had been available at the time Howard wrote *Guenn*, he could easily have taken Simmons's place for the character of Hamor. Described by a woman artist in Concarneau as 'tall, *lancé*, and supremely handsome', he also had an outward charm for which many fell, including the English painter Sir William Rothenstein. A visiting American museum director in 1897 was none the less to write of him that he 'displayed the character of a "big-headed ass" in a more conspicuous manner than heretofore'. He was always very popular with women. In the late 1880s he started up an art school in Paris which attracted mainly female students, all of whom adored him. He reached old age with the distinction of having only painted women and children and never the head of a man, and in 1910 he was to write: 'I have my art and am still a bachelor. There is no finer sport than chasing the clouds with your brush.'

Apart from *Castles in Spain*, Harrison's reputation as an artist rested entirely on his seascapes and *plein air* studies of nude women and children. Before coming over to France to study at the Beaux-Arts in 1879 he had worked for the US Coastal Survey, making maps of the coast of Maine, Rhode Island, and Connecticut. It was in doing this that he had acquired his love for what he described as 'big nature and the sky and the feeling of space'. This love drew him to Concarneau, which was not hemmed in by a valley like Pont-Aven, and which had the advantage of long stretches of beach on either side. A scene observed on the coast near Concarneau was to be the subject of Harrison's best-known picture, *The Wave* (fig. 54) of 1884–5. As at Grez, Harrison acquired here a certain notoriety for his habit of painting the nude out of doors. At first he simply had boys posing for him on the beach. Then, as one journalist described it, 'he had the audacity to pose girls in the landscape sunshine . . . and all the real artists including Bastien-Lepage patted him on the back.'

The great Bastien-Lepage, who normally shunned colonies, stayed in Concarneau in the summers of 1883 and 1884. It is possible that he might have been encouraged to come here by his new friend Harrison, but a more likely reason for his coming is that the constant friend and companion of his last years, the painter Marie Bashkirtseff, used often to visit her cousin, Prince Bojidar Karageorgivich, who had a sketching and fishing resort about four miles along the

coast from Concarneau. Simmons knew all three. Bashkirtseff he described as a 'fascinating blonde vamp' whose charms began to fade after knowing her for about twenty minutes: 'Her hair became unruly, buttons refused to do their duty, and slipper strings burst.' Because she always wore her shoes too small, Simmons once sent her a message saying that he would give a sketch in return for one of her slippers, to which she replied: 'I know the value of a new pair of slippers, but I do not know the value of one of your pictures.' Her cousin Karageorgivich, whose mother was second in line to the Serbian throne, used to keep a collection of her shoes on his mantlepiece. At the time Simmons knew him, he was deeply in love with the actress Sarah Bernhardt, who came to visit him at his resort and try her hand at painting, always managing to leave her painting materials behind.

Simmons found Bastien-Lepage 'one of the most lovable men I ever met'. Harrison was of a similar opinion, and while staying with him at Concarneau wrote to the director of the Pennsylvania Academy of Fine Arts to say that 'I am his friend and chum and find him a stunning, simple, sympathetic and unpretentious fellow.' Though a quiet and then very ill man, Bastien-Lepage was considered by his friends to be always bright, smiling, and quick at repartee. One day Simmons and Harrison came across him painting a stone church just outside Concarneau, and commented on the fact that he was meticulously painting every slate on the roof. They themselves had always been taught at art school to sketch in the subject broadly and only afterwards add the detail that was absolutely necessary. Bastien-Lepage confessed that he was unable to do that, but as a compromise used to take a highly finished picture back to his Paris studio and then wipe out much of the detail. Harrison said that the exhibited picture in the Salon showed little evidence of this method, and Bastien-Lepage was forced to agree with him: '*Hélas! Hélas! Sacré Nom de Dieu! Vous avez raison.* I am so much in love with it when I see it in my studio that I cannot bear to touch it.'

During his first summer in Concarneau Bastien-Lepage responded enthusiastically to a suggestion made by Harrison that he should go on a tour of America, where, he was assured, he would be given a rapturous reception; he planned to go that autumn for about six months, and was only disappointed that Harrison would be unable to accompany him. Nothing came of the trip. The following year he returned to Concarneau on the suggestion of his doctor, who recommended a sea cure for his stomach cancer. Simmons recalled an undercurrent of sadness which could occasionally be sensed beneath his cheerful exterior. As an example of this he quoted the time when one of the young Americans in the colony taught him the words of a Negro song. Despite Simmons's attempts to persuade him otherwise, Bastien-Lepage was convinced that this was 'the pathetic song of a lover mourning for one he has lost', and then proceeded to render it in a voice which Simmons said 'would have brought tears to the eyes of the average audience':

Ze lobstere in ze lobstere pot
Ze bluefish in ze panne,
Zey suffere, oh, zey suffere not;
What I suffere for my Marie Anne.

Bastien-Lepage was to die in Paris at the end of 1884, and his death was followed almost immediately by that of the grief-stricken Bashkirtseff.

With the publication of *Guenn*, the presence in the town of Alexander Harrison, and the seal of approval given to the place by Bastien-Lepage, Concarneau had become by 1884 a colony of exceptional celebrity. Its associates moreover had begun to adopt an increasingly arrogant attitude towards their colleagues at Pont-Aven. Some idea of this can be had from *Guenn*, which features a long description of Pont-Aven (referred to as Nevin) at the time of the annual *Pardon*.

This Nevin may be described, without much exaggeration, as occupied, possessed, and dominated by foreign artists, with a sufficient number of the original race left to serve as models for the invaders. Such was the art atmosphere or art mania prevailing in this painter's paradise, that few tourists were endowed with sufficient strength of mind to resist it. However innocent of art aspiration they had strayed there, however devoid of talent they may be, in the course of a week they were apt to merge into inspired Nevinists, zealous devotees of watercolours or oil . . .

No selection was necessary in Nevin; one could stroll out at random, simply set up one's easel and camp-stool and begin. Benign and indulgent nature had arranged an infinity of subjects. Wherever one turned one's eyes was a choice of little landscapes begging to be transferred to canvas and framed . . . Yet in spite of these legitimate fascinations, a visitor

of an hour was often capable of saying with cold ingratitude: 'Yes, it is a lovely nest, but it is a nest all the same, and one has seen it all before. The little mill, the little stream, the stepping-stones and the foam—why it's a perfect model for a child's drawing-book; nothing could be prettier or less unexpected.' And after leaving the faultless village, the long stretch of bare white road between the rugged walls, with their tangled masses of rough growth, gave one a sense of freedom and distance, and one drew a breath of pure relief . . .'

Simmons shared Howard's feelings about the place, describing it as 'that place of predigested food for artists and ready-made motifs'. He also wrote: 'The British artists passed by Concarneau and went on to Pont-Aven, where there were ready-made landscapes for the water-colourist. Truth to tell, they were frightened by the bigness of the coast and left it to the French and Americans . . .'

In the first half of the 1880s Pont-Aven was visited by a number of artists who were shortly to become important figures in British art. Among these were Frank Bramley, Edwin Harris, Adrian Stokes, Mortimer Menpès (born, in his own words, 'in-artistically in Australia', but later a naturalized Briton), and Stanhope Forbes. Forbes, who later became the mainstay of the Newlyn colony in Cornwall, first visited Brittany in 1881, staying at the fishing village of Cancale on the northern coast. He returned to Brittany early in 1883, and this time based himself in Quimperlé in the south, which he far preferred. His hotel here, the Hôtel Métayer, was more comfortable, and in wet weather he could go angling, which he found a more enjoyable pastime than the interminable rounds of billiards with which he used to kill time in Cancale. The drawback of the place was the predominance of Englishmen on fishing holidays: 'Les Anglais at the hotel are a very ordinary and rather uninteresting set.' There were very few French there: the French, according to Forbes, 'do not seem to take greatly to this part of their native land.' In May, Forbes paid a visit to Concarneau, which he greatly enjoyed, but he decided that it was not a good place to do 'large work in', as it was too 'large and crowded'. In August he was once more in the Hôtel Métayer, this time complaining of 'the painful absence of the female element', but cheering up on hearing of the arrival of two young Englishwomen. By this date the sentimental French genre painter Bonvin was a guest at the hotel, and, according to Forbes, 'turning out rather

indifferent work'. Forbes was waiting anxiously for any news about Bastien-Lepage, who, he said, was still at Concarneau: 'There are at least twenty American artists staying there now. How glad I am I did not remain.' In October he went with a friend called Rowe to Pont-Aven: 'Pont-Aven seemed to be the right thing to do and as Rowe was going I jumped at the opportunity. So there we went by courier, saw innumerable artistic friends and their works, the little village though not looking at its best for it rained most of the time, and back again on foot congratulating myself that I am not living there. The work there is not remarkable, even now there are countless daubers and the place inferior in every way to Quimperlé.' In the interests of economy, he stayed at Gloanec's rather than at Julia's, but none the less still regretted both the time and money spent in visiting the town. He returned to England before the end of the year.

55 Stanhope Forbes, *A Street in Brittany (Cancale)*, 1881. Walker Art Gallery, Liverpool

Forbes's impressions of Pont-Aven could hardly have been more different from those of the American painter Elmer Boyd Smith who arrived here on 2 June, 1883. In his diary entry for that day he wrote: 'Pont-Aven is a quiet little place, it seems a second Arcadia, everybody seeming simple and honest.' Smith put up at Gloanec's, where he found himself surrounded, as indeed he did everywhere in Pont-Aven, by American and English artists. He loved the life of the inn, thought all the young people here were as a rule 'very good fellows', and soon felt as if the place was a second home and he a member of a family whose other members moreover were constantly changing and thus rarely giving one time to become bored with them. Smith and his artist friends amused themselves with the customary outings to the sea, boating trips, and nocturnal walks during which everyone would sing songs. He soon acquired the statutory sabots, and broke them in in the most gruelling fashion, walking the twenty miles to Concarneau and back. As with all his friends and colleagues, he closely observed all the quaint activities which went on in the town, and would sometimes join in them himself. In July one of Madame Gloanec's daughters was married, and there were celebrations involving over three hundred people. There was a huge dinner, followed by dancing which went on for two days: 'We all of course took part in the dances, all of course Breton dances. They were very droll and amusing.' Smith also attended the annual Pont-Aven *Pardon*. An idea of what this occasion must have been like at this time is given in *Guenn*: 'The young men in brown velveteen, and the young women in Rubens hats and Velasquez frills mingled with the folk with amiable condescension, swirling graciously upon the motley costumes and the rough sport. "For us these attitudes, for us these colors, for us this native display of the habits of a primitive people. How picturesquely historic, how vividly antique."'

In Pont-Aven in 1883 the Americans also introduced into the town a tradition of their own: they celebrated the 'Glorious Fourth'. Smith gave a full report of the day, which was the first American national holiday he had celebrated since coming to France. Throughout the day Smith and his compatriots wore buttonhole badges which the American women staying in the town had made for them. The town's streets were lined with the American flag, and 'the Frenchmen as a mark of respect hung out the French flag also'. The town's mayor in fact became one of the most active participants in the celebrations, and was very anxious

that the day should be a great success. In the afternoon the Americans all drove in teams down to the sea, 'where we enjoyed ourselves heartily, being quite a good-sized party'. In the evening they returned to Pont-Aven and here were joined by the townspeople in setting off fireworks and saluting the flags to shouts of 'Vive l'Amérique' and 'Vive la France'. This was followed by a dance, after which the Americans started singing 'America' and then the 'Marseillaise'— 'to the great enthusiasm of the natives who loudly applauded us'. The day, or rather night, finished with a strawberry feast, 'thus ending quite a real "Fourth of July"'. Smith only spent at the most two summers in Pont-Aven, but during his forthcoming years of misery and mediocrity was always to look back on this period as one of the happiest in his life.

Pont-Aven in the early 1880s had a remarkably international atmosphere. Despite the predominance of Americans and British, other nationalities were also very much in evidence. Moreover many who came here had stories to tell of a wide range of exotic regions where they had travelled. The American painter Arthur Hoeber visited the town either in 1883 or 1884, and gave this description of Gloanec's: 'Here were men who had painted Italian sunsets and the blue of the Mediterranean; who had idled under the shade of orange trees at Capri, or studied the cooler tints of the North Cape and the beauties of Norwegian fiords. Others, too, had come from the canyons of Yellowstone, and the land of the Zuñi, with sketchbooks full of suggestive bits, and canvased studies of bright sunlight, or the brilliant colour of savage costume with bead and feather, caught under the blue skies of Arizona.'

Of all the foreign artists in Pont-Aven in this period who were not American or British, among the most interesting were a group of Finnish women painters, Helene Schjerfbeck, Maria Wiik, and Amelie Lundahl. It is unlikely that any of these were noticed at the time for their artistic abilities. Most of the growing population of women artists in Pont-Aven, when not engaged in making buttonholes, seem to have been regarded merely for their marriage potential. They were mainly amateurs, people who sat down in front of the town's 'ready-made motifs', and started calmly and mechanically to reproduce them in watercolour; in other periods these same people might have occupied themselves playing the spinet, embroidering, or studying art history. The narrator of *Guenn* describes one sure way of telling whether a woman artist was serious or not: 'In general in Nevin the

broader the hat, the narrower the talent, the more expansive the frills the more limited the diligence.' These three Finns undoubtedly belonged to the category of small hats and no frills. None the less, it is only recently that their talents have been fully recognized, and even so, only in Finland.

Helene Schjerfbeck, the most remarkable of this group, first came to Brittany in 1881; she was accompanied by an Austrian friend whom she had got to know at the Académie Colarossi in Paris, Marianne Preindlsberger, herself a talented artist. Together they stayed in Pont-Aven and Concarneau. They returned in the summer of 1883, this time basing themselves mainly in Pont-Aven and in the Hôtel des Voyageurs; they were soon joined here by Maria Wiik. Schjerfbeck wrote several letters home describing her life in Pont-Aven. She had been lame since a child, and perhaps as a result of this the locals appear to have gone out of their way to be kind to her. She loved the way they sweetly said to her, *'Bonjour mam'oiselle Hélène'*. They would send her flowers, and the old women would tell her how pretty she was. Marianne Preindlsberger meanwhile began painting at Pont-Aven what was to be her first Salon picture, *Tired Out* (fig. 56), and also met here her future husband, the English painter Adrian Stokes. Schjerfbeck, like all her Finnish women artist friends, was never to marry, although it is known that at some time in her youth she became engaged to an Englishman and that she was so hurt when the engagement was broken off that she never wanted to talk about the affair; in later life she was to consider marriage incompatible with the life of a woman artist.

In January 1884 Schjerfbeck, Preindlsberger, and Wiik were joined in Pont-Aven by Amelie Lundahl; she was followed here later in the year by another Finnish friend, Helena Westermark, who was later to chronicle the lives of these artists, as well as to record her own impressions of Pont-Aven. Westermark felt that there was a resentment in the town against foreigners, all of whom were considered English. At first she stayed at Gloanec's, where she found that the artists had their own special places at table, and ate without any manners: she noticed how the Americans would never wait for the salt cellar to be passed round but instead would empty out, before the meal began, a large pile of salt on the table-cloth in front of them. Later in 1884 she and Lundahl moved to a house on top of the hill just outside of the town. This was owned by three elderly Frenchwomen, one of who had been a music teacher in Guatemala and had brought back

56 Marianne Preindlsberger (Stokes), *Tired Out*, c.1881–2. Whitford and Hughes Gallery, London

with her three large parrots. Life here was certainly more genteel than at Gloanec's, but Westermark and Lundahl seem to have missed the large portions of food. Sometimes after some insubstantial meal, they would take out the Helsinki newspapers sent to them by Westermark's mother and drool over the menus which would be published inside. By the end of the summer of 1884 all the Finnish women in Pont-Aven had gone their separate ways.

Schjerfbeck, Wiik, and Lundahl seem to have taken little interest either in the elaborate genre and historical scenes popular with the American artists in Pont-Aven in the 1870s, or in the Bastien-Lepage-like outdoor studies of peasant life then fashionable in the town. Wiik and Lundahl seem instead to have favoured intimate and subtly painted interior scenes generally featuring women. Schjerfbeck's outstanding achievements in Pont-Aven were her small-scale landscapes and interior views. One of these, *The Door*, probably features the interior of the chapel of Trémalo, which is just above the Bois d'Amour. In contrast to the way Bastien-Lepage painted the chapel at Concarneau with every tile showing, Schjerfbeck has here created a work of a simplicity quite exceptional for the time. Almost all detail has been eradicated, and the colours reduced to the palest greys and greenish browns with just a brilliant orange streak seeping through the crack at the bottom of the door. This painting is not an unfinished study, as the artist has signed it; its proto-abstract qualities and extreme

sensitivity were in fact to characterize the works of the artist's maturity.

Alexander Harrison continued to be the artist looked up tp by all those coming to Brittany; and he remained obstinately in Concarneau, thus forcing the many who anxiously wanted his opinion on their work either to trek over there for the day or else stay in the town themselves. The year of 1885 is a particularly well-documented one in the Concarneau colony's history, thanks to the extensive correspondence of the American painter Howard Russell Butler. Butler, like Harrison, had spent a period working for the US Coastal Survey before becoming a painter; like Simmons he had had a college education and had been on adventurous travels, in his case to Mexico. He had come over to study art in Paris early in 1885. Here he had become closely involved with the American community, making friends with Bridgman, with whom he liked to play tennis, and Arthur Hoeber. He had also met Harrison, whose *The Wave* he considered to be the greatest painting in that year's Salon. His other revelation in Paris had been seeing the work of Bastien-Lepage, a massive auction of whose work had been held in the May following the artist's death; to the envy of all his friends he had even managed to buy a small oil study by the artist for very little money. Other artists whose work he had seen in Paris were Jules Breton, whom he thought technically brilliant but lacking in genius, Léon L'Hermitte, whom he admired for his composition, and the German peasant genre painter Fritz von Uhde, whom he dismissed entirely. He arrived in Concarneau at the beginning of July, and immediately wrote about the place to his parents.

If you have read Blanche Howard's *Guenn* you have had a better description of Copncarneau than I could give you—ever since I have been here, I have been running across the objects and characters mentioned in the book.

The artist hero is himself here, only he is a married man now. His wife is a nice little woman, also an artist . . .

I have not yet seen very much of Guenn, although she was pointed out to me the first or second day—I did encounter her a few days ago down by the river, at the washing—she was teasing one of the old chatterboxes, who finally got up and chased her; but Guenn is a rapid runner and quickly disappeared over the hill.

A few nights ago when we were taking our coffee in front of the hotel and the small boys were capering around, just as described, who should turn up but 'Nannic' the little hunch-back. His face fits the character exactly.

The studio in the loft where I have been working myself for several days is perfectly described in the book.

Altogether I feel as if I had returned to an old home, for I can hardly turn a corner without seeing something that I remember.

Butler rented a room in a house belonging to a retired photographer, Monsieur Gase. This man had amassed a considerable amount of money by the time of his retirement, and had been able to build himself a beautiful, well-appointed house on the coast. It was full of old carved furniture, and also of pictures by eminent artists who had been his friends. 'We have', wrote Butler, 'a piano and everything to make a life agreeable.' He was given a large 'delightful room', looking out on one side to meadows and woodland and on the other to the sea. The house had a one-acre garden attached to it, full of roses and other flowers, and had a photographic studio at the far end, hung with old armour and 'many curious Breton relics'. Butler was given access to this studio, but, as he wrote in his first letter home, he worked also in the wheat loft belonging to Simmons and featuring as Hamor's studio in *Guenn*. His typical day began around seven o'clock, when he took coffee at Gase's, 'in a perfect little gem of a dining-room with tiled floors and oak ceiling'. He would work until five, when he went to have a swim in the sea; the beach was only a five-minute walk from his house. Dinner would generally be around six, in the Hôtel des Voyageurs. He was amazed by the number of languages spoken here: 'At my table at the hotel, we are French, English, American, Russian and Norwegian—everybody there except the Norwegian and myself talks French fluently.' After supper he would often work until twilight.

It was a very agreeable summer for Butler, the weather being neither too hot, nor too cold. He had known places which were far more picturesque than Concarneau (for instance Cantlón in Mexico), but few had been so ideal for studying. It was easy to get models, and, because the locals were so used to seeing artists around, one was able to work without always being surrounded by a crowd of spectators. For Butler the worst aspect of Concarneau came to be its smells.

When he had first arrived in the town he had been largely spared these, as there had been a short period during which few sardines had been caught. However, towards the end of July the catches had become plentiful, and by the beginning of August Butler was writing to his sister with his fingers to his nose.

> If you wanted to be wafted speedily to Concarneau just get three small fish from Jones's, let them stand in the sun for four days, then boil them in sweet oil for half an hour, and hold your nose over the pot for ten minutes you will then be about three thousand miles nearer to your own brother How.
> I don't like to wish bad luck on the fishermen at Concarneau, but I must say I prefer it when their luck is bad.

Butler was hard at work for most of his time in Concarneau, mainly engaged in numerous small figure and landscape studies, but also embarking on an ambitious canvas, *The Seaweed Gatherers* (a profitable local industry this), which was to win him an honourable mention in the Salon of 1886. As has been discussed elsewhere, Butler was critical of the way in which his colleagues seem only to have been inspired to paint when the weather was gloomy. He himself enjoyed the odd storm effect and found charms in the greyest day, but could not help thinking that sunlight was more inspiring, and determined to show his colleagues 'what can be done in sunlight'. The others remained unconvinced, and continued to despair during long sunny spells, calling them 'Butler weather'.

Butler found that the American artists in Concarneau were 'inclined to be lazy and to fritter away their time'. He made an exception of Harrison, who like himself would work late into the evening. He thought that as a painter Harrison slightly lacked imagination, but was none the less outstanding in every other aspect of his art; he felt fortunate to be in the company of such a man. Next to Harrison in importance, Butler rated Simmons. He found Simmons a 'pleasant fellow', but 'not over-humble and of an argumentative nature'; his wife, however, an artist from San Francisco, was 'young and charming', and they had an engaging three-year-old boy. Other than Harrison and Simmons, Butler could discern 'no great talent in Concarneau'. Among those Americans he dismissed in this way were two former students of Gérôme, Arthur Hoeber and Charles Lasar, both of whom had become firmly entrenched in the town by 1885 and were to play a central role in the social life of the colony. Hoeber later made a poor impression upon Butler's parents, whom he met on a brief return trip to the USA in 1886. The parents were worried that their son would turn out like Hoeber, and Butler, then back in Paris, was forced to defend himself. Hoeber, he said, had always been a good friend, kind, full of good humour, and enjoyable company; but, he assured them, 'you must not look at him as a representative of the class to which I would belong either as an artist or a man . . . *Entre-nous*, I have very little faith in Hoeber's art prospects, and he is not a representative of the serious student class.'

As Butler predicted, Hoeber soon gave up painting; after staying on at Concarneau until about 1890 he was to return for good to the USA, and, like Shinn before him, devoted himself to being an art critic. Lasar, on the other hand, was to have a greater success than Butler would perhaps have imagined, soon starting up an art school in Paris, and writing a successful book on art hints for students. He had in fact made a name for himself before coming to Concarneau, although admittedly not for any innate artistic talent. He had to begin with been a dreadful student at the Beaux-Arts, with little talent for drawing. Once when copying a cast from Michelangelo's Medici tomb he had, as a fellow student observed, 'got into a horrible mess with his "angles" and direction of the limbs'. He had then devised an ingenious invention to overcome this problem: this was an 'angle machine', a rectangular frame with a plumb line attached. His finished drawing made with this device had astonished Gérôme. 'Of course you can't draw a little bit, and as for your proportions they simply don't exist. But your angles! They are wonderful—perfect!' Lasar had subsequently come first in drawing in Gérôme's class. At Concarneau Lasar became known for his coldly mathematical approach towards art, perhaps not surprisingly for someone who had to have recourse to devices such as an 'angle machine'. He was also known for the viciousness of his criticisms of other artists' work. This was quite an achievement in Concarneau, where such criticisms, as Butler noted, were hardly in short supply: 'I notice a curious and sensible etiquette among artists since I have been here. One will call on another in the most friendly way and pitch into his work with a vengeance all in the hope of discovering some fault that may serve to help him . . . The best proof that you have done something good is that all the artists come round and find fault with it. But I suppose it is only right that he who makes a hit

should get the blows. The most popular man here is Lasar—he has succeeded in condemning almost everything painted in Concarneau this year.'

Although a vicious critic, Lasar was otherwise much liked by everyone in Concarneau. They all affectionately referred to him as 'Shorty' on account of his comically small and fat features. Despite his physique he was a most enthusiastic and skilled sportsman. He was excellent at billiards, showing his usual ingenuity at overcoming handicaps by climbing onto the table. And in August 1885 he helped lead Concarneau to a resounding sporting victory over Pont-Aven.

Butler, in describing to his parents the events that led up to this victory, began by explaining that 'Pont-Aven and Concarneau are rival artist towns. The artists at each rather look down at those in the other place.' Towards the end of July the Concarneau artists received a challenge from their colleagues in Pont-Aven to a game of baseball. The game was held, 'in true French style', on a Sunday, which meant that Butler, an excellent baseball player but a strict Presbyterian, was unable to play. Pont-Aven moreover had been able to get some practice in beforehand. Accordingly they won, although by a very small margin. The Concarneau team, which was captained by Lasar, then went home 'feeling very blue'. About two weeks later they had a practice match, during which Butler delighted them all with some 'fancy twist pitching'. A return challenge was sent to Pont-Aven, and it was agreed that the games should be held on a Saturday so that Butler could join in. The players this time were 'all Americans and Englishmen who knew the game'. A wealthy man who lived near Concarneau lent them a field and also provided awnings, tables, and chairs for their invited guests. These numbered about fifty and were mostly 'French ladies who were deeply interested in seeing what was to them an entirely new form of sport'. Some of these brought with them American flags which they had made specially for the occasion. What with these and other decorations the lawn on which they played 'was as beautiful as the day was fine'. Concarneau beat Pont-Aven by 47 to 15, 'and this notwithstanding that they had practised nearly every day since the preceding game'. Butler, summing up the match, wrote: 'Most of the credit of the game was due to our little captain, a St. Louis man who is about a head shorter than I am and almost as broad as he is long—we call him "Shorty". He is a very comical fellow and really showed a great deal of skill and pluck in managing his nine.' After the game, which had begun at nine o'clock

in the morning, there was a sit-down breakfast for seventy under the trees. Butler and his colleagues did not return home until five o'clock. For the next few days, very little work was done, as everyone was excitedly talking about the game. By this stage Butler had begun to feel rather stiff and was suffering from a sore nail on the big toe of his right foot. There was much talk of a return match, but Butler refused to agree to this until he knew how long it would take him to get over his injuries. Whether such a match was ever held is not known, but when in the following year, 1886, Butler, Simmons, and other of their Breton colleagues were to find themselves in the colony of St. Ives in Cornwall, they might well have been prompted by fond memories of playing baseball in Brittany to accept the challenge of the nearby Newlyn colony to a game of cricket.

It was not so long after the Concarneau artists had congratulated themselves on the superiority of their baseball abilities over those of Pont-Aven that there arrived in the latter town an artist whose presence in Brittany would eventually consign the Concarneau colony into an art historical oblivion, and indeed make Pont-Aven itself remembered primarily for his own work and that of his followers. This was Paul Gauguin, who arrived in Pont-Aven in May 1886. There was staying that same year in Pont-Aven a Scottish art student from the Académie Cormon in Paris, Archibald Hartrick. In his memoirs, which were not published until 1939, Hartrick wrote that at the time of Gauguin's arrival in the town most of the young artists here were 'striving rather ineffectually' to imitate Bastien-Lepage; 'details of their doings', he added, 'would probably not be of sufficient interest to record, so I go straight to my recollections of Gauguin.' Most art historians of this century have been similarly biased in their assessment of Gauguin. For these writers the history of art is primarily an examination of changing styles, and they have invariably treated the exceptionally complex and lively history of Pont-Aven as a mere phase in the development of the vague stylistic concept known as 'Post-Impressionism'. The contribution of Gauguin and his followers cannot surely be studied in isolation from that of the hundreds of artists who came to the place without any knowledge of, or interest in, their work. In fact, despite the obvious differences in their art, the reasons why all these artists were attracted to Brittany were fundamentally the same. It is only such ephemeral factors as present-day tastes and notions of

stylistic development that have made one group seem more worthy of serious study than the other.

As with van Gogh, Gauguin's life has today acquired a legendary, heroic quality. However, when he first arrived at Pont-Aven his credentials cannot have seemed that impressive. He was on the verge of middle age, had received no formal training as an artist, and indeed had been literally a Sunday painter: he had been a stockbroker for twelve years and received his first lessons in painting (on Sundays) from an office colleague, Émile Schuffenecker. Schuffenecker had later abandoned broking in favour of art, and Gauguin had done the same, except that his decision had not been a deliberate one: he had been given the sack as a result of the collapse of the Paris Stock Exchange in 1882. Schuffenecker was a friend of Pissarro and other Impressionists, and through this connection Gauguin had been able to exhibit with these artists in their group shows of 1880, 1881, and 1882; Monet had protested, apparently saying that he 'didn't care to exhibit with the first dauber who happened to come along'. Gauguin had married a Dane, Mette-Sophie Gad, in 1872, and had four sons, Émile, Jean, Clovis, and Pola, and a daughter, Aline. His wife had not been at all pleased by her husband's decision to devote himself wholly to painting. Matters had become increasingly bad between them, their finances had dwindled, and after they had all moved to Copenhagen in 1885 to be nearer Mette's family, Gauguin had made up his mind to abandon them all there and go back to Paris. He had decided to come subsequently to Pont-Aven after hearing from a Breton painter, Felix Jobbé-Duval that artists here were allowed extensive credit. Once in Brittany he continued to write to his wife, asking her every now and then how his family was doing and gratefully receiving from her the odd cheque and pair of woollen socks; but he had decided long ago that his art mattered more than anything else, and he told her that she would have to wait for at least seven or eight years before he would be in a position to go back to live with her.

On arriving at Pont-Aven Gauguin put up at Gloanec's, which he found very reasonably priced and provided 'food which made you fatter on the spot'. The clientele surprised him: 'Hardly a single Frenchman: all foreigners, a Danish man, two Danish women . . . and lots of Americans.' Soon afterwards he was writing to say: 'My work has given rise to many discussions and I must admit it is rather favourably received by the Americans.' Later he boasted that he was 'respected as the best painter in Pont-Aven . . . and all the painters here, American, English, Swedish, French are clamouring for my advice.' Although such boasts were probably intended as justification for having abandoned his family, he must undoubtedly have caused an immediate stir in Pont-Aven. It is true that he might have been put in the same category of exhibitionist as Défau, an artist whose dramatic rise and fall had already been witnessed by the clientele at Gloanec's. None the less he did paint in a way which was noticeably different to that of most of the town's artists, whom he referred to as *pompiers* or hacks. According to Hartrick, his advice to painters was to 'avoid black and the mixture of black and white called grey'. The combination of his exhibiting history and colourful paintings soon led Gauguin to be labelled an 'Impressionist'. This was hardly a new style of painting (the first Impressionist exhibition had been held in 1874), but it was one which had not yet met with general acceptance among the artists of the day: Julian Alden Weir, later to be regarded as one of the leading 'American Impressionists', had been in 1877 to the third exhibition of those whom he had mistakenly referred to as the 'Impressionalists', and had not been enthusiastic: 'It was worse than the Chamber of Horrors. I was there about a quarter of an hour and left with a headache, but I told the man exactly what I thought. One franc *entrée*. I was mad for two or three days, not only [for] having paid the money but for the demoralising effect it must have on many.' Yet if Gauguin painted in an 'Impressionist' manner, his basic subject-matter was the same as most of his Breton colleagues: quaint scenes of pastoral life, people dressed in local costume, and objects of folkloric interest, such as crudely carved crucifixes. Indeed in his letters from Brittany he reiterated all the hackneyed notions about how primitive the region was. And just as Weir and others had enthused after having purchased a pair of clogs, so Gauguin wrote to Schuffenecker to say that the sound of his own clogs 'resounding on the granite soil' suggested to him 'the dense powerful tone' which he was looking for in his paintings.

Gauguin was certainly a charismatic presence. Hartrick described his appearance: 'Tall, dark-haired and swarthy of skin, heavy of eyelid and with handsome features, all combined with a powerful figure, Gauguin was indeed a fine figure of a man. He dressed like a Breton fisherman in a blue jersey and wore a beret jauntily at the side of his head. His general appearance, walk and all, was rather that of a well-to-

do Biscayan skipper of a coasting schooner; nothing could be further from madness or decadence.' There were artists who fell dramatically under his influence, including, according to Hartrick, a Dutch *pompier* who completely changed his style of painting after just a single sharp glance from him. It also seems that Gauguin loved to dominate far weaker characters than himself. One of these was a twenty-six-year-old painter just out of Bonnat's academy in Paris, Charles Laval, who shortly became the only close friend whom Gauguin made in Pont-Aven in 1886. A more interesting visitor to the town in that year was a nineteen-year-old art student from Cormon's, Émile Bernard. Bernard came here following a chance encounter on the beach at Concarneau with Schuffenecker, who had told him all about Gauguin. Bernard had the attributes of the typical young Parisian intellectual: he was extremely serious, well-informed, argumentative, and arrogant. He turned up at Gloanec's with a visiting card worded, 'Émile Bernard—Impressioniste'. This did not impress Gauguin, who, Bernard said, 'paid absolutely no attention to me, and saw absolutely nothing from my own hand . . .' Bernard and Hartrick returned to Cormon's at the end of the summer, and might well have told their fellow students about this strange artist who had been in their midst at Pont-Aven. One of these students was van Gogh.

Among the American artists staying in Pont-Aven at the same time as Gauguin was a painter who was to achieve a considerable reputation in his own country, Arthur Wesley Dow, who appears with Gauguin in a group photograph taken in front of Gloanec's in 1886. Dow, who had first stayed in this inn in the summer of the previous year, returned here in the same month that Gauguin arrived. He returned in a mood of great confidence, doubtless buoyed by having recently received an unexpected allowance of 400 dollars from his parents: 'This summer will do a great deal for me, so that I shall be able to paint some pictures at good prices. Some of the best painters in France will be here this summer and I expect to learn much from them.' Exactly whom he had in mind is not known, but it certainly was not Gauguin. Though still a student at the Académie Julian, Dow thought the time ripe to begin an ambitious painting for submission to next year's Salon. It was to be a large landscape done in greys and soft colours. Unfortunately the weather this summer did not help him in this, as, unusually for Brittany, it was beautifully sunny for most of the time, and the few grey days were accompanied by downpours of rain, which obviously made painting

impossible. The luck was all on Gauguin's side.

Dow had also other problems to contend with. A strict Presbyterian, he seems to have assumed the role of guardian angel to the English-speaking community at Pont-Aven. When he had come from Paris with a group of his compatriots, it was he who had dealt with problems of tickets, luggage, lodgings, and passports; he had in fact complained that he had all the work of conducting a tourist agency without any of the profits. Once arrived in Pont-Aven, however, his duties were by no means over. There was, for instance, the problem of the Boston man, 'Mr Smith', who had switched from taxidermy to art, becoming a figure of fun among his fellow students. He could not speak a word of French, and it was Dow who had the unenviable task of scouring the countryside in search of cows for this man to paint and then reassuring the Breton peasants that his colleague had no more sinister designs on the animals. Then there was the moral salvation of a New Englander by the name of Stone, who was considered something of a genius by those who knew him well, but who in Paris had squandered both his talent and finances through a life of dissipation and drink and been brought to Pont-Aven for the good of his soul. Dow was to have little luck with him, as Stone returned to America at the end of the summer still an artistic failure and with only a few more years to live.

Most trying of all for Dow were the funeral and other arrangements following the serious illness and death in October of a young English painter friend, 'Mr Clunnie'. Dow considered these of sufficient interest to merit dispatching a lengthy account of the whole affair to the *Ipswich Chronicle*. Dow was in Concarneau when he was summoned back to Pont-Aven by a telegram from Madame Gloanec. He arrived to find his friend lying in bed with a very high fever caught from too much bathing in the Aven and from having rowed for four hours at night with only a thin shirt across his chest. The man's health rapidly declined, and his parents were summoned from England. Dow was the one chosen to go and collect them at the station at Quimperlé and break the news to them that their only son had just died: it was the third death in their family in the past few months, and they had arrived too late in each case. The night of the young man's death Madame Gloanec had called in a Roman Catholic priest to give him the Last Sacrament so that the funeral could be held at the local church; the priest said that as the man was not a Roman Catholic there was nothing he could do. The next day

Dow had sent to the coast for a Church of England clergyman, and another American student had called for a Presbyterian missionary whom he knew in the vicinity. These two priests arrived simultaneously in Pont-Aven, along with the parents. They immediately got into theological difficulties, and the funeral service was delayed because of a heated discussion of the Seven Sacraments. This was too much for Madame Gloanec to bear, and she began to make her own arrangements. Eventually a strange compromise was reached. There was a Breton-style funeral procession in which Madame Gloanec's son carried the crucifix, and Dow and a painter friend held candles. The Anglican parson gave an unorthodox Last Absolution, and the Presbyterian took responsibility for the speech at the grave. The coffin was lowered into the earth to the sounds of 'Abide with Me'. The parents, who had been too upset to attend this strange ceremony, were looked after by Dow, who took them back to the coast. Dow was only just beginning to get over the whole experience when he received news from home that his beloved Aunt Lydia had died. He returned to Paris at the end of the year in a rather morbid state of mind; as a consolation he was to hear in the spring of 1887 that his large landscape had been accepted for the Salon.

Gauguin also returned to Paris at the end of the year. Here he met van Gogh for the first time, and dreamt of going to the tropics. In April 1887, shortly before Dow went back to America for a year, Gauguin, accompanied by Laval, went on a trip to Panama and Martinique. This was not to be the most successful introduction to life in a tropical environment. In Panama, Gauguin, refusing to follow Laval's example and make money from painting bad portraits, was forced to work as a canal digger. In Martinique the two artists fell seriously ill; Laval tried to kill himself, but Gauguin persuaded him out of this. They were back in Paris by Christmas, and Gauguin, still not fully recovered from his illness, went on to Gloanec's in February 1888.

At the start of his second stay in Pont-Aven, Gauguin was feeling very sorry for himself. He complained to his wife: '[I am] all alone in the room of an inn from morning till night. I have absolute silence, nobody with whom I can exchange ideas.' Doubtless he was not consoled by the return of Dow in May. At any rate Dow did not stay long this year, finding, as he said in a letter to the *Ipswich Chronicle*, Pont-Aven in midsummer to be 'much too green for outdoor sketching'. With a couple of friends he took himself off to the Îles de Raguènes, leaving behind him in the town his American fiancée, Millie Pearson. He was to miss one of the key summers in the artistic history of Pont-Aven.

In the summer Gauguin was joined by Laval, Schuffenecker, and many other of his friends and admirers. Émile Bernard returned, and this time entered into a close friendship with Gauguin, even sharing for a while a studio with him in the town. The new atmosphere of excitement was heightened in

TOP: **57** Paul Gauguin, *Brittany Landscape with Swineherd* (Pont-Aven is shown in the background), 1888. Private Collection
BOTTOM: **58** Émile Bernard, *Madeleine in the Bois d'Amour*, 1888. Louvre, Paris

59 Émile Bernard, *Breton Women in a Meadow*, 1888. Private Collection

August by the arrival of Bernard's seventeen-year-old sister Madeleine, who was to serve as a muse to their circle, and be painted by Gauguin and others in the Bois d'Amour. Gauguin, according to Hartrick, strongly objected to casual flirtations. However, he was quite obviously attracted to Madeleine and upset when she seemed to favour Laval. There were growing tension at Gloanec's too: Gauguin's increasing hold on the inn had begun to anger the traditionalists. One of these, Gustave de Maupassant, the son of the writer, insisted that Gauguin should not be allowed to hang up any of his works in the inn; later Gauguin overcame this problem by signing a painting with Madeleine's name. On another occasion Gauguin found one of his drawings inscribed 'inmate of Charenton' (the Paris mental home). The hostilities between the 'Impressionists' and the *'pompiers'* became such that the two factions ended up by having their meals served at different times and in different parts of the dining-room.

Since his last stay in Pont-Aven Bernard and a painter friend called Louis Anquetin had experimented with a style of painting inspired by medieval *cloisonné* enamels, using black outlines to surround areas of unmixed colour. Bernard continued to experiment in this way on his return to Pont-Aven. In July he attended the town's fête, and immediately recorded his impressions of it in a work which was

later to be entitled *Breton Women in a Meadow* (fig. 59). In this he did away with all modelling and colour modulation, and placed figures, reduced to simple heavily outlined shapes, against a uniformly green background. This style of painting was later to be dubbed syntheticism: the preoccupation with synthesizing colour and forms represented an important breakaway from the more conventionally based pictorial principles of the Impressionsists, and was obviously a step in the direction of abstract art. Yet the *Breton Women* is also interesting from the point of view of its subject-matter: included in this representation of quaintly dressed Bretons are a young girl in smart modern dress and two bourgeoises with hats and parasols. Thus Bernard, whether consciously or not, illustrates the contrast between modern tourists and traditional Breton life. Blanche Howard had done the same in her description of the *Pardon* in *Guenn*, but painters had up till then tended to forget that the old existed alongside the new, and simply concentrated on the former. Gauguin, according to Bernard, was deeply impressed by the *Breton Women*, and asked him to lend him some of the colours which he had used for the painting, including Prussian blue, which he did not possess; Gauguin also wanted to have more information about Bernard's *cloisonné* experiments. Soon after (this is still Bernard's account), Gauguin painted *Vision after the Sermon* (fig. 60), another key work in the art of the period.

There was later to be much discussion as to who in fact influenced whom: the issue is not really of much importance to historians, but it was to lead to a decisive break in the two artists' friendship. Gauguin's painting is as uncompromising in its handling of colours and forms as Bernard's but it is the subject-matter which was to be of particular significance. The work might well have been inspired by the wrestling bouts which always accompanied a *Pardon*. However, whereas Bernard's representation of the Pont-Aven fête, for all its stylization, can easily be imagined in naturalistic terms, Gauguin's picture is very unreal: one of the wrestlers has a pair of wings, and some of the onlookers are inexplicably praying. Whereas Bernard allowed the modern world to enter his painting, Gauguin has gone to the opposite extreme and evoked the timeless, spiritual qualities that artists and tourists loved to find in Brittany; however, unlike the academic painters of his day, he has expressed these qualities not simply through the representation of devout postures but also through the strangeness of the overall composition. The work was to be central in

the history of Symbolist painting, a movement in art which signified a retreat from the realities of modern life. On completing the painting, Gauguin and his friends had it carried in procession to the church in the nearby hamlet of Nizon and offered it to the priest. The Nizon priest understandably refused the painting, saying that it was not sufficiently religious and would not be understood by his parishioners.

There was yet another highly influential painting executed in Pont-Aven that summer. This was produced by a student of the Académie Julian, Paul Sérusier, who had come to Pont-Aven for the first time

that year. He had stayed at Gloanec's, but had kept mainly apart from Gauguin's circle, whose conversations had none the less intrigued him. On the day before he was due to leave, he finally plucked up the courage to go and see Gauguin, whom he found ill in bed. He showed him one of his paintings, and Gauguin told him to meet him the next day when he would give him a lesson in the Bois d'Amour on how to paint nature. The spot they chose was a conventionally pretty one, right next to the river and looking towards the much painted Moulin David; a photograph exists showing Thomas Hovenden

60 Paul Gauguin, *Vision after the Sermon*, 1888. National Gallery of Scotland, Edinburgh

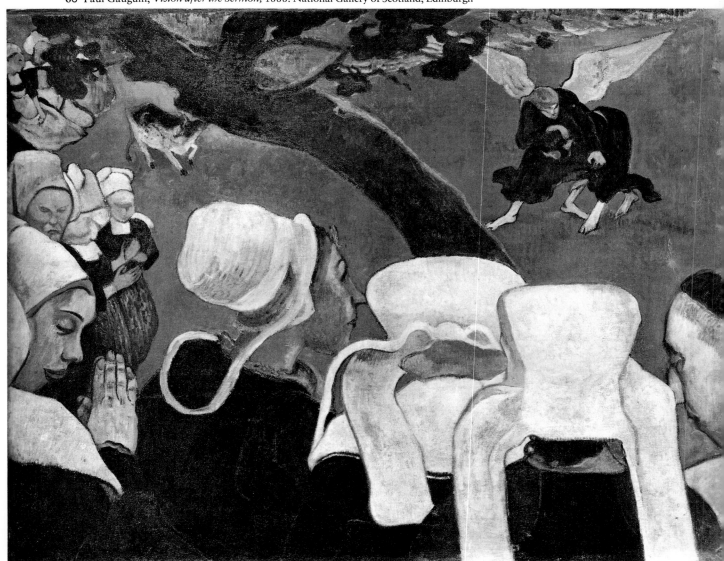

61 Arthur Wesley Dow, *The Sands of Raguènes*, 1888. Ipswich School Committee, Massachusetts

painting from exactly the same spot about ten years earlier (fig. 43). The words of advice given to Sérusier by Gauguin are among the most repeated in the history of nineteenth-century art: 'How does that tree look to you? It's a vivid green, isn't it? So take some green, the best green you've got on your palette. And that shadow's blue, really, isn't it? So don't be afraid—make it as blue as you can.' Perhaps so as not to waste expensive canvas on this experiment, Sérusier used a cigar-box lid. At any rate he was very pleased with the end result, and on his return to Paris he showed it to his slightly bewildered fellow students, among whom were Bonnard and Maurice Denis. Out of all this was to emerge a new group of artists, the Nabis (the Hebrew word for prophets), who were to rationalize Gauguin's achievements.

While all these exciting developments were happening in Pont-Aven, Millie Pearson continued to wait here for the return of her fiancé Dow from the Îles de Raguènes. She had begun to grow impatient. In one of her letters home she claimed that it had rained throughout the past month of July and that in consequence all the town's artists had been reduced to 'wild despair', and 'most of the French artists are leaving'. She had acquired an intense dislike of cider, and sympathized with her compatriot, William Raught, who could not wait to get back to America so as to drink tea and coffee with his meals; unfortunately Raught had to stay in Pont-Aven because he had 'not money enough to live anywhere else'. She herself longed for champagne, but doubted whether she could persuade the locals to stock it. She and her

companions had other wishes: 'Mrs B. groans for baked beans more than anything else, but I sigh for ice-cream and lemonade—something good and cool is what I talk about.' She reckoned there was only one lemon available in the town and 'it would take a Vanderbilt to afford it'. To console herself, she bought some cherries—'here the people eat their stones and all'—and made a cherry pie; but it turned out to be 'only a poor apology for a pie'. At least she was improving her French: at table a rule had been instigated 'that for fifteen minutes no English shall be spoken'. Dow had written to her to say that he had done some of his best work ever in the islands, and she was greatly looking forward to seeing it. Apparently one of Dow's friends who had gone with him, 'Mr Wigand', had greatly improved his colour, 'but I don't suppose that he would give Mr Dow any credit for it—there is a great deal of healthful rivalry between them'. She imagined that as soon as Dow was satisfied with his Raguènes work, he would want to take it to Concarneau, 'for Harrison and some of the strong ones to criticize . . .'.

In Concarneau in the summer of 1888 life went on very much as before, undisturbed by any ripples of artistic innovation. Simmons and Butler may have left, but Harrison, Hoeber, and 'Shorty' were all back, this time each having a studio in perhaps the same wheat loft where Hamor, Staunton, and Douglas had had their adventures in *Guenn*. One of the newcomers in town this year was an American student from the Académie Julian, Cecilia Beaux. The main reason for her wanting to work in Concarneau was the presence here of Harrison and 'Shorty', both of whom she had met in Paris in the winter. She came with a woman painter friend. On the train journey from Paris, a large, strong woman had entered their compartment just before Concarneau. This turned out to be Julia Guillou, whose reputation was well known to them, and whose 'generous personality instantly forged a strong link of promise for our summer'. They arrived at their destination: 'Of course, we drove at once to Les Voyageurs, with which we were already acquainted in a novel *Guenn*, then at the height of its popularity. The famous Madame came out to greet us. As per my letter, "She is a beauty, and exactly like the description . . .".' They stayed at the hotel long enough to savour the warmth of the atmosphere and the generous portions of good food; they found everything here worthy of a picture despite 'the thoroughly bourgeois appointment of the dining-room, where no

62 Cecilia Beaux, *Study for 'Twilight Confidences': Two Breton Women, Concarneau,* 1888. Pennsylvania Academy of the Fine Arts, Philadelphia

trace of primitive beauty could be seen, outside Madame and the servants.' Soon, however, they took up lodgings in a small house on the outside of the town. They were slightly disappointed with their landlady, Madame Valdinaire, who lacked both personality, and, worse still, a *coiffe*. Another frustration for Beaux was her inability to get a most beautiful girl whom she saw several times passing outside her window to pose for her. She approached the girl's parents, who were known to Madame Valdinaire, but was met with monosyllables. After this it suddenly dawned on her that the locals 'did not really like *les artistes*'. She started some canvases on the beach, but, knowing Harrison's reputation for daringly painting the nude out of doors, was disappointed not to come across any naked models posing there; in any case she did not understand how it would have been possible, 'for there are signs up everywhere that it is *défendu* to *se baigner sans être*

convenablement vetu'. Instead of finding nudes on the beach, she found only 'horrid little Breton girls' pestering her for money.

When the summer was well advanced Beaux moved into a vacated studio in the loft where Harrison, Hoeber, and 'Shorty' worked. She had found Harrison at first to be 'blasé and cold', but was by this stage completely enamoured of him. There was one exciting moment for her when there was a knock on her studio door, and instead of the model whe was expecting, in came Harrison: 'Oh I thought you were my model,' she said; 'No,' he replied, 'but I will be your model some day—that is if you want me.' She was amused by the contrast between Harrison's 'long, thin, aristocratic proportions' and those of 'Shorty' ('you don't think I call him this to his face'). 'Shorty' was an unending source of amusement to her: 'As usual I always have to say—if *you only* could see Shorty— sitting on a low strip of wood that goes round the studio—in his long jersey and fat—taking off a big fat man at the hotel . . .' However, while Harrison rarely criticized her work, 'Shorty' was rather too generous with his opinions, most of which were generally rather negative: once he told her that she had 'bit off more than [she] could chew', an expression which she had never heard before and found picturesque. She also wrote: 'You never saw anything as scientific as Mr Lasar. It is splendid for a teacher but I'm afraid it will be the ruin of him as a painter.'

In her letters home and autobiography, Beaux dwelt at length on the entertainments she and her colleagues enjoyed at Concarneau. On one occasion Harrison and Hoeber gave a fancy dress party in their studio. There was no music or dancing, but, for Beaux at least, the occasion was a great success. She came dressed up as a tube of Rose Dorée, her favourite oil colour, while her woman friend, May, disguised herself as a palette. Harrison acted 'a big coloured woman—Mrs Johnson' to Hoeber's 'Mr Johnson, a coloured gentleman in a dress suit'. The former stuffed himself out with a pillow and wore a turban, a red plaid gingham waistcoat, a blue petticoat, and white drawers edged with broad lace: 'Oh it was too overwhelmingly funny and beggars description, especially when [one] knows his usual style and presence.'

Unlike Pont-Aven in 1883, there were no celebrations for the 'Glorious Fourth', but there were of course those for what Beaux considered the French equivalent, the Fourteenth of July. In the afternoon all the guests in the town's hotels congregated in the main square to watch a group of Bretons dancing around a

greased pole to the sound of bagpipes: 'such a queer rhythmic dance—little more than walking about but with a clap all the time.' The madame of the Voyageurs had arranged for a large number of extra tables and benches to be placed in the square, and here, after an early supper, Harrison and his associates all sat, admiring the candles and Japanese lanterns which she had had placed on all the neighbouring houses. Soon they all wandered down to the old town, where there was more Breton dancing in the Market Hall. They found the bagpipe music and the clap of sabots to be infectious, and they suddenly all started dancing 'a ring around the roses' on the cobblestones outside. Afterwards they returned to the hotel for a 'real dance' in the salon. Among those who took part in this were Mrs George with her 'golden hair tumbling around her ears and down her back', and Louise Kinsella, the youngest of the company, who both in her features and dress reminded Beaux of the heroine of Millais's painting *A Huguenot*. The male artists, meanwhile, looked 'quite swell in their corduroy knickerbockers and gray tans', Harrison being the 'biggest and swellest of all—in every possible way'.

With the advance of the summer Beaux reported an invasion of bourgeoises into the Voyageurs, which threatened to crowd out the Americans. Then suddenly the season neared an end, and everyone, tourists and artists alike, started leaving. By the end of the autumn Beaux, Hoeber, and Harrison were among the few foreigners left in the town. Harrison boasted to Beaux that this was his favourite time of the year; later, however, he had to retract this statement, telling her that he had begun to feel lonely, and in a depressed mood had varnished out one of his paintings.

A few days before her own departure Beaux became 'quite prankish' and decided to have a supper party in her attic. A series of problems arose. Beaux had decided that the centrepiece of the dinner was to be a chicken salad, and her landlady, Madame Valdinaire, had offered to choose and cook the chicken. However, when the cooked chicken eventually turned up, Beaux realized that the meat was by no means going to be enough for her guests. In this moment of crisis, she decided she would bolster the salad with some veal and hoped that no one would notice the difference. She surreptitiously took herself to the one butcher in Concarneau, anxious lest one of her guests would see her. Just outside the shop she saw someone passing on the other side of the street. She breathed a sigh of relief. It was only Harrison, 'head in air as usual . . . only

thinking of the clouds and whether the sun would be out tomorrow at four-fifteen'. There was no chance of being noticed by him. Evening came, the guests were about to arrive, and then her fire went out. This was particularly unfortunate as she had intended to begin the meal with scrambled eggs and fried potatoes. In the ensuing chaos with the arrival of the guests, Harrison was firmly told to sit down and look at the newspapers, while Hoeber was asked to start up the fire and deal with the eggs. Beaux went downstairs to ask Madame Valdinaire if she could use her stove to fry the potatoes on. A sudden inspiration made her decide to cook the potatoes '*à la Lyonnaise*', for which dish an onion was needed. Madame Valdinaire claimed to have one, and she embarked on a lengthy search through a series of drawers which contained such distasteful objects as the remains of Monsieur Valdinaire's suspenders. The meal began, and Hoeber, in high spirits after having triumphantly succeeded with the fire and eggs, started crawling under the table saying that he was looking for the butter. 'Such,' concluded Beaux, 'are the feasts of Bohemia.' The season at Concarneau was a turning point in Beaux's life. It persuaded her to persevere in her art and to break an engagement with a Philadelphia man. She was later to become a wealthy society portraitist, working in a virtuoso style rather similar to that of Sargent.

Gauguin's autumn in 1888 had been rather more troubled than Beaux's. Ever since arriving in Pont-Aven in February he had kept up a correspondence with his new friend, van Gogh, who was urging him to come and stay with him in Arles in Provence. Perhaps as a result of hearing reports about Pont-Aven, van Gogh was anxious that a similar community of artists should be set up in the south of France, to where he himself had just moved and which was not as yet very popular with artists. Gauguin went to Arles in October, and soon witnessed the Dutch artist's decline into insanity; he left in December after van Gogh had threatened him with a razor-blade and then cut off his own ear. Back in Paris by the end of 1888, Gauguin planned an exhibition which would give greater publicity to what he and his circle had achieved in Pont-Aven during this last productive year; he intended to have a special pavilion in the grounds of the International Exhibition which was to be held in the spring of 1889. This proved impossible and Gauguin returned to Pont-Aven in April. He immediately went back to Paris after Schuffenecker had suggested that he and their circle could show their

work in a café which was very near the International Exhibition site. In May the Café Volpini announced an exhibition of the *Groupe Impressioniste et Synthétiste*. The conditions for display were crude, and the show was a commercial failure and attracted only a negative critical response. Gauguin retreated to Pont-Aven in a state of deep depression. When Bernard wrote from Paris to tell him that the exhibition had even caused anger among the Impressionist old guard, he wrote back: 'your letter reaches me in a countryside which is at present equally mournful'.

This year at Pont-Aven he rented as a studio the manor-house of Lezaven, the very same place where many years back Wylie, Bridgman, and others had painted, thanks to the generosity of the notary Tanguy. Here Gauguin executed two of his best-known Pont-Aven works, the *Yellow Christ* (fig. 63) and the *Belle Angèle*. The former was inspired by a yellowing wooden crucifix in the chapel of Trémalo. The second painting was a portrait of Madame Satre, who lived next door to Gloanec's. Gauguin had refused to show the sitter the work while he was engaged on it, but had intended to give it to her afterwards. When she eventually saw the portrait, she exclaimed '*Quelle horreur*', and refused to accept it. Her husband was not too pleased with the work either, interpreting the ugly primitive mask placed next to his wife as an allusion to himself. The summer once again brought to Pont-Aven a large number of Gauguin's admirers, including Meyer de Haan, the son of a wealthy Dutch industrialist, and Sérusier, who had seen the Café Volpini exhibition and told Gauguin: 'I have imbibed the poison. I'm with you from now on.' Yet Gauguin soon began to feel thoroughly dissatisfied with Pont-Aven, finding it this year 'full of an abominable crowd'. By September Gauguin, Sérusier, de Haan and others in their circle moved on to a nearby fishing hamlet, Le Pouldu, where they put up at an inn run by Marie Poupée. Unlike Gloanec's, they had this place almost entirely to themselves, and were allowed a free hand in decorating it. They remained here until the end of the year.

One wonders what Clement Swift, who had become disillusioned with Pont-Aven by the beginning of the 1880s, would have thought of the place at the end of the decade. By this date a new hotel had opened up on the main square, the Hôtel de Bretagne, which had a café attached to it called the Café des Arts. Meanwhile Julia's establishment had become so popular that in 1889 it acquired an enormous adjacent building (now the Hôtel de Ville); before long, Julia would begin

advertising her hotel in England, offering sketching excursions, French conversations, and so on for prospective 'young lady students'. The Gloanec empire was also rapidly expanding, and soon Madame Gloanec's son would take over the Lion d'Or and convert and enlarge it into the Hôtel Gloanec (later Gallicized to Glouannec).

It was not simply the growing number of tourists, academic painters, and finishing-school girls who were destroying the peace of Pont-Aven. It was also the town's reputation, which Gauguin had so greatly helped to promote, of being a place where all manner of eccentricities could flourish. Large numbers of exhibitionists were thus encouraged to come here, all of them desperately anxious to draw attention to themselves and their art by resorting to ever more absurd gimmicks. Mortimer Menpès, who had first come to Pont-Aven in the early 1880s, was a witness to the place's transformation in the second half of the decade. Admittedly he found the increasingly competitive atmosphere of the town rather stimu-

63 Paul Gauguin, *The Yellow Christ*, 1889. Albright-Knox Art Gallery, Buffalo

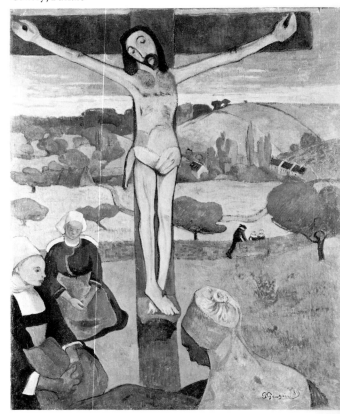

lating for a 'timid young artist'. It was with affection and not contempt that in 1899, in an article for the magazine *Mainly About People,* he was to write of the innumerable eccentrics that by the late 1880s had come to populate this 'amazing nest of French and American painters'. Menpès described one man who would never start a painting until he had drunk three glasses of absinthe and bathed his face in ether, another who was working on a series of merry-go-rounds 'over which Paris would go crazy', and others 'who had a theory that you must ruin your digestion before you could do a masterpiece'. In addition to such idiosyncratic artists there were representatives of all the then fashionable Parisian art movements: Menpès referred to the 'Stripists', the 'Spottists' ('a branch of the Dottists, whose difference from the latter was too subtle for my comprehension'), and the 'Primitives', who apparently were identified by 'a walking stick carved by a New Zealand Maori'.

In the International Exhibition in Paris in 1889, where Gauguin had been unable to show, Harrison was awarded a gold medal and the Légion d'honneur. In this same exhibition Dow won an honourable mention for a painting, *Au Soir,* which had been executed under Harrison's supervision at Concarneau, to where Dow and his fiancée had moved after his return from the Îles de Raguènes. A reputation established and a marriage in sight, it was now time for Dow to go back to America, where he was soon to enjoy a successful career as a landscapist and art teacher (Georgia O'Keeffe was one of his many well-known pupils). Shortly after his return to his native Ipswich, Massachusetts, late in 1889, he reported to a friend on what the summer that year had been reputedly like in Brittany: 'Pont-Aven was crowded while Concarneau was empty—a crowd of *nouveaux* went to the latter place waiting for Harrison, but he went to Algeria, and the disgusted *nouveaux* shook off the smells of Concarneau and fled.' One of the *nouveaux* that year had been Robert Henri, who was later to achieve fame as a leading member of the group of American realist painters known as the 'Ash-Can School'. Henri stayed in Concarneau long enough to have a glimpse of the girl who was known to have been the model for Guenn: 'We saw her on the beach walking along quite as naturally as if she had never drowned herself there for love. She passed with her sister Jeanne and her husband—a good-looking young fellow. Was she a beauty? Well, I didn't fall in love with her at first sight, but she was very good looking. Grown rather plump. Others saw

her and say they think her one of the prettiest women they have seen here. She didn't look very sentimental or book-like, but looked very much as any contented, good-looking young Brittany wife might.'

Gauguin and his friends stayed on in Le Pouldu until the end of 1889, and returned there in the summer of the following year. Émile Bernard, who had been prevented by his parents from joining them in Le Pouldu in 1889, spent the summer of 1890 on his own in Pont-Aven. Difficulties between his family and Gauguin had been caused by the latter's attitude towards his sister Madeleine. Disturbed by Madeleine's affection for Laval, Gauguin had written to her urging that she should become an '*androgyne sans sexe*', and not yield to earthly passions; this letter had been intercepted by Madeleine's father, who had told her to have nothing more to do with Gauguin. Madeleine was later to marry Laval just as he was dying of tuberculosis; she then contracted the illness herself and soon followed him to the grave. Gauguin never forgave Laval for taking Madeleine away from him. In 1890 he continued to be friendly towards Émile, but early the next year in Paris was to break completely with him as a result of Émile's complaining about not having received enough credit for Gauguin's development as a 'syntheticist' and 'symbolist'. In the spring of 1890 Gauguin left on his first trip to Tahiti, where he was to remain until 1894.

In the summer of 1891 Paul Signac, an artist whom Menpès would have classified either as a 'Dottist' or 'Spottist', paid a brief visit to Pont-Aven. Both Signac and his mentor Seurat were artists whom Gauguin had once scathingly referred to as 'those chemists with their little dots'. It might thus have been with a certain satisfaction that Signac was able to report on the awfulness of a place where Gauguin and his followers had once based themselves: 'Yesterday I was at Pont-Aven. It's a ridiculous countryside with little nooks and cascades, as if made for female English watercolourists. What a strange cradle for pictorial symbolism. Everywhere painters in velvet garments, drunk and bawdy. The tobacco merchant has a sign in the form of a palette: Artist's Materials [in English], the maidservants in the inn wear arty ribbons in their headdresses and are probably syphilitic.'

Gauguin returned reluctantly to Pont-Aven in the spring of 1894 and put up at the Hôtel Gloanec (the former Lion d'Or). He had intended to stay at Le Pouldu, but had found Marie Poupée's inn closed down and the owner herself become hostile to him, even refusing to hand over paintings which he had

entrusted to her care. At Pont-Aven this year he made two new friends, Armand Séguin and Roderick O'Conor. The former was a timid man whom Gauguin on one occasion supposedly forced at gunpoint to use colours straight from the tube. The latter made an ideal drinking companion and someone to whom Gauguin could confide his favourite position in sexual intercourse: he was an extremely original Irish 'Stripist' who later in life was to slip into obscurity in Paris, and, in the guise of Clutton, be portrayed as the failed artist in Somerset Maugham's *Of Human Bondage*.

Both Séguin and O'Conor accompanied Gauguin on a day trip to Concarneau in May. Also in the party was Séguin's wife, Gauguin's Javanese mistress Annah, and a parrot. This group must have made a strange sight, and as they walked along the quay, some small boys threw pebbles at them. Séguin grabbed one of the boys by the ears. Unfortunately he happened to pick on the son of a sailor standing nearby, the pilot Sauban, who responded by punching Séguin. Séguin's bravery was not up to confronting a person like this, and he jumped into the harbour to escape. Gauguin now joined in, hitting Sauban himself, but soon finding three other sailors on top of him. The fight ended with a broken ankle for Gauguin and a cracked rib for Madame Séguin, who had presumably made an ill-judged attempt to intervene. Gauguin recuperated at Gloanec's, during which time Annah ran off to Paris and ransacked his studio there. Returning himself to Paris in November, Gauguin made plans for what was to be his final trip to Tahiti.

Gauguin's fight at Concarneau was perhaps the most dramatic incident in the later artistic history of the place. Artists continued to come here in the summer, including Harrison, who, as an ever more pompous and conceited member of the American artist community in Paris, lived to see his reputation fade. The one full-time member of the artist colony here was Charles Fromuth, a Philadelphia man who had first come here in 1889 and remained until his death in 1937. He never acquired much of a reputation in America, but his highly competent pastels, with their interesting Japanese-like compositions, were admired by Rodin and the leading Norwegian painter Frits Thaulow. Fromuth had missed Gauguin's famous fight of 1894 (he had been in Paris at the time) but in 1901 was himself able to attract the attention of sailors on the quay by bringing here Rodin and Thaulow, both of whom were proudly wearing the insignia of the Légion d'honneur. Yet apart from

moments such as these, Concarneau was hardly the bustling colony which it had been in the 1880s. The English painter Nina Hamnett visited the place in 1923 and was depressed to find on the quay 'about fifty old ladies and gentlemen with easels, all painting boats'. Today few in the town are aware that artists have ever been here.

Finistère remained very popular with artists throughout the 1890s, and through the works of such French academic painters as Charles-François Cottet, Lucien Simon, and Louis Latouche, a vogue for Breton subject-matter was maintained in the Paris salons. However, outside France during this period, there was a waning interest in scenes of Breton peasants and fishermen, and by the beginning of the twentieth century a reaction against such subject-matter occurred in France as well.

With Gauguin's final departure for Tahiti in 1895, most of his followers dispersed. During Gauguin's first visit there, a number of them, including Jan Verkade, Charles Filiger, and Maxime Maufra had continued to

64 Roderick O'Conor, *Breton Peasant Knitting,* 1893. Private Collection

65 The harbour at Concarneau, 1896, scene of Gauguin's fight with the sailors

stay together in Le Pouldu, and indeed had even been able to witness the arrival there of the first American artists (all of whom put up at the hamlet's rival inn, Père Goulven's). Subsequently, at least three of Gauguin's followers emulated their master's retreat from the world: Sérusier went to live on his own in the village of Châteauneuf-du-Faou in the heart of Brittany's Black Mountains, and both Filiger and Verkade took themselves to the monastery of Beuron in Germany. Bernard enjoyed great success in Paris, but after his precocious beginnings had by now lost his direction as an artist. Only one of Gauguin's followers, Émile Jourdain, remained in Pont-Aven, and indeed did so for the rest of his increasingly depressing life. Jourdain had arrived in Pont-Aven in 1886, one month before Gauguin. Although from a wealthy background, he soon spent his inheritance, and in 1907 he and his family were evicted from their house. Neighbours took pity on them and allowed them to live in a nearby attic. Six years later his wife abandoned him, going off to Brest with her four children to try and make a living there. Jourdain died in 1931 in abject circumstances.

At least one artist in the twentieth century spent a crucial period of his youth in Pont-Aven. This was the English Expressionist painter Matthew Smith, who wrote of his first stay in Pont-Aven in 1908–9, 'my life began; my mind began to open up'. His shyness and social awkwardness prevented him from making any contact with the painters around him. However, at this date it is unlikely that there was anyone in the

colony of comparable talents. By 1923, according to Nina Hamnett, the place was mainly filled with 'really terrible English colonels and their wives and daughters'. The last well-known artist to work in Pont-Aven was probably the Fauve Maurice Vlaminck, who used to come here regularly in the early 1950s, at a time when he was well advanced in his artistic senility. He shared the town then with only a handful of other painters, one of whom was a young Swede, Evert Lindfors, then straight out of art school in Paris. Looking for a studio in Pont-Aven, Lindfors was offered a ramshackle manor on the outskirts of the town. This turned out to be none other than Lezaven, the interior of which then seems to have been as untouched by time as it had been when Wylie and his American friends had made their first reconnoitre here in 1866. Among the debris of paintbrushes and other objects lying around in the building, Lindfors wishfully imagined he found belongings of Gauguin. Today Lezaven still remains quiet and little visited, with no indication of how famous a studio it had once been. Elsewhere in Pont-Aven, however, Gauguin and his followers are fully commemorated. A plaque to them marks the site of the former Pension Gloanec in what is now the Place Gauguin; and until very recently there was an ungainly board in the Bois d'Amour with the inscription: 'Devant vous le site qui a inspiré Sérusier pour le tableau dit le Talisman.' It is these artists who are referred to as the 'Pont-Aven School', rather than the innumerable artists from America, Britain, and elsewhere who came here long before them. The day when the town's once cobble-stoned streets were lined with American flags is a curious but now forgotten moment of history.

The colony at Pont-Aven can be seen in many ways as the successor to that at Barbizon. It assumed an enormous importance at a time when the latter was largely living off its past reputation. Moreover it represented a stage further in the development of the 'primitive' ideal, leading Gauguin and a number of other artists to escape completely from the contemporary world. The search for the 'primitive' was also to be continued in the innumerable colonies that had been set up outside France by the early 1880s, several of which were to remain lively centres of artistic activity long after Pont-Aven itself had begun to decline. Yet in studying these later colonies, it is not so much a question of assessing differences in geographical location but rather of tracing the effects upon artists of advancing age and the consequent fading of ideals.

4
The Blue Hour

SKAGEN (DENMARK)

THE LARGE presence of Scandinavian artists in France in the 1870s and 1880s, and in particular in Paris and Grez-sur-Loing, signified an important change of direction in Scandinavian art. In the first half of the nineteenth century, these artists had mainly been trained in Germany, above all in the Düsseldorf Academy, which specialized in history painting. With the growing importance of landscape and *plein air* painting, and the widespread reaction against conventional academic training, France came to be increasingly favoured by artists. In the case of Denmark, there were also strong political reasons for artists to switch their allegiance in this way: towards the middle of the century relations between the German Confederation and Denmark were rapidly deteriorating, and in 1864 Bismarck's armies invaded Denmark, leading to the treaty whereby Denmark lost Schleswig Holstein. When this happened the Swedish king, Karl XV, who was himself a painter, called on the artists of his country to break off all contacts with Germany, and to study instead in Paris, where his mother's second cousin, Napoleon III, was Emperor.

As with the American and British artists in France in the second half of the nineteenth century, those from Scandinavia took at first only an extremely limited interest in the Impressionists, and instead came inevitably to admire Bastien-Lepage. None the less, in their own way, they represented a generation of artists in revolt. This became especially apparent on their return from France. The first half of the 1880s was marked by a series of conflicts throughout Scandinavia between largely French-trained artists and the principal academic and exhibiting institutions in their countries, many of which continued to favour German-

inspired art. The former began to found alternative establishments: thus in Denmark the Free School, later to be called the Artists' Study School, rose up in opposition to Copenhagen's Royal Academy of Fine Arts; and in Finland the Artists' Association developed as an alternative to the conventional Fine Arts Association.

The antagonism between such bodies was especially strong in Norway and Sweden. In Norway, where there was then no Academy of Fine Arts, the art world centred up till the 1880s around a number of privately owned art societies, most notably the Christiania Art Association (Oslo was called Christiania from 1624 to 1925). The latter patronized German rather than Norwegian artists, and the few Norwegians whose works they did buy were invariably those who had been trained in Germany. Matters came to a head in 1880 with the refusal of an otherwise admired painting by a young French-trained Norwegian artist, Nils Gustav Wentzel. Another Norwegian painter, Erik Werenskiold, who moreover was one of the first Scandinavians to write sympathetically about the Impressionists, wrote to a Christiania newspaper about the bitter feelings that had been caused generally among painters by the rejection of Wentzel's canvas: 'This is the same bitterness which makes those who live at home only long to get out, while those who are abroad pray to God to deliver them from ever having to live here at home.' He later suggested a new system which the Association could adopt when selecting its purchases. When his proposals were turned down, a large number of artists went on strike. In 1882 the Association finally capitulated, and at the same time there was born an alternative exhibiting body (which organized what were initially called the

Autumn Exhibitions), which was run by the State, but was also sympathetic to young artists.

In Sweden, the very favourable atmosphere towards artists which had existed in Karl XV's reign changed considerably for the worse under his unsophisticated successor Oscar II. Many of the young artists who found themselves in France in the 1870s and the early 1880s, such as the Grez artist Carl Larsson, found it at first much better to stay here than to return to their bleak and now strongly philistine country. Yet by the mid-1880s these by now homesick artists had determined to go home and fight for improved conditions for themselves. Their struggle was directed principally against Stockholm's Royal Academy of Fine Arts, which had just acquired a very reactionary director,

and also controlled both Stockholm's National Museum and the main exhibiting society in this city, the Stockholm Art Association. In April 1885 the French-trained Swedes opened in Stockholm what was to be an extremely successful exhibition called 'From the Banks of the Seine'; in 1886 they formed themselves into the Swedish Artists' Union.

Just prior to returning to Sweden from Grez, Larsson had written: 'Why in the name of turquoise not paint Swedish landscapes direct in Sweden?' This sentiment typified the spirit of nationalism that by now had become very strong in all the Scandinavian countries. All these countries felt threatened in some way. Denmark, with the loss of Norway to Sweden in 1814 and then of Schleswig Holstein to Germany in

66 Christian Skredsvig, *The Son of Man* (set in the village of Fleskum), 1891. Nasjonalgalleriet, Oslo

1864, was much smaller than it had been for much of its history. Norway desperately wanted independence from Sweden, which in turn was suffering both from having ceded Finland to Russia in 1809, and from losing an ever-growing number of its working population to America. Finland, meanwhile, which is geographically not part of Scandinavia but which had been under Swedish rule for many centuries, was as unhappy about the continuing domination of Swedish language and culture as about being annexed to Russia.

Allied with their obsession with the *plein air* realism of Bastien-Lepage, many of the new generation of Scandinavian artists were interested generally in the representation of the rural poor. Moreover it was in the more backward parts of their countries, where folk traditions had been best preserved, that artists and intellectuals hoped that the seeds would be sown of a national revival. Their passionate concern with their folk cultures was reflected not only in the subject-matter of much Scandinavian art, but also in the adoption of indigenous peasant styles of architecture for studios and other buildings, the collecting of traditional craftware, and the creation, in such places as Skansen in Sweden, of among the first museums in Europe in which a variety of peasant buildings were brought together in an open-air setting.

It would of course be misleading to suggest that the young rebellious artists of this period represented a united front. A number of the more extreme radicals, those whose sympathies had been unhesitatingly with the politics of the Paris Commune, saw the inherent conservatism of adopting a strongly nationalistic outlook. They found distasteful the sentimental, moralizing attitude towards the rural poor shown by so many of their compatriots, and were more genuinely concerned with the economic conditions of the working classes. In Norway there was formed a very radical and controversial group calling themselves the Christiania Bohemians. Its leaders were the poet Hans Jaeger and the painter and writer Christian Krohg; among its younger members were the latter's most famous pupil, the painter Edvard Munch. In his then scandalous book, *From the Christiania Bohemia* (1886), Jaeger wrote down a list of the 'Bohemians' Commandments', one of which was, 'Thou shalt hate and despise all peasants; for example Bjørnstjerne Bjørnson . . .' Bjørnson ranked alongside Ibsen as Norway's leading writer of this period, and like Ibsen took up the cause of realistic drama. He was also an extreme nationalist, and one of those whose righteous

tone in advocating the peasant life offended the Bohemians. The latters' anarchistic views extended to an attack on all conventional notions of morality. Another of the Commandments was, 'Thou shalt sever they family roots'. This, combined with the Bohemians' pleas for sexual liberation, was also offensive to Bjørnson, who responded to Jaeger's book by writing a play defending family life called *The Glove*. The leading painter who was opposed to the Bohemians, and in sympathy with the so-called 'Romantic Nationalism' of Bjørnson, was Erik Werenskiold; his liberal stance in other matters, just like Bjørnson's, only serves to underline the complexities and contradictions of this period of Scandinavian cultural history.

One of the most complex and important intellectual figures of this time was the Danish literary critic Georg Brandes, who is perhaps best known outside Scandinavia for his writings on Ibsen. Politically, Brandes was in sympathy with the extreme left in Denmark, among whose active members were his brother Edvard, and Viggo Hørup. These were in opposition not only to the autocratic government of J.B.S. Estrup, but also to the moderate left, whose sympathies were with those of the poet, theologian, and educationalist N. F. S. Grundtvig, who earlier in the century had combined a liberal outlook—which had led to the foundation in Denmark of an enlightened 'high school' system, intended to spread education across a broader section of the population—with strong patriotism and deep-rooted Christianity. Georg Brandes encouraged a much more international outlook among the Danes, and introduced to the Danish public some of the most original figures in modern European literature, in particular realists such as Zola, Guy de Maupassant, and the Goncourt brothers. At about the same time as Jaeger was under attack for *From the Christiania Bohemia*, Brandes found himself at the centre of a controversy resulting from an article he wrote calling for more open information on sex, and attacking the sexual asceticicism of unmarried women as being a 'miserable thing, an unnatural thing, a sacrifice that is often made to a worthless prejudice'. A believer in his youth in the proto-existentialist views of his famous compatriot, Kierkegaard, Brandes came in later life to be a supporter of the German philosopher Nietzsche, whose writings he helped make well known throughout Scandinavia. He was in complete agreement with what he described as Nietzsche's 'profound disgust with democratic mediocrity'; however, he was

strongly critical of the German's indifference to the struggle of women and the sufferings of the masses.

Some understanding of the cultural and intellectual make-up of Scandinavia at this time is essential for an understanding of the formation of the various artist colonies here. Of course, as with artist colonies generally, the primary impulse behind them was no more profound than the desire to paint in the open air. This desire among the Scandinavians was the most obvious expression of their advocacy of contemporary French art, as well as a symptom of the nostalgia which many of them felt for a period in their youth spent in a French colony such as Grez. The concept of '*plein-airisme*' had its advantages and disadvantages when applied to the portrayal of the Scandinavian landscape. The midnight sun during the summer months meant that painters could work for much longer periods out of doors; moreover the so-called 'blue hour', when, around 10 p.m., the low summer sun dissolves the atmosphere into a blue haze, resulted in some of the most distinctive and haunting Scandinavian paintings. However, the Scandinavian winters are longer, darker, and colder than anywhere else in Europe, making outdoor painting increasingly difficult from as early as mid-August onwards. A large number of landscapists here seem admittedly to have responded to these adverse conditions in a competitive spirit, titling some of their pictures by the temperature outside: the Finnish painter Victor Westerholm's work, *Minus 40° to Minus 37° Centigrade*, must surely have set a record.

Just to the south of Christiania, in the small town of Modum, the Norwegian painter Frits Thaulow established in the 1880s what was perhaps the first outdoors painting school in Scandinavia: he called this place the 'Plein-air Academy'. The brother-in-law of Gauguin, Thaulow was a great Francophile and, with Werenskiold, one of the first Scandinavian supporters of the Impressionists (in 1895 he was to invite Monet to hold an exhibition in Christiania); however, like Werenskiold, he himself never attained their freedom of colour and brushstroke. In the controversy in Norway between the Bohemians and 'Romantic Nationalists', Thaulow occupied a neutral position: his intentions at Modum were simply to teach landscape painting in the spontaneous realistic manner then so fashionable in France. In the summers of 1886 and 1887, Werenskiold and his followers, including Christian Skredsvig (who had been in Grez in 1882), Kitty Kielland (a friend and former student of L.-G. Pelouse at Cernay-la-Ville and in Brittany), Harriet Backer

(who had been taught for a brief period by Bastien-Lepage and visited Brittany with Kielland), and Eilif Petersen, gathered at the hamlet of Fleskum in between Modum and Christiania. All these artists were strongly nationalistic, and, as well as being interested in the portrayal of the Norwegian people, wanted to express the Norwegian spirit in their landscapes. Fleskum borders on the region of Norway known as Telemark, a then unspoilt and completely rural district which to these artists and other nationalists represented the spiritual heart of Norway.

A more long-lived colony was on Åland, the Finnish island halfway between Finland and Sweden. The main artist here was Victor Westerholm, who came to Åland in 1880. At first the artists devoted themselves to straightforward representations of landscape, but from the late 1880s onwards they were increasingly concerned with portraying the local people. The islanders were all Swedish-speaking, as were the artists who painted them. Åland came to have for the Swedish population of Finland a nationalistic importance similar to that of the inland region of Karelia for Finnish patriots such as the painter Albert Edelfelt and Axel-Gallen Kallela.

Sweden's most important colony was at Varberg, a small town on the Swedish coast just to the south of Göteborg. This was formed in 1892 by a group of artists—Richard Bergh, Karl Nordström, and Nils Kreuger—who had all been to Grez in the early 1880s. They all met again at Varberg as a direct result of their seeing earlier in 1892 an exhibition of Gauguin's works in Copenhagen. The main motif which they painted at Varberg was the sombre medieval fortress which dominated the harbour, a building which for them symbolized the inherent strength of Sweden; they rendered it in a greatly simplified and unnaturalistic style. In 1897 another small community of artists, most notably Bjørn Ahlgrensson, Gustaf Fjaestad, and Fritz Lindström, grew up around Lake Racken near Arvika in the inland Swedish province of Varmland. The work of this group represented a further development in the symbolical representation of the Scandinavian environment, and was also indicative of the growing morbid introspection of much Scandinavian art, suggesting in this case the effects on the mind of living in isolated rural surroundings.

By far the largest and most famous Scandinavian colony, and moreover the only one which attracted artists from all the Scandinavian countries, was at Skagen in Denmark. A remarkable number of the leading Scandinavian artists, writers, and musicians

67 Skagen, *c.*1880

came here at some stage in their careers, including Peder Severin Krøyer, Frits Thaulow, Christian Krohg, Christian Skredsvig, Eilif Petersen, Holger Drachman, Hans Jaeger, Georg Brandes, J.-F. Willumsen, Hugo Alfvén, and Carl Nielsen. Even Ibsen was once expected, although in the end he never made it. The colony at Skagen brings together so many of the different facets of the cultural and intellectual life of Scandinavia during this period and does this in what becomes from the early 1880s an ever more compelling narrative with very dramatic moments and an intensely sad ending.

Skagen is situated on a peninsula at the very tip of Jutland, the northernmost province of Denmark. The peninsula, known as the Skaw, is mostly flat and covered in heather, but interspersed with extensive sand dunes and recently planted woods. The land ends at a point called Grenen, where the North and Baltic seas meet dramatically along a definite line, with a noise which reminded Krohg of the constant roaring of cannon. Even today, and in the height of summer in what is now an exceptionally popular tourist resort, one can wander for miles along the white sandy beaches without meeting a single person.

Properly speaking, Skagen comprises two places. There is Gammel (or Old) Skagen, a tiny village on the slightly wilder northern shores of the Skaw, and Nye (or New) Skagen, now a small town, about a mile away on the opposite shore. The latter was where the artist colony was centred. Both places are in fact very old settlements, dating back to at least the fifteenth century. Today only one monument survives from their earlier days, and does so in a state which testifies to the difficulties of living on a sandy promontory. This is the so-called 'Buried Church' which is about a mile due south of Nye Skagen. Only the tower of this church peers out of the sand, a fact which inspired Hans Christian Andersen to write a story called 'Tale of the Dunes' about a man who lives underground in the lower half of the building. In reality there is no such lower half, for in the eighteenth century, when ever-shifting sands forced the church to cease functioning, it was all taken down, and only the tower rebuilt as a symbolical gesture and perhaps with a view to the tourist interest of today.

For most of the nineteenth century Skagen was little more than a cluster of small and extremely simple houses, some of which where originally thatched. There was not even a harbour. At this period the only trees in the wind-exposed neighbourhood were concentrated in a small wood, the 'Plantagen', on the southern end of Nye Skagen. This had been created by an enlightened mayor, J. C. Lund, who had built his own house in the middle of it. After he died in 1828, his house was used by those members of the district council who were reponsible for clearing the large sand drifts that were constantly being formed. The rest of the village population were mainly occupied with fishing. An additional and more profitable source of income was derived from the salvaging of the in-

numerable ships that were wrecked, particularly on the southern shore: in 1825 twenty-five ships were wrecked on this shore alone. A common subject for the Skagen artists to paint was that of fishermen lining up against the beach to watch a ship in difficulty. Their concern was less with the possibility of human lives being lost than whether or not the ship was carrying a wealthy cargo. There was great disappointment when a ship was found to be English, for this usually meant that she was carrying only coal.

Almost all the visitors to Skagen up to 1890, when the railway was built, had tales to tell about the difficulties in getting there. The nearest large town was Frederickshaven about twenty-two miles to the south. From there one could travel by mailcoach along the beach, on which the firmer sand was found preferable to the shifting soft sand which invariably blocked the main inland road. An alternative was to go by boat, although, as there was then no harbour at Skagen, the final stage of the journey had to be done by rowing boat; sometimes, when the tide was very low, fishermen were required to wade out and collect passengers on their backs.

The first important painter to work at Skagen was Mathias Rørbye, who came in 1833 and 1847. A number of artists worked here from this time onwards, although it was not until the 1870s that any real artistic community begun to be formed, and even then only a handful of artists remained outside the summer months. In August 1859 Hans Christian Andersen visited Skagen, and was later able to publicize the place through his 'Tale of the Dunes'. He put up at the village's only inn, which had been started in 1840 by Erik Brøndum and his wife Hedewig Møller. This family also owned the main village store. As a treat for the famous writer, Hedewig sent someone down to the shore to see if there was any freshly caught plaice. Andersen became impatient for his dinner, and greatly upset Hedewig, who took to her bed and gave birth to a girl, who was to be christened Anna. The unusual circumstances of the birth led Hedewig to believe that her daughter would become an artist.

In 1871 Holger Drachman came to Skagen, with his first wife, Vilhelmine. Drachman is today best known as Denmark's greatest poet of the late nineteenth century, although at this date he was also a competent marine artist. He was soon to describe Skagen as an 'El Dorado for artists', and was himself to become closely associated with the place, where he wrote some of his best poetry. He sympathized with Georg Brandes's social criticisms and pleas for a more internationally based Danish literature, yet he himself became increasingly romantic as a writer and an ever more fervent patriot. The subject of most of his Skagen poems was the lives of the local fishing population, which he implausibly depicted in terms of noble simplicity. His own life could hardly have differed more from this ideal, being filled with an endless succession of love affairs and nervous crises.

Drachman returned to Skagen in 1872, this time with both his wife and Frits Thaulow, who was also to become a regular visitor there. Later in the summer a painting pupil of Drachman arrived, Carl Locher. Locher had then hardly begun to paint, and was only to achieve maturity after spending a short period in France later in the 1870s; thereafter he was to be regarded as one of the leading Danish painters at Skagen. Among the other arrivals at about this time were two painting students from the Copenhagen Academy of Arts, the Dane Karl Madsen and the Norwegian Christian Skredsvig. The former subsequently worked as an art historian, becoming the first director of the Skagen Museum and writing the authoritative book on the Skagen artists; he was also to be one of the first Danes to take a sympathetic interest in the Impressionists.

Madsen's and Skredsvig's enthusiastic descriptions of Skagen encouraged a fellow student of theirs in Copenhagen, Michael Ancher, to come here in 1874. Ancher was to play a central role in the life of the colony, and, together with a later artist visitor here, Peder Severin Krøyer, was to be the artist whom the Danes today most closely associate with Skagen. He was in fact a very uneven painter, whose art has really only a provincial significance. He himself was hardly ever to leave Denmark, spending almost all his remaining life at Skagen after 1874. Essentially a figure painter, he was first to achieve a reputation for rather romanticized scenes of the fishermen's life.

To begin with, Ancher, like the other early painters at Skagen, had great difficulties in obtaining local models. Stories grew up that he had to persuade fishermen to come and pose for him, first by offering them beer, and then schnapps. Eventually he found a very willing model in Lars Gaihede, who together with other members of his family, was to be painted by many of the early Skagen artists. Gaihede, an enormous ugly man with a big toe reputedly as large as a fist, lived in a squalid house where chickens would lay eggs in the bed and whose walls were so full of holes that passing fishermen in the morning could rouse the owner from his sleep simply by putting a

hand through one of the holes and grabbing his toe. After the first painting session with Gaihede, Ancher and an artist friend found that they were itching all over, and on removing their shirts discovered themselves to be covered with fleas. Thereafter they kept their distance from their model. Another model of Ancher's was an elderly blind imbecile known as Poor Christian, who had been denied confirmation in his youth because he was rumoured to have made a local girl pregnant; he lived just behind Gaihede's cottage, and, if the weather was good, spent his days pacing up and down outside his house, chewing tobacco and humming a mixture of jolly verses and funeral dirges.

When Ancher first came to Skagen, he found that the local inn, Brøndum's, had just burnt down, and he had been forced to stay, in rather cramped style, in a nearby house which had three guest rooms. The rebuilt Brøndum's, which was completed by the end of the year, was a less primitive place than the original inn, which had had a ship's deck incorporated into the interior, and a layer of sand on the floor which had impaired the balance of those, like Drachman, who had had too much to drink. The new building was long and low, and in grey brick; the growing popularity of Skagen was to consolidate the reputation of the establishment for being a place favourable to artists. Taking a great interest in the artistic life here, and closely observing the paintings and sketches that begun to be hung on the walls, was the young girl whose birth had been precipitated by Andersen's impatience, Anna Brøndum. As a result of encouragement from Drachman and Thaulow she went in the mid-1870s to the drawing school of Vilhelm Kyhn in Copenhagen, where she was to study until 1878. By the time Anna had taken up her studies here, two of her cousins, Martha and Henrietta Møller, had already acquired an interest in art, and had begun to receive instruction at Skagen under Karl Madsen.

In 1875 another Danish artist later to be intimately connected with the colony arrived at Skagen. This was Viggo Johansen, whose speciality was simple interior scenes in a seventeenth-century Dutch manner. The year 1875, however, was to be remembered for the visit to Skagen of a young Greek painter called Jean Altamura, who had been sent to Denmark by the Greek king to study marine painting. An extremely witty, charming, and handsome young man, he made a deep impression on everyone at Skagen during the one summer he spent there: as late as 1913, 1875 was to be known in Skagen as 'Altamura Year'. He seems to have enchanted Anna Brøndum, then back from

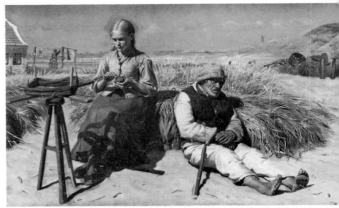

68 Michael Ancher, *Figures in a Landscape* (Tine Per Normands and 'Poor Christian'), 1880. Hirschsprungske Samling, Copenhagen

Copenhagen for the summer, and in doing so aroused the jealousy of Michael Ancher, who was especially upset when one day Anna tasted the young Greek's tea before giving it to him. Ancher need not have worried. In the following year Altamura was to return to Greece and die of tuberculosis. Anna was at any rate decidedly in love with Ancher, and, much to the amusement of her cousins, Martha and Henrietta, would secretly go and smell the painter's overcoat when it was left in the entrance hall of the inn.

Thaulow, now married, returned to Skagen in 1879, and through him his compatriot Christian Krohg came to the village later in the same summer. Krohg was among the most original artists and stimulating minds associated with Skagen. At his father's insistence he had originally trained as a lawyer, but in 1874 he had given this up to go with his friend Eilif Petersen to study painting in Karlsruhe. In 1875 he had been in Berlin, where he had met the German realist painters, Adolf Menzel, famous now above all for his rather sinister interior scenes of contemporary German life, and Max Liebermann, then just back from Barbizon. He had also had an influential meeting with Georg Brandes, who had introduced him to the writings of the Goncourts, and in particular to their grotesquely realistic novel of artist life set partly in Barbizon, *Manette Salamon*, which was always to remain one of Krohg's favourite books. He himself became an excellent writer and was always to combine painting with perceptive and socially committed journalism.

The day Krohg first came to Skagen, the tide was

very low, and a fisherman had the unenviable task of carrying the massively built painter to the shore. Thaulow immediately knew that his friend had arrived when a villager reported seeing a bald elderly man with a long white beard walking along the beach with Thaulow's wife. Krohg was in fact only twenty-seven. He soon became very enthusiastic about Skagen, and later wrote that it was the only place which he loved where he could return again and again without feeling any disappointment. Coming from the land of the mountains and fiords, he was pleased and fascinated to be in a countryside which was so flat. He also found the people here to be much more open, easygoing, and sociable than the Norwegians. He greatly liked Brøndum's, which he described as 'grand and elegant' and with a dining-room which was 'tastefully decorated with works of art'. The food here for him was delicious and abundant, including as it did as much fresh fish, oysters, and excellent game as one could wish for.

Shortly after arriving Krohg was able to witness the consequences of a shipwreck on the southern shore.

The rescue operation was not the dramatic affair with men heroically braving the elements which he had been led to expect after having read perhaps Drach-man's poetry. Instead the sun was shining, and the sea was calm. Most shipwrecks, commented Krohg, tended to happen in weather like this, as the captains would then become overconfident. On this occasion Krohg noted how everyone on board the wrecked ship calmly stood on top of the vessel waiting for some reaction from the shore. None of the fishermen standing there, however, seemed very keen on lending a hand. Eventually there was some discussion as how best to tackle the rescue operation. Krohg joined in this and made an uninformed suggestion about the use of the rescue boat, which appalled the fishermen. The chosen solution was to shoot a rope out to the ship from what Krohg mistook initially for a camera. Everyone was saved without any problem, and eventually retired to schnapps and bed at Brøndum's. The captain meanwhile was anxious that a representative of his company's insurance firm should arrive on the scene before the ship was completely destroyed. Krohg

69 Christian Krohg, *Port your Helm!* (Niels Gaihede), 1879. Nasjonalgalleriet, Oslo

70 Christian Krohg, *The Netmender* (Ane and Niels Gaihede), 1879. Nasjonalgalleriet, Oslo

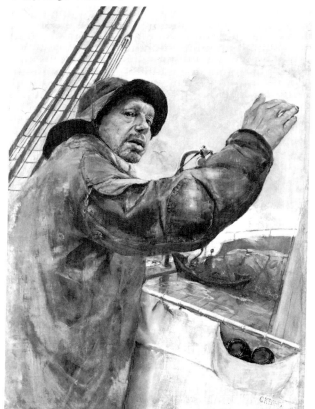

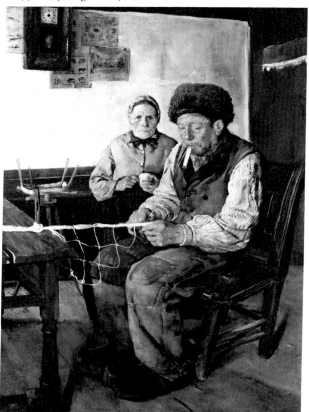

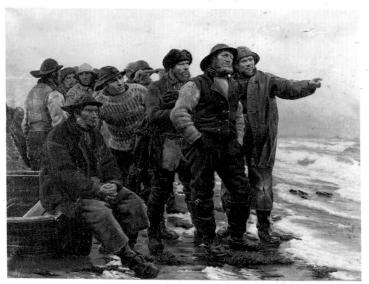

71 Michael Ancher, *Will She Clear the Point?*, 1879–80. Royal Collection, Copenhagen

soon lost interest in shipwrecks, as six more were to happen during his first two-month stay at Skagen.

During this same summer, Krohg was interested in painting a pilot of a fishing-boat out at sea, and asked Ancher if he knew of a suitable model. Ancher suggested Lars Gaihede's brother, Niels. Krohg was soon on friendly terms with everyone in the Gaihede family, and all the figure paintings which he executed on his first visits to Skagen were to feature members of it. After completing *Port your Helm!* (fig. 69), which shows Niels Gaihede in action, Krohg painted Niels in a more characteristic pose mending nets, with his wife looking sternly on: Niels, a more ponderous and slow-witted personality than his enormous brother Lars, seems to have spent most of his days engaged in this activity. Krohg's paintings of fishermen are, like his description of the shipwreck, matter-of-fact and unsentimental. His concern with the smallest detail is made evident in *The Netmender* (fig. 70) by his inclusion in the background of popular engravings of boats, animals, and Leonardo da Vinci's *Last Supper*.

Ancher's more dramatic and heroic approach to such subjects is illustrated in *Will She Clear the Point?* (fig. 71), which was exhibited with great success in Copenhagen in the spring of 1880, and was purchased by the Danish king Christian IX. Its success helped fully to establish Ancher as a painter, as well as to spread Skagen's reputation as an artist colony. In the summer of 1880 both Ancher and Johansen received awards of money from the Danish government, which encouraged them in their matrimonial plans.

In 1880 three important marriages took place in Skagen. In the spring Karl Madsen married Anna Brøndum's cousin, Henrietta Møller. On 12 August Johansen married the other cousin, Martha, settled in a house just to the west of the Plantagen, and thereafter used his wife as the constant model in his interior scenes. One week later in August Michael Ancher was married to Anna Brøndum, and together they moved into a long house in the garden of Brøndum's hotel: Lars Gaihede's reaction on seeing inside the house was to say that he had never seen anything so beautiful in the whole of Denmark. For the wedding Anna's teacher Vilhelm Kyhn had sent her a china dinner service, enclosing a note telling her that now she was to become a housewife it would be better if she were to throw all her painting equipment into the sea. Anna fortunately took no notice of this, and she later became one of Denmark's most popular women painters, specializing in ever more brightly coloured views of quiet domestic life. The marriage of three leading Skagen artists to three local girls who spoke the Jutland accent led to the artist community's being much more fully accepted by the villagers. But it was Anna Ancher who was to be the most important link between these different worlds, dividing her time equally between the two. She would spend her mornings painting, and her afternoons with her mother in the kitchen of the hotel, which was both a popular meeting-place for the village women and a place where the less fortunate among the villagers received free bowls of soup. In the evenings Anna would feature prominently in the artist gatherings in the hotel dining-room, where she would be joined by her equally popular brother Degn.

Peder Severin Krøyer, already by 1880 the only Danish artist since the neo-classical sculptor Thorvaldsen to have achieved an international reputation, was shortly to become part of the artist community. He had in fact been born in Norway and of a Norwegian mother. His birth had been the result of his mother's being raped by the director of a Stavanger mental hospital during one of her periodic stays in that institution. He had subsequently been fostered by his mother's childless sister, who was married to a distinguished Danish zoologist, Henrik Krøyer. In later life there was to be much rivalry between the two sisters as regards the upbringing of

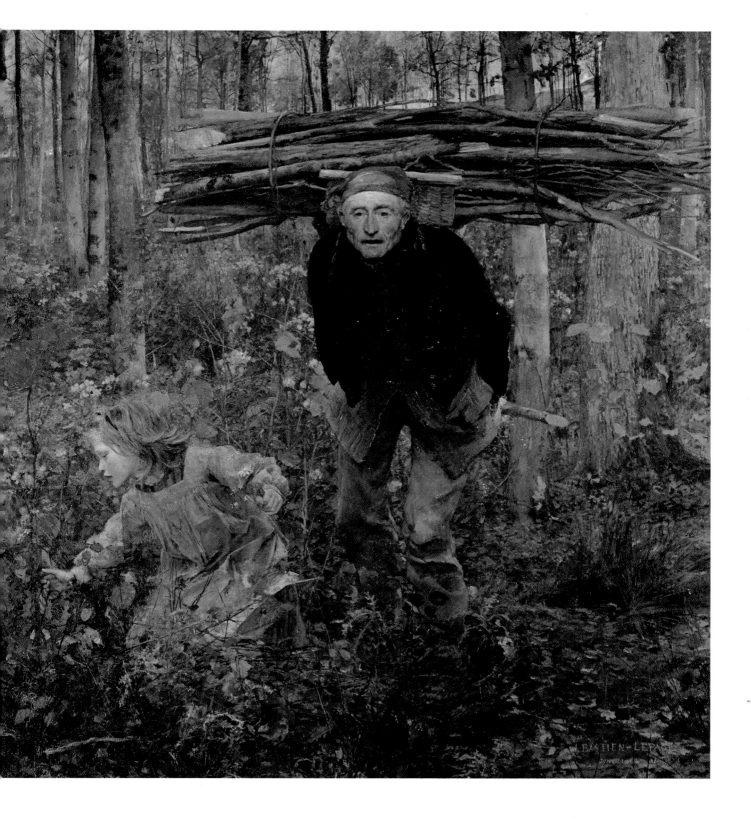

ABOVE: **Plate 2** P. S. Krøyer, *Summer Evening on the Southern Beach*, 1893. Skagen Museum, Denmark

RIGHT: **Plate 3** Carl Larsson, *The Old Man and the Nursery Garden*, 1883. Nationalmuseum, Stockholm

PREVIOUS PAGE: **Plate 1** Jules Bastien-Lepage, *Le Père Jacques*, 1882. Milwaukee Art Museum

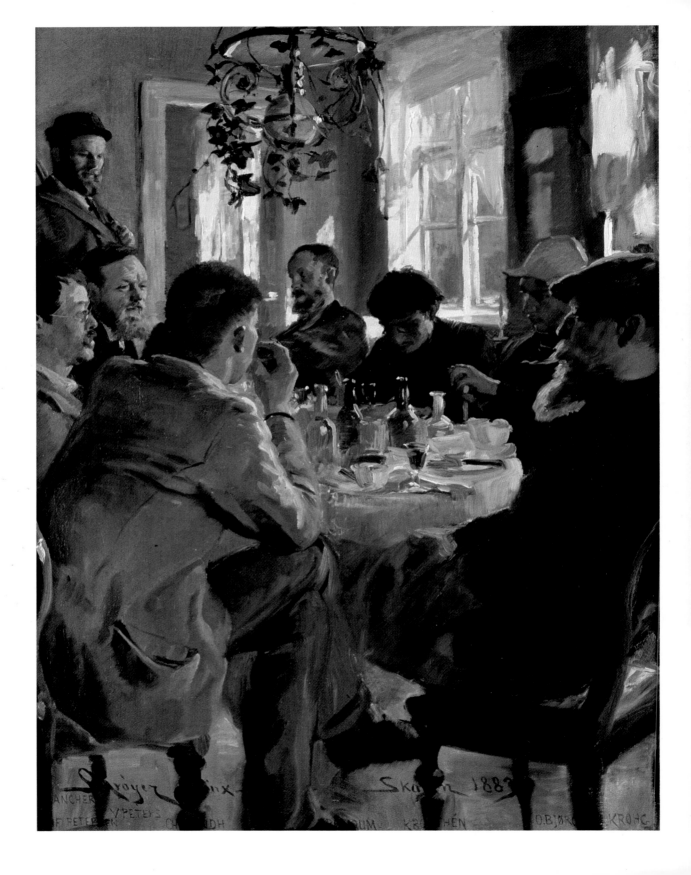

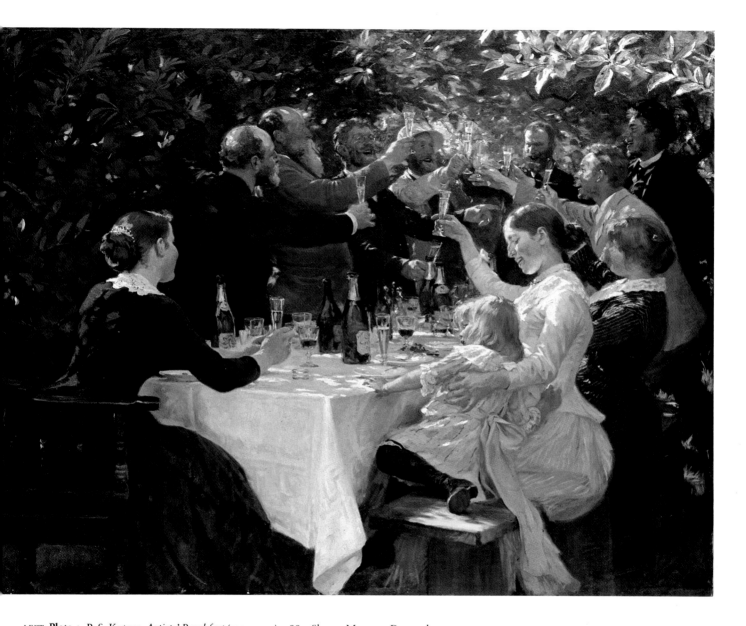

LEFT: **Plate 4** P. S. Krøyer, *Artists' Breakfast* (see p. 100), 1883. Skagen Museum, Denmark

ABOVE: **Plate 5** P. S. Krøyer, *Hip, Hip, Hurrah!* (see p. 104), 1884—8. Göteborgs Konstmuseum, Sweden

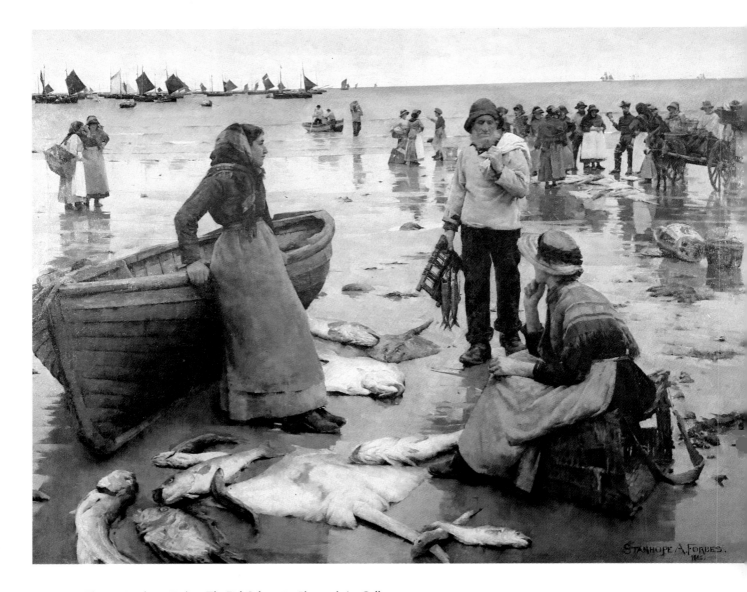

Plate 6 Stanhope Forbes, *The Fish Sale*, 1885. Plymouth Art Gallery

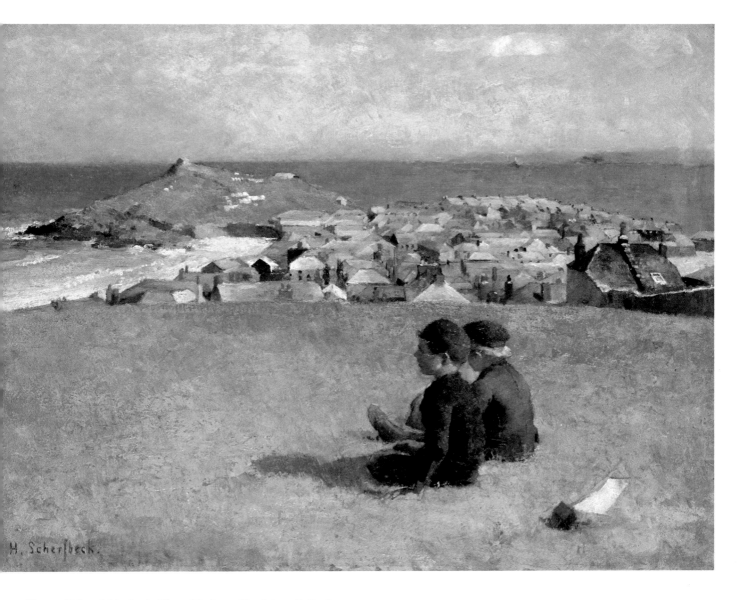

Plate 7 Helene Schjerfbeck, *View of St. Ives*, 1887. Private Collection

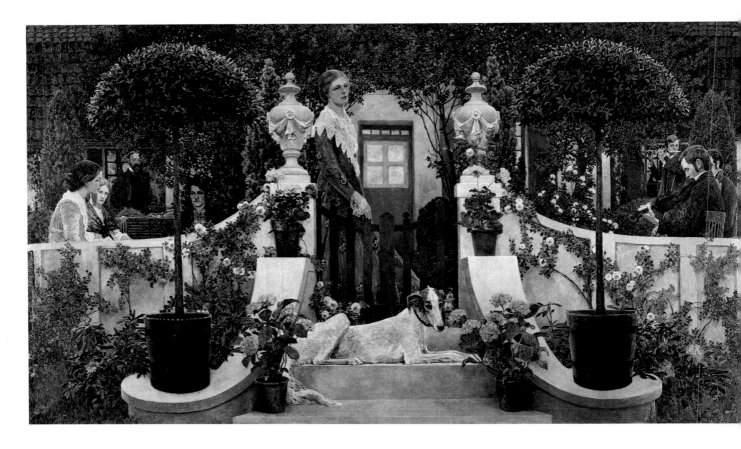

Plate 8 Heinrich Vogeler, *Summer Evening at the Barkenhoff* (see p. 128), 1904–5. Ludwig-Roselius Sammlung, Böttcherstrasse, Bremen

their 'son'. Although Krøyer had spent most of his childhood and early adolescence in Copenhagen with his aunt and uncle, the latter consistently refused to adopt him. He was not to be adopted until 1882 after the uncle had died and when he was already thirty. He would have to wait another seven years before receiving Danish citizenship.

Krøyer's inauspicious family life was partly compensated for by remarkable precocity as a painter. He had entered the Academy of Fine Arts in Copenhagen at the age of thirteen, and in the second half of the 1870s had spent long periods in France, Italy, and Spain, rapidly increasing his reputation as an artist and particularly as a portraitist. At Cernay-la-Ville, where he had spent the spring and early summer of 1879, he had befriended Pelouse and sketched R.A.M. Stevenson; later that year he had been briefly in Pont-Aven, and then Concarneau, where he had become acquainted with Alfred Guillou, the founder of this colony. Other friends from his days in France included the English painter Adrian Stokes, whom he may have met at Pont-Aven, and Alexander Harrison, who had been staying in 1879 at Grez, which was just a few miles from Cernay-la-Ville.

72 Anna and Michael Ancher in the doorway of the former grain-drying store of Brøndum's, 1880s

Christian Krohg had first met Krøyer at Göteborg in Sweden in 1877, when the latter was having a large exhibition of his works. Krohg's description of this meeting is very revealing about Krøyer's character, and hints at the tensions that would always underlie the surface of camaraderie and high jinks that formed such a component of life at Skagen during the 1880s. Krohg's first memory of Krøyer was of him seated in the middle of a group of admiring women whom he was entertaining by holding a table napkin as if it were a mandolin and 'strumming' on it while singing in his reputedly excellent voice, 'O Beatrice, O Beatrice'. Krøyer had later told Krohg that he had never liked the latter's paintings, but that despite this he could see that he and Krohg would become close friends. This, Krohg wrote, was in fact never to happen, although Krohg was never to lose his admiration for Krøyer's art. Krøyer's supremely confident mood at Göteborg had been buoyed by the success of the exhibition, which had received such favourable criticisms that Queen Louisa of Denmark had come over specially to see it. Krøyer had found her comments on art to be extremely ill-informed, and when dining with her at Göteborg had become so bored with talking to her that he had begun restlessly to drum his fingers against a wine bottle, a gesture of impatience which had lost him her support of his art. He had not really cared about this, as he had by then so many other influential patrons.

Krøyer had probably heard much about Skagen from acquaintances such as the painter and sculptor Laurits Tuxen (who had first come here in 1870), Drachman, and Madsen. But his decision to work there for the first time in the summer of 1882 had resulted from a chance encounter in an international exhibition in Vienna earlier in the year with Michael and Anna Ancher, then on their first trip abroad, who spoke enthusiastically about their home village.

Ancher was in fact not at all pleased when on 19 June Krøyer arrived at Brøndum's. In his diary entries for this time, he recorded his jealousy of the much fêted Danish painter, whom he thought would become much more of a centre of attention there than himself and attract too much outside interest in the village. Krøyer meanwhile was not immediately enthusiastic about Skagen because the weather then was terrible, and he hated his room at Brøndum's, describing it as extremely spartan, with an imitation oak dresser, the most tasteless floral wallpaper, and a mirror so pitted with green marks that on looking into it one thought one had the most awful disease. Fortunately he soon

was able to rent a neighbouring cottage, found for him by those of his admirers at Skagen who were very keen that he should remain. After a period of about two weeks of doing no work, as was his custom every time he first arrived at a place, Krøyer began to paint a large canvas showing fishermen at Brøndum's store, with Anna Ancher's brother Degn behind the counter. Michael Ancher was apparently furious that Krøyer had set up easel in the shop belonging to his wife's family, sensing perhaps that Krøyer was not only closing in on him but that he had begun to disrupt the quiet pattern of everyday life at Skagen which Ancher was so anxious to maintain. In addition, Ancher was probably annoyed at the ease with which Krøyer had been able to get villagers to pose for him; many of them had doubtless been encouraged to do this after having heard about his fame from local newspapers. Admittedly since the time that Ancher had had such

difficulties in obtaining models, posing to artists had become a more acceptable part of village life. By this date the main problem was that the villagers had begun to realize how much the paintings of them fetched, and were indignant that the artists should receive so much more money for their works than they did, when they had put into them an almost equal amount of time.

Ancher was eventually able to overcome his initial hostility to Krøyer, at least to the extent of being able to spend much time happily in his company, and to continue to admire him greatly as a painter. The summer of 1882 seems at any rate to have been a congenial one at Skagen. Thaulow and Krohg were both back this year for the first time since 1879, the latter coming here almost directly from Grez, where he had painted the portrait of his friend Karl Nordström. After a ten-year interval, Drachman also was back,

73 P. S. Krøyer, *In the Store during a Pause from Fishing,* 1882. Hirschsprungske Samling, Copenhagen

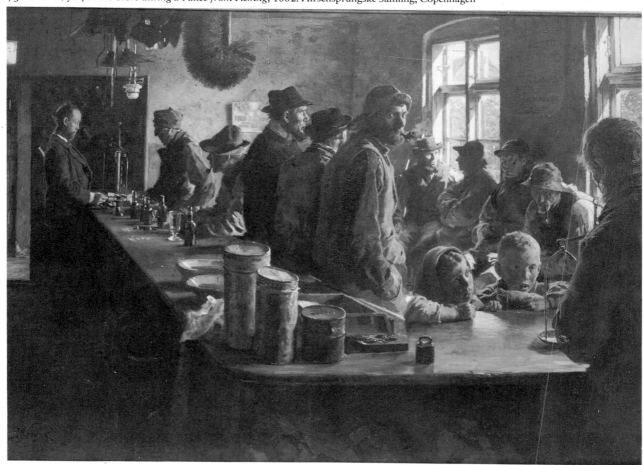

this time with his second wife, Emmy. One day Drachman, Emmy, and Krøyer went out in a fishing boat, and were forced by rough weather to spend the night at sea on a lightship. Emmy was violently sick, managed to get some sleep, and still feeling very ill woke up to be told by Krøyer not to move as he had been inspired to paint her in this state.

Another new arrival at Skagen this summer was a young Swedish painter, Oscar Björck, then straight out of the Academy of Arts in Stockholm. Björck and a painting companion of his from Sweden put up at Brøndum's, where they signed themselves in as 'Swedish painters', a description which Björck was later to admit as being rather pretentious when applied to two people who had barely left art school. They felt as depressed immediately on arriving at Skagen as Krøyer had been about four weeks previously. Rain kept them all day in their grey and spartan hotel room, and by the evening they were quite ready to go back to Sweden. Then there was a knock on their door from Mrs Brøndum. She had been sent up by the artists to ask the 'Swedish painters' if they would like to come and join them in the dining-room. This was the start of what was to be a memorable summer for Björck. The young painter was certainly overawed by the members of the Skagen colony, whom he considered as a 'shining' company of people. He was impressed by how Drachman was always encircled by a crowd of admirers, found Krohg to be marvellously sociable and open, Michael Ancher authoritative and with a deep feeling for people, and Anna Ancher the personification of kindness, 'a ray of sunshine'. He left Skagen on a warm August evening, with the Anchers lying on a beach, and Krøyer singing behind them.

Björck then went to Paris, longing all the time to return to Skagen, which eventually he did in the summer of the following year, 1883. His return here was frowned on by the Academy of Arts, who had given him a travel scholarship in the hope that he would spend it solely in the major artist centres of Europe. The company at Skagen that year included most of those of the previous year. Among the new-comers was a very serious Swedish painter called Jacob Krouthén, who had apparently philosophical inclinations and a constant desire to visit Ceylon. There were also at least three Norwegians, one of whom was Vilhelm Peters, who had come with his wife and small child; a rather conservative painter, he made his name in the colony essentially for his abilities as a storyteller. The other two Norwegians were

74 Christian Krohg, *Sleeping Mother* (Tine Gaihede), 1883. Rasmus Meyers Samlingen, Bergen

Krohg's friend Eilif Petersen, and Charles Lundh, an artist whom the Stevensons would have dubbed a 'snoozer', as he did hardly any painting at Skagen, but instead spent most of his days reading English novels. Lundh lived together with Björck and Krohg in a house, near to Brøndum's, which was to become in the following year the permanent home of the Anchers.

The most important first-time visitor to Skagen in 1883 was Georg Brandes, whom Björck said everyone in the colony wanted to paint. Björck added that the famous critic made a wonderfully still model even though one sensed his mind to be constantly active. Brandes himself was later to describe his first visit to Skagen and the people whom he encountered there. Krøyer, he wrote, 'still seemed loved by Gods and men'; Björck had 'uncontrollable hair', and Krohg was going through 'a period of witty cynicism'. Everyone, Brandes concluded, was ceaselessly drinking, eating, discussing, and condemning.

Krøyer seems to have first acquired the taste for belonging to a close-knit community of artists at Cernay-la-Ville. At the inn where he had stayed, in the company of Pelouse, R.A.M. Stevenson, and others, there had been a tradition of decorating the dining-room with portraits of those artists who had eaten there: this tradition existed in other artist inns, and Siron's in Barbizon had silhouettes of the artists drawn straight on to the walls. Krøyer's main contribution to

the Cernay dining-room had been his picture showing a group of artists—including himself painting the scene—gathered around the table. Such an expression of camaraderie had obviously had an especial appeal to Krøyer, for it was to be the subject of several of his later paintings. In Skagen in the summer of 1883, shortly after Brandes had left, he proposed to do a similar painting set in Brøndum's dining-room; this would form the centre-piece of a decoration to be placed in the room itself comprising portraits of all the artist visitors there. Krøyer painted the group portrait, *Artists' Breakfast* (plate 4), that same summer. In the painting are to be seen Charles Lundh, Eilif Petersen, Vilhelm Peters, Michael Ancher, Degn Brøndum, Jacob Krouthén, Oscar Björck, and Christian Krohg. All are shown in an intensely serious and contemplative mood. The other portraits for the room would accumulate over the years, with unfortunate consequences for the dining-room table, which provided the wood for the panels on which many of them were

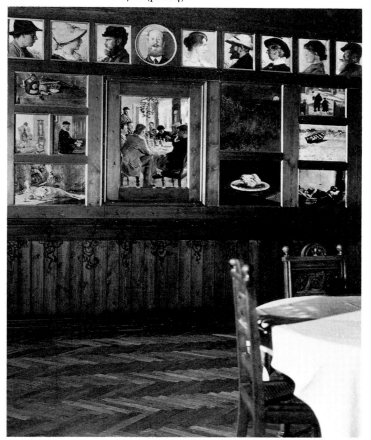

75 Dining-room decoration at Brøndum's, including P. S. Krøyer's *Artists' Breakfast* (plate 4)

painted. In 1906 the architect Thovald Bindesbøll devised an elaborate framework in which to set them all.

Krohg described how Krøyer's presence at Skagen succeeded in disrupting the relatively peaceful hard-working atmosphere that had existed previously in the colony: Krøyer, he wrote, 'partly managed to drag us from what he thought was our pedantic industry.' The problem, continued Krohg, was that Krøyer had such extraordinary facility as a painter that he could achieve in a few days what others would take weeks to do. In the summers of both 1882 and 1883 everyone was amazed by how little time Krøyer spent painting, particularly at the beginning of the season, but by the end he had produced more works than almost everybody else. No wonder he had soon acquired the nickname of the 'new Aladdin'.

In his long periods of free time, Krøyer exercised his almost pathological need to organize people into doing group activities and having a constant series of celebrations. Up to the time of Krøyer's arrival, one of the main sources of entertainment had been hunting, a favourite activity of Michael Ancher, who indeed can be seen wearing his habitual hunting outfit in Krøyer's dining-room group portrait. Krøyer immediately became an enthusiast of the sport himself, always arranging hunting parties, despite the fact that—like Murger at Marlotte—he seems never to have caught anything. But it was the evenings that provided the greatest outlet for Krøyer's talents as an entertainer. He instigated at Brøndum's dining-room what he called the 'evening academy', the main purpose of which, according to one of its participants, was the 'pursuit of pleasure'. Dining-room life at Brøndum's was certainly not always as intense as is portrayed in Krøyer's group portrait. In fact the parties put on here in the evenings by the artists acquired such a reputation for liveliness that tourists were very keen to become involved in them themselves. On one occasion a particularly boring family hung around the dining-room waiting for such a party to start up. The artists, anxious to get rid of these people, hid the champagne, feigned tiredness, and then one by one said they were going to bed. As soon as the family had also retired, the party could at last begin. Unfortunately Thaulow had misunderstood the artists' earlier intentions and had really gone to bed. He had to be woken up and brought, draped in sheets, into the dining-room.

As at Siron's in Barbizon, the atmosphere at Brøndum's came increasingly to resemble that of an exclusive and sometimes adolescent-minded club.

There was even an elaborate system of fines worked out for those who broke the 'club's' rules: rocking on one's chair was ten öre; leaving one's teaspoon in one's cup twenty-five öre; and making a noise by dragging a cork across the table fifty öre. But the largest fine was imposed on the Danish marine painter Olsen, who was charged two kroner every time he started beating up Krohg's dog; asked why he did this, he replied that it was simply for the satisfaction of seeing the pleasure on the dog's face when the beating stopped. All the fines were saved up for the parties that, according to Krohg, were arranged by Krøyer on the slightest pretext. As at Grez, there were parties for saints' days, birthdays, arrivals, departures, and so on. There were even parties organized each time a painting was finished for the dining-room. Krøyer would sometimes spend up to two days preparing for these occasions. There were parties held on the beach which would go on all night, only to be interrupted by the arrival of the early morning fishermen, who would sometimes join in for a drink. There were of course masquerades, at which some of the women would shock the villagers with their scanty costumes. One woman thus attired apparently even managed to incur the displeasure of Krøyer, who though himself a lover of dressing up, and of course the one most responsible for arranging the masquerades in the first place, was sometimes not in the mood for frivolity. One of the many female singers who were always coming to Skagen at this period and with whom Drachman was often falling in love, had decided to try out her evening costume, which comprised the lightest of veils worn over a completely blackened face and body. She showed this to Anna Ancher in the kitchen of Brøndum's, and Anna found it so amusing that she told the singer to go and show it at once to Krøyer, who was then painting on the beach. Krøyer, however, could not even manage a smile.

One of the best remembered parties was that given for Eilif Petersen's birthday in August 1883. The celebrations began in the morning with the birthday boy being woken up by Krøyer with a bottle of champagne hidden under a flower pot. The highpoint of the day was to be the dance held in the hotel in the evening, at which Krøyer, dressed up as a knight, was going to play the piano. However, when the evening came, it was realized that the men far outnumbered the women; in fact there were just Anna Ancher's sister, Agnes, and Krøyer's mistress, Helene Christensen, the local organist. The men were restless to dance. Outside, meanwhile, the fishermen with

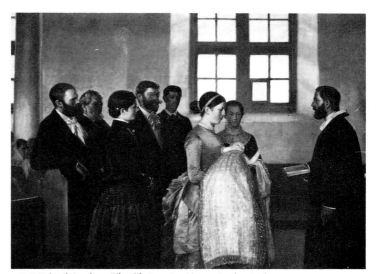

76 Michael Ancher, *The Christening* (Anna Ancher is shown holding her baby Helga; behind her stand Marianne Stokes and P. S. Krøyer), 1884. Ribe Kunstmuseum, Denmark

their wives and daughters were peering expectantly through the window. Someone then had the idea of inviting them all in for a drink. This they gladly accepted. Soon they were removing their shoes and dancing old-fashioned polkas until the women's clothes swirled. Liberal quantities of champagne, punch, and rum toddies began to have their effect. People started disappearing for short periods into the garden. Björck flirted with the fisher-girls, then went outside himself. Here he tripped over a body. It was Krohg. Knowing that Krohg had a remarkable ability to hold his drink, Björck decided that Krohg must have been very ill indeed and carried him immediately home to bed. When Krohg woke up the next morning, admittedly not feeling at his best, he was furious at hearing what Björck had done, and said that he had gone outside simply to refresh himself for more dancing. By this stage Krohg had probably forgotten that during this same party he had challenged a young estate owner to a duel. Fortunately someone had been able to pacify the two.

Only a week or so before, on 18 August 1883, another party had been held which had ended abruptly for the person whose birthday it had celebrated, Anna Ancher. Anna had taken to her bed and by the next morning had given premature birth to a girl, who was to be named Helga. Helga was soon to

77, 78 P. S. Krøyer, *Portraits of Marianne and Adrian Stokes*, 1886. Skagen Museum, Denmark

be one of the principal models of the Anchers; she also featured in the canvases of other members of the colony, including those of Krøyer. The christening was arranged for 21 October, by which date most of the artists, including Krøyer, who always maintained a house and studio in Copenhagen, would normally have been away from Skagen. However, Krøyer, Krohg, and Petersen agreed to be godfathers and promised to come back to the village for the occasion. The christening was held, and Michael Ancher thought it would be a good subject for a painting. At this point the godfathers protested, insisting that they really had to get back home. Ancher was none the less not to be deterred and was eventually to complete the painting two years later (fig. 76), with some of the participants in the original occasion replaced by others who happened to be available as models.

In the spring of 1884 Krøyer visited Grez, where he met up with Björck, then recovering from a 'nervous fever' and unable to drink because of acid in the stomach, and Eilif Petersen. All three of them went back to Skagen in the summer. By this time the Anchers had moved into their new home where Krohg, Lundh, and Björck had been the year before. This summer Björck and Krøyer shared the Anchers' old house in the garden of Brøndum's hotel. Opposite this was a small grain-drying store used at one time by the Anchers as a studio and now occupied by Krøyer and Björck, the latter soon decorating its walls with full-length caricatures. One of the social highpoints of this summer was a luncheon party held in the garden of the Anchers' new house on a brilliantly sunny day. A German marine painter called Stoltenberg photo-

graphed the occasion at the moment when all the guests had stood up to propose a toast. After seeing the photograph, Krøyer immediately saw the possibilities of basing a large and ambitious canvas on it, and soon had models posing in the Anchers' new garden. It was now time for Michael Ancher to protest. One of the advantages of his having moved house was to be slightly further away from the hotel, and thus be able to enjoy greater peace. He told Krøyer to take his easel and models elsewhere immediately. Just as Ancher had decided to go ahead with *The Christening* in the previous year, Krøyer persisted with his idea of painting the outdoor lunch: the canvas was to be begun, then abandoned, then begun again, and only brought to completion in 1888, by which date the work, *Hip, Hip, Hurrah!*, bore rather less resemblance to the occasion it was commemorating.

At the end of 1884 Björck returned to Sweden, and would not come back to Skagen until 1888. Other important members of the colony, including Krohg, Thaulow, Petersen, and Drachman also went elsewhere for long periods in the middle of the 1880s. There were of course new visitors to Skagen during these years. In 1885 and 1886 Adrian Stokes and his new wife, Marianne (née Preindlsberger), came to stay here with Krøyer. Adrian Stokes had met not only Krøyer at Pont-Aven, but also Marianne, who had been there in 1884 accompanied by her Finnish friend Helene Schjerfbeck. Madsen described Stokes as a 'typical John Bull, fat, like a bulldog, who painted landscapes—featuring sand dunes and sheep—which were typically English in colour and treatment.' Marianne, according to Madsen, was a delightful personality and a very gifted painter. She was able to step in as one of the godmothers in Michael Ancher's picture *The Christening*: she is shown holding the baby's bonnet. Both Marianne and Adrian were also asked to contribute their portraits for the Brøndum's dining-room.

A mutual friend of the Stokeses and Krøyer was Alexander Harrison. The Stokeses seem to have visited Concarneau in the February following one of their two visits to Skagen and to have given an enthusiastic report of the Danish colony to the American painter. Harrison, who was then encouraging American dealers to buy Krøyer's works, became keen on coming to Skagen himself. He told Krøyer in a letter that he was bored with Brittany, and that he and some of his American colleagues at Concarneau had had the idea of looking for somewhere else to work that year, and had talked about Skagen. In fact, he continued, he

knew for certain that a group of his American friends would definitely be coming to Skagen that summer. He himself, however, would be worried about travelling so far without having first had further particulars about the character of the place, the cost of living there, the expense of the journey, and so on. It seems that Krøyer took his time in answering this letter, and that at any rate all the Concarneau painters abandoned their plans for a Danish trip.

Krøyer and Harrison had a certain amount in common as painters, not least their interest, developed in the 1880s, in painting *plein air* studies of nudes on the beach. More importantly, they both continued to regard Bastien-Lepage as the greatest painter of their age at a time when they themselves had acquired a taste for subject-matter different from his, and had progressed from a soberly realistic manner to a brighter and more sensual one. In 1885, following the death of Bastien-Lepage at the end of the previous year, Krøyer was made responsible for organizing the Danish contribution to an international subscription towards the cost of a monument to the French artist in his home village of Damvillers: Krøyer persuaded Danish artists to contribute, including the Anchers and other prominent members of the Skagen colony. Unlike most of his Danish contemporaries, and also unlike Harrison, Krøyer seems to have taken a certain interest at this time in the Impressionists. However, in

79 Artists in the garden of the Anchers' house, Skagen, 1884

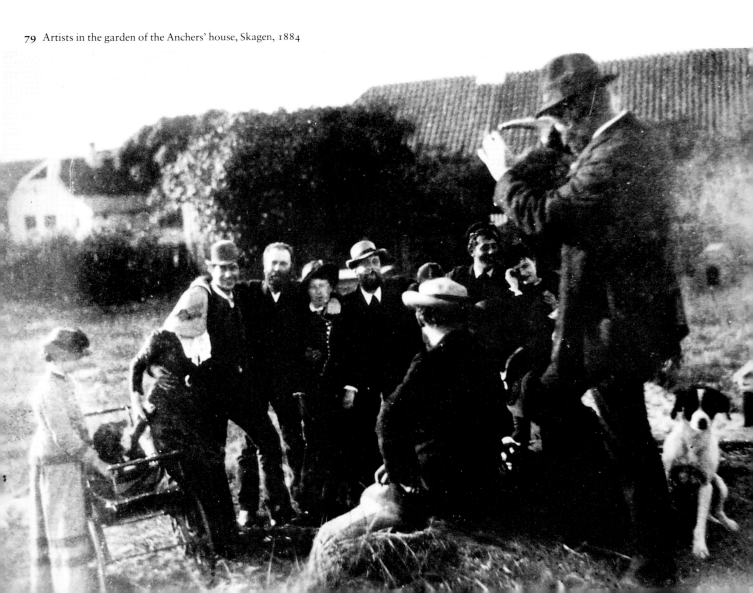

his eyes, the freedom of brushstroke that he admired in these artists' work (an admiration evident in his Brøndum's dining-room group portrait) was exploited to greater effect by Bastien-Lepage in being balanced against areas of more carefully handled paint.

The main point of contact between the Impressionists and Denmark in the 1880s was Gauguin, whose wife was Danish and had a sister who was married to Thaulow. Through this connection Thaulow, Drachman, and Madsen had gone together to see Gauguin in Paris in 1877. In 1884 Gauguin had come to Denmark and had submitted a canvas to an exhibition organized by the Academy of Arts in Copenhagen. It had been turned down by nine votes to two. One of the two votes had come from Krøyer. In 1885 Gauguin was able to have an exhibition of his paintings at the Society of Friends at Copenhagen. Gauguin later boasted that such was the antipathy felt by the Danes towards his work that the authorities insisted that the exhibition close after only five days. This was in fact the normal amount of time allotted to all the exhibitions put on by this particular society. Gauguin's statement, which has been accepted by all art historians who have written on him, had naturally a certain basis in truth, in that the exhibition was indeed controversial. Even in Skagen in the summer of 1885, artists were apparently violently debating the merits of this painter. What exact part Krøyer took in all this is not known. Gauguin meanwhile thought Krøyer one of the better Danish painters. None the less he had a low opinion of most foreigners who took only a half-hearted interest in Impressionism, and moreover had a considerable antipathy to Danes in general. In Paris in 1886, he met up with Krøyer and two other Danes at the eighth exhibition of the Impressionist group, and wrote afterwards to his wife that these painters 'are always coming to see if there is something good that they can take from us. *J'ai lavé la tête à Krøyer qui ne savait si c'était du lard ou du cochon* [I so befuddled Krøyer that he didn't know if he was coming or going].'

Christian Krohg was the Skagen artist who had the deepest interest in the Impressionists. The seventh exhibition of these artists, which he had seen in Paris at the beginning of 1882 and been so enthusiastic about, influenced both *Karl Nordström at Grez* (fig. 18) and the paintings which he executed later in the year in Skagen. The latter, all of members of the Gaihede family often seen in unflattering postures, are much brighter in colour and more technically daring

than his Skagen pictures of 1879. None the less when Krohg was to assess in later life the main influences on him during this stage of his career he was to single out first and foremost Bastien-Lepage, and only then the Impressionists, whose art, he was also to confess, he had not then really understood. Indeed he had interpreted Impressionism as meaning essentially a socially committed investigation of the realities of modern life. It was for this reason that he called the anarchist writer Hans Jaeger the 'Manet of the North'.

In the years in which he was away from Skagen, in the mid-1880s, Krohg was becoming increasingly notorious in Christiania for his radical social views and his involvement with the anarchist group, the Bohemians. In 1886 he published a novel *Albertine*, which chronicles the fate of a poor girl whom society forces into prostitution. The novel caused a scandal comparable to that of Jaeger's *From the Christiania Bohemia* of the same year. The following year Krohg brought to completion an enormous painting featuring one of the more controversial scenes in the book, when Albertine, then an innocent girl and laughed at by the prostitutes, is brought into a police clinic for an examination for venereal disease; it was this particular humiliation that finally seals the girl's fate. The work was exhibited the day after the book was seized by the police, and soon an enormous number of people came to see it. One of these was Hans Jaeger, who, however, was disappointed by the picture, finding it insufficiently realistic and 'even less impressionist than the book'. Krohg and Jaeger worked closely together at this time, not only as leading members of the Bohemians but also as joint editors of a journal called *The Impressionist*, which published articles on controversial social issues by themselves and other radical writers such as Georg Brandes. They even shared the same mistress, Oda Lasson. In 1888, when Jaeger finally came to be imprisoned for *From the Christiania Bohemia*, Krohg and Oda thought it an opportune moment to get married, and decided to come to Skagen, where they imagined they would be safe.

At the beginning of the summer of 1888 Krøyer wrote to Björck that a 'wonderful crowd' had assembled at Skagen that year, and that at last he would be able to complete his *Hip, Hip, Hurrah!* (plate 5). Björck soon came to Skagen himself, for the first time since 1884; he was now married and shortly to become an eminent teacher at the Stockholm Academy of Arts. In 1884 he had contributed to *Hip, Hip, Hurrah!* by doing an oil sketch of Krøyer which was to serve as the basis for the latter's self-portrait in

the final composition. This year Krøyer wanted to paint Björck himself into the large picture. However, Björck appears to have been disappointed this year by Skagen and was anxious to move on. The year before he had been in Italy and been impressed by the 'elegance' of the fishermen there; in contrast the fishermen at Skagen seemed to him now rather too 'lumpish'. He soon left, never to return. Krøyer, however, found other willing models for the picture, including Degn Brøndum, Krohg, and a new arrival in the colony, the Swedish landscapist Thorvald Niss, who served in the picture as a replacement for Eilif Petersen who had not been able to come to Skagen that year. Krøyer had decided to paint the picture in his own garden rather than in the Anchers', and had thus been able to receive the fuller co-operation of Michael Ancher. The two Anchers were included in the picture, as well as their now four-year-old daughter, Helga. Near the latter was placed Krøyer's mistress, Helene Christensen. In the intervening years since 1884 Helene had been made pregnant by Krøyer and, without telling him about this, had travelled to America where

she had suffered a miscarriage. In *Hip, Hip, Hurrah!* she is shown rather apart from the rest of the group, her back to the spectator. The completed picture, for all its would-be spontaneity and warmth, is strangely cold and contrived. There is certainly something deeply ironic about it, not only in the light of the immense problems that arose in its making but also in its evocation of the Skagen colony as a group of people existing in perfect happiness and friendship.

Another new visitor to Skagen in 1888 was the Finnish portraitist, Hanna Rönnberg, later to be associated with the colony at Åland. She had arrived at Skagen just before Christian Krohg, at a time when everyone was eagerly speculating about what the latter's wife would be like. Oda and Krohg finally arrived, and everyone found her good-looking and charming, and wanted to paint her. The couple were given another wedding feast. Hanna Rönnberg was soon on very friendly terms with them, and was to write an account of them at this time in her memoirs. She described how when the weather was fine the couple would go for long walks on the beach, or else 'sit down by the sea drinking coffee, with Krohg playing Andalusian songs on the lute. She characterized the radical social critic as someone who loved the luxuries of life, in particular good food and drink. The house which he and Oda moved into in Skagen came to be covered with precious exotic objects from all over the world, including a polar-bear skin and an enormous divan covered with oriental rugs. Rönnberg found that every time Krohg opened his mouth ideas and 'blood-red paradoxes' were strewn from it like seeds. Oda meanwhile sat quietly and listened. A favourite theme of Krohg's was that one should always unhesitatingly follow one's natural inclinations, never be bothered by responsibility or indeed be answerable for anything. These views were shortly to be put to the test.

Hanna Rönnberg, despite being to all appearances a typical blonde Scandinavian, was rumoured to have gipsy blood. At any rate she was known to be able to tell people's fortunes with cards. One day she did this for Oda, and discovered that a dark gentleman was very shortly to give her trouble. Oda of course immediately thought of Jaeger, but then discounted the idea as she knew he was still in prison. However, just to reassure herself, she telegrammed to Christiania, only to be told that Jaeger had just been released and was making his way to Skagen. Oda had sworn an oath to Jaeger that if she were ever to leave him she would give him morphine and then shoot him while he

80 Christian Krohg, *Oda Krohg*, 1888. Nasjonalgalleriet, Oslo

lay in a drugged state on her lap. On hearing about Oda's marriage, Jaeger had behaved so wildly in prison that he had been compelled to go on a diet of bread and water. The severity of this dietary regime had led to his sentence being considerably shortened, which was why he was now so unexpectedly free. Krohg and Oda now hurriedly packed and moved temporarily to the hamlet of Kandestederne about six miles to the south, leaving instructions that no one should tell Jaeger of their whereabouts. No sooner had they left Skagen than Jaeger turned up at Brøndum's asking for them. Degn Brøndum said that they had gone south, but no one knew exactly where. Undeterred, Jaeger set out to look for them, taking with him only a bottle of brandy. Night came and still, to everyone's concern, Jaeger had not returned. Finally Jaeger came back, looking, according to Rönnberg, like a ghost. After bursting into a 'strange frightening laugh', he proceeded to eat with enormous appetite what he described as the first proper meal he had had

for months. He had been unsuccessful in his search. None the less he stayed on for a week or so in Skagen, during which period he seems to have made a rather unfavourable impression on the Skagen colony. He was apparently quite willing to tell strangers the most intimate details of his life. In the meantime Oda and Krohg were becoming distinctly bored at Kandestederne and moved on to Gammel Skagen, where they soon became equally restless; they sent a message over to Brøndum's for people to come and visit them in the evenings and play cards. At last Jaeger left, telling everyone in the hotel that they would no longer think him mad when they read about the full details of the morphine pact in a book which he intended to write on his return to Christiania. In later life Oda was to have an affair with the Norwegian poet, Jappe Nilssen, whose depression when she broke with him as well was to inspire Munch's painting called *Melancholy*. While this affair lasted, Krohg was to display rather more of the carefree attitude that he had boasted

81 Dining-room at Brøndum's, 1890, with (from the left) Degn Brøndum, Hulda Brøndum, Anna Ancher, Marie Krøyer, Michael Ancher, and P. S. Krøyer

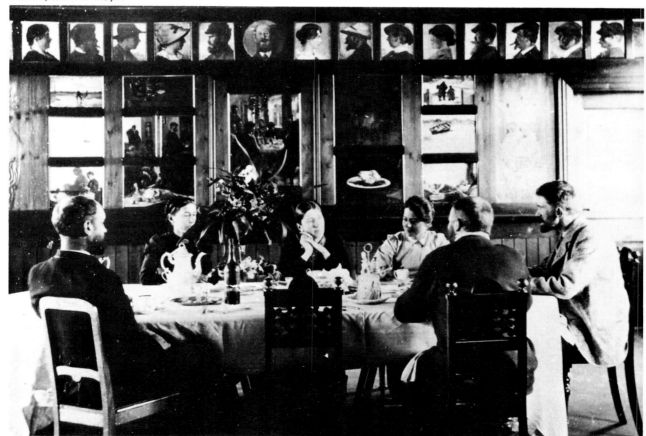

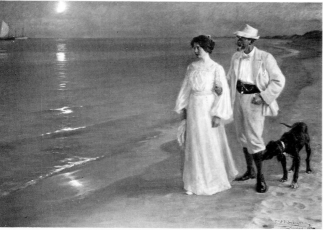

TOP: **82** Krøyer's house in the Plantagen, Skagen, *c.* 1908
BOTTOM: **83** P. S. Krøyer, *Summer Evening on Skagen Beach*
(Marie and P. S. Krøyer), 1899. Hirschsprungske Samling,
Copenhagen

about before Jaeger's arrival at Skagen: surprising his
wife making love one warm summer's day with
Nilssen, he simply asked if the weather was not too hot
for such activity.

Towards the end of 1888 many of the Skagen artists
went on to Paris to prepare for the International
Exhibition to be held there in the following year. This
was to be the occasion on which the French critics at
last recognized the importance of modern Scandi-
navian art: in the previous International Exhibition of
1877 their art had been dismissed as naïve and
provincial, one critic writing that 'art vegetates in
Denmark, lives slightly in Sweden, and doesn't exist at
all in Norway.' Immediately before the Anchers

themselves came to Paris early in 1889, Skagen was
visited by a leading Danish theatre critic, Otto Benzon.
The reason for his coming here, at this unusual time of
the year, was that he desperately needed to escape
from severe emotional problems in Copenhagen. His
wife, who was expecting a baby, had just left him after
hearing that he was having an affair with her mother.
The Anchers and the few remaining artists at Skagen,
including Hanna Rönnberg, were worried that he
might kill himself. None the less the place soon
cheered him up, and he discovered an unexpected
talent for painting: the moment he presented to the
Brøndum's a painting for their dining-room signified
to the Anchers and others his complete recovery.

Meanwhile in Paris in the winter of 1888–9, Krøyer
had met up by chance with an outstandingly beautiful
young woman to whom he had taught painting in
Copenhagen several years previously. In May, while
still in Paris, Krøyer wrote letters to his aunt and
mother expressing his happiness that this young
woman, Marie Triepcke, had agreed to marry him. He
returned with her to Skagen in the summer of 1891,
arriving there by the newly opened railway. They
settled in the house where Viggo and Martha Johansen
had lived just after their marriage in 1880. This house
was modestly decorated when the Krøyers first came,
but was soon furnished in the luxuriously elegant
manner which had grown increasingly important to
Krøyer over the years. Such elegance was also to
characterize the interior of the house into which he
and Marie were to move four years later: this was the
house in the Plantagen which had formerly belonged
to the early nineteenth-century mayor, J. C. Lund.

By the time of his return to Skagen in 1891, Krøyer
had begun to dress in an increasingly stylish and
outlandish way. The growing crowd of summer
tourists brought to Skagen by the new railway would
look up in surprise when Krøyer cycled past in white
homespun clothes, 'English socks', and 'Molière
shoes' with 'Norwegian buckles'. However, the
villagers' interest was concentrated more on Marie,
who shocked them all by wearing 'reform clothes'.
With her elegant and distant manner, Marie did not
endear herself to the locals, who none the less took
rather more kindly to her when they heard that she
was a good cook.

In the 1890s the colony at Skagen was not as
artistically important or as intellectually vital as it had
been in the 1880s. However, it was during this period
that Krøyer painted what are today perhaps his most
popular works, which—to judge by the frequency

84 Holger Drachman and his third wife, Soffy Drewsen, at Skagen

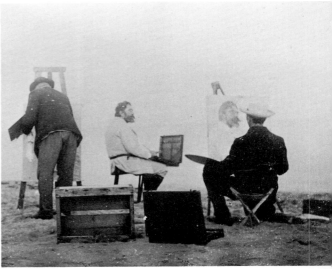

85 Michael Ancher (left) and Julius Paulsen (right) painting P. S. Krøyer at Skagen, 1906

with which they are reproduced on calendars and greetings cards—still exert a remarkably wide fascination even though the artist who painted them has largely been forgotten outside Denmark. These all feature Marie, dressed elegantly in white and seen against the southern beach at Skagen in the distinctively blue light of a Scandinavian summer evening.

The marriage of Marie and Krøyer was by no means as idyllic as these pictures might lead one to expect. From its start Marie was ill with nervous crises. She seems moreover to have been generally regarded as cold and egocentric, someone who wished to isolate herself from society by creating her own self-contained world of aesthetic reverie. Much less sociable than Krøyer, she was also perhaps more intelligent and sophisticated. During the long periods when Krøyer was working in Copenhagen, Marie preferred to remain on her own in Skagen. In 1894 she and Krøyer had a baby daughter, Vibeke; but this did little to bring the two closer together. After many years of marriage, Marie was eventually to tell Krøyer that she had never loved him and had simply married him because of his fame as a painter. In 1899 Krøyer spent his first period of confinement in a mental home.

At about this time a young Swedish composer, Hugo Alfvén, visited Copenhagen and saw at an exhibition Krøyer's most successful full-length portrait of Marie. Alfvén asked his hosts if they knew anything about her, and was told that she had a reputation as a *femme fatale*. About a year later, in 1900, Alfvén went to Taormina in Sicily and found by chance that she and Krøyer were staying near his hotel. They became friends, and Krøyer invited him to come and join them the following year in Skagen. He took up their invitation, and there carried on an affair with Marie which inspired him to write at the same time his greatest musical work, the *Midsommarvaka*. In 1902 Marie joined Alfvén in Sweden, leaving her daughter behind in Skagen.

In this same year Drachman returned to Skagen, bringing with him this time a sister of Oda Krohg, the young Soffy Drewsen, who was shortly to become his third wife. Soffy had two other sisters, Bokken and Alexandra: the former was a previous love of Drachman, the latter the second wife of Frits Thaulow. Drachman and Soffy decided to settle permanently at Skagen and acquired a house near that of Krøyer. After writing a sarcastic birthday tribute to Krøyer in 1903, Drachman distanced himself more and more from his former companion. Drachman soon began also to have serious quarrels with Soffy that generally ended with his having to be taken to hospital in a state of extreme nervous tension.

Krøyer was himself increasingly confined at this time to mental institutions, during which periods his daughter would sometimes be looked after by his

former mistress, Helene Christensen. His illness was diagnosed as 'dementia paralitica' and, if triggered off by his problems with Marie, had almost certainly been inherited from his mother. It was moreover exacerbated by a syphilitic infection which he had probably contracted in Paris in his youth and which was now also making him lose his sight. In his manic moments in hospital he would get out of bed in the middle of the night and furiously sketch the other patients. On one occasion, he imagined that he had been crowned king of Norway, a delusion which Krohg thought perfectly illustrated Krøyer's lifelong obsession with his Norwegian origins. In his periods of relative sanity at Skagen, Krøyer's enthusiasm for socializing and entertainment seems to have been undiminished. His main new Skagen friends were the Brodersens, a rich couple who had recently moved into the village. The portly Henny Brodersen was notoriously flirtatious with the Skagen artists, had an illegitimate son by one

of them, and seems also to have had an affair with Krøyer, whom she constantly mothered. Krøyer, the Anchers, and the Brodersens all planned to be buried in the same plot in the Skagen cemetery, a plot which Krøyer used to visit repeatedly as part of his daily constitutional strolls.

Krøyer's last major canvas, the *St John's Night Party* (fig. 86), was completed in 1906, after having been abandoned several times as a result of the artist's illness. It commemorates one of the bonfire parties that are held in Scandinavia on Midsummer's Night. Many of Krøyer's circle are featured in it, and it is an interesting psychological document. On the left-hand side of the picture can be seen Krøyer's daughter Vibeke (being lovingly talked to by her grandfather, Valdemar Triepcke), the Anchers, and Soffy and Holger Drachman (the latter dressed characteristically in a black cape and wide-brimmed hat, and looking like an Old Testament prophet). Henny Brodersen

86 P. S. Krøyer, *St. John's Night Party,* 1906. Skagen Museum, Denmark

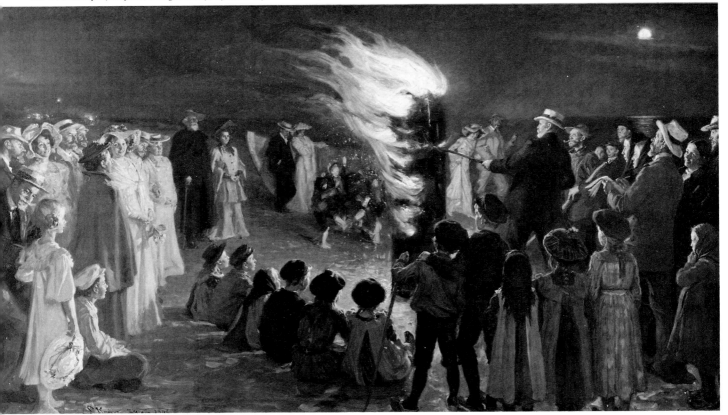

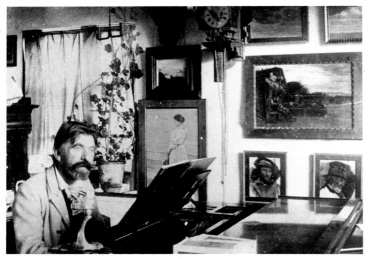

87 P. S. Krøyer at the piano in his study, 1909, one of the last photographs taken of him

stands just behind Anna Ancher and is the only one in the company to look away from the bonfire and smile in the direction of where Krøyer had presumably placed his easel. Her husband is in the right background, cheerfully running along the beach arm in arm with another woman. Strangely enough, Marie and Hugo Alfvén were invited to come and stay in Skagen the year the picture was begun, 1904, and were included in it as sad, wistful, background figures, isolated both from each other and the lively world around them. Marie found herself snubbed by everyone in Skagen that year, with the exception of the Anchers. She was happy neither with Sweden, nor with Hugo Alfvén, who was spending an increasing amount of time away from her. Eventually Alfvén was to leave her, and she was to die a lonely figure in Stockholm in 1940. Vibeke moved to this city herself, and still lives there, reluctant to talk about her sad childhood in Skagen.

In 1907 Drachman broke completely with Krøyer, after having told him in a letter that they were now completely incompatible and had never really been friends in the first place. There were important celebrations in Skagen this same year for the opening of the harbour (an event presided over by the Danish king), and for the twenty-fifth anniversary of Krøyer's first arrival in the village. In the following year the local chemist Klaebel proposed the setting up of a museum devoted to the place's many artists. Drachman died at the beginning of 1909, enjoying at the end of his life an affair with a very young local girl, Ingeborg Andersen ('The Rose of Skagen'). Drachman's ashes were placed in an urn at the very tip of the Skaw overlooking the point where the North and Baltic seas meet; the urn was designed by the most renowned Danish artist associated with Skagen in its later years, J.-F. Willumsen, a symbolist artist who had stayed with Gauguin at Le Pouldu. Krøyer died in November 1909, shortly after having returned from Venice, where he had had an exhibition of his works and spent his time longing to be back in Skagen. Krohg's last memory of him was in Paris in 1906, sitting outside a café, 'strumming' a table napkin as if it were a mandolin, and singing, 'O Beatrice, O Beatrice'.

Krohg had spent little time in Skagen after 1888. At the turn of the century he had moved to Paris and become a teacher at the Académie Colarossi. He returned to Norway in 1909 to become a much respected director of the newly founded Christiania Academy of Art. Several of the Skagen colony's original members, including the Anchers, Carl Locher, Karl Madsen, and Laurits Tuxen lived on happily in the village until their deaths. Today Drachman's house of his later years and the house to which the Anchers moved in 1884 have been preserved as museums. Krøyer's house in the Plantagen also survives, with much of its original furniture. Brøndum's hotel remains, although rebuilt in red brick after fires in 1954 and 1959. The dining-room decorations have been removed to the museum across the road devoted to the Skagen painters. Part of this museum is housed in the Brøndum's garden house where the Anchers settled immediately after their marriage and where Krøyer and Björck once lived. The nearby grain-drying store, once used as a studio, is now a garden shed. The Skagen artists continue to enjoy enormous popularity in Denmark, and for the many tourists who come to Skagen a visit to the various sites associated with these artists provides, on rainy days, a pleasant alternative to the beaches.

5

In the Nest of the Gentry

ABRAMTSEVO (RUSSIA)

THE REACTION against academic art set in earlier in Russia than in Scandinavia and elsewhere in Western Europe, and took a slightly different form. In 1863 a group of artists studying at the St. Petersburg Academy of Art complained about the fact that the subject they had to paint for their diploma assignment was chosen by their teachers. They demanded the freedom to make their own choice, particularly as many of them were more interested in painting contemporary subjects rather than the dreary historical and mythological themes invariably favoured by the Academy. The Academy retaliated by stipulating as that year's assignment *The Banquet of the Gods in Valhalla.* Thirteen painters, and one sculptor, subsequently resigned from the Academy. In so doing they were jeopardizing their chances of ever exhibiting and selling their work, in which matters the Academy then had complete domination. They countered this problem by forming the Artists' Cooperative Society. Their ideals were strongly influenced by the social revolutionary N. G. Chernyshevski, whose doctoral thesis, *The Aesthetic Relations of Art to Reality,* had asserted that reality was superior to its imitation in art and that consequently subject-matter in art was more important than form. Many of the works exhibited by the Cooperative Society had a contemporary social relevance, such as scenes from the oppressed lives of the serfs. The society closed down after only a few years, having for the whole period of its existence been closely monitored by the police and vilified by the reactionary press. Its ideals none the less lived on, and led to the formation in 1870 of the even more ambitious Society of Travelling Art Exhibitions. This had the novel idea of putting on exhibitions not only in Moscow and St. Petersburg but also in other Russian towns, and thus help bring art to a wider public. Its members and associates came to be known as the Wanderers, and included almost all the leading Russian painters in the 1870s and 1880s.

The extent to which the progressive artists in Russia in the second half in the nineteenth century had a genuine social commitment is questionable and has undoubtedly been exaggerated by Soviet historians. The interest of many of them in the picturesquely downtrodden was perhaps as purely sentimental as that of most artists elsewhere. What can be said, however, is that, in contrast to many other European countries, the anti-academic movement in Russian art of this period was encouraged initially more by a concern with subject-matter than by any enthusiasm for contemporary French art. Russian attitudes towards the latter were in fact often negative. One of the most famous genre painters to exhibit with the Wanderers, Vasily Perov, had been sent on a six-year scholarship to Paris in 1862, but had asked permission to return to Russia after only two years there. Ilya Repin, perhaps the best known of all the Russian painters of this generation, once wrote: 'Modern French painting is so empty, so ridiculous in content: the painting is talented but there's only painting—no content at all.' Artist contemporaries of his such as Antakolsky, Polenov, Serov, and Vrubel all shared this view. An exception was none the less and perhaps inevitably made for the French artist whose work seemed so obviously important for its content, Bastien-Lepage. His *Rural Lovers* was exhibited with great success in Moscow in 1885, and was alluded to at length in the correspondence of Polenov, Serov, and Korovin.

The main reason for the antagonism shown generally towards French art in Russia during this period was the particular form of nationalism which came to affect that country's arts. The Scandinavian and other Western European artists who were strong nationalists found their admiration for everything French to be quite compatible with their love for their own country. One of the main impulses behind Russian nationalistic art, however, was the rejection of all aspects of Western culture, a culture which had so dominated the arts in Russia up to this time. Nationalism was now the principal motivating element in Russian art and architecture. Architects were reviving Russian styles of earlier periods; painters were executing scenes both of contemporary Russian life and Russian history. The widespread interest in Russia's past was extending further and further back in time, from the Russia of Peter the Great, to Ivan the Terrible's Moscow, to twelfth-century Kiev.

In the 1890s a group of young artists and intellectuals based significantly in St. Petersburg, which has always been the centre of West European culture in Russia, favoured a renewal of cultural contacts with the West. This group, which came to be connected with the journal *The World of Art* and included Valentin Serov, the stage designer Leon Bakst, and the impresario Sergei Diaghilev, rose up almost in opposition to the Wanderers, whose intense nationalism and ideological realism they found rather boorish. There were inspired instead by the principles of art for art's sake. None the less the very decorative art associated with them contained numerous traditional Russian motifs and was often inspired by Russian themes. A sort of by-product of this group was the Ballets Russes, which counted among its many achievements the first production of Stravinsky's *The Rite of Spring*, which was subtitled *Scenes of Pagan Russia*.

Rural conditions in nineteenth-century Russia were perhaps more backward than in any other European country. The abolition of serfdom in 1861 if anything worsened the lot of the peasant, who was now either displaced from his land or else forced to pay heavy taxes for it. The second half of the century saw a major agrarian crisis, with large quantities of wheat exported elsewhere. Industrialization came very late to Russia, but by the end of the century its effects on traditional rural life had become very apparent and were the subject of a harrowing short story by Chekhov, called *Peasants*.

The suffering peasant became a major theme in the

88 Rear view of Mamontov's house, Abramtsevo, as it is today

art of the Wanderers and their associates. The reality of rural life in Russia, however, was perhaps too uncomfortable to inspire the setting up of any village community of artists such as was to be found elsewhere in Europe. However, at Abramtsevo about thirty miles north of Moscow there developed another type of artist colony, a type which was to become especially popular in America this century. Abramtsevo was not a village but rather the summer estate of a wealthy industrialist, Savva Mamontov, who encouraged artists, writers, and musicians to come and stay with him there in the summer months. Most of Russia's leading artists of the late nineteenth century were attracted to the place, where, thanks to the hospitality and financial support of the Mamontovs, they were able to develop their notions about the virtues of peasant life with the minimum of confrontation with the real world.

Mamontov's estate at Abramtsevo survives today. The principal residential building is a low, long, wooden construction which dates from the early years of the last century. It stands on top of a slight hill and looks down on one side through a dense birch wood to the Vorya River which forms at this point a series of wide pools. The surrounding countryside is for the most part gently undulating, tree-covered and interspersed with small villages in which picturesque wooden houses can be seen alongside characteristically bleak Soviet blocks of flats. Many Muscovites have modest summer dwellings here. Mamontov's estate has been converted into a humble and now

pleasantly decayed museum, and attracts large numbers of Russian tourists. It occupies an important place in Russian culture, and not simply because of the former presence here of Mamontov and his associates. Two of the rooms in the museum are devoted to the Slavophile writer Sergei Aksakov, who moved to the estate in 1843 and wrote here his charming stories of country life, most notably *Notes on Angling* (1847). Among the distinguished literary figures who were Aksakov's guests at Abramtsevo were Nicolai Gogol, who began here the second part of *Dead Souls*, and Turgenev, who conceived here the plot of *A Nest of Gentry*. Mamontov acquired the estate in 1870, following the death of Aksakov.

Mamontov came from a rich commercial family, and had been brought up mainly in Moscow. He was a dynamic and versatile personality. He had an early interest in the arts, in particular in music and the theatre, and his excellent singing voice led him to have singing lessons in Milan in the early 1860s. From 1866 he embarked on his career as an investor, and railway and mining magnate; he was always to show a considerable flair for business, although his willingness to take enormous risks was eventually to bring about his downfall. After his father died in 1869 he became the main shareholder in the Moscow–Tuoitze railway, which had been built by his father about nine years previously. The money which came to him on his father's death facilitated his purchase of Abramtsevo. His principal residence was always to remain in Moscow.

Mamontov set about enthusiastically the task of arranging his new summer home, and wrote at this time that 'it seems that there is nothing happier in life than preparing a new nest.' Like many Russian landowners, he was soon engaged in philanthropic activities involving the local peasantry. In 1871 there was a cholera outbreak in the neighbouring villages, and Mamontov, aided by a group of young medical students from Moscow, took on the task of looking after in Abramtsevo those who fell ill. Soon afterwards he had built on his estate a hospital and school; both were constructed in wood and in a traditional Russian style. From the beginning it seems that Mamontov also had plans to revive at Abramtsevo the cultural life that had existed in Aksakov's day. His plans were to take on a more tangible shape after a long trip abroad in 1873–4.

This trip had been prompted by the ill health both of his wife, Elizaveta Grigorevna, and his second son, Andrei. They went first to Italy. In Rome they met the sculptor M. M. Antakolsky, and the landscape painter Vasily Polenov, both of whom were the recipients of bursaries from the St. Petersburg Academy of Art. They also made friends in Rome with the art historian Adrian Prakhov, who was later to make a name for himself for his researches into early Russian art and architecture. The Mamontovs, Antakolsky, Polenov, and Prakhov spent much of their time together in Rome, Prakhov taking them all on sightseeing trips round the city, and Antakolsky teaching Savva Mamontov how to sculpt. The latter resolved that his new friends should eventually come and join him and his wife at Abramtsevo.

The Mamontovs returned to Russia by way of Paris. The young Repin was then staying there. Repin had been a brilliant student at the St. Petersburg Academy of Art, which had awarded him in 1871 a gold medal and six-year travelling scholarship. In 1873 he had won international recognition as a realist painter when he exhibited his *Volga Bargemen* in Vienna. That same year he came to Paris. One of the closest friends he made there was the American Pont-Aven painter, Frederick Bridgman, who was inspired by reports of the *Volga Bargemen* to paint his *Boatmen on the Nile*. He also became acquainted with Turgenev in Paris, and painted his portrait at this time. Turgenev was one of those Russian intellectuals who believed that the future of Russian culture lay in a closer assimilation of the culture of Western Europe. He was very interested in painting, and had a large Barbizon School collection, including works by Diaz de la Peña, Jacque, Dupré, Rousseau, Corot, and Daubigny. After initial misgivings he was to develop a great appreciation of the Impressionists, and write, as early as 1876, that the future lay with these artists. Repin himself only admired the Impressionists for their realism and not for their technique. His discussions on art with Turgenev seem none the less to have been of some concern to one of his mentors in Russia, Vasily Stasov, with whom he regularly corresponded while he was in Paris. Stasov was a critic and historian who had done considerable research into ancient Russian art. A close adherent of the ideals of the Wanderers, he was strongly opposed to all that Turgenev stood for.

In Paris the Mamontovs not only become friendly with Repin, but also with a Russian pianist, Valentina Serov, who was the widow of the Russian composer and music critic, Alexander Serov. Valentina was staying in Paris in the autumn of 1874 with her eleven-year-old son, Valentin, who had a precocious talent for

drawing and was then receiving tuition from Repin. The Mamontovs invited Repin and the Serovs to Abramtsevo. The Serovs became the first of those whom the Mamontovs had met on their trip abroad to take up this invitation, and on their return to Russia in the summer of 1875 they immediately came to Abramtsevo. Valentin was to spend much of his childhood and adolescence here.

The sort of artistic community which Savva Mamontov had envisaged for Abramtsevo, however, was not to materialize until 1877, by which time Prakhov, Polenov, Antakolsky, and Repin had all settled in Moscow. They began to visit the Mamontovs' Moscow home in the winter and to stay at his Abramtsevo estate in the summer. Their circle was soon enlarged by Polenov's sister Elena and by the brothers Viktor and Appollinari Vasnetzov, two former students of the St. Petersburg Academy of Art.

All the artists who gathered at Abramtsevo at this time were sympathetic to the ideals of the Wanderers; it is possible that, as Elena Polenova was later to write, they regarded their circle here as representing a strongly pro-Russian movement in the arts, and that they saw great significance in Abramtsevo being near Moscow rather than St. Petersburg. Yet it is unlikely that Abramtsevo would have been much more than a pleasant summer resort had it not been for Savva Mamontov's extraordinary ability to inspire activity

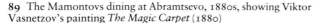
89 The Mamontovs dining at Abramtsevo, 1880s, showing Viktor Vasnetzov's painting *The Magic Carpet* (1880)

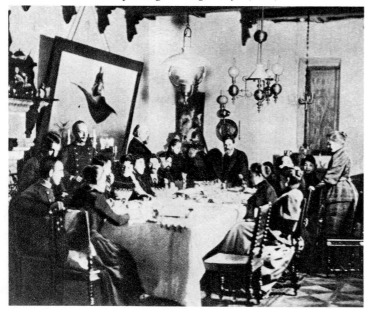

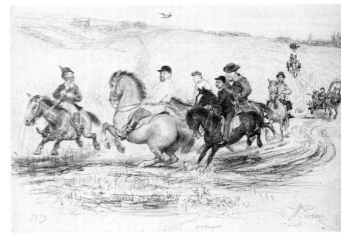
ABOVE: **90** Ilya Repin, *Members of the Abramtsevo Colony on Horseback* (Mamontov is shown on the rearing horse in the centre), 1879. Abramtsevo Museum, USSR
OPPOSITE: **91** Detail of Abramtsevo church as it is today

in people. Viktor Vasnetzov referred to Mamontov's 'electric current igniting the energy of those around him'. Repin wrote how when everyone at Abramtsevo was feeling tired and fed up with working, Mamontov would 'come down on us life a refreshing shower, merrily sprinkling us with his kind observations and indispensable advice.' Mamontov himself directly contributed to the creative life of the colony, devoting himself at first primarily to sculpture and singing. His versatility was no less infectious than his energy, and was perhaps to be an important factor in encouraging everyone in the colony to extend their talents well beyond painting.

The paintings inspired by Abramtsevo and its surroundings in fact constitute perhaps the least important of the colony's achievements. Repin said that Abramtsevo was an excellent place to work, as the surrounding villages were full of peasants who were willing to be models. Yet apart from a few oil sketches, he appears not to have painted the local peasantry. Instead he began work there on an interior genre scene, featuring a returning revolutionary, called *They Did Not Expect Him*, and, after reading a crude letter in Mamontov's possession written by a Cossack soldier, thought up his historical canvas *The Cossacks writing a Letter*. Neither of these paintings, which are among his best-known works, have any closer connections with the place. The other artists who worked in the colony in its early years mainly

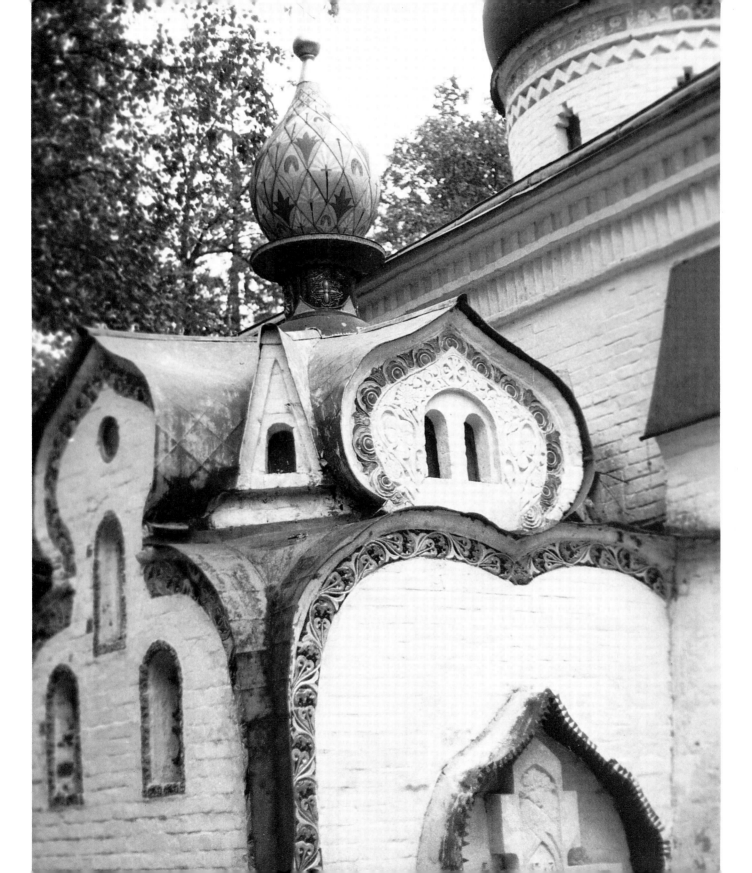

concentrated their painting energies on the execution of modest oil sketches of the surrounding countryside. The main exception was Viktor Vasnetzov, who claimed that the appearance of the local peasants gave him the idea of how to paint the figures in his celebrated historical work *The Warriors*. He also saw the landscape near Abramtsevo in terms of the setting of traditional Russian folk tales that now came to enjoy a renewed importance in Russian culture. He named one of the pools on the Vorya River below the estate 'Alionushka's Pond', and painted here one of Mamontov's daughters in the guise of this heroine of Russian folklore.

The first and principal communal achievment of the Abramtsevo artists had little to do with painting. In the spring of 1880 the Vorya River burst its banks, blocking the way to the nearest church, and forcing many of the villagers to attend the more domestic service held in the Abramtsevo home. From this grew the idea that the Abramtsevo colony should undertake together to built a church on the estate. Mamontov's wife, Elizaveta, was deeply religious, and indeed was involved with the revival of the liturgy of the Orthodox Church. Others in the colony were less religious, yet none the less found that the presence nearby of one of the most important centres of Russian Orthodoxy, the Trinity Monastery of St. Sergiy of Radonezh (now the Zagorsk Historical and Art Museum), was of great symbolical and emotional significance.

It was decided to incorporate into the Abramtsevo church a selection of some of the most interesting features of early Russian art and architecture. For this purpose the Abramtsevo artists made study trips to various parts of Russia, during the course of which they benefited particularly from the learning of Polenov, who, in addition to being a landscape painter, taught archaeology at Moscow University. The main design of the church, however, was entrusted to Viktor Vasnetzov, who had recently executed the interior decoration of one of Russia's most important medieval revival buildings, the cathedral of St. Vladimir at Kiev. When Vasnetzov presented his Abramtsevo plans to the others in the colony, numerous modifications were suggested, including the addition of ornamental designs inspired by carvings on local peasant buildings. The main source of inspiration for the building was the architecture of fourteenth-century Novgorod. Virtually every member of the colony had a hand in the decoration of the interior, undertaking such a wide range of tasks as embroidering covers, painting icons,

designing and executing the iconostasis, decorating the windows, and even laying the mosaic flooring. The church was consecrated in 1888, and used shortly afterwards for the marriage of Polenov. It was to function until the Revolution, witnessing the burials of Mamontov's wife (1908) and of two of their children, Andrei (1891) and Vera (1907).

The completion of the Abramtsevo church can be seen as the culmination of the first major period in the colony's history. Later that same year, and much to Mamontov's annoyance, Repin severed his connections with the colony. The reasons for this might lie partly in his recent friendship with Tolstoy. Tolstoy, who at that time had books published by Mamontov's brother, Anatoly, met Savva Mamontov on only one occasion, and apparently took a dislike to him. Mamontov meanwhile was anxious that the great writer should associate himself with his community. Tolstoy would have none of this, and moreover may have influenced Repin into thinking that such a place as Abramtsevo was a disruptive influence on a painter, being excessively parochial.

Despite Tolstoy's rebuke and Repin's departure, Abramtsevo continued to play at least an important symbolical role in the history of late nineteenth-century Russian art. The 1880s saw Serov reach maturity as an artist. Shortly after graduating at the St. Petersburg Academy of Art he returned to Abramtsevo and painted here his famous *Girl with Peaches*, which is a portrait of Mamontov's daughter, Vera, sitting in the Abramtsevo dining-room. This brightly coloured work, with the figure placed *contre-jour* against the window, suggests a knowledge of the Impressionists, yet by this date Serov had had virtually no direct contact with contemporary French painting. The work is at any rate indicative of the change in Russian art from the late 1880s onwards, away from the anecdotal realism of artists such as Repin towards a more overtly pictorial manner.

Other leading Russian artists of the later years of the nineteenth century came to be associated with Abramtsevo. Polenov introduced to the circle two of his pupils, Korovin and Levitan, both of whom were to be known as among the greatest of Russian landscape painters. Another new member of the circle was Mikhail Nesterov, a painter of stiff, stylized, and rather mystical canvases. At Abramtsevo he painted his best-known work, *The Vision of the Youth Bartholomew* (fig. 92), which records a miracle which happened outside the Trinity Monastery of St. Sergiy of Radonezh. The landscape background of this work

92 Mikhail Nesterov, *The Vision of the Youth Bartholomew* (the Abramtsevo estate is shown in the background), 1889. Tretyakov Gallery, Moscow

is based on one of the most attractive views in the Abramtsevo estate. The site from which the work was painted was soon to be marked by a porcelain bench by a more important Abramtsevo artist of this later period, Mikhail Vrubel. Vrubel was introduced to the place by Serov, with whom he had studied at the St. Petersburg Academy of Art. After completing his studies there, Vrubel had worked as a restorer in the medieval church of St. Cyril at Kiev, and had then visited Venice, where he had been deeply impressed by the Italo-Byzantine mosaics in St. Mark's. Vrubel came to Abramtsevo in 1890, and he returned the following year, when he wrote to his sister: 'I am once again at Abramtsevo, and once again . . . I begin to hear the intimate national note which I so anxiously want to capture on the canvas and in ornament.' The influence of Byzantine and early Russian art is evident in his often very symbolical canvases, which are both highly decorative and expressive. The greatest works he produced in Abramtsevo, however, were not in painting but rather in a medium which had previously been unknown to him—porcelain. His experiments with this medium led to the invention of a novel form of glazing which gave to the porcelain and decorative objects that he produced at Abramtsevo a peculiarly vivid glow.

Ever since the building of the local church, the Abramtsevo artists had devoted their energies more to craftsmanship than to painting. The Mamontovs, and

in particular Elizaveta, shared the concern of the English Arts and Crafts philosopher William Morris about the impact of industrialization on traditional crafts. In the course of the 1880s and 1890s a number of peasant-style wooden buildings were built on the estate, as well as a curious wooden folly called the 'chicken-legged house', which was inspired by peasant folklore. Two of these new buildings served as the porcelain studio (presided over by Vrubel) and the carpentry studio. The latter was begun as an extension to the school which had been built on the estate in the early 1870s, and was intended as a place where local peasant children could be trained in the art of traditional carving, which was now in danger of dying out. Polenov's sister, Elena, who also specialized in the production of beautifully illustrated books of fairy tales, was put in charge of this. Many of the artists in the colony helped her out by providing designs for furniture and other objects which the children could then carve. Once Viktor Vasnetzov produced a design for a cupboard which included a stylized crow in a traditional Russian peasant style. It is certainly revealing of peasant taste at this time that the children who executed it left out the crow and put in its stead a stylized flower taken from a mass-produced book of ornament by the contemporary French architect Viollet le Duc. The artefacts that came out of the Abramtsevo workshops were at first difficult to sell. Eventually an excellent outlet for these works was found in a Moscow toyshop owned by Mamontov's sister-in-law, Maria Aleksandrova (the wife of the publisher Anatoly).

Savva Mamontov probably did not have quite the same degree of enthusiasm for the arts and crafts activities of Abramtsevo that his wife had. After the completion of the church his interests seem at any rate to have been directed more towards a rather different enterprise, one which harked back to his first loves— the theatre and music. Poetry readings, charades, and musical gatherings had been among the principal forms of entertainment in the colony's early days, as indeed they were in many contemporary households. However, these soon developed into fully fledged theatrical productions. They were mainly evolved in Mamontov's Moscow house and only then brought to Abramtsevo. All the members of the colony would join in, not only designing and executing the costumes and sets, but also acting. Serov proved to be a most enthusiastic comic actor, despite his normally lugubrious manner. At first Mamontov would sometimes write the plays and take on the principal role.

93 Scene from a domestic production of *The Black Turban* at Abramtsevo, 1884, with Mamontov in the centre

Later the productions became increasingly professional, and eventually led to the formation of Mamontov's opera company in Moscow, which was to boast of putting on the first productions of Rimsky-Korsakov's operas and launching the renowned bass singer Fedor Chaliapin.

Mamontov's role as a patron of the arts continued to be very active right up to the late 1890s. In 1898 he agreed to pay half the costs of the journal *The World of Art*, with which Serov was associated. (The other half was to be paid by an enemy of Mamontov, the Princess Tanisheva, who in 1893 had set up at Talaskino near Smolensk a colony on similar lines to Mamontov's at Abramtsevo.) By associating himself with this journal Mamontov was lending his support to the new generation of advanced Russian artists, just as he had previously been a partisan of the Wanderers. In 1899 he planned to build the permanent Moscow base for his opera company, and also began preparations for the Russian contribution to the International Exhibition to be held in Paris at the end of the year. However, on 11 September, he was arrested on charges of misappropriation or at least mismanagement of his railway and factory investments. When he was in prison he received a letter signed by all those who had been connected with his circle. They spoke of his enormous contribution to the arts in Russia, of the debt which they all owed him, of the wonderful times which they had all had in his Moscow house and at Abramtsevo, and so on. Yet it seems that few of them bothered to visit him at this time, which deeply upset him. In July 1900 the charges against him were dropped, yet his business and artistic enterprises never recovered. He was to die of pneumonia shortly after the Revolution, a forgotten man.

During the period when he was under arrest, his Abramtsevo estate was visited by a young German poet, Rainer Maria Rilke. Rilke was especially excited by the local church, and indeed found it a more moving place than the mighty medieval cathedral of St. Sofia at Kiev. Shortly afterwards he returned to Germany, and gave an account of his Russian experiences to a group of artists who had gathered in the north German village of Worpswede.

6
Blood and Soil

WORPSWEDE (GERMANY)

IN JANUARY 1871 the king of Prussia was crowned German emperor, thus successfully concluding Bismarck's single-minded policy of unifying Germany under Prussian domination. Cultural life in Germany, however, continued to be as fragmented as it had been before, remaining divided between a number of different centres, most notably Berlin, Düsseldorf, Hamburg, Dresden, and Munich.

Of these centres, Düsseldorf had been the most important in the first half of the nineteenth century, when it had attracted artists from all over northern Europe and also America. The Düsseldorf Academy of Art was always run on the strictest academic principles, and concentrated exclusively on the teaching of history and mythological painting even at a time when landscape and genre painting had acquired an increasing importance elsewhere. By the 1870s Munich had become a livelier and more international art centre than Düsseldorf. Most of the leading central European artists of this period were trained here, as were innumerable American artists, in particular those who were German in origin or who came from American cities dominated by German institutions, such as Cincinnati.

In the 1870s Munich acquired a special reputation as a centre of peasant genre painting. This was due largely to a former pupil of the Munich Academy of Art, Wilhelm Leibl, who in 1871 became the pivotal figure of a loosely assembled group of artists known as the Leibl circle. Perhaps the greatest influences on Leibl's art were Millet and the French realist painter Courbet. In 1869 the latter invited Leibl to come to France. He stayed there two years, during which period he was mainly in Paris, but was also briefly in

Barbizon to be near Millet. By the 1880s the Leibl circle had broken up, but its influence remained central to advanced art in Munich well into the 1890s. The tradition of peasant genre painting which it had encouraged made Munich especially susceptible to the art of Bastien-Lepage, whose *Beggar* (fig. 5) and *Poor Fauvette* won enormous critical acclaim when shown at the International Exhibitions held in Munich's Glaspalast in 1883 and 1888 respectively. Then in 1890 the group of Scottish admirers of Bastien-Lepage, known as the Glasgow Boys, were also exhibited at the Glaspalast and enjoyed a similar success.

Yet even in Munich and Berlin—which had soon come to rival the former city as the main centre of advanced art in Germany—the portrayal of drab rural life and the adoption of open-air painting continued to meet with much official disapproval as late as the end of the nineteenth century. Kaiser Wilhelm II, in a series of public lectures given about this time, urged all the artists of his country to abandon such painting in favour of a more heroic and academically based manner.

The many artist colonies which grew up in Germany from the later 1890s represented, like their counterparts in other countries, an obvious expression of dissatisfaction with academic attitudes towards art. However, unlike the colonies in Scandinavia, Britain, and America, those in Germany were made up of artists who, while greatly admiring French painters such as those of the Barbizon School, had actually little direct experience of living in a French colony. Dachau was one of the most important of the German colonies. Although today the place has acquired less pleasant associations, in the nineteenth century it was

a very popular weekend resort for those living in Munich. A large number of artists worked there from about the 1850s onwards, but it was not until the late 1880s that a group of artists began to stay there on a more permanent basis. The central figure in this group was Adolf Hölzel, who lived there from 1885 to 1910. In his portrayal of peasant life, he gradually developed away from the realistic genre manner typical of most of his Dachau colleagues to an increasingly mystical and stylized one.

In its heyday Worpswede was a much smaller colony than Dachau, yet it is now the most widely known of all the German colonies. Its reputation was undoubtedly helped by its being the subject of a book by the poet Rainer Maria Rilke. Its fame today, however, is principally due to its close associations with one of the most popular of German painters, Paula Modersohn-Becker.

Worpswede is a village about twenty miles north of Bremen and about thirty miles from the North Sea. In the 1880s the main form of transport from Bremen was a weekly mailcoach. However, the land here is so flat that the journey from Bremen can be made by bicycle in one and a half to two hours. This is probably the best way to appreciate the local scenery, which is so devoid of striking landmarks that it can leave no impression at all if crossed hurriedly by car. The only part of it which can in any way be called dramatic is the Teuffelsmoor (Devil's Moor) just north of Worpswede. This enormous stretch of marshland, cut into by the River Hamme, impresses through its bleakness. In the nineteenth century the Teuffelsmoor provided an important source of local income—peat cutting. Some of those then engaged in this activity used to live on the moor in small peat-covered stone or wood constructions which, even given the romantic preconceptions of the artists and tourists who visited the area in this period, must have seemed like the dwellings of a primitive people. The village of Worpswede is in contrast quite a homely place, a scattered collection of dwellings gathered round a low wooded hill. Originally many of the houses had extremely thick thatched roofs which reached almost down to the ground and which from a distance could well have been mistaken for haystacks. Before the arrival of the artists, the population was made up principally of peat-cutters and peasants. There was also a large hostel for poor people situated in what is now the town hall. Walking through the wood behind the village one reaches the top of the Weyerberg, which, although only fifty-seven metres high, is one of

94 Peat boat on the River Hamme, c.1900

the highest points in the vicinity. Here the wood opens up, and one is offered a wide view of the surrounding landscape, which, seen from this angle, takes on a very different, almost idyllic aspect. From here one is also spared the sight of the numerous suburban-style houses which have grown up in the village in recent times.

In 1884 a student from the Düsseldorf Academy, Fritz Mackensen, came to this then scarcely visited village on the recommendation of an eighteen-year-old Worpswede girl, Mimi Stolte, whom he had met in Düsseldorf. He stayed in Worpswede with Mimi's parents. The locals seem to have found Mackensen's enthusiasm for the place difficult to understand. One evening Mackensen commented to a sower on how beautifully clear the sky then was. To the latter, however, such an evening just meant that it was going to be a very cold night. This uncomprehending attitude towards artists on the part of the locals was to continue into the next decade when the place became established as a colony. One peasant was then to comment that painting was simply a 'way of passing the time'. According to Rilke, the villagers and the artists were always to keep a certain distance from each other.

Mackensen returned to Worpswede in 1886, and again in the summer of 1889, when he brought with him a friend from the Munich Academy, Hans am Ende, and another from the Düsseldorf Academy, Otto Modersohn. One of the latter's diary entries for

that summer reads: 'glorious grey day; woman in the field against the sky—Millet.' Later in the summer Mackensen and his friends were joined by another student from Düsseldorf, Carl Vinnen. They all came back to Worpswede the following year. Apart from am Ende, they were all members of a student club at the Düsseldorf Academy called the Tartarus, which had been founded in 1885 as a form of protest against the rigidly academic training at the art school. The main function of the club, however, was not so much to discuss art but rather to drink and socialize. Mackensen and his two friends were slightly ridiculed by their Tartarus companions for enjoying such an unpromising-sounding place as Worpswede. One of the few who were genuinely interested in what they had to say about the village was Fritz Overbeck, who went there with them in the summer of 1892. Two years later another Tartarus member, Heinrich Vogeler, also began to associate himself with the village.

96 Stadt Bremen inn, Worpswede, c. 1900

95 From the left: Hans am Ende, Otto Modersohn, Fritz Overbeck, and Fritz Mackensen, c. 1896

When these artists had originally come to Worpswede their intention had simply been to work there during the spring and summer months. Almost immediately, however, they began to regret not being able to stay for the autumn and winter, thinking that to do so would be the only way in which they would really get to know the place. Subsequently they all bought or rented property in the village, and apart from various trips abroad and to other parts of Germany, lived here all the year round. To begin with, they often used to meet in the Stadt Bremen inn (now the Trattoria da Angelo); however, this place was never to become one of those celebrated artist inns which offered unlimited credit to artists, had walls covered in paintings, or were converted into crowded studios and living quarters. Artist life in Worpswede revolved mainly around individual homes.

A great encouragement to the ideals of the early Worpswede artists was a strange rambling book called *Rembrandt as a Teacher* by Julius Langbehn. This was published in 1890 and had a wide following all over Germany. It was avidly read and discussed at Worpswede, Overbeck calling it a 'Bible of Art'. Langbehn was a psychotic, solitary writer who in the mid-1870s had studied art history and archaeology at Munich and become associated with Leibl and some of his circle. He had subsequently spent almost fifteen years travelling and researching for *Rembrandt as a Teacher*, which in the end had little to do either with Rembrandt—other than to emphasize how the Dutch

master was spiritually a German—or with art history.
Essentially, it was a textbook of what has been called
the 'Volkish' movement. This movement had grown
largely out of a dissatisfaction with Germany after
1871. A great amount of idealism and even utopianism
had led up to the unification, but the reality of political
unity had turned out to be rather prosaic. Urbaniz-
ation, industrialization, and the other consequences of
materialism were leaving their mark in an ever more
obvious way; many people thought they were destroy-
ing those ancient German traditions which they had
imagined unification would help to preserve. Lang-
behn, in common with other Volkish theorists,
extolled the primitive simplicity of peasant life and the
purity of youth. He detested the scientific and
materialistic concerns of his age, and hoped for a
world in which the artist would be hero and in turn
inspire a revival of folk art. His artistic ideal was
Rembrandt, who concerned himself with the common
man and had the virtues of 'simplicity and quiet
greatness'. In contemporary art Langbehn detested
equally the exponents of art for art's sake and of
vulgar naturalism. He believed that 'the new German
art will have to base itself on the peasantry' and
thought that the peasant genre paintings of an artist
such as Wilhelm Leibl pointed to the artistic tendency
of the future. The more sinister side to Langbehn's
philosophy, and indeed to Volkish theory in general,
was its combination of nationalism with violent
racism, antisemitism and anti-liberalism. The cultural
background to Nazism and the Third Reich was
clearly being formed.

When the Worpswede artists first settled in the
village they were undoubtedly motivated by strong
idealism. Mackensen urged them all to 'stick together
on this piece of land, so that we may later stand
upright as trees in the arts.' The image of trees, and the
idea of natural regeneration, was very common to
Volkish writers such as Langbehn. In addition
Worpswede artists were great enthusiasts of
Nietzsche, whose writings encouraged them in feeling
that they were above the preoccupations of ordinary
middle-class society. Yet it would be wrong to suggest
that in the 1890s any of them had deep or even
informed interest in politics or philosophy. In fact
their ideas about life seem at this stage to have been
very confused. Modersohn claimed that two of the
main literary influences on him then were the writings
of Bjørnson—which were of course extremely
nationalistic—and Zola's *La Terre*. Zola, a socialist
and pro-semite, was considered by Langbehn as the

'arch-enemy of the people', and someone whom all
Germans should learn to hate. The muddled political
standpoint of the Worpswede artists in these early
years was later to be emphasized by Vogeler: 'We were
all then politically illiterate. We were dreamers who
lived in a house of cards which any storm, any social
upheaval could easily have overturned. We had no
serious goal, we vegetated from one day to the next,
and painted whatever Nature put directly in front of
our noses.'

In the rather conservative context of late nine-
teenth-century German art, the Worpswede artists,
with their antagonism towards academies and
insistence on basing themselves in a village and paint-
ing largely out of doors, were seen as representatives
of the avant-garde. None the less, in the broader
context of European art at this time, their work was
relatively conventional. Their artistic heroes of the
past were Dürer and Rembrandt. A saying of the
former, describing the way in which art was implicit in

97 Fritz Mackensen, *Madonna of the Moors*, 1892. Kunsthalle,
Bremen

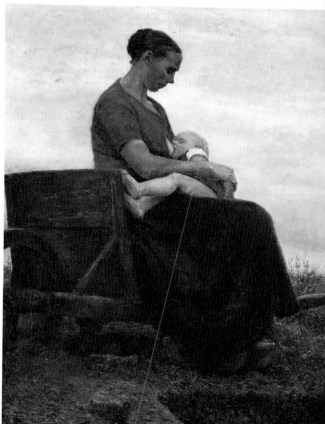

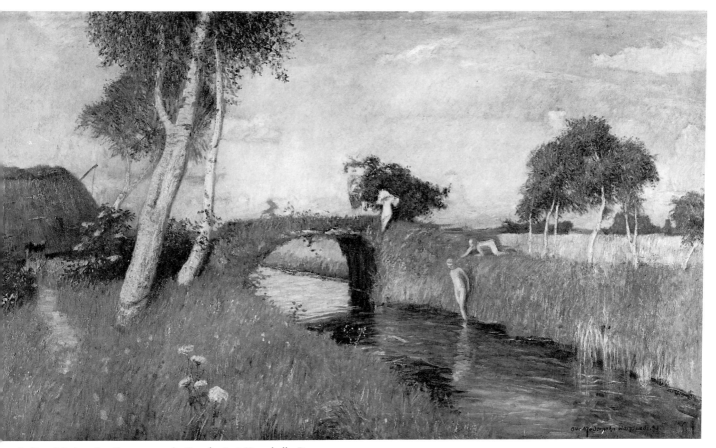

98 Otto Modersohn, *Summer on the Canal*, 1896. Kunsthalle, Bremen

nature, was apparently painted on the walls of one of their studios, and, according to Vogeler, impressed some of the French artists who came to visit Worpswede. Rembrandt meanwhile was described by a later member of the colony as 'the God of Mackensen'. Of the artists of their own century, the artists admired Bastien-Lepage and the Glasgow Boys. However, their particular obsession was the Barbizon School painters. In their search for the essential mood of a landscape, they can clearly be seen to have been influenced by the poetic realism of an artist such as Théodore Rousseau. In Rilke's monograph on Worpswede, which concentrated largely on trying to evaluate the artists' 'philosophy of nature', the artists' preoccupations were also traced back to German Romantic painters such as Caspar David Friedrich, whose work had combined extreme realistic observation with deep-rooted symbolism.

Apart from Mackensen and Vogeler the first Worpswede artists were almost exclusively landscapists, and, in the case of Hans am Ende, Carl Vinnen, and Fritz Overbeck, rather mediocre ones. Vogeler, as shall become apparent, should really be considered separately from this early group, and was at any rate too young (he was twenty-two when he first arrived at Worpswede) and not sufficiently established in the colony to make a name for himself by 1895, when the group first exhibited together. In the first half of the 1890s, the two contenders for the artistic leadership of the colony were Otto Modersohn and Fritz Mackensen. In the previous decade the two had been extremely close friends, Mackensen once writing to Modersohn that 'in a short time I came to love you as much as my own brother.' However, their rivalry at Worpswede was to drive them gradually apart. Otto Modersohn specialized in rather large landscapes,

which combine careful attention to detail with powerful simplification of forms. The small figures occasionally included within them are very stylized and seem to form an inherent part of their surroundings. Mackensen was principally a figure painter. One of his first important Worpswede canvases was the life-sized *Madonna of the Moors* (fig. 97). The theme of maturity and the 'earth mother' was one very dear to Volkish writers, and Mackensen here treats it in a grand heroic way reminiscent of Millet's approach to the portrayal of peasant life. Like all those with an artistic interest in the peasantry, Mackensen was very impressed by what he imagined to be the intense religious fervour of these people. On his first visit to Worpswede he had written to a friend: 'To look at these people at any time is wonderful; but now imagine them at a mission service, deeply devout

under the open sky. This morning we went by a carriage to a nearby village and I listened to four preachers until six o'clock at night. That means that I sketched these devout people during the sermons. I am blissfully happy at the thought of later making this into a painting.' It was not until 1892 that he began to carry out this project. *Prayers on the Moor* (fig. 99) was painted completely out of doors and was so large that the artist had to attach it to the wall of the village church. Whenever there was a storm at night, he would get out of bed and try to protect his work as best he could. It was finally completed by 1895 and shortly to enjoy a great success.

In the winter of 1894–5 the Worpswede artists exhibited together for the first time in the Kunsthalle at Bremen. The exhibition drew a mixed response from the public and strong antagonism from con-

99 Fritz Mackensen in front of his painting *Prayers on the Moor* (1892–5)

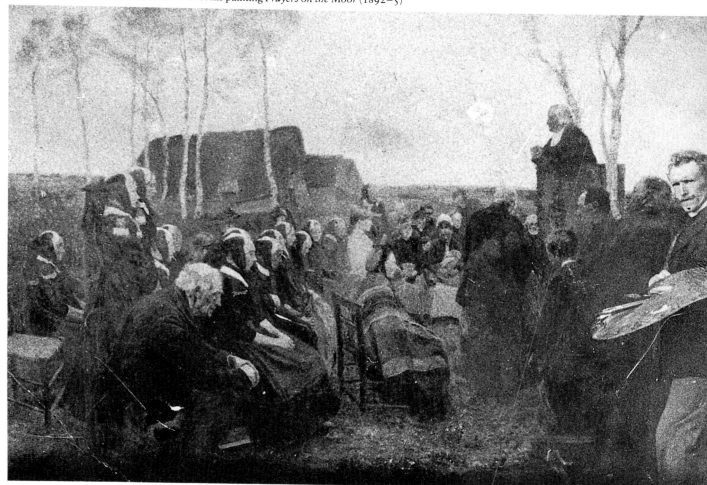

100 Heinrich Vogeler, *The Three Kings* (Worpswede is shown in the background), 1897. Private Collection

101 Martha Vogeler with her daughters, (from the left) Mieke, Bettina, and Mascha, 1900s

servative critics. The bastion of official taste in Bremen was Arthur Fitger, who in addition to being a critic was a painter of turgid historical and allegorical works. He termed the Worpswede painters the 'Apostles of Hate' and the room in which they exhibited at Bremen the 'Laughter-Room'. None the less on the strength of their Bremen showing, the Worpswede artists were asked to contribute to the International Glaspalast Exhibition held in Munich in the spring of 1895. When they exhibited their work there, they won general acclaim, and were likened to the Glasgow Boys. Mackensen was awarded a gold medal for his *Prayers on the Moor*, an honour which led to a number of people coming to study under him in Worpswede in the following years.

In these same years Vogeler was becoming more and more of a centre of attention in Worpswede, largely as a result of his gradual creation of a fanciful and elegant house and garden on the south-western side of the village. Vogeler came from a wealthy family and had been able to realize this *art nouveau* fantasy, called the Barkenhoff, after having received his father's inheritance in 1895. The style of this place was indicative of

how different Vogeler was as an artist to the others in the colony. Vogeler's interests indeed lay less in painting than in illustration and design, in both of which arts he evolved an extremely intricate *art nouveau* manner. His few canvases are also very decorative, and further reveal his aetherial sensibility. Despite his statement about everyone at Worpswede in this period doing straightforward paintings from nature, Vogeler himself always romantically transformed reality. In a painting of 1897 (fig. 100) he turned Worpswede in winter into Bethlehem at the time of Christ's birth, and made the younger of the Three Kings look like a lovesick troubadour.

Vogeler extended his artistic fantasies to his lifestyle. He loved dressing up, and would have himself photographed in a variety of costumes, ranging from that of a knight in armour to that of an early nineteenth-century dandy. When in about 1897 he fell in love with a very young Worpswede girl, he did so in an equally extravagant way. The girl in question, Martha Schröder, was a peasant's daughter who worked as a maid in the Stadt Bremen. Her elder sister, Maria, had already been associated with Fritz Mackensen, who

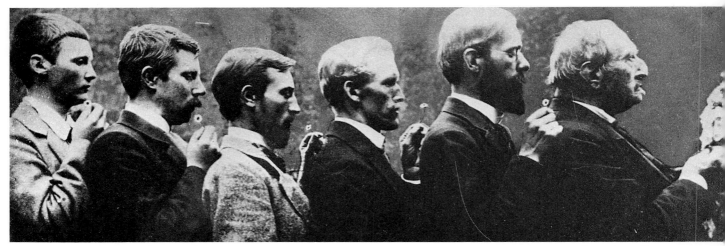

102 From the left: Heinrich Vogeler, Hans Müller-Brauel, Fritz Overbeck, Fritz Mackensen, Otto Modersohn, and Hermann Allmers, 1898

had the reputation in the village of being a great womanizer. In his memoirs Vogeler made frequent references to the very confident and chauvinist way in which Mackensen would make advances to women. In contrast Vogeler characterized himself as being exceptionally shy, despite his sometimes extrovert appearance. Moreover he felt that Martha was initially mistrustful of him because of his wealth and elegant manner. Soon, however, she began to respond to her shy suitor. During the long period of courtship, Vogeler gave free vent to his fantasies by clothing Martha in medieval costume and posing himself as an earnest knight or troubadour anxious for her favours. His desire to alter Martha's image according to his whims did not limit itself to devising fantastical costumes for her (an activity in which he was to continue to indulge in later life). He was also determined to re-educate this simple country girl and ensure that she had a firm knowledge of German culture.

In the summer of 1897 a young woman art student from Bremen came to stay in Worpswede. Paula Becker, as she was then called, came from a cultured well-off family with aristocratic connections. Her parents had at first been sceptical about their daughter's becoming a painter, thinking this to be a difficult and unsuitable career for a woman. Reluctantly they had allowed her, in 1896, to study at the Berlin School of Art, which was one of the first German art schools to accept women as students. In Worpswede, during her summer break from the school, she took instruction under Fritz Mackensen. She seems to have been exceptionally happy during her first stay in the village, as is revealed in her letters and diary entries of this time. She had very romantic notions about the place and its surroundings, and, on at least one occasion, filled a rucksack with some sandwiches and a copy of Goethe's poems, and wandered alone all day on the moors. In an ecstatically worded diary entry for 24 July 1897, she exclaimed: 'Worpswede, Worpswede, Worpswede! . . . It's a wonderland, a land of the Gods!' In this same entry she also gave her first impressions of some of the artists in the colony. She begun with Mackensen, whom she described as a famous man, with an enormous fund of energy and a deep understanding of the local peasantry. However, her favourite among the artists at this time was Vogeler, whom she affectionately referred to as 'little Vogeler'. She found him not as hardworking as Mackensen, but loved him for his quiet charm and because he was so much of a dreamer. She wrote that he was someone who lived in his own world. He always carried in his pocket a copy of the works of the medievel minstrel Walter von Vogelheide, read poetry whenever he could, and frequently played the guitar which he kept in his studio. At this date Paula appears to have had little contact with the other artists in the colony. Otto Modersohn, then recently married, she hoped she would get to know better, as she thought that there was something very sympathetic about his manner and liked his paintings.

Paula herself was primarily a figure painter who was to aim in her art for effects of ever greater simplicity. She was soon to find Mackensen's approach to the figure too 'genre-like' and to think instead that the local peasantry should be represented in a style approximating to runic script. However, she was not

to achieve artistic maturity until the next decade, when she had direct contact with contemporary French art, in particular with that of Cézanne.

In the autumn of 1898, she returned to Worpswede after having completed her course in Berlin and been on a trip to Scandinavia. She was now to establish herself more permanently in the village, and soon acquired a studio a few minutes' walk from the Barkenhoff. This year at Worpswede, Mackensen had another woman student, Clara Westhoff, whom Vogeler soon saw walking arm in arm with her teacher on the moor. She immediately became a very close friend of Paula's. She was also a very talented student, but was to practise as a sculptor rather than as a painter. Two other women artists who came to be Mackensen's pupils at about this time were Marie Bock and Ottilie Reyländer. In a small colony such as Worpswede, all these women were more likely to receive attention as artists than they would have done in a city. None the less their sex appears to have prevented them even here from being taken really seriously as artists. It is significant that Rilke's 1903 monograph on Worpswede makes no mention of any of them. Paula read with great interest the diaries of Marie Bashkirtseff, which refer on several occasions to the difficulties of being a woman painter. Unlike Bashkirtseff, however, Paula played no part at all in the growing woman's movement of this period: she once went to a lecture in Berlin on *Goethe and the Emancipation of Women* and came out disagreeing with the hostile attitude towards men 'shown by these modern women'. She had in fact little interest in politics generally, and the few political views she expressed were hardly radical. She apparently used to tell Vogeler that what Germany really needed was a strong dictator-like figure such as Napoleon.

Paula continued greatly to enjoy herself at Worpswede, and took an active part in the community's social life, which included regular musical gatherings at the Barkenhoff (held by candlelight in the 'White Room'), poetry recitals, and parties. At parties Vogeler would sometimes take out his guitar and sing 'nigger songs', and there would be much dancing—an activity for which Paula had apparently unlimited energy. But the most publicized communal event in Worpswede in the late 1890s was the celebrations in honour of the visit to the village of the poet Hermann Allmers. A Bremen newspaper reported that all the Worpswede artists had dressed up in medieval costume and carried the poet in triumph into the village on a flower-strewn cart. The truth of the story was

rather different. On the day Allmers was expected, everyone had indeed put on their costumes and waited patiently outside the village for the poet to arrive. However, when he did not turn up (he had been delayed and was not to come until the following day), the triumphal entry was cancelled. Rather than to lose an important opportunity for publicity for the colony, Clara Westhoff volunteered to cycle to Bremen and claim that the event had actually taken place. Her account was accepted by everyone, and came to be included in many of the early articles on the Worpswede colony.

In December 1899 the Worpswede artists had their second group exhibition in the Bremen Kunsthalle. This time the criticism of the press was directed principally against the women artists in the colony, the reactionary Fitger finding the works of Paula and her woman friends to be indicative of the 'miserable lack of ability' to be expected of the 'naïve beginner'. This was the first time that Paula had shown her works in public, and the director of the Kunsthalle had asked Vogeler beforehand to dissuade her from doing so. Almost immediately after the exhibition Paula went off to Paris, accompanied by Westhoff. Paula enrolled at the Académie Colarossi, while her friend studied sculpture under Rodin. Much of the two women's free time in the city was spent together. Among the French artists whose work Paula came especially to admire during this trip were Millet, and two specialists in Breton subject-matter, Lucien Simon and Charles Cottet. At an exhibition in the gallery of Ambroise Vollard she also had her first encounter with the art of Cézanne. In June of 1901, towards the end of Paula's stay in Paris, Otto Modersohn, his wife, and Fritz Overbeck came to the city. Modersohn's wife died while she was there, and Otto soon came to enter into a close friendship with Paula. Otto listed in his diary the qualities which he liked in Paula. Like him, he wrote, she was totally dedicated to art, and had a love of 'Nature, country life, Worpswede, old houses, old establishments, etc.'. In addition she was 'outwardly charming, sweet, strong, healthy, energetic', and had a cheerful, lively fresh temperament' which Otto found compensated for his own rather more sober one.

Otto, Paula, and Westhoff were once again in Worpswede later in the summer of 1900. This same summer Rilke, then just back from his trip to Russia, first came to the village. He had been invited to stay here by Vogeler, whom he had met on a trip to Florence in 1898. On his first evening here he and Vogeler went for a walk on the moor and on re-

103 Paula Modersohn-Becker and Otto Modersohn, *c.* 1900

entering the village met a woman standing outside in the dark. It was Westhoff. She and Rilke soon embarked upon a conversation about Russia, and as this continued Westhoff went indoors to bring out a spirit lamp so that they might talk longer. Rilke, who had immediately liked Worpswede, soon came to figure prominently in the social gatherings of the colony, becoming particularly good friends not only with Vogeler and Westhoff, but also with Otto and Paula. He continued to enthuse over Russia, and introduced Vogeler and others to the work of authors such as Tolstoy and Dostoevsky. He also undoubtedly helped to foster Vogeler's interest in Communism.

In the autumn of 1900 Paula and Otto announced their engagement, and Paula went off briefly to Berlin to learn how to cook in preparation for the marriage. She was joined there by Westhoff. The wedding was held in Worpswede in May of the following year. There were two other weddings in the village that spring: that of Vogeler to Martha Schröder in March, and of Rilke to Westhoff in April. The latter, after their marriage, settled in the nearby village of Westerhede.

By this date there were growing tensions within the colony, with two main opposing camps now formed. On the one hand there were Fritz Mackensen and Hans am Ende, both of whom were becoming increasingly reactionary; indeed they were soon to join the German army as reserve officers. On the other hand there were the Vogelers, the Modersohns, and the Rilkes. One rather minor incident which occurred shortly after 1901 clearly brought out the hostility that had by now developed between these two factions. One day Paula was posing naked to Otto in the wood behind Worpswede. She was seen by a local who immediately went to report the incident to everyone in the village. There were rumours that there had been an orgy. Mackensen and Hans am Ende were incensed. They found it disgraceful that the Modersohns should have upset the moral sensibilities of the villagers, and thought that the two offenders should be made to leave the colony. Vogeler went to see Hans am Ende about this, and was challenged to a duel, which of course never took place.

The Barkenhoff, which was the main meeting-place for Vogeler and his friends, was unquestionably the intellectual centre of Worpswede, and included among its guests at this time such distinguished representatives of contemporary German culture as the writer Gerhart Hauptmann. (On her first visit to Worpswede in 1897, Paula had in fact invoked Hauptmann's fantasy novel, *The Sunken Bell,* to describe the magic of the village and its surroundings.) A musical gathering at the Barkenhoff is the subject of a large canvas by Vogeler, *Summer Evening at the Barkenhoff* (plate 8) of 1904–5. In this the artist is seen playing a violin, his wife is in the centre of the picture, and the group to the left of her includes (from left to right) Paula, Otto, and Clara. The mood of this highly stylized picture is sad and contemplative.

Even within the Barkenhoff group of friends, the atmosphere was not altogether harmonious. Westhoff, after she had married, was considered by both Paula and Vogeler to have become a much less lively person. She seemed to be living just for her husband, and the two of them were spending less and less time with their Worpswede friends. This particularly upset Paula, who once wrote a purposefully formal letter to Westhoff to complain about her behaviour. In this she regretted that a woman should so love her husband that she should lose her own identity and neglect her relations with other people. She also said how she found it so much more natural that people should live as communities rather than as isolated families. The break in her friendship with Westhoff, however, was only temporary, and at any rate the latter's marriage was shortly to break down.

More long-lasting was Paula's disillusionment with Otto, which had also set in shortly after marriage. She

noted in her diary that she was no less lonely when married than she had been as a child. She wondered whether it would not be better to live with the illusion that one day one might be able to find a perfect soul-mate than to be daily confronted with the evidence that this would never be possible: 'The feeling of not being understood is heightened in marriage by the fact that one's entire life beforehand had the aim of finding a being who would understand one.' It was not that Otto was an especially unsympathetic husband. Indeed he had an enormous admiration for his wife's work, and was himself greatly influenced by its ever more daring simplifications. The main problem was that Paula felt that to develop as a painter she needed to be much more on her own, and above all to get away from the claustrophobic environment of Worpswede.

Paula visited Paris for the second time in 1903, and made two further visits to the city between then and 1907. During these same years she painted all the works by which she is now best remembered. The residents of the Worpswede poorhouse, in particular

104 Paula Modersohn-Becker, *Old Dreebein*, 1904. Kunsthalle, Bremen

an ugly old woman dwarf known as 'old Dreebein', provided her with the subjects of several of these works (fig. 104). Other favourite subjects included Worpswede children, suckling mothers, and herself. She painted herself nude a number of times—an indication perhaps of her morbid self-preoccupation at this period, as well as of her desire to portray the human figure in an ever more primitive manner. All the works of these years were far bolder than anything else produced at Worpswede at this time, yet were not to be fully appreciated until after the artist's death.

In February 1906 Paula embarked on what was to be her last and longest visit to Paris. About three weeks after arriving there she wrote to her sister: 'I am becoming something—I am living the most intensely happy time of my life.' The same could not have been said of Otto, who on her insistence had remained behind in Worpswede and was now pleading with her to come home. When his pleas failed he even mounted a campaign among his friends to put pressure on her. Overbeck was one of those who reluctantly wrote to her on Otto's insistence. Eventually, and contrary to Paula's wishes, Otto came out to see her in Paris in June. He returned in the autumn for a longer visit. Finally in the spring of 1907, Paula came back to Worpswede. By this time she was pregnant by Otto, and unable to do much painting. On 2 November she gave birth to a daughter. Just over two weeks later, as she got out of bed for the first time since her confine-ment, she suffered thrombosis of the leg and a fatal heart attack. She was thirty-one. Her tomb was designed by a German sculptor and architect, Bern-hard Hoetger, whom she had met and become very friendly with on her last visit to Paris.

Hoetger himself came soon to be closely associated with Worpswede, and in the 1920s was to build here some strange *art nouveau* monuments. With Hoetger's arrival, the village came principally to attract craftsmen rather than painters, and has con-tinued to do so up to the present day. The original colony faded out soon after Paula's death. Otto, too sad now to remain in Worpswede, moved in 1908 to the nearby village of Fischerhude, where he was to marry for the third time, then become estranged from his wife, and die in 1930; his house there is preserved as a museum of his work. The same year that Otto left Worpswede, Clara Rilke-Westhoff moved to Paris to be near Rodin, for whom Rilke had recently worked as a secretary. Overbeck, who had settled in the Swiss Alps after 1905, died in 1909. In the following year Mackensen took up a post as professor in the art

school at Weimar; he was to come back to Worpswede in 1918, by which date the only remaining member of the colony still associated with the village was Vogeler.

The second half of Vogeler's life sadly illustrates the dangers to which inveterate dreamers are subject. In 1910 his wife, Martha, whom he had tried to mould into the ideal woman, fell in love with a young visitor to the Barkenhoff. In the ensuing personal crisis, Vogeler was undecided as to whether he should emigrate to a remote island, perhaps one of the Shetlands, or to a city. He chose to go to Berlin, and remained there until the outbreak of World War I, when he volunteered enthusiastically to fight for the German army. The war killed Hans am Ende, and made Vogeler intensely disillusioned with Germany. In 1918 he wrote an irate letter to the Kaiser, and would have been executed had it not been for his reputation as an artist. He was briefly interred in a mental home instead. He returned to the Barkenhoff, where Martha and their children were still living. From now on he embraced Communism as whole-heartedly as before he had immersed himself in Germany's medieval past. The Barkenhoff was turned into a sort of commune, and its beautifully landscaped but useless grounds were transformed into crop-producing gardens. Factory workers, anarchists, radical pacifists, and other politically-minded figures came to be associated with the place. It was also visited by such distinguished left-wing writers and artists as Martin Buber, Heinrich and Thomas Mann, and Diego Rivera. Martha made her final break with Vogeler in 1920 when a woman known as 'Red Mary' came to live with him at the Barkenhoff. 'Red Mary' later went off with another man whom she met here. By 1923 it had become obvious that the commune experiment had failed, and he handed his property over to Red Aid, an organization devoted to the care of underprivileged children of workers and political prisoners. In 1927 he was finally obliged to move to Moscow. This must have delighted Mackensen, who had frequently reported the political activities of the Barkenhoff to the police. In 1938 Mackensen wrote an article about Worpswede and its artists in the *Nationalsozialistischer Gaudienst*. In this he talked

105 Tomb of Paula Modersohn-Becker by Bernhard Hoetger, Worpswede

about Vogeler as having been 'a good German' until he had fallen victim to Communism; significantly this sentence was omitted when the article was reprinted after World War II. There is much speculation as to what exactly happened to Vogeler during his years in Russia. It is known that he was briefly married again, expelled from the Communist Party, and sent to Kazakhstan, near the Caspian Sea. It seems that he died in Siberia in June 1942 after having been forced to work on road construction. Someone later claimed to have seen his dead body covered in lice.

7
The Rákóczi March

NAGYBÁNYA (FORMERLY HUNGARY)

THE LEADING Hungarian artists of the nineteenth century spent much of their lives outside their country. They found the artistic environment of Hungary too conservative and parochial to allow them fully to develop their talents. One of the best known of these artists was Mihály Munkácsy, who after being trained in Düsseldorf settled in Paris in the early 1870s. He spent the summers of 1873 and 1874 in Barbizon, where he had gone to be near his friend and compatriot, László Paál. He painted landscapes and peasant genre scenes, but was best known for his portrayal of episodes from recent Hungarian history. As with many of the greatest Hungarian writers and musicians of the nineteenth century, Munkácsy's work reflected his country's struggle against Austrian domination. The War of Independence (1848–9), in which the Hungarians were defeated by the Austrians only after the latter had invoked the aid of the Russians, provided Munkácsy with the subjects of many of his paintings. These paintings always featured scenes illustrating the bravery of ordinary Hungarian people, and can be compared with the portrayal of the Vendean wars by Brittany-based contemporaries of Munkácsy such as Robert Wylie. Munkácsy's sombre and expressive canvases were enormously admired in Paris in the 1870s, and indeed continued to have great popular appeal and win the artist much official acclaim right through the next decade. However, to the serious art critics of the 1880s these works had begun to seem very old-fashioned in comparison to the lighter and subtler art of Bastien-Lepage. In 1892, only two years after Munkácsy had been awarded the Légion d'honneur, Low encountered him by chance in Paris and found him then to be a most pathetic figure who kept on repeating that the only way to maintain his success in the salons was to paint lighter and lighter ('*faire clair, voyez-vous, il n'y a que ça*'). Low was not surprised to hear shortly afterwards that the artist had been taken to a mental home.

Despite the fame which both Munkácsy and Paál acquired in France, relatively few of their compatriots came to join them there. By far the most important centre for Hungarian artists in the nineteenth century was Munich. The many Hungarians who worked in this city from the 1870s onwards are today virtually unknown outside Hungary, perhaps largely because the greatest of them came back in later life to work in their native country. Most of them developed in Munich an interest in peasant genre painting—the speciality of this city—and on their return home largely devoted themselves to the portrayal of rural Hungary.

For the artist fascinated by picturesque rural life, nineteenth-century Hungary offered a wealth of motifs. Folklore traditions continued to be very strong here right up to the end of the century, with each district of the country having its own distinctive and generally highly colourful costumes and craftware. The richness of Hungary's folklore was to a large extent due to the country's having comprised a multitude of different races. In the nineteenth century the Magyars—the original Hungarians—represented only a small proportion of the country's total population. They were mainly based on the Great Plain, the enormous stretch of virtually treeless lowland which occupies most of present-day Hungary. For the Hungarian nationalists of the last

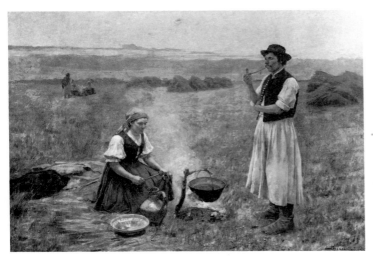

106 Sándor Bihari, *Preparing the Evening Meal*, 1886. Hungarian
National Gallery, Budapest

century this area had understandably strong
emotional associations. One of the leading Hungarian
poets of this period, Sándor Petőfi, who was later to
die fighting in the War of Independence, spent much of
his short life walking around the Great Plain. He
wrote that the landscape here was the most beautiful
that he had ever known, because its uninterrupted
flatness suggested for him the concept of freedom.

It was thus rather ironical that one of the first artists
to encourage an interest in painting the life and
scenery of the Great Plain was an Austrian, August
von Pettenkofen, who first came here in 1849 while
serving as a soldier in the Austrian army. He was then
stationed in Szolnok, a small town on the banks of the
Tisza River about forty miles south-east of Budapest.
He found the market-place here, with its white
thatched houses so characteristic of the region, to be
especially quaint, and was also attracted by the
various gipsy encampments that were located in the
vicinity. He returned to Szolnok in the early 1850s, and
thereafter came here regularly as a painter for the rest
of his life. Through his example a large number of
Austrian and Hungarian artists began to spend the
summer months in Szolnok. Among the latter were
Lajos Deák Ébner, who had studied in Munich and
worked in 1873 in Barbizon with Munkácsy and Paál,
and Sándor Bihari, who had been told about Szolnok
after meeting Pettenkofen in Paris. Both were special-
ists in peasant genre, and produced some of their best

works at Szolnok. By 1899 so many Hungarians had
started coming to Szolnok that a group of them,
including Bihari, wrote to the major of the town
suggesting that he should have studios built for them.
In this petition they emphasized how important it was
for the future of Hungarian art that a colony should be
allowed to thrive in such a typically Hungarian town
as Szolnok. Szolnok became officially established as a
colony in 1902, with the building of the first munici-
pally financed studios. The greatest artist associated
with the colony at this time was Adolf Fényes, whose
paintings of peasant life are more simplified and con-
cerned with purely formal qualities than the generally
more detailed and anecdotal works of his Szolnok
predecessors. By this date other places on the Great
Plain had come to be closely associated with artists. In
and around the market town of Hódmezővásárhely
there gathered a group of artists, headed by János
Tornyai, who came to be known as the School of the
Great Plain. Tornyai, a painter of peasant birth who
worked in a sombre manner reminiscent of
Munkácsy, had ambitions that Hódmezővásárhely
should one day become a 'Peasant's Paris'.

Yet the greatest Hungarian colony grew up not in
the Great Plain, so beloved by the Hungarian national-
ists, but in a small town in the northernmost part of
Transylvania, an area of exceptionally complex ethnic
make-up and which now belongs to Romania. Nagy-
bánya, as this town was called, played a major role in
the history of Hungarian art, but it was also the most
international colony in eastern Europe, attracting in
large numbers artists not only from Hungary, but also
from Romania, Germany, Poland, Russia, Bohemia,
and the Balkans.

In tracing the history of Nagybánya's artists one has
to go back to Munich in the 1880s. At the beginning of
this decade there arrived in the city a painter of
Armenian aristocratic background called Simon
Hollósy. Hollósy's family had originally been called
Corbul, but, like many of the minority nationalities in
Hungary, had made their name Hungarian. (Hollósy
is a direct translation of Corbul, which means 'crow'.)
Hollósy studied at the Munich Academy of Art, but
left before completing the course. In common with
many of his contemporaries in Munich, he became
obsessed with the art of Bastien-Lepage. Seeing
Bastien-Lepage's *Beggar* at the Munich Glaspalast in
1883 led him to paint his coyly erotic *Husking*, the
greatest of his peasant genre paintings of this period.
In the second half of the 1880s, Hollósy, then still only
in his twenties, started up his own school in Munich.

This soon became a most prestigious establishment, attended by students of many different nationalities. Hollósy apparently had extraordinary abilities as a teacher, and was a most engaging and magnetic personality. He was very unconventional, and despite his aristocratic upbringing cultivated a very plebeian manner. He had a habit of smashing his canvases over his head when he was not satisfied with them, and would shock polite society by turning up at dinner parties without socks and often after climbing through the window.

In 1896 two of Hollósy's former students, István Réti and Lajos Thorma, suggested to Hollósy that he should bring his school that summer to Nagybánya, which was Réti's and Thorma's home town. The idea appealed to Hollósy, particularly as he had recently received a commission to paint a castle near to Nagybánya at Huszt (this is now in Russia). It was thought that the mayor of Nagybánya, Olivér Thorman, who was known to be sympathetic towards artists, would be interested in helping to finance the whole enterprise. A letter was written to Thorman, defining the aims of having a large group of artists working in Nagybánya: 'Only if nurtured by the soil of our native land, only beneath a Hungarian sky and by renewed contact with the Hungarian people, can Hungarian art acquire strength, achieve greatness, and become genuinely Hungarian.' Thorman was very keen that the renowned Hollósy should come to Nagybánya and agreed to pay him and forty painters the second-class train fare to the town from the Hungarian frontier. In addition, the town would provide a temporary studio for use as a school. The conditions were that Hollósy should stay for at least six months; if a longer stay were envisaged, then the town would be prepared to build a more permanent studio. Despite such a show of generosity on the part of Thorman, Hollósy was still worried about the financing of the trip: for all his success as an artist and teacher, he was constantly harassed in life by financial problems. Fortunately another of his former pupils, Béla Iványi Grünwald, had recently completed a large picture, which everyone thought would fetch a large sum of money. Grünwald volunteered to go on ahead to Budapest, and submit this work to the large exhibition to be held there that year as part of the celebrations in honour of the thousand years of Hungary's existence. Once exhibited, he was convinced that the work would be sold. He would then send the money to Hollósy in Munich.

Everyone in Hollósy's circle in Munich looked forward eagerly to going to Nagybánya. Hollósy had managed to persuade twenty-six Hungarians, nine Germans, three Russian Poles, one American (E. Johnson from Boston), and one Englishman (Cohn-Fowler from Calcutta) to come with him. Apart from Réti, Thorma, Grünwald, and another Hungarian, Oszkár Glatz, all these artists were still students. Réti, who was later to be the chronicler of the Nagybánya colony, was put in charge of the administration of the trip. He found himself having to answer innumerable questions about Nagybánya. Apparently not even all the Hungarians knew where the place was. However, the strangest questions came from the foreigners, and in particular Johnson, who was intending to come to Nagybánya with his mother and grandmother. According to Réti, Johnson had 'as much idea about Hungary as about central Asia'. He wanted to know whether people slept in beds in Hungary, whether there were proper houses there, whether horse milk was still the national drink, and whether it was true that the Hungarians ate raw meat tenderised by being placed under a horse's saddle. The last was apparently a widespread myth about the Hungarians. Réti reassured Johnson on all these points and even said that 'the English eat meat much rawer than we do.'

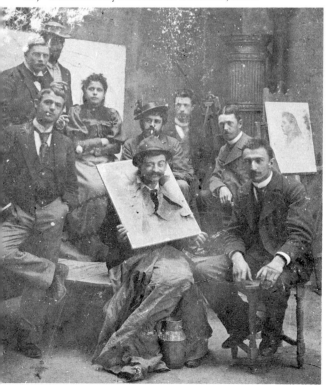

107 Simon Hollósy and students at Munich, 1880s

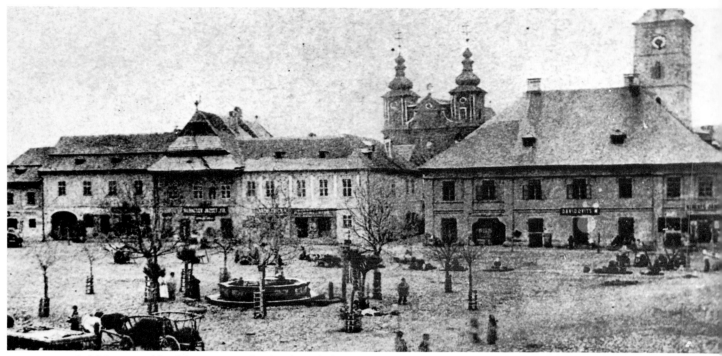

108 Main square, Nagybánya, c. 1890, showing the Catholic church and the St. Stephen Tower

Shortly before the intended date of departure, another Hungarian artist living in Munich, Károly Ferenczy, said that he wanted to join the group. Unlike the others going to Nagybánya, Ferenczy had not previously had any connections with Hollósy. He had studied principally in Italy and France, and was then well established in Munich as a genre painter much influenced by Bastien-Lepage. Everyone in Hollósy's circle greatly admired his work, and thought that his decision to come with them augured well for the success of the venture. The only uncertainty which now troubled Hollósy was that he had not yet received any money from Grünwald, who had been in Budapest for some time, and, Hollósy assumed, must surely have sold his painting by now. Eventually Hollósy and his group set off for Nagybánya, still not having heard anything from Grünwald. It was concluded that the money would be waiting for Hollósy in Budapest, where they all intended to break their journey.

They arrived in Budapest late in the spring of 1896 to find that Grünwald's picture had been rejected for the Millennium Exhibition. Instead they mainly found in this exhibition the most turgid academic works. Almost everything on show confirmed their feelings about how artistically backward Budapest then was.

They were shocked that no one here seemed to have been aware of the achievement of Bastien-Lepage or indeed of any of the recent developments in art. There was one artist in the exhibition, however, whose work did impress them all. This artist was Pal Szinyei Merse, an idiosyncratic and reclusive painter who had reached artistic maturity in Munich in the 1870s but had still to achieve a reputation other than as an eccentric. He painted a wide range of works, from symbolist fantasies to straightforward landscapes, but a particular speciality of his was scenes of figures in outdoor settings. One of the most original of these was the *Picnic in May* of 1873. In its vivid rendering of the effects of bright sunshine on a group of figures it is reminiscent of some of the work of the Impressionists; yet it was painted at a time when these artists had not yet exhibited together. The acclaim which Merse received from Hollósy's circle was the first real recognition that he had had. He was also very pleased when they invited him to come and see them at Nagybánya later in the year.

Although the Millennium Exhibition generally was a disappointment to Hollósy and his companions, Budapest in 1896 had much else to offer them. In honour of the millennium celebrations, a part of the

city had been transformed into a cultural centre, in which were several new museums, including one incorporating architectural elements taken from famous Hungarian buildings. An underground railway had also been built: this was the first in continental Europe, and was closely based on that of London. There were constant inaugurations and other festivities, and a general feeling of excitement and patriotic fervour filled the city. This mood seems to have affected all those going to Nagybánya. Moreover, a temporary solution was reached to Hollósy's financial problems. Grünwald had felt very ashamed, particularly in front of the foreigners in their group, about his failure to sell his painting. He had subsequently tried to make up for this by looking for other ways to raise money for Hollósy. Hollósy himself was incapable of doing any organizing, and in this respect was completely dependent on others. Eventually Grünwald had persuaded Oszkár Glatz's godfather to lend Hollósy 5,000 florints. At last they could set off for Nagybánya. They all left in a mood of great optimism, and with a belief that something very important was about to happen.

The whole town of Nagybánya was out to greet them at the railway station. The townspeople had imagined that such a distinguished artist and teacher as Hollósy would be a frail old man with a long white beard. Instead they were now confronted with a young-looking man of commanding presence and with a most impressive shock of black hair, which everyone thought appropriate to a man named 'crow'. Hollósy gave a very emotional speech, in which he was lavish in his praise of Réti and Thorma. As always, he spoke in disjointed sentences, jumping from one theme to another. Then the time came for them all to

109 Present-day Romanian girls of the Máramaros wearing the traditional Sunday costume, which is still in regular use

be taken by coach to the studio which the town had prepared for them. In the central square of Nagybánya, the youngsters from the town, who had gone on foot, joined up with the party and surrounded the coaches. In his emotion Hollósy tossed his hat into the air. The studio turned out to be a former barn which had been used for storing hay: it had been beautifully converted, and all the wood had been freshly planed down. Hollósy was asked anxiously what he thought of the place, and if it would be suitable for use as his school. 'Pigsty,' he replied, then adding: 'that's what it'll be like after we've been here.' Everyone was delighted with the studio and with the rooms that had been found for them nearby. Shortly after unpacking, the Hungarians in the group wanted to introduce the foreigners to the local gipsy band. Gipsy music and old Hungarian songs were a particular obsession of Hollósy. It was as if, Réti suggested, Hollósy wanted to recall those now distant years of his youth which he had spent in Hungary.

Nagybánya is a small town dating back to medieval times. One of the few surviving monuments of the town's medieval past is the tall St. Stephen Tower, which dominates the Nagybánya skyline. Near this is the town's central square, which is bordered by nineteenth-century buildings in a squat baroque manner. To the south of the town lies an extensive and very fertile agricultural plain. To the north is a series of steep, distinctively-shaped hills, which look as if they have been taken from a Japanese landscape painting. They are covered in chestnut trees, which, when the artists arrived, were in full bloom. It was the northernmost part of the town which had been designated for the artists. They shared the area with the local mining population, most of whom lived in a group of low, ramshackle houses lining a road called the Street of the Red Valley. The town had been a mining centre for many centuries, and in fact its name means 'large mine'. Mining engineers were brought in from France and England, most of whom could not speak a word of Hungarian, even though many had been resident in Nagybánya for periods of up to ten years. They were thus extremely pleased at the arrival of the artists, as they at least had other people to talk to. Most of the population in Nagybánya itself was Hungarian, but the villages nearby were mainly Romanian. The hills behind the town mark the beginning of an extremely wild and largely mountainous district of Transylvania called in Hungarian the Máramaros. Today it must be one of the few areas of Europe where the villagers continue to wear their

110 Market-place, Nagybánya, c.1890

traditional costumes and live in wooden houses adorned with intricate carvings. Much of the area in the nineteenth century was too inaccessible to attract many visitors, and even now few tourists go there. It would have been a perfect painting ground for the Nagybánya artists, but Oszkár Glatz was the only one determined enough to paint there; to do so he had to disguise himself in peasant costume and construct a makeshift hut to sleep in.

All those who had accompanied Hollósy to Nagybánya, but in particular the foreign artists, were excited by the variety of ethnic types to be seen in the town, especially on market days, when colourfully dressed peasants and gipsies from miles around would fill the place. Even the miners, with their expressive blackened features, seemed picturesque to the artists and to offer limitless artistic potential. Hollósy's pupils were all very pleased with the models they had to paint, so different from the ones to whom they had been used in Munich. The new models included gipsy boys, peasants in long cloaks, and, to use Réti's words, 'shaky old men with squashed faces'. Unfortunately there were difficulties at first in persuading many locals to pose. Thus to begin with, the same models had to be used again and again.

Teaching in Hollósy's school had begun almost immediately, with the models placed outside the studio in the shade of large chestnut trees. This was in itself a novelty to the students, who in Munich had always painted indoors, with the model lit from only one side. Everyone continued to be impressed by the brilliance of Hollósy as a teacher, although now, having to spend so much time with him, they also began increasingly to see the more tyrannical side to his character. Every evening, in what is now the main park of Nagybánya, Hollósy would give a guitar recital, and would reprimand severely all those of his students who failed to turn up.

Whereas Hollósy had come to Nagybánya with the intention of staying for only the summer months, Károly Ferenczy, his main rival among the experienced artists who had accompanied him there, had always been interested in the possibility of settling in the town on a more permanent basis. He made a definite decision to do so almost immediately on seeing the place. His family and furniture arrived from Munich about a month later. The house into which they all moved was to be his main home until the end of his life. It survives to this day—a small building with a garden overlooking the woods that lead up to the foothills of the Máramaros.

Réti wrote that when Ferenczy first arrived at Nagybánya, he seemed like 'a young English officer from a Kipling short story who had found himself serving in some distant outpost in India'. Ferenczy was tall, distinguished, and always immaculately dressed. He was, as Réti admitted, the exact opposite in character to Hollósy. Yet, to begin with, the two men had a great respect for each other. Ferenczy found Hollósy to have a magnetic personality, and Hollósy, who normally disliked people who were so polite and attentive to dress as Ferenczy, was none the less very impressed initially by the latter's aristocratic manner. Moreover Ferenczy, in his first year at Nagybánya,

111 Károly Ferenczy and his son Béni, c.1910

112 Károly Ferenczy, *Sermon on the Mount*, 1896. Hungarian National Gallery, Budapest

made an effort to overcome his normally very aloof and reserved nature, and would join in the colony's lively social life which Hollósy was so keen to promote. This took place mainly at Berger's café (now the Minervul Hotel) on the main square of the town; here all the artists would sit talking and listening to gipsy music, sometimes until dawn.

Although after a couple of months or so at Nagy-bánya it was clear that all the artists here were enjoying themselves, the promise of great artistic achievement which had originally lured them to the place showed little sign of being fulfilled. Apart from teaching and socializing, Hollósy himself had yet scarcely done anything. He despised regular work, and was always telling everyone that one should only paint when 'inspired by the muse'; Réti's terse comment on this was that the muse was unlikely to come unless one were seated in front of a canvas.

Hollósy considered conversation to be as creative as painting, and the persuasiveness with which he argued this made many of those around him feel the same. Eventually, however, he had to abandon his principles, and, in Réti's words, 'more out of moral obligation than real desire', he began working on a picture in the mining suburb of the town. Every day he was surrounded by a throng of chattering people expecting some miraculous transformation of his canvas. This did not happen. The picture in fact progressed extremely badly, and would have been abandoned had Hollósy not been afraid to disappoint his admirers.

The other experienced artists in the colony were having a similarly unproductive time. Grünwald worked slowly on a picture of a blind miner which was not to be finished until the following year. Réti pottered on with some small works that he had begun

113 Simon Hollósy, *Sketch for the Rákóczi March*, 1899.
Hungarian National Gallery, Budapest

in Munich the year before. Thorma, who had executed
a very successful painting before coming to Nagy-
bánya, now contented himself merely with stretching
a huge canvas and contemplating future compo-
sitions. Even Ferenczy, who had a great facility for
painting, found it difficult to embark on any really
ambitious work. Then, however, inspiration came to
him. It struck when he was walking one evening in the
grounds of a Minorite monastery on one of the hills
above the town. Suddenly he imagined a picture in
which Jesus would be sitting here addressing a large
crowd of people. He soon afterwards began working
on such a picture *in situ*, using locals, artist friends,
and members of his family as models (fig. 112). He had
everyone dressed up in a variety of costumes, includ-
ing a suit of armour. For all its fantasy, the picture was
perhaps intended to express the communal spirit for
which all the artists in Nagybánya were striving.

What really did manage to instil some creative
vitality and sense of purpose into the colony was the
result of the visit to the town of a leading Hungarian
poet called József Kiss. Kiss would read out his poems
to the artists in what Réti described as a harsh eerie
voice which soon cast a spell on everyone present. Kiss
found that he had never before had such a responsive
audience, and conceived the idea of bringing out a de
luxe edition of his poems with illustrations by the
leading artists in the colony. The idea aroused great
enthusiasm among the artists. At last, as Réti said,
they could all now be united in a concrete communal

endeavour, rather than just hang around waiting for
the muse to come or having endless discussions on the
need for a group identity. With the exception of
Hollósy, everyone began working on the commission
almost immediately. Typically, Hollósy decided to
defer his contribution until the winter; he was event-
ually to produce fewer illustrations for the book than
anybody else.

Kiss's association with Nagybánya undoubtedly
helped to draw outside attention to the colony.
Journalists from Budapest and elsewhere started
coming to the place. Among these was Károly Lyka,
one of the most perceptive Hungarian art critics of this
time, and soon to become one of the greatest sup-
porters of the Nagybánya artists. He was also the first
writer to 'discover' Pal Szinyei Merse. Merse himself
took up the invitation of the artists to come to
Nagybánya, and arrived later that summer. Unlike
Lyka, he was not especially excited about the work
which he saw here, and confided to Thorma that he
considered Hollósy to have hardly any talent at all.

As the summer neared its end, Hollósy thought that
it was about time to begin work on his commission to
paint Huszt castle. The castle was of great historical
significance to Hungary, and the Huszt town council
had commissioned a picture of it as a nationalistic
gesture in honour of the Millennium celebrations.
Hollósy set off to Huszt accompanied by Grünwald,
who was to take photographs of the castle. It was these
photographs that provided the basis for Hollósy's
picture, which he did not begin in earnest until his
return to Nagybánya a week or so later. Once again he
was hampered by lack of enthusiasm for the task, and
worked on the picture slowly and badly. Then—or at
least so Hollósy later claimed—work on the picture
started going extremely well. However, no sooner had
the muse paid this belated visit, than a local bailiff
came along and confiscated the work on account of a
debt incurred by the artist in his youth. Lawyer friends
of Hollósy were able to help him out of trouble, but by
this stage the humiliating incident had become
common knowledge in Nagybánya, and news of it had
even reached Huszt. Hollósy, greatly depressed by the
whole affair, abandoned his picture and swore that he
would never again return to Nagybánya.

The time had come for everyone to go back to
Munich. Only Thorma and Ferenczy remained
behind. Summing up the first summer in Nagybánya,
Réti had to admit that it had not been an unqualified
success. There had been, he said, too much excitement
and expectation for any serious work to have been

done. None the less, as soon as everyone was back in Munich, plans were made to return to Nagybánya the following summer. Even Hollósy had by now overcome his disillusionment with the place, and forgotten his oath never to go back there. Olivér Thorman, the Nagybánya mayor, renewed his offer to pay for the studio and the artists' train fares. This time, however, Hollósy was not prepared to spend the summer there unless he could be assured beforehand of additional financial sponsorship. On his suggestion, Thorman wrote to the Ministry of Culture in Budapest to see if they would be willing to sponsor Hollósy. They agreed to this on condition that all the work produced by the Nagybánya artists that summer was exhibited in Budapest in a group show in the autumn.

The number of artists who went to Nagybánya in the summer of 1897 was greater than in the previous year. There were both more students and young estab-

114 Béla Iványi Grünwald, *Sketch of a Poster for the Nagybánya Exhibition*, 1897. Hungarian National Gallery, Budapest

lished painters, most notable among whom was the peasant genre painter István Csók. With the prospect of the autumn exhibition in Budapest, everyone this year began working furiously. Hollósy embarked on one of the most ambitious works of his career. The subject of this was inspired by the life of the Transylvanian prince Rákóczi II, who at the beginning of the eighteenth century had been at the head of Hungary's first major uprising against the Austrians. Hollósy envisaged a scene of people marching for freedom (fig. 113). He worked on the canvas out of doors, posing his models in the privacy of a large garden. He was to struggle with this picture for many years to come, and was never to finish it.

The Budapest exhibition turned out to be a great success, even though Hollósy himself had nothing to show in it. The Nagybánya artists, for all their differences, were seen as united in their advocacy of outdoor painting and in their rejection of turgid academic principles. The Nagybánya colony was now fully established. The autumn show became a regular feature of the Budapest art world, and an increasing number of artists, from all over central and eastern Europe, came to spend their summers in Nagybánya. The townspeople greatly welcomed all the publicity which their town was now receiving. Even large groups of tourists now started coming. The miners soon came to depend on the extra income to be derived from both letting out rooms in their houses and posing, which became in fact a major local industry: prospective models from all over the region would come into Nagybánya for the week, and assemble on Monday mornings outside the town's main studio. It was not so long before they would even consent to pose naked.

Ironically, with the growing importance of the colony, there developed increasing tensions between Hollósy and its other leading artists. Hollósy was inordinately jealous of the success of anybody else, and felt threatened in particular by Ferenczy, who was rapidly becoming regarded as the more important artist. When eventually Hollósy managed to complete some works for an autumn group exhibition, he was indignant that he would have to show them alongside those of other members of the colony. In the group exhibitions of 1900 and 1901, he succeeded in having a separate room for himself and his pupils. The indignation that such behaviour aroused among the others was exacerbated by the widespread dislike in the colony of Hollósy's second wife, whom he had married in 1898. A maid at Berger's café, she was

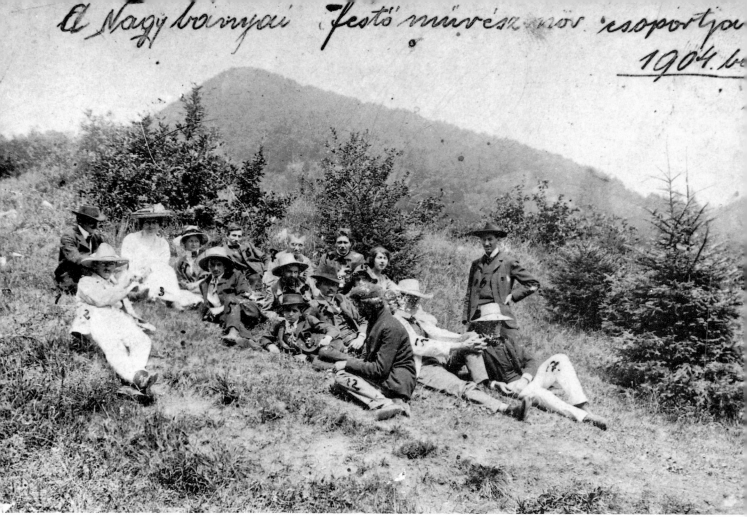

A Nagybányai Festő művész nös csoportja 1904. ba

115 Artists at Nagybánya, 1904

generally considered to be stupid and petty-minded, and was even accused by Thorma of being a whore, an affront which almost led to a duel. She was also very protective towards Hollósy, angry that his paintings should fetch less than those of some of the other artists, and keen that he should dissociate himself from the social life of the colony. In the autumn of 1901, as a result of what Réti described as an 'incident of a personal nature', Hollósy left Nagybánya for good. In the following summers he was to take his school to Técső, a town (now in Russia) about sixty miles to the north of Nagybánya; he died in relative obscurity in the Máramaros town of Seghed in 1918. Despite the antagonism which had built up against him in the colony, his departure was none the less

greatly regretted there. To the end he had remained an exceptionally invigorating teacher, even if his talents as a painter seemed now much less significant than had originally been imagined.

The year after Hollósy's departure from Nagy-bánya, a series of permanent studios was finally built in the town. These had of course been planned for some time, but delays in building them had been caused by the death of Olivér Thorman in 1899. The completion of the studios coincided with the inauguration of the Nagybánya Free School, which was intended to replace Hollósy's establishment and to be run on more democratic lines. Réti, Thorma, Grünwald, Csók, and Ferenczy were among those who became teachers here.

Ferenczy was by this date a reclusive figure, and took no more part in any of the colony's social activities. However, he was now recognized by everyone in the community as the most important painter among them. Nagybánya and its surroundings inspired almost all Ferenczy's greatest works. As with his *Sermon on the Mount* of 1896, many of his paintings featuring the locality contain a strange mixture of fantasy and realistic observation of an outdoor scene. A favourite activity of his was to go horse-riding on his own in the woods behind his house. On one such excursion by dusk, he claimed to have had a mystical experience. He afterwards painted a series of pictures of the *Three Kings*, in which he used the wood as the setting, and had foresters posing as the protagonists. To him, the local people in and around Nagybánya had a 'biblical character'. A favourite model of his was his servant János Mancz, who was known by everyone in the town as 'Sir John', because he was the illegitimate son of an English mining engineer. 'Sir John' appears in at least two biblical paintings by Ferenczy with a Nagybánya setting, including *Joseph and His Brothers* (alongside Ferenczy's son Valér) and *The Deposition* (fig. 116), in which he is portrayed as the dead Christ. He was also the model in one of Ferenczy's most famous naturalistic works of the first decade of this century, *October*. This was painted in the artist's garden at Nagybánya in 1903, and exemplifies the artist's search at this time for a naturalistic style based on an ever greater simplification of forms and colours.

116 Károly Ferenczy, *The Deposition* (the model for Christ was Ferenczy's servant 'Sir John'), 1903. Kultúrpalota, Tîrgu Mures, Romania

In about 1908 the ubiquitous English painter Adrian Stokes, accompanied by his Austrian-born wife Marianne, visited Hungary and later produced a book about their experiences in that country. In the introduction he wrote: 'Hungary is less frequented by foreign visitors than other great countries of Europe; still it has charms beyond most. In spite of modern development—in many directions—the romantic glamour of bygone times still clings about it, and the fascination of its peoples is peculiar to them.' At the beginning of their trip the Stokeses painted at the town of Kalocsa on the Great Plain, where they surprised the locals by wanting to paint the dreary surrounding countryside. Later they went to Transylvania. They passed Nagybánya, which they had heard was 'frequented by painters', but 'failed to find anything particularly characteristic or charming' about the town.

However, among artists generally, there was still no sign that Nagybánya was losing its popularity. It had even begun to attract a new generation of progressive artists, among whom were a group of young Hungarians who were later to call themselves the Activists and to introduce Cubism and Constructivism to Hungary. Many of the artist population in Nagybánya now stayed there all the year round, finding it an extraordinarily cheap place to live. The miners had apparently even come to accept paintings in return for food and accommodation; they knew how much money some of these paintings could fetch. To Réti, the younger generation of Nagybánya artists were not as polite to the townspeople as he and the first artist settlers had been. For him the place had lost its former intimacy.

In the second decade of this century both Réti and Ferenczy became professors of art in the Academy of Art in Budapest. From now on Ferenczy began to spend an increasing amount of time in Budapest, where he also acquired a mistress. He devoted himself now more to painting indoor rather than outdoor subjects, and his work suffered a sharp decline in quality. When he died in 1917, he received respectful obituary notices, but, as Réti noted, there was no full recognition of his early achievement. His three children all became artists, two of them important ones. These were Noémi and Béni, both of whom achieved an enormous reputation in Hungary for their work in tapestry and sculpture respectively. Noémi's greatest tapestries featured very simplified representations of the Nagybánya landscape and people, and were inspired by both medieval and folk art. Like

Noémi, Béni spent most of his youth in Nagybánya, where he became an excellent football player under the enthusiastic guidance of 'Sir John's' engineer father. However, as his interest in art became greater, he felt increasingly the need to leave the town and move to a city such as Budapest or Vienna. Early in the 1920s he helped organize a miners' strike in Nagybánya, and was subsequently forced to take refuge in the Máramaros. He rarely revisited the town afterwards.

117 Street of the Red Valley, Nagybánya, as it is today

Nagybánya became Romanian in 1918, and its name was changed to Baia Mare. Romanian artists had always come to Nagybánya, but now they came to dominate the place. Today the Romanians prefer to forget that the town ever played such a major role in the history of Hungarian art. The Hungarians meanwhile now tend to exaggerate the nationalistic motivations of the first Hungarian artists who went there. Although these artists were undoubtedly patriotic, they probably also flaunted a love of Hungary in the interests of receiving local sponsorship for their activities. At any rate, of their group only Réti showed any extreme nationalistic tendencies. He apparently disliked teaching Romanians, and in the original text of his book on Nagybánya made comments on Romania which his editor thought wise to suppress.

The centre of present-day Nagybánya and the part of the town where the artists all settled remains little altered by modern development. Yet there hangs over the whole place not the 'glamour of bygone days' which Adrian Stokes found generally in Hungary, but rather the sadness of decay. At least one of the artists from the town's Hungarian past continues to live there at the time of writing. This is the ninety-eight-year-old Antónia Csikós, who fondly remembers the lively artist parties and dances that took place on the terrace of her house in the Street of the Red Valley. Even an artist colony, centred around the Free School buildings, continues to function. The artists associated with it are all given studios and financial support by the municipality. Such official colonies are found throughout eastern Europe, and generally in places that have long been popular with artists. Two of the best known in Hungary are at the largely rebuilt towns of Hódmezővásárhely and Szolnok. The latter colony is on an island in the Tisza River, and comprises a series of modern artist studios replacing those that were built here in 1902 at the instigation of Bihari, Tornyai, and others. The present buildings look out on to a landscape of tower blocks.

8
From Breton to Briton

NEWLYN AND ST. IVES
(GREAT BRITAIN)

ONE OF THE main characteristics of British nine-teenth-century art is its insularity. Until about the 1870s British artists were trained almost exclusively in their own country, and few foreign artists came to study here. Moreover many of the greatest British artists up to this time, such as Blake, Turner, Constable, and the Pre-Raphaelites were strong individualists whose art is too eccentric to be closely related to any of the major European artistic traditions. From the 1870s onwards, however, more and more British artists came to study on the Continent, and in particular in France. They were all deeply affected by contemporary French art, and under its influence began increasingly to practise outdoor painting and to portray the life of the peasant and fisherman. Most of them, after an initial period of study in Paris, spent time working in the French countryside, usually in an artist colony such as those at Barbizon, Grez, and Pont-Aven.

This cosmopolitan trend in British art of the late nineteenth century inevitably had its critics, and even today there are those who would argue that from the 1870s onwards British art began to lose much of its national identity. At all events Britain's French-trained artists, like their counterparts in Scandinavia and elsewhere, came in the 1880s into open conflict with the traditional art institutions of their country. The most important of these institutions was the Royal Academy, whose summer exhibitions still determined to a large extent the success or failure of an artist. The French-trained artists felt that the Academy was generally unsympathetic towards them, and in 1886 a group of them formed an alternative exhibiting institution called the New English Art Club (NEAC).

Most of Britain's young artists of this period came to be associated with this. Although they were all united in a love of French art, there were those among them who believed Bastien-Lepage to be the greatest artist of their age, and others who thought more highly of the Impressionists. The former group, who were undoubtedly in the majority to begin with, had opportunities to get to know Bastien-Lepage and his art not only in Paris and Concarneau, but also in Britain itself: works of his were exhibited in London and Glasgow, and he himself paid a visit in 1882. The supporters of the Impressionists were under the aegis of the American-born painter James McNeill Whistler, who achieved considerable public notoriety in Britain after being accused in 1877 by the renowned writer and critic John Ruskin of 'throwing a pot of paint in the public's face'. Among Whistler's followers were Walter Sickert, who in 1892 published a very critical essay on Bastien-Lepage, and Philip Wilson Steer. By the end of the 1880s Sickert and Steer together had come to dominate the committee of the NEAC and thus give full support to the artists known as the 'British Impressionists'.

Curiously, Britain's French-trained artists began in the 1880s to identify themselves with specific parts of London. The then cheap and shabby riverside district of Chelsea was especially popular, and one of the streets here, Manresa Road, came even to be known for its 'colony of artists', all of whom were members or associates of the NEAC. Yet it was of course the formation at this time of colonies in rural areas of Britain which represented the most obvious expression of British allegiance to the ideals of recent French art. A number of colonies grew up in Scotland, all with

associations with those Scottish followers of Bastien-Lepage known as the Glasgow Boys. These artists congregated at first in the popular Highland resort of Brig O'Turk, where they seem to have shunned painting the spectacular local scenery which had been represented so frequently by artists of earlier generations. Instead, one of them, James Guthrie, painted here his *Highland Funeral,* an especially grey and sombre work which can perhaps be compared to the German painter Fritz Mackensen's *Prayers on the Moor* (fig. 99). Guthrie's painting was the first fully to establish the Glasgow Boys' reputation. In subsequent years the Boys avoided the Highlands altogether and devoted themselves to painting some of the drearier agricultural areas of the Scottish Lowlands. A group of them joined Guthrie in the lowland village of Cockburnspath, where he painted some of the works, such as the *Hind's Daughter* (fig. 118), that were his closest stylistically to the rural genre scenes of Bastien-Lepage.

The most famous colony in the north of England was at the Yorkshire fishing village of Staithes, a place which had previously been very hostile to outsiders and whose main attractions to artists were its picturesque bleakness and the harsh lives led by the local fishermen. The East Anglian coastal village of Walberswick had an altogether more homely appeal. This village also became much visited by artists in the 1880s, attracting most notably Philip Wilson Steer. Steer used local fisher-girls as his models, but instead of taking any sentimental interest in their lives transformed them into brilliant patches of colour in sunlit beach scenes.

By far the most popular part of Britain for artists in the 1880s was the peninsula of Cornwall. A significant proportion of the artists who came here had worked beforehand in Brittany. It will be remembered that the part of Brittany where Pont-Aven and Concarneau are situated used to be called Cornouaille. An Irish artist visitor to Pont-Aven in the early 1880s, Helen Trevor, wrote; 'Look at the name Cornouaille . . . Is it not Cornwall in other spelling? All its folklore and traditions are the same as those in that part of England—almost identical.' Many of the visitors to Brittany and Cornwall in the nineteenth century did not simply emphasize how the two regions had the same Celtic roots. They also commented on the remarkable similarities between their landscapes. Both regions are characterized by a wild rocky coastline and an interior featuring wide stretches of moorland interspersed with rocky outcrops, and prehistoric mounds and stones (called 'quoits' in Cornwall).

As with Brittany, hardly any of the artists who worked in Cornwall in the nineteenth century were native to the region. Artists came here not only from all over Britain, but also from other countries, making Cornwall perhaps the only rural area of Britain with a truly international appeal for artists. Most of the innumerable foreigners here were Scandinavians or, above all, Americans. The Americans indeed played almost as important a role in promoting appreciation of the area as they had done in Brittany. Cornwall had for the Americans most of the qualities that they had admired in Brittany, including the supposed resemblance between its coastline and that of north-eastern America, and the fact that only the Atlantic separated them here from their home country. Then there was the added advantage that the locals all spoke their language, even if they did so in a way which was not always comprehensible.

The main drawback of Cornwall in comparison to Brittany was that its people, although sharing some of the Bretons' quaint superstitions and religious beliefs, did not have the picturesque costumes to go with these. The absence of such costumes was in fact characteristic of Britain as a whole, and was regretted by many painters who worked here. In an article which appeared in the *Magazine of Art* in 1885, a critic wrote: 'The English peasant, who has dropped such distinctive costume as he ever wore, and arranges himself instead in a shabby genteel imitation of his social superior, is far from the picturesque.'

The artistic life in Cornwall in the late nineteenth century centred around the two fishing villages of Newlyn and St. Ives, which are about ten miles from each other, on the south and north sides of the peninsula respectively. The colonies in both places were formed in the early 1880s, and attracted artists not simply for the summer months: many even stayed all their lives. The St. Ives colony was originally made up largely of foreign artists, and was thus the more internationally renowned of the two. But it was essentially through the works of the Newlyn artists, almost all of whom were British, that the London art world came to recognize the importance of Cornwall as an artistic centre. For this reason all the artists who worked in Cornwall at this time, no matter where they lived, came to be known in Britain as the 'Newlyners'.

Newlyn had a reputation up to the 1890s as being an exceedingly backward place. Yet it is only about two miles from Penzance, which in the nineteenth century was a small, prosperous, and largely modern town

with a regular train service to London. Newlyn is built on the side of a hill, from the top of which one can clearly see all of Penzance, as well as the church-crowned outcrop beyond, known as St. Michael's Mount, which bears a certain resemblance to Mont St. Michel in northern Brittany. The countryside behind and to the west of Newlyn is largely agricultural, and in marked contrast to the bleak moorland near St. Ives. The old part of Newlyn comprises a series of very steep, narrow streets, all of which were once cobbled. The 1859 *Murray's Handbook to Devon and Cornwall* described the stone-walled and grey-tiled fishermen's cottages that can still be seen here as having 'picturesque interiors, of which glimpses are obtained through an open doorway or window'. It added that these houses 'will exceedingly delight artists who entertain "a proper sense of dirt", and in this respect, indeed, may call to mind the semi-barbarous habitations of some foreign countries such as Spain.' The smells of both garlic and fish apparently used to fill the air. Outside each cottage was generally a mound of

118 Sir James Guthrie, *A Hind's Daughter*, 1883. National Gallery of Scotland, Edinburgh

decomposing fish heads and entrails, on which unwary visitors to the village would sometimes slip.

In November 1883 the painter Stanhope Forbes arrived back in England from Britanny, where he had been staying that year, principally in Quimperlé. Forbes's mother was French, and his father an Anglo-Irish businessman who managed railways in Ireland and Belgium. Their main home was in London, where Forbes now went to join them. Forbes had studied at the Royal Academy in London, and at Bonnat's studio in Paris, after which he had spent two summers and autumns painting in Brittany. He was now twenty-seven, and felt ready to establish himself more fully in his own country. After spending December and January with his parents, he went on in February 1884 to Penzance with the intention of finding a picturesque nearby village to paint in. After his recent experiences of living in France, he seems initially to have had difficulty in accustoming himself to travelling in England. After only two days in Penzance, where he put up at the Union Hotel, he wrote to his parents to say, 'what precious bad cooks the English are,' and 'what a cheerless place an English hotel in out of the way places generally is.' In his search for a village to settle in, he first of all considered Porthleven, but then decided on Newlyn, where by chance he met up with a painter, Ralph Todd, who had been staying in the same hotel as him in Quimperlé, and was now with his fiancée, Miss Clement, whom he had met there. There were other painters then working in Newlyn, including Walter Langley and Edwin Harris, both of whom had likewise recently been in Brittany. Forbes also heard that a painter called Leghe Suthers, who had accompanied him from Brittany to England in 1881, had spent the summer in the village. Forbes recorded his early impressions of Newlyn in his letters to his parents. He wrote that the village was 'a sort of English Concarneau, and the haunt of many painters'. Doubtless he was also reminded of the Breton town by the intense smells here, in this case of pilchards rather than sardines. For Forbes one of the great merits of Newlyn was that 'we are so near to Penzance and yet far enough for the place to be quite primitive and suitable for artistic purposes'. Penzance was a very convenient place to go shopping, and also provided evening entertainment for the artists, such as concerts in the town hall. Forbes described it as a 'very fair specimen of an English watering place frequented by people who would not venture into a dirty hole as Newlyn'. Like most of the Newlyn artists Forbes was never to paint Penzance. He acquired the reputation of

being an unflinching realist, yet, in common with so many artists of his generation, he had no artistic interest in the reality of modern life.

He and many other visitors to Newlyn in the 1880s were similarly selective in what they chose to admire in the local people. These people had to convey in their manner and dress something of the hardship of their lives. A later Newlyn artist, Frank Richards, was in this respect very disappointed with the local fisherfolk, preferring instead those of Lowestoft on the east coast of England: 'The "Lowestofters" . . . are in my opinion a finer set than their Cornish brothers; they are not prim, dainty and clean as are so many of the West Country fishermen—they are grimy and stalwart, and strong, and more often than not their faces are "as black as your hat".' In contrast, the poet and art critic Alice Meynell saw considerable artistic potential in Newlyn's fisherfolk, finding them 'always paintable'. For her, 'a fishermen in a jersey is one of the few modern Englishmen not burlesqued by his garments.' She was none the less highly critical of how modern fashions had begun to affect the dress of the local women. Particularly offensive to her was the way these women would dress up on Sundays or feast days. Then they would 'show what unnecessary indignity can be offered in contemporary England to the human figure.' She reported with horror a carnival once held in Penzance, at which all the local fisherfolk turned up:

All day long on the day of the carnival in question the population walks up and down in front of the seaward facing houses, with absolutely no amusement to distract its thought from its own personal appearance. At night there are certain uncouth processions by torchlight, which involve a great deal of waiting at the street corner to cut off the pageant in mid-career, after which the carnival is over. But young womanhood . . . assuredly never betrayed itself more completely. The Newlyn painters are good realists, but even they would have hesitated at the human documents to be studied up and down the Cornish strand on that vacant summer day.

In his early days at Newlyn Forbes clearly missed the picturesque costumes which he had been able to paint in Brittany. However, despite the lack of such costumes in Cornwall, he found generally that the locals 'seemed to fall naturally into their places, and to harmonize with their surroundings.' For him, as with Meynell, the only discordant note was caused by some of the local women, who though to his tastes much prettier than those of Brittany, 'revel in fringes, pigtails, crinolettes and other freaks of fashion all very well in a stylish London beauty, but appalling with these surroundings of sea, boats, fish, etc.'

Yet for Forbes and other artists who came to Newlyn, the slight defects of appearance in the locals were minor faults in comparison with the bigotry of these people. In Brittany the religious fervour of the locals had simply provided artists with picturesque subjects to paint, but here it began to encroach on their lifestyles. Soon after arriving in Newlyn, Forbes wrote to his father:

I am in a hotbed of narrow-minded bigotry and bigotry of the worst kind, snivelling low church primitive methodist bigotry—oh ye railers at the blind papists and at the wicked ways of people across the water, come down here to study these people. Study the effects of religion upon ignorance—I wish people who say, oh you must have religion to keep the lower classes in order, would come to such a place as this and see the people as they really are, without it is true any very glaring and obvious vices, but with all the petty ones developed by their wretched intolerant canting education. All the men, or nearly all, are teetotallers and every one of them goes to church or chapel and keeps the seventh day holy, and the effect of this abstinence from strong drink and indulgence in strong prayers is to make them a most disagreeable set of people, full of hypocrisy and cant.

Such bigotry would sometimes make life barely tolerable for the artists. Forbes reported how if any artist confessed to drinking occasionally he would immediately be labelled a drunkard, and if he painted on a Sunday, he ran the danger of being stoned and having his canvas and easel smashed.

The largely teetotal population of Newlyn meant that there was no public place in the village where artists could meet and drink as they had been used to doing in Pont-Aven, Concarneau, and other places in France. The social life of the colony thus took place mainly in one another's houses. In their first year here most of the Newlyn artists lived and had studios in rented property in the vicinity of Trewarvenneth Street, today the most picturesque of Newlyn's remaining old streets. This area was so much the artist centre of the village that a small lane here was soon dubbed 'Rue des Beaux-Arts'. As for studios, the

119 Trewarvenneth Street, Newlyn, 1880s

artists used various types of buildings, ranging from old fish-lofts to the top rooms in shops. At some point in the 1880s a former school building on Trewarvenneth Street was converted into the 'Trewarvenneth Studios'.

In his first weeks in Newlyn Forbes had mixed feelings about the other artists in the village. He declined Todd's offer of sharing a sitting-room with him, as he felt that he did not know or like him well enough. Later he became more friendly with him, though he had to confess that the man was 'not a genius'. The most talented among the artists were Thomas Gotch and Walter Langley. The former seems to have left the village before Forbes had had a chance to get to know him, and was not to return here until 1886. Langley, whom Tolstoy was later to single out for special praise among the artists of his day, did not immediately endear himself to Forbes, who thought him 'a bit of a bore and far too earnest and enthusiastic at the wrong time'. In March 1884, Forbes wrote to his parents: 'It would be a delightful life this, if only I had friends around me, but with such an unsympathetic set as I have here to associate with, the chief pleasure goes.' Matters soon improved with the arrival in the spring and summer months of other artists at Newlyn. By the end of the year Forbes could write home: 'I am living wonderfully well, I always think how much more comfortable I am here than in a Breton hotel, and thank my stars I am not now in Quimperlé.' The new artist arrivals included Rowe, a friend from Breton days who had been with him in Pont-Aven, and Millard, whom Forbes described as a 'decent quiet fellow and an addition to our society'. Another arrival was Chevallier Tayler, who was soon sharing a house with Forbes. Tayler made little contribution to the artistic output of Newlyn, but was generally regarded as a wonderful asset to the colony's social life.

Although Forbes enjoyed himself increasingly in Newlyn in the course of his first year there, his painting seems to have absorbed most of his attention at this time. He told his parents shortly after arriving in the place that he had 'struck gold in the way of subjects'; later he was to call the place an 'artistic Klondyke'. Forbes, like the other Newlyn artists, was almost exclusively a figure painter. Fortunately, he and his colleagues had apparently no difficulty in obtaining local models, who, however, were much more expensive than in Brittany. The only serious problem which Forbes encountered resulted from his insistence on always painting out of doors. He found initially that the prettier local girls were too shy to pose in the streets. These girls would probably have been even more reluctant to do so had they heard that in Cancale in Brittany Forbes had accidentally almost killed one of his models by placing her—in the interests of studying the exact tones of her figure against a background of grey slate roofs—on top of a high parapet, from which she had subsequently fallen.

Forbes's letters from Newlyn during his first year there are full of allusions to the importance of having grey weather to paint in. On one occasion he even had to forgo an invitation to a ball 'because it may be the only grey day in the week'. At least he was able to see the absurd side to this obsession. After painting in a cold wind so strong that his palette had broken in his hand, he wryly commented that 'the weather is grey enough to please me.' All the others in Newlyn shared his love of grey weather. By 1893, the painter Frank Richards was to have to admit that Newlyn was 'by no means so grey a place as it is painted', and that in fact there was a 'good deal of Italian blue in summer'.

Another characteristic of the work of Forbes and his associates was their use of wide brushes. Other British artists of this time also adopted this technique; but it was the distinction of the Newlyners to be referred to as the 'square brush school'. Like their interest in painting in grey light, their use of such brushes probably derived from a desire to follow Bastien-Lepage's example. The Scottish painter Archibald Hartrick recalled that at this time there was a great debate in art schools throughout Europe and America as to whether he painted with large or small brushes. To resolve this matter, Alexander Harrison decided to ask Bastien-Lepage himself, who, although then painting with small brushes, responded to Harrison's inquiry by immediately taking out some brushes two inches wide, and, in the words of Hartrick, 'produced results equally fascinating for his admirers.' 'I believe,' concluded Hartrick, 'this was the origin of what became known as the "square brush act". Stanhope Forbes introduced it here, where it became the hallmark of the Newlyn school.'

For much of 1884 Forbes was engaged on an ambitious canvas of a fish sale on the Newlyn beach. He had had the idea for this only a few weeks after arriving in the village. He had planned at first an enormous canvas measuring nine by five and a half feet, but after many weeks of doing oil sketches on the spot, settled for a more modestly sized picture. This he began in June and worked on until December. Characteristically he portrayed the beach at an angle from which Penzance was completely out of sight. He

120 Fish sale on the beach, Newlyn, 1880s

painted the work almost entirely out of doors, and in so doing experienced increasing difficulties with the onset of winter. On 11 December he wrote: 'I sallied forth to have another go at the large picture. I got blown about and rained upon, my model fainted etc.' A long spell of grey weather prompted him to protract his stay in the village almost until Christmas, by which time he had finally completed *The Fish Sale* (plate 6). Before going to London to spend Christmas with his parents he heard of the death of Bastien-Lepage.

> So the greatest artist of our age is dead. Poor fellow. I had heard there was no hope for him but I thought it might be a picture dealer's report. I wish I had met him at Concarneau last year. His reputation you will see will now increase in a wonderful manner though always among artists generally there is very little lack of appreciation of his work. But when they come to collect all his wonderful pictures, as I hope they will in Paris, shortly people will I am sure admire him more than ever. His influence on all the young painters already so great will become more powerful than ever. I feast in a great opportunity for the British critic to make an ass of himself and look forward with dread to the various comments on this great loss to painting.

When Forbes had first come to Newlyn in 1884 he had only intended his stay there to be a temporary one; and in fact it was not until 1889 that he was to make a conscious decision to settle permanently in the village. None the less, from 1884 onwards he was rarely to be away from the place for any significant length of time. After a short period in London at the end of his first year there, he returned early in 1885. In the spring of that year his *Fish Sale* was exhibited at the Royal Academy. It received enormous critical acclaim, and indeed first made the public aware of the existence of what soon came to be known as the Newlyn School of painters, of which Forbes was now the acknowledged head.

Forbes's social life in Newlyn improved greatly that year, and artists whom he had previously disliked or known only slightly now presented themselves to him in a very sympathetic light. He reported a party given at the house of Edwin Harris and his wife, at which, after a 'wonderful dinner beginning with ducks and ending with a joint', the guests presented tableaux, and then danced quadrilles, waltzes, and polkas to a banjo accompaniment from Langley. Forbes found Mrs Harris to be 'very amusing', and she pronounced him a good dancer. Even Langley was 'very amusing without his wife'. Langley's banjo moreover was a definite asset to the colony's social life: on at least one future occasion it was to lead a nocturnal procession of drunken artists through the village with everyone singing, 'As they walked home in the light of the moon'.

Many new artists came to Newlyn in the course of 1885. Among these was Frank Bramley, who was later to paint one of the most famous of the Newlyn School pictures. Another was Frank Detmold, who took up lodgings in the same house where Forbes, Tayler, and others were ensconced. According to Forbes, 'Detmold with a large experience of French artistic resorts says he never saw a place with such facilities as this.' Soon, however, he was grumbling about the food he had to eat there, and he ordered a cookery book in the hope of showing the locals how to prepare French food.

In November 1885 a young Canadian painter, Elizabeth Armstrong, came to Newlyn together with her mother. She had first studied painting at the Art Students League in New York, and had there come successively under the influence of Millet (whose work William Morris Hunt was then promoting enthusiastically in America) and Bastien-Lepage. She had continued her studies in Munich under the American painter William Merrit Chase, and in 1882 had gone to Brittany. There she had stayed at the Hôtel des Voyageurs in Pont-Aven, where she had met Edwin

Harris. She claimed that while she was in Pont-Aven she had heard stories of a very talented English painter called Stanhope Forbes, who was then staying in the neaby town of Quimperlé. Her interest in Forbes had been renewed in London in the spring of 1885, when she had seen *The Fish Sale* at the Royal Academy. It was only at a dinner party given by the Harrises shortly after her arrival in Newlyn later that year that she was finally able to meet him. Forbes reported the occasion: 'On Friday night I went round to the Harrises' and was introduced to the young lady artist Miss Armstrong. She cannot be said to be pretty but is a nice intelligent and ladylike girl. I had a very long and interesting talk with [her] about Pont-Aven and all my old friends there . . .'

Elizabeth Armstrong stayed on in Newlyn into the following year, 1886, and Forbes began to spend an increasing amount of time with her. In February he had a party in his house, to which, among others, she, Langley, and Harris came. They played 'roulette,

121 Elizabeth Armstrong and her mother with a group of artists at Newlyn, c. 1885, including Stanhope Forbes (seated in the centre) and Norman Garstin (far right)

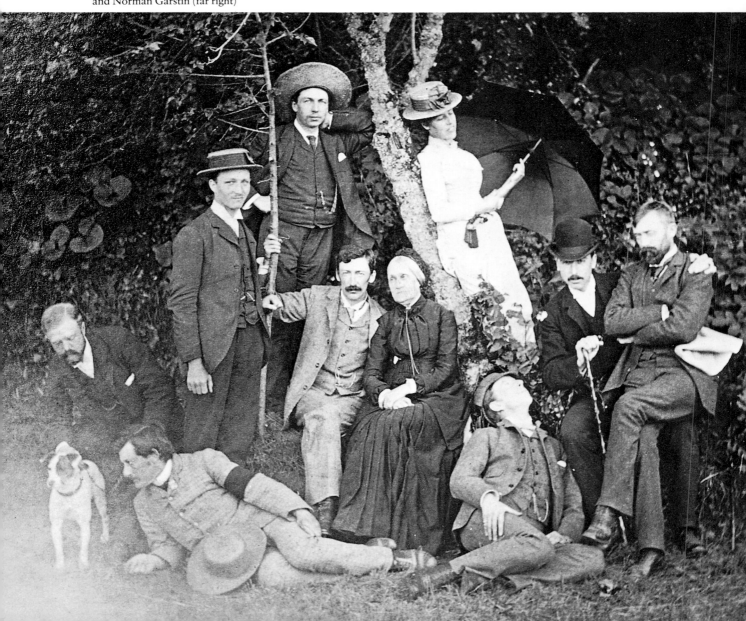

Uncle Sam, and Snip Snorum and kept it up until half past twelve', by which time Forbes began to worry about what Elizabeth's mother would think of her daughter for staying out so late. By the spring he and Elizabeth were engaged. Forbes's mother was not pleased by this, thinking it a bad idea that two people of the same profession should get married. She told her son that there were 'plenty of pretty girls in London'. Later in the year Forbes's aunt, Alice, was to come to Cornwall to see her nephew and form her opinion on the engagement: 'I fear love-making and painting don't go together. Stannie has not done much of the latter and oh! to say he is silly over Miss Armstrong is to say nothing. He is *too* foolish and does not care who sees him. If I were Miss Armstrong I should box his ears.'

Love affairs came to disrupt the lives of many other Newlyn artists during this year. Forbes gave a full account of these to his mother, perhaps partly to justify his own behaviour. Todd had by now broken off his engagement to Miss Clement and, having apparently reached the decision that he would never make enough money out of painting, was in hot pursuit of a rich widow in her late twenties. Just in case he should fail in this venture, Forbes asked his mother if she knew of 'any rich woman who might like him . . . for he is ready to take anyone.' Millard, with whom Todd shared a studio at this time, had recently jilted a girl and was now, much to Forbes's surprise, deeply in love with somebody else: 'Poor Millard. His affair is the funniest I ever heard. He has scarcely seen the girl, who is far from pretty though buxom and bonnie. She must have been astounded at his offer.' Later Millard was to break off his friendship with Todd as a result of a quarrel over yet another girl.

With the arrival of the summer months there came to Newlyn a crowd of young female art students. A local newspaper reported that many of the easels that now strewed the Newlyn beach 'like shells' belonged to 'girls from South Kensington establishments'. Forbes wrote: 'There are a whole heap of lady artists down here now, some with husbands some without. They cover the beach at low tide.' Forbes met at least two of them, but did not succumb to their charms, finding them 'ordinary creatures'. The other single men within the colony were less resistant to this female invasion. Most of them, according to Forbes, were now 'fooling away their time running after girls'. The caricaturist Fred Hall was 'simply mad', while Bramley, always a quiet man, had been made 'mute' by love. He had fallen for a 'very nice looking stylish girl'; but the affair was progressing badly. Forbes and others thought that the problem lay partly in Bramley's 'deuce of a temper'.

That summer Forbes was to be joined in Cornwall by his mother. It was decided that she, together with Mrs Armstrong and her daughter, should spend July and August in St. Ives, which was more equipped as a summer resort than Newlyn. They were to stay at the White Hart Hotel in a room with what Forbes described as a 'very amusing outlook right into the harbour'. 'It will', he said, 'be like Cancale.' Forbes was to join them in St. Ives for much of the summer. Near the beginning of their stay, he and Elizabeth Armstrong were going for a walk near their hotel when they ran across a boy carrying a paintbox. The owner of the box turned out to be someone whom Elizabeth had known in Brittany. It was 'Simmons of Concarneau'.

St. Ives is a small town with a most impressive position. It is on a hill which slopes down to form a long promontory, narrow in the middle and ending in a mound largely bare of houses and known as the Island. The northern of the two bays formed by this promontory has an extensive sandy beach, Porthmeor Beach. Mrs Forbes had a great love of swimming, and the existence of this beach was undoubtedly an important factor in making her stay at St. Ives rather than Newlyn. The lower and older part of St. Ives, 'Downalong', was where the poorer people of the town used to live. It was also here that the town's first artists mainly acquired their studios, a number of which were to be found in a group of fishing lofts overlooking the northern bay. However, almost all the artists in this period had lodgings in the upper and wealthier part of the town, which was much cleaner than anywhere in Newlyn. There were at least two hotels in St. Ives in the 1880s, the White Hart and the Tregenna Castle; the latter was just outside the town and described by the American painter Howard Russell Butler as 'a very superior hotel'.

Before 1877 the traveller to St. Ives had to take a very slow coach from Penzance which only ran once a day, and was apparently always met on arrival by a large group of townspeople anxious to see if there was any 'stranger from foreign parts'. Then in 1877 a branch of the London to Penzance railway was opened here, and, according to a history of the town written in 1892 by John Mathews, the place 'soon began to receive the advance guard of the host of London visitors, the majority of whom belong to the wealthy class.' St. Ives

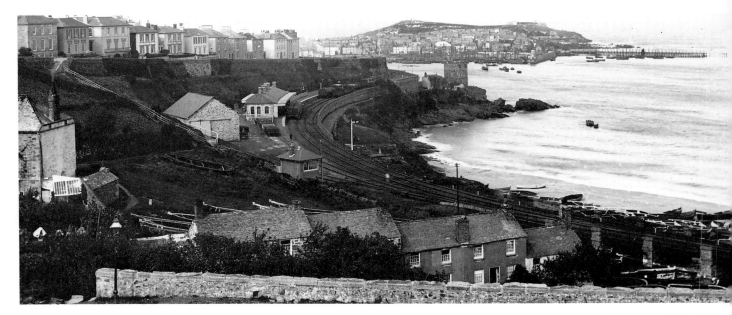

ABOVE: **122** St. Ives, 1880s, showing the original broad-gauge railway tracks
RIGHT: **123** The seine boat of Jas. Jennings, St. Ives, 1880s

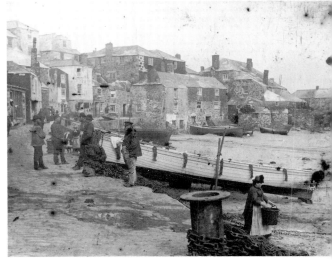

had the advantage over Newlyn as a potential tourist resort not only because of its greater cleanliness and charming beaches and position but also because of the wild beauty of the coastal scenery to the west of the town. In this direction lies the village of Zennor, which can be reached from St. Ives by a perilous footpath which is constantly ascending, descending, and twisting around bays. Mathews surmised the reaction of the early tourists to the St. Ives environment:

The visitor from London thinks to himself that the natives of the place must enjoy the surroundings immensely. He is quite mistaken. The genuine unsophisticated native cares for none of these things, and will declare to you that St. Ives is a "dead-an-alive" old place, devoid of any interest to a cultured mind. He [the native] thinks things would be tolerable if a nice new marine parade were built around the shore of the harbour, and the Island turned into public gardens like they have at Penzance. But in default of these and other similar advantages of a ripe civilization, your Ivesian sighs for the more artificial charms of a popular watering place. He has never been on to Porthminster beach in his life, and would as soon think of swimming to Cardiff as of walking to Zennor.

The tourists who came to St. Ives in the years immediately following the opening of the railway were in fact still relatively few in number. It was only from about the late 1880s onwards that the town came to be an important tourist centre. It was to develop as such concurrently with its growing reputation as an artist resort. Among the first artists known to have worked here are Whistler and two of his pupils, Mortimer Menpès, then briefly in England from Pont-Aven, and Walter Sickert. They spent a few weeks here doing landscape sketches at the very beginning of 1884, the same time in fact that Forbes was settling in

at Newlyn. Forbes paid his first visit to St. Ives in November of that year, but stayed just for the day. He wrote afterwards: 'I am delighted with it but I doubt whether it would be as good as Newlyn for figure painting.' Later artist visitors to Cornwall were apparently to share this view, as the landscape painters among them were always to be attracted principally to St. Ives and the figure painters to Newlyn. Butler wrote that the 'true discoverer' of St. Ives was the then highly popular French marine painter and lithographer Émile Vernier. Vernier does not seem to have come here until 1885, but the prints that he then made of the town and its surroundings might have done much to spread the place's reputation. By the following year artists had started coming to the town in significant numbers. Strangely, few of these were British. It is certainly tempting to say of St. Ives what Edward Simmons wrote about Concarneau, namely that it was passed through by the British ('they were frightened by the bigness of the coast') and left instead to the Americans.

Simmons, together with his wife, had arrived in St. Ives only a few weeks or so before his paintbox had been spotted by Forbes and Elizabeth Armstrong. He had left Concarneau at the end of the previous year, 1885, and had spent most of the intervening months in Spain. He was to remain in St. Ives until about 1891, when he finally returned to his home country. A chapter of Simmons's autobiography, *From Seven to Seventy*, is entitled 'From Breton to Briton', and begins by describing the effects of his move from Brittany to Cornwall: 'Going from Concarneau to St. Ives was like moving from the thirteenth to the seventeenth century. No more thatched roofs, no more floors of beaten earth, no more manure piles in front of the houses. The roofs are of slate, topping little stone houses, with quite proper floors . . .'

Simmons soon found himself in St. Ives in the company of old friends. Butler came here at the end of July, also about seven or eight months after leaving Concarneau. He described St. Ives as a 'quiet and lonesome place', and was very struck by its beauty: 'the French coast cannot boast of a single spot as beautiful as St. Ives. Here the water is pure and clear as crystal—the old town is fully as picturesque as Honfleur; the fishermen are splendid models—the coast is rugged and the sea heavy—colour exceedingly rich—the only drawback is—as on the coast of Maine—the sea-fogs.'

Butler had been invited to stay with Simmons and his wife but left them after only a week, feeling that he

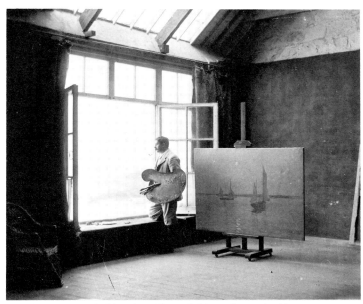

124 A painter, probably Julius Olsson, in his studio overlooking Porthmeor, St. Ives, *c.* 1900

needed more space to himself. None the less he continued to play 'logomachy' with them in the evenings: 'It accomplishes a double purpose. It gives me company and at the same time keeps Simmons from talking as much as he otherwise would.' Butler took lodgings at the very top of the town, from where he could 'keep [his] eye out for effects.' Although he said he was 'surrounded by friends' in St. Ives, he preferred to eat on his own: he found that in England 'you pay for every potato, chop, egg or pot of cream that you consume', and that if there were a group of you eating it was impossible 'to keep the accounts straight'. As compensation, the local cooking was in his opinion excellent: 'they know how to cook, and such baked apples and cream as I get here were never equalled by the Queen of Sheba herself . . . It is a most agreeable change after the artificiality of Parisian dinners.' That year Butler stayed in St. Ives until about the middle of October. During this time he was engaged on a large seascape which he intended to send to the Paris salons in the spring. He used as a studio the top floor of one of the Downalong fishing lofts which overlook Porthmeor Beach. It had taken him two days to find the place and a further two days to convert it. The conversion, which he had done himself, had included cutting a window in the roof and 'whitewashing or

rather grey-washing the interior'. There was no stair-case, so the studio had to be reached by ladder. In times of high tide the building apparently seemed to rise out of the sea.

Another former associate of Concarneau then living in St. Ives was a woman painter called Edith Lees. Simmons remembered her in Concarneau as a 'young girl, wide eyed, eager, temperamental, thirsting for knowledge of life, but knowing as much of it as the bird just out of the egg.' She had then insisted on being chaperoned all the time. Now she was married to the writer on sexual reform, Havelock Ellis, and shortly to embark on a notorious lesbian relationship. Among other residents in the town at this time were Adrian and Marianne Stokes, and Frank and Emma Chadwick. Both couples were veterans of French painting colonies, and friends of the Concarneau painter Alexander Harrison. Adrian Stokes was already known to Stanhope Forbes, who had been with him in Pont-Aven in 1883, the year before Adrian met his future wife, Marianne Preindlsberger, there. He had now the reputation of being one of England's most promising landscape painters, and Marianne, who had had a work of hers, *Madonna, Light of the Earth*, purchased the year before by the Liverpool Art Gallery, was rapidly establishing herself as a figure painter. In between various trips abroad and periods of residence in London, the Stokeses were to continue to come to St. Ives until at least the late 1890s. The Chadwicks had come to St. Ives from Grez, where they had met each other two years previously. They were prominent members of the St. Ives colony in the second half of the 1880s, after which they returned permanently to Grez. The Swedish-born Emma Chadwick (née Löwstadt) was the more talented of the two as an artist, and was to win a medal in the Paris Salon of 1887. She seems to have been the first of the many Scandinavians soon to be associated with St. Ives. Frank Chadwick was a Bostonian who fortu-nately had a sufficient private income not to have to make any money from his painting. Apart from him, Simmons, and Butler, there were apparently various other young American painters staying in St. Ives in 1886, and many more were to go there in the following decade.

By 1886 a heated rivalry had already developed between the colonies of Newlyn and St. Ives. This was perhaps inevitable, given the proximity of the two places and the fact that many of the artists seem to have wanted to relive their experiences of life in the rival Breton colonies of Pont-Aven and Concarneau.

In a letter of 5 September, Butler wrote to his sister about an event which had taken place on the Saturday of the previous week: 'It was a most exciting day. The artists of Newlyn (where there is a colony of young English artists known as the "square touch school" hopelessly trying to climb over into the kingdom of art without going through the straight and narrow gate), these artists challenged the artists of St. Ives to suspend labour and play them at cricket.' This was the first of what was to be an annual series of cricket matches between the two colonies. Butler, Simmons, Chad-wick, and Adrian Stokes were among those who made up the first St. Ives team. Apart from Chevallier Tayler, Millard, and an artist called Scully, it is not known who played for Newlyn on this occasion. However, it is probable that, as in future years, the team was then captained by Bramley, and that Langley and Hall both took part. Forbes was to be a keen participant in later matches, but apparently on this occasion he simply went along to watch Tayler play.

The first match was held at St. Ives, and the home team won. Butler proudly reported to his sister that 'notwithstanding our American element here we beat these Englishers at the rate of 86 to 50. The highest score was made by Chadwick from Boston.' This triumph was rather marred by an unfortunate incident which took place at the end of the game when every-one was fooling around on the field. The ball was tossed up in the air, and Millard and Scully both rushed to catch it, neither of them apparently seeing the other. There occurred what Butler described as a 'most remarkable accident'. The two men collided with each other, Scully badly damaging his nose in Millard's mouth, and Millard losing several teeth, badly spraining his jaw, and then, after falling backwards on to the ground, receiving 'a slight emission of the brain'. 'It was awfully sad,' Butler wrote, 'we had been having such a delightful day.' Some of the artists ran for water, others to fetch a doctor. Butler held Millard in his arms for about twenty minutes, while other artists tried to clear the blood which was now pouring out of Millard's eyes, nose, and mouth. There were fears that he might die. Then the doctor arrived and said that it would take Millard about a month to recover. Simmons volun-teered to look after him for a few days at his home, after which a house was to be hired for him in St. Ives by a group of Millard's friends, who were to take turns to stay with him until he got better.

Once Millard had been taken care of, the Newlyn artists were able to give further thought to the match

which they had so shamefully lost. 'The Englishers', Butler wrote, 'are very much cut up over their defeat and we have agreed to play a return match tomorrow. We will probably let them win.' The Newlyn painter Frank Richards was to describe the later cricket activities of the two colonies in an article in the *Studio Magazine* of 1895: 'for lighter enjoyment on a hot summer's day, we indulge in cricket. Newlyn versus St. Ives is the match of the year, generally terminating in a victory for the home team over their friendly opponents.' Richards referred to Adrian Stokes as 'our opponents' most formidable man at St. Ives' and described Edward Simmons as another of their team's 'energetic and good cricketers'. In this same article Richards also wrote that the Newlyn artists, because they 'work so hard in the week and rest on Sundays, and are all teetotallers and go to bed at 10 p.m., had acquired the reputation among the artists at St. Ives of being "wey-necked mourners", a body of men following in the wake of a funeral.' Richards added: 'Yet, when on the cricket field there is little trace of such a melancholy spirit in us.' Near the end of his life, Forbes was to refer to cricket in a talk on his early days at Newlyn: 'There was at one time, I regret to say, a rather bitter rivalry between the painters of Newlyn and the neighbouring colony of St. Ives. Oh it was nothing to do with painting, or art of any kind; it was much more serious, for it concerned cricket.'

At the end of the summer of 1886 Forbes's mother left St. Ives and returned to London. Forbes was thus now able to settle down to a longer period of work in Newlyn. He retained none the less the use of a studio in St. Ives, and was to go back there on a number of occasions in the coming months. The Armstrongs joined him in Newlyn early in the autumn at about the same time as did Forbes's aunt, Alice. Alice noted with amusement 'the friendships that exist between these artists' and that everyone was 'in and out of each others rooms and houses at all times of the day'. As in most colonies, an important feature of artist life in both Newlyn and St. Ives was spending time in other peoples' studios and offering critical advice on their work. Soon this habit led to the artists of both towns going on group outings to see what was going on in the studios of their rivals. Those among them who had been at Concarneau were probably better equipped than the others in knowing how to condemn a painting at great length, having been used to listening there to such masters of this art as 'Shorty' Lasar. Butler, however, retained a characteristic reticence: although

he could express strong criticism of the Newlyn artists in his letter to his sister of 5 September 1886, he always limited himself in the presence of these artists to a few polite and appreciative phrases. Simmons, in contrast, and in true Concarneau style, was liable to become a quite vociferous critic. Forbes once had the misfortune to experience this: 'You should have heard Simmons talking about my picture . . . He excelled himself and criticized it in several languages but principally in French and American. It was something to listen to him on what he called the game of the colouring, which I afterwards found out meant the *gamme* (French—scale or key) and thus I said nothing and he talked for half an hour after which I had my revenge for I went round and saw his work.'

Later in the autumn of 1886, Butler went back briefly to America to see his parents, and the Armstrongs returned to London. When in London Elizabeth began to spend much of her time with Whistler and Sickert. This greatly worried Forbes, who wrote to her in December: 'really I cannot find words strong enough to show my contempt for these. I feel sure a time will come when you will see it too . . .' 'Sickert,' he added, 'I most particularly desire never to meet again.' Both Forbes and Sickert were founder members of the NEAC, which had been formed earlier that year. Forbes's hatred of Sickert and his associates is indicative of the tensions that had already developed within the club, and also of Forbes's own increasingly ambivalent feelings towards it. He had joined because he felt the Royal Academy to be 'essentially bad in every way'. Yet it was difficult to reconcile this view with the fact that the Royal Academy had regularly exhibited his works since 1878, and in the previous year had even shown his most acclaimed painting to date, *The Fish Sale*. Forbes was in fact never to break his association with the Royal Academy, and in consequence was to distance himself from the more progressive tendencies in British art.

Elizabeth Armstrong was safely back in Newlyn early in 1887, just in time to attend a ball to which all the Newlyn artists had been invited by their colleagues in St. Ives. She, Forbes, Millard, and Tayler went over to St. Ives for this occasion in a 'capital trap' which they had hired in Penzance. Afterwards they all had what Forbes described as a 'punching time'. Among those attending the ball were the Simmonses ('the little woman looking rather interesting') and the Chadwicks. Frank Chadwick had on a 'more singular costume than ever', comprising a white waistcoat, a black 'paget coat', and a folding top hat. The top hat

was a particular source of amusement to the 'damsels of St. Ives', who would scream with excitement every time Chadwick let it fly open. At the beginning of the evening Forbes tried talking with Emma Chadwick, but 'what with the music and her pronunciation' had great difficulty in understanding a word she said. Shortly afterwards she was 'dragged away' from the ball by her husband. The Simmonses also left early, 'as Mr Simmons does not dance'. Forbes himself was initially reluctant to do so, but was encouraged to join in when he saw that the St. Ives women were 'not up to waltzing'. Instead they favoured polkas and other such simple dance steps that Forbes felt that even he could manage. Miss Armstrong, or 'Lizzie' as Forbes now called her, had an especially enjoyable time at the ball. She was rated by Millard and others to be a 'crack dancer', and indeed hardly left the dance floor from nine o'clock in the evening until three in the morning, when her party all set off back to Newlyn. Forbes now thought that he really must take dancing lessons.

If Forbes still lacked confidence as a dancer, he had acquired another talent—acting. This was in fact an activity which was rapidly becoming an acknowledged speciality of the Newlyn artists as a group. Charades and muscial gatherings had always been a feature of their evening social life. Soon these had developed into full-blown pantomimes. By 1887 they had acquired the use of the St. John's Hall, Penzance; and by 1890 they were even to be asked to bring one of their performances to the town of Falmouth about forty miles away. The St. Ives artists were always invited to come over to see these 'theatricals', which also received extensive coverage in the local press. One paper even wrote: 'It is usual, and it is fair, to judge amateur performances by an amateur standpoint, but we may say in all sincerity that there are many professional players who might be content to take lessons in their art from some of the members of the Newlyn Artists Dramatic Society.'

Forbes's interest in acting grew increasingly obsessive, and his letters to his family began to contain interminable descriptions of every production that he was involved in. 'Lizzie' once wrote to his mother: 'Stan seems to be more gone on the subject of theatricals than ever. If he gets tired of painting you will know what his profession will be.' Forbes became particularly renowned for his impersonation of old men. In an 1887 production entitled *Freezing a Mother-in-Law*, Forbes acted what he described as a 'foolish weak old man frightfully hen-pecked'. Also taking part in this production were Thomas Gotch

and his wife Caroline. The Gotches, both of whom were painters, had first come to Newlyn in 1883, but had left early in the following year before Forbes had apparently had a chance to meet them. They had returned to the village in 1886. Forbes had not initially taken to them, describing Caroline as 'very aesthetic and untidy', and comparing Thomas to an unmade bed; he had also deplored the way in which they dressed up their small daughter as a little boy. However, the enthusiasm which they had shown for the 'theatricals' had soon endeared them to Forbes. In *Freezing a Mother-in-Law*, Caroline Gotch acted Forbes's wife. Forbes thought that her make-up for this was superb, but felt nervous every time he was on stage with her, because her acting was 'far from good' and she had not learnt her lines properly. He found, in contrast, that Thomas Gotch excelled in his role as a retired colonel, and even succeeded in creating on stage a character who was 'far more rational . . . than T. C. Gotch is himself'. 'It is a pity', wrote Forbes, 'that he does not always act.' Another participant in this production was Norman Garstin, who had first come

125 Norman Garstin (left) with Stanhope and Elizabeth Forbes at Newlyn, late 1880s

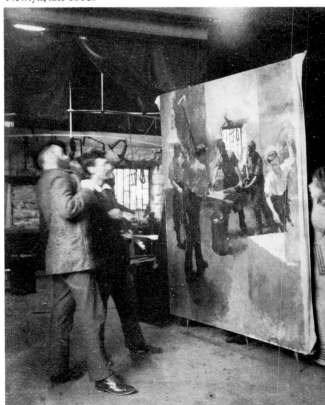

to Newlyn in the previous year. Forbes felt complete confidence when acting alongside him. Garstin was in fact to be a key figure in all the Dramatic Society's future productions. On one occasion he was to cause an uproar by making his exit through the scenery rather than through the door. On another he was to be required to emerge soaking wet from a shower; not wishing to have a tub of water thrown over him, he was to request the effect of dampness to be achieved with just a few drops of water, saying that he preferred 'a drier style of humour'.

In addition to spending an increasing amount of his time acting, Forbes took up playing the cello in 1887. He did this while engaged in painting *The Village Philharmonic*, a work which was to be his greatest success in the Royal Academy since *The Fish Sale*. It is an interior subject featuring a humble muscial gathering in a cottage. The Newlyn painters had originally developed a reputation largely as outdoor painters. Now they had begun to extend their principles of realism to the portrayal of interiors in a natural light. As Alice Meynell wrote: 'It is in their studies of interiors no less than in their open-air work that the Newlyn School proves this love of truth. An interior, lighted as its own window lights it, without convention, is as rare as a landscape studied in the unity of the light of the sky.' 'Lizzie' told Forbes's mother in 1887 that 'in the interest of [Forbes's] health he had better train his public to like interiors.' Although Forbes was to succeed in doing so (almost all of his Royal Academy successes of the coming years were to be of interiors), the painting of an interior was often as troublesome as working out of doors in the English climate. Forbes was to experience particular difficulties while painting inside the local smithy: the smoke, grime, and bad light which he encountered there were to lead him—as he afterwards shame-facedly confessed—to abandon his principles and make a reconstruction of the shop in his studio.

In 1887 Frank Bramley began work on an interior scene which was to achieve quite exceptional renown. This, *The Hopeless Dawn*, is also the only work by which Bramley is known today. The subject of the fisherwoman whose loved one has been lost at sea was very popular among artists who lived in fishing villages, and inspired at least two works by Langley. Bramley's painting was executed in what another Newlyn artist described as a 'hopelessly dark studio at the corner of the Rue des Beaux-Arts'. This studio was on the upper floor of a tiny two-floored house comprising only two rooms. Below Bramley lived a fat old woman who had lost both her arms in a railway accident. She used her small room both as a shop, where potatoes, cabbages, and turnips were sold, and as a school for young children. Her teaching activities provided a constant distraction for Bramley working above, as loud shouts of ''old yer row, yer griert bull-dog' and 'sit down you stinking elephants' would permeate the floorboards. Stanhope Forbes for one was unable to understand how Bramley could put up with all this.

By the summer of 1887 'Lizzie' had begun to feel that it would be better if she and Forbes worked further apart. Forbes now seriously thought of leaving Cornwall altogether for a while. He told his mother that Newlyn was 'too relaxing' for him. He was briefly tempted to go back to Brittany, but then decided against it, as Breton paintings were now apparently selling badly in England. Then he considered Holland. However, he was worried about going to any place where he would be on his own, for he knew that in such circumstances he would become 'so miserable' that he would want to 'throw it up' after only a few weeks there. In the end he remained in Newlyn, while 'Lizzie' once again went back to St. Ives.

St. Ives that summer was certainly a more exciting place to be than Newlyn. Many Newlyn painters apart from 'Lizzie' were going there for the season, as well as a host of others. 'St. Ives', Forbes wrote, 'will be crowded this year with people from all parts of the world. Plenty of new Americans . . . there will be more people there than there were last year.'

Howard Russell Butler was back again in St. Ives in July, after having spent time in Paris and Spain following his brief return visit to America. He was struck by how many tourists there were there that year, and noted that the Tregenna Castle Hotel, which had rooms for sixty guests, was completely full. He himself took lodgings in a house owned by a Mrs Dumble, who did all his cooking and housework for twelve shillings a week. He had the same studio as the year before, and now employed a small boy to look after it, carry his painting equipment, clean his brushes, and do various odds and ends. For all this the boy was paid at first five, then six, pence a day. He was called Daniel Lander, and Butler referred to him as 'Deronda'.

Butler was soon indulging once more in his love of physical activity, and this year was able to fit in both a swim and a game of tennis in his midday breaks. He also took part in another cricket match. The St. Ives team were now beaten by the 'Newlyn Englishers', but

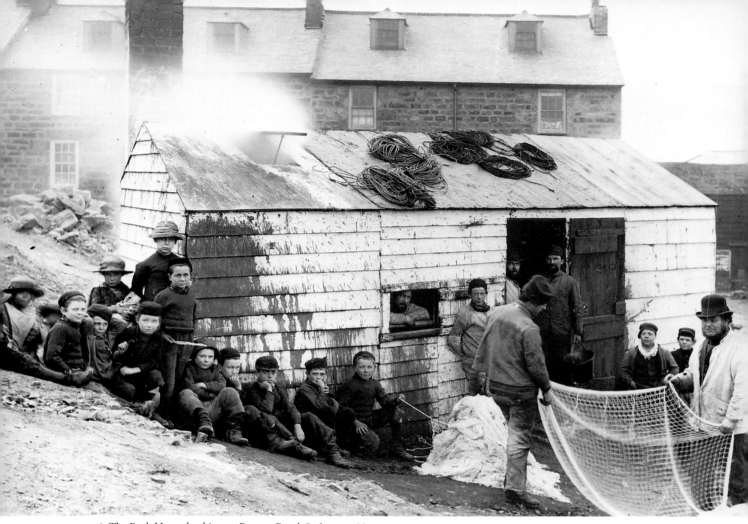

126 The Bark House backing on Barrow Road, St. Ives, c. 1880

everyone had a 'most enjoyable day' and 'there were no mishaps.' The return match was postponed indefinitely because of poor weather.

Among the various new acquaintances whom Butler made that year in the town were the local curate, whom he thought a 'pleasant fellow and a capital hand at tennis', and the vicar. These two clergymen were often to be found in the vicinity of Butler's studio. This was of course in the poor part of the town, the area where morals were reputedly at their laxest, and thus where the ministrations of the Church were most needed. Butler described most of his neighbours as 'dissenters' or 'non church-goers'. This year he found himself 'thrown a great deal with the poor people here', and wrote about them at length

in a letter to his mother: 'There are carpenters and fishermen and ship chandlers all around me working in similar shops to mine. I often talk with them and if I don't know them all I am known to all. I like the men and the boys—they are a rough lot, but there are some fine rustic characters among them. But the women all seem to be fiends—they will beat a child of three years old—and the little girls are most insolent—all are slovenly, given to over-dressing, lazy and filthily dirty. The curse of this town is gossiping.

Butler's letters of this time also reveal how remarkably cosmopolitan St. Ives had become. In one of these letters, addressed to his father, he indicated that during that year's stay he had developed an interest in the state of modern Russia through conversations that

127 Helene Schjerfbeck, *The Convalescent,* 1888. Ateneum in Taidemuseo, Helsinki

the house, was completely white apart from a black stove, and had an impressive stucco ceiling. From this room she had a magnificent view of the sea and town.

Schjerfbeck found that in England facilities for looking after foreigners were not as good as they were in France. None the less, she wrote, one soon learns to adapt oneself to these different conditions. Apart from the local girls, whom she thought exceedingly plain, she was most enthusiastic about the Cornish environment and people. She was to remain in St. Ives until early in the following year, and return again in 1889; this last time she encouraged a Finnish friend from Pont-Aven days, Maria Wiik, to come with her. During her first stay in the town, she used to attend evening classes three or four times a week given by Adrian Stokes. In these she was able to draw fishermen clad in oilskins and sou'westers. The only problem about such models, she reflected, was that they had to spend too much of their time fishing. Her most ambitious St. Ives work was the mawkishly senti-

he had had with a Finn and 'an English sympathizer with the nihilist movement in Russia'. In another letter, he wrote: 'There are many artists here—lately there has arrived a young lady from Finland—she has a wonderful talent and is a most interesting person altogether, although unfortunately lame—there is also a Russian lady here—neither speak any English, but both are fluent in French. We have in our colony in addition to the Finn and the Russian, an Austrian, a German, a Norwegian, a Swede, an Irishman, a Scot, a Canadian, four Americans and several Englishmen—we had a Greek whom we are glad to have got rid of . . .'

One of the Scandinavians who had come that year to St. Ives was the Norwegian landscape painter Bernt Grønvold. Little is known about him other than that he had trained in Munich and Paris, and was to stay in St. Ives until 1888. The lame Finn whom Butler fondly referred to was none other than Helene Schjerfbeck. She had come here largely through the insistence of Marianne Stokes, with whom she had visited Pont-Aven and Concarneau in 1884. Soon after arriving in St. Ives she wrote home to say that she was surrounded here by 'Pont-Aven veterans'. She lived and worked in a tower-shaped house belonging to a family called Robinson, who were friends of Forbes, and from whom Forbes himself had rented a studio in the previous year. Schjerfbeck's studio was at the top of

128 Helene Schjerfbeck, *The Bakery,* 1887. Hedmanska Samlingarna, Österbottens Museum, Vasa, Finland

129 Street scene, St. Ives, 1880s

mental *Convalescent* (fig. 127), the subject-matter of which was perhaps intended as a comment on her own lameness. This work, which was awarded a gold medal at the Paris International Exhibition in 1889, is much more detailed and conventional than most of her other paintings of this period. More to present-day tastes is her study of the St. Ives bakery (fig. 128), which is a work of extreme subtlety and near-abstract simplification. The work has more in common with paintings by St. Ives artists of the 1920s and 1930s than with anything done by Schjerfbeck's contemporaries in the town.

The Swede whom Butler mentioned in his letters was almost certainly Anders Zorn. Zorn was not only to become, with Carl Larsson, the leading Swedish artist of the late nineteenth century, but also to acquire an international reputation at this time comparable almost to that of Bastien-Lepage. He was born in 1860 in the small town of Mora, about two hundred miles north of Stockholm in the province of Dalarna, one of the regions in Sweden with the strongest folk traditions. He was the illegitimate son of a peasant woman, who took responsibility for his upbringing, and a wealthy businessman. Zorn's peasant connections, like those of Millet and Bastien-Lepage, were an undoubted bonus in helping to develop his reputation. He himself was always to remain very proud of them,

despite the fact that he was to spend much of his life in aristocratic circles. Some of his greatest paintings were of peasant life observed in the surroundings of his native Mora, which was always to be his main home, and where in his old age he built an outdoor museum comprising some of the few remaining traditional peasant houses of the area. In between his periods at Mora, he travelled throughout Europe and America, visiting, among other exotic places, Transylvania and Moscow, where he painted a portrait of Savva Mamontov. He was to have a particular success in America, enjoying there the patronage of Isabella Stewart Gardner. Among his American friends was Alexander Harrison.

Zorn had first come to England after completing his training in the Royal Academy in Stockholm in 1881. He had spent four years based largely in London, followed by almost two years of continual travelling, taking in France, Italy, Spain, the Balkans, Turkey, and Algeria. In 1887 he had returned to England together with his wife, Emma Lamm, whom he had married in 1881. He and Emma had decided to have a brief trip around Cornwall before taking a boat from Plymouth back again to Spain. With them in Cornwall was a young English painter, Alice Miller, whom Zorn had met two years previously and for whom he and his wife had a great respect both as a person and as an artist. The first place they visited in Cornwall was Penzance, where they arrived on a beautiful summer's evening. The town had enchanted Zorn, who had loved the way in which young couples would walk and flirt up and down the promenade. He had thought such behaviour to be characteristically English. Then they had come to St. Ives, and had soon abandoned their plans to go on to Spain.

Like the other artists in St. Ives, Zorn lived in the upper part of the town and worked in Downalong. In a letter to a Swedish friend, Hugo Greber, Emma described the latter district as a place where fishermen lived in cramped and dirty surroundings. According to her, these surroundings had less effect upon the health of the people who lived there than upon their moral standards, which she considered to be very low. She was shocked that boys of eighteen or nineteen were made to marry fourteen-year-old girls simply to keep the latter from being corrupted. She emphasized that the part of the town where she and the artists lived was by contrast spacious and comfortable, and that it was thus much easier for the inhabitants of this district to have high moral standards. From 'these aristocratic heights', she sarcastically added, the poor district of

the town seemed simply a component of a beautiful view. There was certainly no chance of her or any of her friends socializing with anyone down there.

Emma wrote that there were so many artists in St. Ives that it was 'difficult to have the moon to oneself.' She was none the less glad that there were such people around, as otherwise their social life would have been very dull indeed. They became friends with Adrian Stokes, to whom Zorn referred as the 'competent Stokes'. Their closest friend among the American community, however, was Edward Simmons. Simmons, 'one of America's best painters' according to Zorn, came round to have tea and to play chess with them almost every evening. Emma thought him 'clever in chess and conversation', and even more talkative than she was. In contrast Simmons described Zorn as 'a man with great hypnotic quality, who did not talk much, but dominated without speaking.' Whenever Simmons became argumentative, Zorn would remain silent, mutter 'I agree', and go back to do some work.

131 Anders Zorn, *Boats, St. Ives*, 1889. Zornsamlingarna, Mora, Sweden

130 Anders Zorn, *Fisherman, St. Ives*, 1888. Musée des Beaux-Arts de Pau, France

One day Zorn heard that Emma Chadwick, a friend of his from art school days, was living in St. Ives, and in a state of great excitement immediately went off to see her. He returned home very disappointed. Mrs Chadwick had greeted him coldly, and had had difficulty in talking Swedish. The Scandinavians with whom Zorn did spend much time in St. Ives were Schjerfbeck, of whose work he thought very highly, and Grønvold. Zorn thought Grønvold a 'most engaging and original personality', and he was indebted to him for lending him and his wife Norwegian books.

Usually on days when Zorn had great difficulties in working (these apparently were signified by his moustache stiffening and turning upwards), he would go on a tour of the Downalong studios. Once, however, he decided instead to visit Newlyn and see what the 'Englishers' were up to. In one of the studios here he was shown a picture which he thought he would politely compliment by quoting a line by Ruskin about the sea. Afterwards he pondered on the 'nauseating English habit' of trying to give a poetic mood to a painting by sticking trite little phrases on to the frames. The Englishman's enjoyment of a painting, he added, lay exclusively in reading the title in a catalogue.

Before coming to St. Ives, Zorn had worked largely as a watercolourist. He continued to use this medium here, and astonished Simmons with the boldness and originality with which he did so. Once Simmons found him in a backyard 'throwing pails of water against a six-foot watercolour propped up against a wall; asked what he was doing, Zorn replied that he was 'bringing it together'. On another occasion a thunderstorm

came up just after he had left a watercolour lying in a garden. Afterwards he and Simmons rushed out to inspect the damage, which Simmons thought to be irreparable. Zorn, however, just said, 'Now I can make a fine picture.' He was able to conceal all the raindrops that had fallen on it, except those in the foreground. He decided to turn these into footprints, which, according to Simmons, were later much praised for their naturalness. The picture was to have a great success when exhibited in the Grosvenor Gallery in London.

In later life Zorn was to be admired above all for his virtuoso oil paintings and etchings. It was in fact at St. Ives that he first began to work in oils. Emma was not very pleased with this new development in his art, finding it now much more difficult to clean his brushes. His first picture in this new medium portrayed her reading a newspaper (fig. 133). The he began a large picture showing, in his own words, a 'fisherman and a girl flirting in a way which I believe

133 Anders Zorn, *Portrait of the Artist's Wife: Emma Zorn reading a Newspaper*, 1887. Zornsamlingarna, Mora, Sweden

unique to England.' They lean, without touching each other, against a parapet, and stare out towards a full moon which rises above the St. Ives harbour (fig. 130). The view was from just outside Zorn's house. Emma commented that there was a great fashion in St. Ives at this time to paint couples looking at the moon with their backs turned to the viewer. Because Simmons had told Zorn what materials to buy for this picture, Zorn jokingly called himself Simmons's pupil while at work on it. According to Simmons, Zorn was 'as peevish as a child when I dared to criticize the fact that he had put the moon in the due north.' Zorn remained in St. Ives up to the early spring of 1888, when he went over to Paris, where his large oil of the fisherman and his sweetheart was exhibited at the Salon of that year. It won an honourable mention and great critical acclaim in the press, and was purchased by the French government.

'Lizzie' Armstrong stayed on in St. Ives for the winter of 1887–8. She found the town in this season to be 'rather miserable, muddy and deserted', and was glad when she returned to Newlyn early in 1888. 'It seems', she wrote to Forbes's mother, 'so much more home-like over here . . . especially as I have a comfortable studio instead of the bleak damp place I have left behind and which Mrs Simmons is at present having the full benefit of.'

The social season at St. Ives renewed itself in earnest later in 1888 with the formation of the St. Ives Arts Club. The first meeting of this club took place in a studio known as the 'Foc'sle', belonging to the Australian painter Louis Grier. Grier had come to St. Ives by 1887, and had soon acquired a reputation of

132 W. H. Y. Titcomb, *Primitive Methodists* (the model for the preacher was Louis Grier), c.1889. Dudley Art Gallery

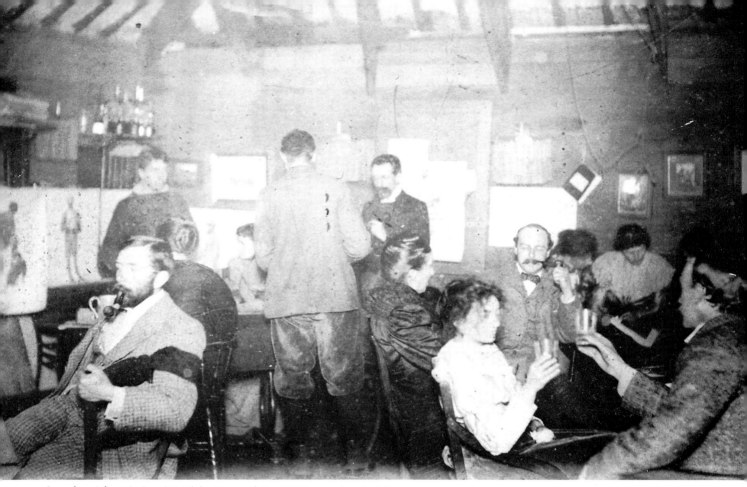

134 Saturday night at St. Ives Arts Club, 1895, with Louis Grier seated on the left

being more of a drunkard than a painter. He was an enthusiastic participant in the St. Ives versus Newlyn cricket match, and was known to be the finest bowler in the county when sober. When an English colleague of his, W. H. Y. Titcomb, embarked on a work entitled *Primitive Methodists* (fig. 132), having failed to secure the services of the local Methodist preacher as a model, he was, ironically, to ask Grier to pose instead. Grier was obviously the ideal person to help launch a club intended principally for socializing, and he was later to write a most lively history of this institution. At first its members used to meet every Saturday, and there were no women present. However, according to Grier, these early meetings were judged by some to be 'rather slow'. It was then decided that the club would greatly benefit if women were to be allowed to join it. 'The following Saturday,' Grier wrote, 'we mustered over sixty members of both sexes, and it was conceded by all that we had started a going and pleasant con-

cern. This time we had a piano on the spot, and as we boasted some members possessing considerable vocal and instrumental talent, things began to "hum" a little more. The light charade was indulged in too (much to the detriment of the Foc'sle draperies), and it was amusing to see a heavy-weight, in the shape of one of England's hopes in Landscape Art, chirping about on settees and things as Little Tom Tit guised in simple drapery with a seven-foot mahlstick under it by way of a tail; while a six-foot genius from Boston stalked him with a mighty gun.' The artist portraying 'Little Tom Tit' was Adrian Stokes, known both for his promise as a landscape painter and for his 'John Bull' physique. The Bostonian could either have been Frank Chadwick or Lowell Dyer, a painter known for some reason as the 'Boston Swedenborgian' and much appreciated in the colony for both his wit and cricketing abilities. Despite its growing success the first attempt at an art club was to be short-lived. In the following year Grier

found himself engaged on a 'masterpiece' and was unwilling to allow the club to have its meetings in his studio. It was not until 1890, when a permanent meeting-place was found for the club, that the institution was to be properly established. The new club had Adrian Stokes as its first president and included among its members, Grier, Simmons, Titcomb, and Sir Leslie Stephen, father of Virginia Woolf and Vanessa Bell.

In 1889 Forbes had another major Royal Academy success with *The Health of the Bride* (fig. 135), his most ambitious interior to date. Like Bramley's *Hope-*

less Dawn, it was purchased by Henry Tate, whose large collection of British art was soon to form the basis of the Tate Gallery in London. With the proceeds from the sale of his painting Forbes was appropriately now able to marry 'Lizzie'. The marriage took place on 7 August 1889, and was attended by most of the Newlyn and St. Ives artists. A guest wrote of the wedding reception that 'as we were all artists and their connections . . . the company could not fail to be entertaining.' A much commented-upon absentee was an amateur painter and friend of Forbes called Arthur Bateman, who also infuriated everyone in Newlyn by missing the cricket match against Newlyn that took place on the following day.

135 Stanhope Forbes, *The Health of the Bride,* 1889. The Tate Gallery, London

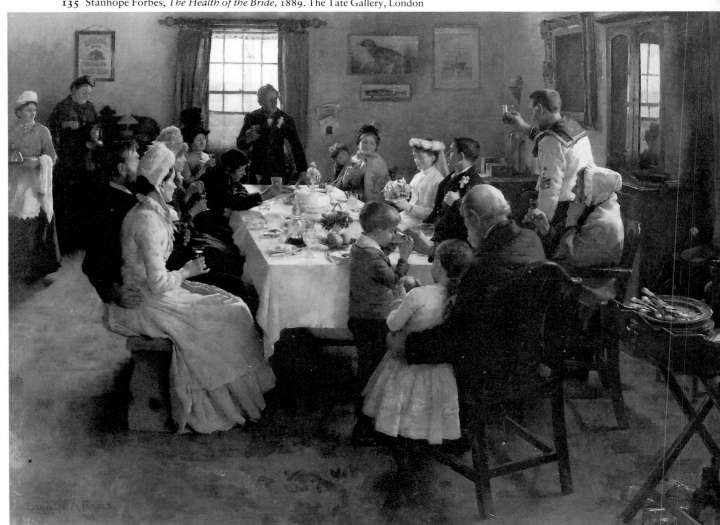

136 Elizabeth Forbes, *School is Out*, 1889. Guildhall, Penzance

Forbes's marriage can be seen to bring to an end the first and by far the most important period in Newlyn's history as an artist colony. In this same year the first major article on the Newlyn painters appeared. Its author, Alice Meynell, described them as 'the most significant body of painters now working in England'. By now the first of a series of modern glass studios had been built at the top of the hill known as the Meadow. These studies were opened on certain days to the public; on one such day in 1889 a painter reported that they were visited by 'thousands' of people from all over the neighbourhood. However, now that the Newlyn colony had come to be established in this way, it began, paradoxically, to play a diminishingly vital role in British art.

In the course of the 1890s many of the Newlyn colony's original members left the village. By 1899 Stanhope and Elizabeth Forbes were among the few of the early settlers still remaining there. It was out of nostalgia for the camaraderie that had once existed in the colony that in this year the Forbeses opened an art school in the Meadow. Elizabeth Forbes died in 1912, and their only child Alec was killed in World War I. Forbes lived on until 1947, remaining true to his original artistic principles to the end. In a lecture given in his old age at the Penzance Public Library he said of the early years of the Newlyn colony that 'in those unenlightened days we even ventured to put stories on canvas for we did not then realize the enormity of such practices and that true art should be restricted to the representation of dishes of unwholesome fruit or three

herrings on a badly drawn plate.' As well as attacking modern art, he also railed in his last years against the modernization of Newlyn and what he considered the wanton destruction of so many of the village's picturesque streets and houses. 'What sort of legacy', he once said, 'are we of the present-day leaving for our descendants?'

The Newlyn of today is in fact a relatively quiet and unspoilt place which still lives largely off its fishing industry. Ironically, one of the most prominent of the new buildings put up in the village since the 1880s is the Passmore Edwards Gallery, built in 1895 to display the work of the Newlyn artists. This grand example of Victorian civic architecture today contains within it virtually nothing of these artists, and serves largely as a solitary reminder of the fame which they once enjoyed. The village is now twinned with a town whose artistic past is equally little remembered—Concarneau.

St. Ives developed from an exclusive resort frequented by artists and wealthy visitors to a bustling tourist town, which today at least triples its population in the summer months. Downalong is no longer a poor fisherman's quarter but a district full of art galleries, antique shops, and 'Bed and Breakfasts'. Artists still work here, and some can even be seen in the streets with their easels, making a considerable profit from their paintings by selling them to passing tourists. One artist is reputed to be able to spend the winter months in the Bahamas from the proceeds of

137 Stanhope Forbes painting *February Sunshine* at Newlyn, 1909

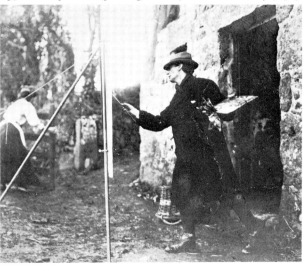

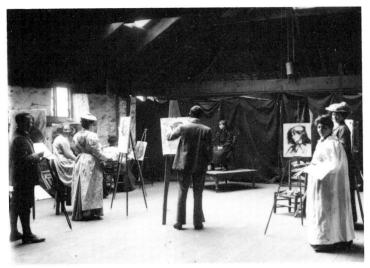

138 Art school at St. Ives, *c.*1900

such sales. In contrast to Newlyn, one is reminded everywhere in St. Ives of the former importance of its artist colony. Even the Arts Club is still running, although the meetings, which are now mainly genteel gatherings of people not connected with the Arts, are admittedly somewhat different in character from what they must have been like in earlier days. There are two photographs on the Club's walls of some of the original members, all of whom have otherwise been forgotten here, as they have been elsewhere in St. Ives. Today the colony is remembered for a later period in its history.

In the 1890s the popularity of St. Ives among artists continued to grow. Although a less cosmopolitan place than it had been in the 1880s, it still attracted as strong an American contingent as ever. One of the later American artist visitors here was the marine painter Frederick Waugh, a veteran of Barbizon, Grez, and Brittany, and a protegé of Alexander Harrison. Another was Harrison himself, who came here in 1899 following a month in Mora with Zorn, 'living simply and making sketches'. He stayed in St. Ives at the Tregenna Castle Hotel, and wrote shortly after arriving there that he had found in the town 'numerous old chums and acquaintances'.

The colony became increasingly conservative in outlook in the course of the next two decades, and by the 1920s seemed in danger of going the way of most colonies, and fading into obscurity. Then in about 1925 a poor retired fisherman living in Downalong, Alfred Wallis, perhaps inspired by the sight of artists working around him, decided to take up painting. He executed crudely simplified pictures of old-fashioned boats, using decorator's paint and scraps of old board given to him by the local grocer. Everyone considered him to be simply an eccentric until in 1928 two leading young English artists, Ben Nicholson and Christopher Wood, went on a day-trip to St. Ives and by chance saw some of his paintings. They were deeply impressed. Wallis was to die unknown by the public at large and in extreme poverty in 1942. Yet long before then he acquired an enormous reputation among an elite group of artists who were trying to break away from conventional methods of representation and were moving towards complete abstraction. A number of these artists, including Nicholson and his first wife, the sculptor Barbara Hepworth, moved to St. Ives at the outbreak of World War II. The town soon became known as a centre of the avant-garde, and in the 1950s and early 1960s was associated with a new generation of British abstract artists, including Terry Frost, Roger Hilton, Peter Lanyon, and Patrick Heron. A number of major figures associated with American abstract art, such as the painters Mark Rothko, Larry Rivers, and Mark Tobey, and the art critic Clement Greenberg, all came over to St. Ives from America during this period to see the work which was then being produced in the town. Today there is still much discussion as to the extent to which the St. Ives abstract artists were influenced by their American contemporaries and vice versa. Issues such as whether it was a British or an American artist who was responsible for the first vertical stripe painting continue to be hotly argued. It seems none the less difficult to imagine that any of the major artist centres of Europe at this time were as lively as their American counterparts. At all events it had by now become as important for the young European artist to visit America as it has been formerly for the young American artist to come to Europe. New York had superseded Paris as the artistic Mecca of the Western world. Moreover, artist colonies continued to thrive in America at a time when in Europe they were mainly curiosities of the past. It was, as shall now be seen, by no means coincidental that the great majority of these American colonies dated back to a much earlier period in the country's art, to the time in fact when American artists swarmed into Barbizon, Grez, Pont-Aven, Concarneau, and even St. Ives.

9

Victorians in the Modern World

PROVINCETOWN (MASSACHUSETTS, USA)

FOR ANYONE who had enjoyed the communal and rural life of an artist colony, it was often difficult to adjust to being back home again. For American artists the experience of returning home following a period in a colony in Europe was an especially difficult one. They had been attracted to Europe by its old traditions and monuments, and the lure of a continent where art was not simply a commodity intended for a museum, but seemed, in the words of Butler, 'a living thing'. Now the Atlantic separated them from all this. It was as if they had returned from a romantic past to a philistine present. A handbook published by the Boston Art Students Association in 1887 strongly recommended the American student to spend a few years living in Europe. However, it warned, such a period of residence abroad 'invariably unfits a man or woman to live at home afterwards'.

When in the winter of 1866 the painter Benjamin Champney arrived back in his native Boston almost immediately following his summer at Pont-Aven, he wrote to his former Pont-Aven colleague, Earl Shinn: 'And now how does Boston, HOME, appear again! Alas, it has a belittled, dirty and forlorn aspect to me. Everything goes helter skelter. Everybody is in a hurry and everything is done in a haphazard sort of way. I was homesick and out of temper, disoriented . . . What a pleasant summer we had at Pont-Aven! It will always be a pleasant memory to me . . .' Will Hicock Low, the chronicler of Bohemian and Arcadian life in Barbizon and Grez, made his first return visit to America in 1877. He soon had a 'sense of being extraneous to the life of Manhattan'. Many other young painters returned that year from their studies abroad, and had similar feelings to him. Low described himself and those other artists as 'argonauts bearing what they fondly conceived to be the golden fleece, ravished from the old art of Europe, to find that it was esteemed to be only dross by the self-sufficient inhabitants of our island.'

In common with the French-trained artists from other countries, those from America shortly after arriving back home felt dissatisfaction with their native art institutions. The year that Low first came back from France, he and other like-minded individuals formed in New York the Society of American Artists (SAA), which was intended as an alternative exhibiting institution to the ultra-conservative Academy of Design. Crudely speaking, the majority of the French-trained American artists of the 1870s and 1880s were open-air painters in the Barbizon and Bastien-Lepage traditions. Then, from about 1890 onwards, French Impressionism began to play an important role in American art. In 1895 a group of painters broke away from the SAA, and later exhibited together under the name of the Ten American Painters. At least two of these painters, Julian Alden Weir (an associate of both Barbizon and Pont-Aven) and 'Simmons of Concarneau', had earlier in their lives been strongly opposed to Impressionism; now, like the other members of the 'Ten', they became the leading American exponents of Impressionism, and is such were regarded as among the most progressive artists in America at this time. Two other members of this group were John H. Twachtman, who had been in Grez in the 1880s, and Childe Hassam, a largely Paris-trained painter who visited Pont-Aven in 1897. The American Impressionists essentially did little more than to apply some of the prettier and more colourful effects of the French Impressionists to the portrayal of

their native country. The year 1908 saw the formation of yet another group of artists, the 'Eight', one of whom, Robert Henri, had spent an important period of his youth in Pont-Aven. These artists reacted against the timid, imitative art of the 'Ten' and their associates to create a more distinctively American style of painting. They were soon dubbed the Ash-Can School and the Depressionists on account of their love of drab subjects from contemporary American life. Although today they are known primarily for their paintings of New York, they also worked in a number of the rural places favoured by their Impressionist predecessors. The 'Eight' exhibited together in the famous Armory Show in New York in 1913. By this date, however, they were no longer in the forefront of contemporary American art. This show included the works of the leading artists from France, America, and elsewhere associated with Post-Impressionism, Fauvism, Cubism, Futurism, and other major avant-garde movements of the time. With this highly influential show, America first established itself as a leading force in twentieth-century art.

In a lecture given in Chicago in 1910, Low said: 'It has been and still remains the habit of painters to congregate in various villages of France, and it is pleasant to think that a like good habit has to some extent been transplanted to these shores.' In fact the rapid growth of such places in America from the 1880s onwards, combined with a concurrent vast improvement in the training facilities for artists in that country, meant that by 1910 it was no longer necessary for the young American artist to spend a period in France. In almost all these American colonies, there existed at least one private art school—frequently run by a veteran of a French colony—which taught open-air painting in the summer months. Sometimes the establishment of such a school was the main reason for the formation of a colony. Other colonies grew up as a result of the presence in a village of a wealthy patron who would encourage artists to come and stay in his or her house. Such houses were the American equivalent of the famous artist inns of Europe.

Although most of the many American artist colonies of the late nineteenth and early twentieth centuries were formed initially for the sole purpose of painting out of doors, there were also a number of others that were set up at this time, by private individuals and generally in remote rural areas, simply to provide quiet working conditions for anyone involved in the arts. Two of the most famous of these are Yaddo and the MacDowell Colony, both of which are still thriving today. The idea for the latter grew out of the belief of Marian MacDowell, wife of the composer Edward, that her husband had been driven mad by the pace of city life and by being cut off from the pleasures of the countryside. Apart from being founded in a spirit of back-to-nature idealism, places such as Yaddo and the MacDowell Colony, with their institutional and monastic character, had virtually nothing in common with the main French artist colonies of the late nineteenth century. Yet even those American colonies that had been founded on the principles of the French ones, and often by veterans of the latter communities, invariably acquired—if they lasted long enough—a different artistic character to their prototypes. They soon became as important for sculptors, writers, and musicians as they were for painters, and moreover continued to thrive at a time when the preoccupations with open-air painting and the portrayal of rural life were no longer central to the visual arts. Artists genuinely interested in the countryside were by now best advised to pursue this interest on their own, and leave the colonies to those who simply wanted to be creative and to lead a type of Bohemian life that could almost equally well be led in a city.

The great majority of the original American artist colonies were founded on the east coast. In 1877 the former Barbizon painter, and friend of Millet, William Morris Hunt started up one of the first of America's

139 (continued overleaf) Henry Rankin Poore, *The Fox Chase*, 1901–5. Florence Griswold House, Old Lyme, Connecticut. This was painted across the narrow eight-foot long mantle in the dining-room of Florence Griswold House, which appears on the extreme right. Childe Hassam is shown stripped to the waist (above); Henry Rankin Poore is running in a cap and white pullover; and the overweight Henry Ward Ranger is waving his cane and trying to catch up with the others

open-air painting schools at the fishing village of Magnolia, Massachusetts. Like so many of these schools, Hunt's mainly comprised young female art students, most of whom adored him. One of these, Helen Knowlton, in fact became his mistress and biographer. The nearby seaport of Gloucester, and Cape Ann on which it is situated, soon also began to attract large crowds of artists and tourists, many of whom came over to Magnolia and pestered Hunt so much that whenever he wanted to paint outside he was forced to wear a placard with the words, 'I CAN'T TALK, I CAN'T HEAR'.

The Pont-Aven landscapist William Lamb Picknell, after returning home from Brittany in 1880, scoured the Massachusetts coast for a village to paint, and ended up in Annisquam on the northern coast of Cape Ann, where he was soon joined by two friends from Pont-Aven days, the brothers Frank and Bolton Jones, and about thirty other artists. In 1889 two more Pont-Aven veterans, Arthur Wesley Dow and John Kenyon, came over to visit them all for the day: 'It was very jolly,' Kenyon wrote, 'a regular American Pont-Aven; all hands going round to the studios and all the work being taken out for inspection.' Dow, Kenyon, and yet another former Pont-Aven painter, Amsden, were then based in Dow's native town of Ipswich, about fifteen miles north-west of Annisquam, which had a tidal river that Kenyon described as being 'much like the Aven'. They had also just returned from Brittany, and in their intense nostalgia for the place had covered their studios with Breton bric-à-brac, and taken again to wearing sabots and berets. Dow was soon to open up his own school of painting at Ipswich.

Long Island in New York State became very popular with painters from the late 1870s onwards. Artistic life on the island was centred on the southern village of East Hampton, which rose to fame in 1878, when it was first visited by a renowned New York 'sketching club' called the Tile Club, whose members included Twachtman, William Merrit Chase, and the one-time associate of Barbizon and Pont-Aven, Julian Alden Weir. In *Lippincott's Magazine* of 1883 there appeared an article on East Hampton entitled 'The American Barbison'. It listed as among the main attractions of the village to artists not only the ramshackle old cottages but also the quaint elderly people who lived there: 'Wonderfully numerous and varied are the "characters" of the village; and this adds greatly to its artistic value. Old farmers with their homely saws, grizzled whalemen, fishermen, and wreckers and life-saving men, may all be met here.' Alexander Harrison and Childe Hassam were among the many artists who spent the summer in the village in 1888. Then in 1891 William Merrit Chase founded an art school nearby, just outside South Hampton. Chase was a Munich-trained artist who was later to become a member of the 'Ten'. He was also one of the most influential American art teachers of his generation. His Long Island school, the Shinnecock Summer School of Art, became extremely successful, and led to countless more artists and their easels filling up the available surrounding countryside in the summer months. This new influx of artist visitors supposedly inspired an old farmer to ask Chase: 'What on earth do you folks find worth painting around these parts?'

The Connecticut coast played a particularly important part in the development of American Impressionism. The two main colonies here were at Cos Cob near Greenwich and at Old Lyme near the estuary of the Connecticut River. The former developed as a colony from 1890 when Twachtman visited the place and reputedly exclaimed: 'This is it!' He soon started up painting classes here, in which he was assisted by

Weir. Other associates of this colony in its early years were Hassam, Willard Metcalf, and Theodore Robinson. Metcalf was a veteran of Grez, Pont-Aven, and the mainly American colony that had been built up at Giverny in Normandy. Robinson, the intimate friend of the Stevensons, had been an habitué of both Barbizon and Grez, as well as one of the 'discoverers' of Giverny. The principal meeting-place for the Cos Cob colony was a boarding house belonging to the Holley family, who were very sympathetic towards artists. Charades, sporting activities, and similar entertainments took place in and around Holley House and became inevitably as central to the life of the colony as painting. Old Lyme was 'discovered' in 1899 by a traditionally minded Barbizon painter called Henry Ward Ranger, who determined to make of the village 'the new Fontainebleau in Connecticut'. He found a rambling and slightly decrepit colonial house, the owner of which, Florence Griswold, agreed to take him in as a paying guest. Soon an art school was set up in the village, and later an Art Association. The most distinguished artist visitors to the place were all invited to stay with Griswold, who styled herself 'the keeper of the colony'. Her guests included Hassam, Metcalf, Edward Simmons, and Henry Rankin Poore. It was Poore, who had stayed in Barbizon in 1884 with the marine painter Frederick Waugh, who suggested that Griswold should follow the practice of the artist hotels of France and have the dining-room of her house decorated by members of the colony. He himself contributed to this decoration a narrow eight-foot long canvas for the mantle of the fireplace, called the *Fox Chase* (fig. 139). It portrayed in a humorous light all the Lyme artists at work and play; new artists were added to it over the years, and at least one deleted for having left without paying his bill. The spirit of high jinks which it conveyed was apparently characteristic of life in the colony, which was noted for its impromptu musical and theatrical entertainments, parlour games such as the 'Wiggle Game', quoits competitions, and practical jokes such as painting the shell of a box turtle with coloured spots and pretending to Ranger that the animal underneath was an exceptionally rare breed. A controversy arose within the colony between those who painted in a sombre Barbizon manner and the Impressionists. Poore and Ranger, the main representatives of the former group, were dubbed 'the baked-apple school of art' by their principal opponent among the Impressionists, Childe Hassam. In the end Ranger left the place in a huff, saying that it had become 'too civilized' for his tastes.

The most important and long-lived of the inland colonies in the eastern USA was at Woodstock in upstate New York. The village was originally developed as an Arts and Crafts centre under the aegis of Ralph Radcliffe Whitehead, a wealthy dreamer who had studied at Oxford University in the 1870s and had been inspired by the ideas of William Morris, as well as by Ruskin's vision of a model community in the form of the Guild of St. George. Whitehead's colony was named the Byrdecliffe Colony, and the craftware

140 Shinnecock Summer School of Art, 1890s

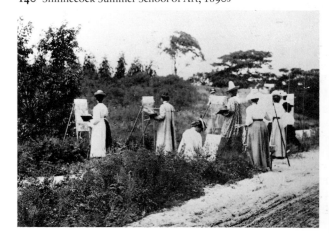

produced by it soon earned the nickname 'Bored Stiff'. Then in 1906 Birge Harrison (Alexander's brother, and a veteran of Grez, Pont-Aven, and Concarneau) established at Woodstock the Art Students' League Summer School, where later two members of the Ash-Can School, Robert Henri and George Bellows, taught. In the Depression years Woodstock became notorious for the riotous costume balls that were put on by the colony's artists every August on the night of the full moon. These events, known as the Maverick Festivals, were brought to an end in 1931 following well-founded rumours of nude midnight orgies. Artists have continued to settle in and around Woodstock up to the present day. Today, however, the place is perhaps best remembered for the celebrated rock festival held here in 1969. This was presided over by the musician Bob Dylan, and was a key event in the drugs and sex revolution of the 1960s.

Apart from a few quaint immigrants and elderly folk, the eastern USA could hardly offer the artist a race of people as picturesque and old-fashioned in their traditions and costumes as the French and in particular the Breton peasantry. In his search for the genuinely primitive and exotic, the American artist had to head out west, where the Red Indians, with their feathered headdresses and tribal dances, provided motifs comparable to Breton coiffes and *Pardons*. Henry Mosler, a Pont-Aven veteran who painted historical genre scenes similar to those of Wylie and Hovenden and ran a successful studio in Paris, paid a visit to Arizona in 1885, carrying with him a letter of introduction which began: 'A distinguished artist of Paris, France, desires to visit various tribes in the Indian territory, in connection with his studies in his profession.' At about this time Elmer Boyd Smith, who had participated in the Thanksgiving celebrations in Pont-Aven in 1884, also came to Arizona. According to Dow, who took a great interest in the lives of all his former Breton colleagues, Smith was 'near being killed by Indians for making love to a squaw'; later Smith ended up as an art teacher in Kansas City, where he would suprise everyone by turning up at exhibitions sporting a beret. The main colony in the west of America was at Taos, New Mexico. One of the first artists to come here was Henry Rankin Poore in 1888. However, the colony was not started up until several years later. Its early members were mainly French-trained and portrayed the life of the local Indian population in a very literal and illustrative manner. In 1917 the writer and socialite Mabel Dodge Luhan bought a house here, and through her the English writer D. H. Lawrence, as well as such major American painters as Robert Henri, Georgia O'Keeffe, and Marsden Hartley came to the area. Taos today is an exceptionally noisy tourist and artist centre, whose visitors often attract more attention than do the few remaining Indians.

There were many other colonies established in America at the turn of the century, including those of Santa Fe in New Mexico, Carmel in California, New Hope in Pennsylvania, Cragsmoor in New York State, and Monhegan Island off the coast of Maine. Yet none of these colonies, or indeed any of the ones discussed so far, had the size or importance of Provincetown, Massachusetts.

Provincetown (known generally as 'P-Town') is situated at the tip of Cape Cod, a long peninsula reminiscent in its scenery if not its shape of the Skaw in Denmark. Much of the landscape of the Cape is gently undulating and wooded until one reaches Welfleet, a small village about five miles south of Provincetown. From here the trees give way to marsh and heathland, interrupted near the coast by spectacular sand dunes where it is quite possible to lose one's direction. The dunes end in sandy beaches that owing to the clarity of light here seem almost endless. Provincetown is a long, sprawling town of white wooden houses that have grown up mainly around a single street, Commercial Street. The southern end of the town is called 'Downalong' and the northern end 'Uppalong'. The skyline is

141 Commercial Street, Provincetown, *c.* 1900 (cf. fig. 148)

dominated by the late nineteenth-century Pilgrim's Memorial monument, a tower inspired by medieval Sienese architecture and situated on top of a slight hill.

Provincetown is a very old colonial settlement, and many of its residents can trace back their ancestry to the Mayflower Pilgrims, who stopped off at the Cape on the way to Plymouth in 1622. From the early eighteenth century onwards, the town was the third most important whaling centre on the east coast. In the course of whaling expeditions local ships would stop at ports in the Azores, where they would pick up numerous Portuguese seamen, many of whom later settled in Provincetown. By 1875 the town's Portuguese population outnumbered that of the native Yankees. Today they are still very much in evidence:

they continue to talk their own language, and run their own shops and restaurants.

The possibilities for Provincetown's exploitation as an artist and tourist centre opened up in 1873 with the building of a railway to the town. One of the relatively few visitors who at first profited by this was an artist called Thovald, who had been commissioned to do some desert pictures which he thought he might be able to paint in the dunes near Provincetown. Thovald's reports about the place encouraged other artists to paint there. But it was not until after Charles Hawthorne's arrival in 1898 that Provincetown began to develop into a bustling artist resort. Hawthorne was one of Chase's most promising students. He had studied at the latter's Long Island school, where he

had met his future wife, Marion, and, in 1896, had assisted Chase in teaching. In 1897 he had stayed at the fishing village of Zandvoort in Holland. This was a popular place for artists, and both Chase and Stanhope Forbes's wife, Elizabeth Armstrong, had spent time there. Coming back to America in 1898, Hawthorne decided to set up an open-air art school which would be run on similar lines to Chase's. He searched the east coast for a suitable place to establish this school, and at first decided upon a village in his native state of Maine. Then he came to Provincetown, where he soon opened the Cape Cod School of Art. He was to keep a house in Provincetown until his death in 1930.

Hawthorne was almost exclusively a figure painter, and one of the great attractions to him of Provincetown was its Portuguese fishing population. These people had for him all the ruggedness befitting those who spent much of their lives at sea, together with an exotic character resulting from their nationality. They were to inspire some of his best works. Hawthorne must surely be regarded as one of the last great exponents of the realistic tradition of the late nineteenth century. The style in which he painted can be linked to that of the Munich peasant genre painter, Wilhelm Leibl, under whose influence Hawthorne's teacher Chase had fallen while studying at the Academy in Munich in the early 1870s. Hawthorne worked directly on to the canvas without making any preparatory drawings, made extensive use of a palette knife, and boldly juxtaposed pure colours in a way that was to be much admired by some of the abstract painters who later settled in Provincetown. Yet for all this he always retained an extreme clarity in his rendering of the figure, and a realism so pronounced that one of his paintings of a fisherman was to be used by a Texas doctor to illustrate skin cancer caused by overlong exposure to weather. In maintaining such a realistic style, Hawthorne cut himself off from the most progressive tendencies in Western art in the early years of this century, and in so doing ensured that after his death his reputation would significantly decline. Today he is a little-known figure, even in American art. If he is remembered at all it is principally for his abilities as a teacher, an inkling of which can be had from his posthumously published views on the art of painting.

A 1901 brochure advertising the Cape Cod School of Art described Provincetown as the 'oldest and most picturesque fishing hamlet on the New England coast. It seems impossible to realize when first setting foot in the village that one is only three or four hours from

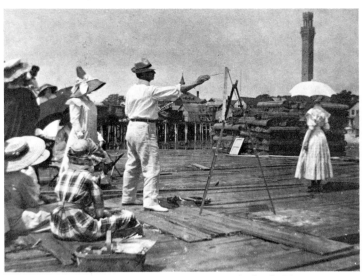

142 Charles Hawthorne's painting class (Cape Cod School of Art) on the pier at Provincetown, c. 1915

Boston. For the very reason of its obscure position Provincetown has kept its refreshingly primitive character, not having been rendered colourless by the inroads of summer excursionists.' By this date, however, the town was gradually filling up with artists, some coming simply for the summer months, and others more permanently. Fishing lofts were everywhere being converted into studios; there were now eight hotels and many more boarding houses. One of the most popular of the latter was the Figurehead House on Commercial Street. This exceptionally cheap place was run on the understanding that none of its guests would make a fuss about the lack of plumbing.

Hawthorne's art school was an immediate success and attracted throngs of students. Hawthorne had wondered just before coming to Provincetown how Chase had managed to 'do as much as he did with all those women togging around'. However, his own students were mainly female. They found him a glamorous figure, and he in turn was notoriously flirtatious with them, especially in later life. The high point of the teaching week was when Hawthorne, dressed in white shoes and clothes, would bring his classes outside to paint from the model on the town pier. These outdoor classes usually attracted a large crowd of tourists and townspeople. The success of Hawthorne's art school was to lead to four other

similar schools being opened in Provincetown by 1916, by which date the Provincetown Art Association had also been inaugurated.

Writers started moving into Provincetown early in the second decade of this century. The great majority of them came from New York's Greenwich Village, the area of the city with the highest concentration of writers, artists, and intellectuals. Among the first to arrive were Mary Heaton Vorse, Hutchins Hapgood, Neith Boyce, Susan Glaspell, and George Cram Cook (known always as 'Jig'). They formed their own self-contained community and had little to do with the painters in Hawthorne's circle, who, in comparison to them, were very conventional in their political and social outlook. Susan Glaspell, in her biography of her husband 'Jig', wrote that she and the writers around her were regarded by the other members of the colony as 'radical, wild'. She none the less thought that she and her friends, although mostly in rebellion against their conventional middle-class families, were not as unorthodox as they were made out to be, and at heart had an 'instinct for the old, old things, to have a garden, and neighbours, to keep up the fire, and let the cat in at night'. In his autobiography, *A Victorian in the Modern World*, Hutchins Hapgood described their circle as comprising essentially 'workers', people who 'lived pleasantly together, made love, had occasional bouts with Bacchus, and did what conventional people would call unseemly things, but [who] had a rather steadfast purpose in life . . .'

The outbreak of World War I effectively closed off European travel for Americans. This had the effect of swelling the number of visitors to Provincetown in a most alarming manner. It was also then, in the summer of 1914, that the real radicals arrived, people whom Hapgood characterized as 'the Anarchists, the I.W.W.s, the females militantly revolutionary about sex-freedom, and the Cubists and Post-Impressionists in Art'. The latter were now enjoying much publicity following the enormous success of the Armory Show the previous year. Among them, according to Hapgood, was a 'Cubist illustrator named Stuart', who had a little studio on the beach where he and his radical friends 'all danced and drank, and went in swimming at night, with Cubic costumes and without them.' The most important of the new avant-garde artists to come to Provincetown was Charles Demuth, who was later to paint the local Methodist church in a Cubist style, and earn a reputation as one of America's leading Cubist painters. One of the ringleaders of the radicals was the writer Mabel Dodge Luhan. Hap-

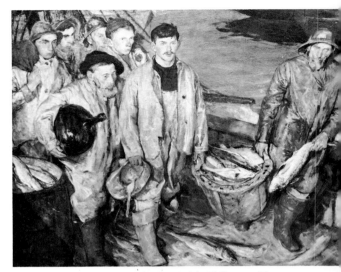

143 Charles Hawthorne, *The Crew of the Philomena Manta*, 1916. Provincetown Art Association, Massachusetts

good wrote of her: 'Surrounded by her new "faithful" at P-Town, she made it her business to keep them together in a little group, and also almost unconsciously to impregnate them and all others she could reach with the suspicion and dislike for all those outside the group.' Hapgood now found that the atmosphere of Provincetown had become extremely unpleasant, with everyone revealing a 'certain instinct to destroy each other's personalities'. Yet he and his circle came increasingly to socialize with the radicals, even joining in occasionally in some of the latter's nude bathing parties. And in the summer of 1915 they were all to get together in the devising of a theatrical event which was to have major repercussions for the history of the American theatre.

As in other artist colonies, members of the Provincetown colony used to entertain themselves by putting on plays of a largely comic nature. The first of these were given at the home of Hapgood and his wife Neith Boyce. Then it was decided to make a theatre out of an old fish house on one of Provincetown's wharfs. The greatest enthusiast for this was 'Jig', who soon began to describe the aims of such a theatre in the most serious terms: 'One man cannot produce drama. True drama is born only of one feeling animating all the members of the clan, a spirit shared by all and expressed by the few for the all. If there is nothing to take the place of the common religious purpose and

passion of the primitive group, out of which the Dionysian dance was born, no new vital drama can arise in any people.' The fish house was cleared of boats and nets, seats were made out of planks placed on sawhorses and kegs, and lighting was provided by lanterns with tin reflectors. Everything, from the conversion of the building to the painting of the seats, writing of the plays and acting, was undertaken by members of the colony. The first play which was performed here, a Freudian satire by 'Jig' and Susan Glaspell called *Suppressed Desires,* was a great success, despite the occasional disappearance of an

144 Edwin Dickinson, *Interior,* 1916. Collection of Mr and Mrs Daniel Dietrich II, on loan to the National Academy of Design, New York

umbrella through holes in the theatre floor. Another of the plays put on later this same summer was again by 'Jig'. Entitled *Change Your Style,* it concerned the stylistic divide between the painters of Hawthorne's generation and the 'Cubists and Post-Impressionists in Art'.

Hawthorne, like many of his followers, remained obstinately opposed to the great changes that were now affecting the art world. In the winter of 1915–16 he painted one of his best-known scenes of the fisherman's life, *The Crew of the Philomena Manta* (fig. 143). Most of the models for this were in fact not fishermen at all, but his students. It was executed in one of a series of studios recently built into a disused timber warehouse. Day's Lumberyard Studios, as these were called, were extremely noisy and primitive: there was just one outside toilet to serve the many artists who worked in the building, some of whom responded to this situation by using instead the sinks in their studios. Working here at the same time that Hawthorne was engaged on the *Philomena Manta* was Edwin Dickinson, one of Hawthorne's most outstanding pupils. In 1916 Dickinson brought to completion his remarkable *Interior* (fig. 144). The legacy of Hawthorne's teaching is evident in the work's realistic rendering of the figures (two of the models were from the Portuguese fishing community), but Dickinson has transformed this influence through an extremely original imagination and sense of composition. Of all the Provincetown painters, Dickinson was one of the few to fit happily into both the world of the traditionalists and that of the modernists.

In the summer of 1916 the more progressive members of the colony became actively involved in another season of the newly formed theatre. Hawthorne and his friends meanwhile had something else to distract them. This was an artists' club called the Beachcombers, which was founded in July of that year. The name of the club was probably derived from a line from Robert Louis Stevenson's novel *The Wrecker*: 'For the Beachcomber, when not a mere ruffian, is the poor relation of the Artist.' The club was restricted to male artists and had its meetings in a place they called the 'Hulk', which was another fish house on one of the town's wharfs. It was not long before its members were organizing charades, pantomimes, and costume balls, in all of which Hawthorne himself was to take an enthusiastic part. The general tone of the club is exemplified in this unpublished ditty entitled 'Ballad of the Beachcomber Saturday Night':

They piss and drink and raise
 dispute on politics and art
With many a 'kiss my ass, you jerk!'
And many a curse and fart.
They fart and argue strongly, Boys,
Of Art and Sophie Tucker,
With many a 'Balls to you, my friend!'
And many a 'Nuts, you fucker!'

The radicals were more in evidence in Provincetown in the summer of 1916 than ever before. Prominent among the new arrivals was the journalist Jack Reed, then one of the most fêted writers of Greenwich Village. His Communist sympathies would shortly take him to Russia, where he was to write his famous account of the Russian Revolution, *Ten Days That Shook the World,* and where he was also to die. He was a former love of Mabel Dodge Luhan, but was now with Louise Bryant, who had just abandoned her husband in California. Reed's and Luhan's turbulent love life had inspired in the previous year a play by Neith Boyce called *Constancy.* Reed and Bryant hired a little shack together on the beach behind Province-town, and invited numerous friends from Greenwich Village to come and stay with them there. One was Hippolyte Havel, an anarchist whose political and social views were too strong even for Reed, but who proved himself an excellent cook. Another was the painter Marsden Hartley, who overstayed his wel-come and was accused by Reed of not even making any intellectual contribution to the household. Two other Greenwich Village artists who came to Provincetown that year were the painter and sculptor William Zorach and his painter wife, Marguerite. William had been asked to Provincetown to start up a summer school of modern art. In the end no student enrolled for this. Hartley and the Zorachs were among the best known of that year's progressive artists, all of whom were now mockingly labelled 'Futurists'.

Reed, Bryant, and the Zorachs all joined in that year's theatrical activities on the wharf. Another participant in these was a young playwright called Eugene O'Neill, who witnessed at Provincetown the first production of one of his plays. The play in question was *Bound East for Cardiff,* which had a sombre seafaring theme, and apparently had its première on a very foggy evening with a fog-horn sounding constantly in the distance. In his early years O'Neill was obsessed by tales of life at sea; apparently in Provincetown he far preferred the company of fishermen to that of writers or artists. William Zorach

145 William Zorach, *Seiners, Provincetown,* 1916. National Museum of American Art, Smithsonian Institution, Washington, DC

was going to work with him in 1916 as a stage designer, but found that they had different views as to what a stage design should look like: 'Gene insisted everything had to be factual. If a play called for a stove, it couldn't be a painted box. It had to be an honest-to-goodness stove. If there was a sink, it had to be a real sink. I used to try to make him understand that a stage is a work of art like a painting. It is a world in itself or at least an illusion of a world. You cannot, for instance, have a real tree or a real ocean. There at least, you have to accept the illusion. I could make no impression on him.' The plays put on that summer at Provincetown received so much outside attention that the company, by now known as the Provincetown Players, decided to take them to New York. Thus were

launched both the career of one of America's greatest playwrights and the concept of the small-scale group theatre. The first of the plays that transferred was a symbolical piece by Louise Bryant. Jack Reed and William Zorach acted in this, and Marguerite Zorach produced an abstract stage design which doubtlessly would have appalled O'Neill.

By the summer of 1916 tourist and press interest in Provincetown had reached an unprecedented pitch. Coachloads of tourists would drive into the town, and as soon as a large group of painters was seen at work, the driver would shout out, 'There are the artists!' An article in the Boston *Sunday Globe* of 27 August, headed 'Biggest Art Colony in the World at Provincetown' (fig. 147), noted that 'the thing that staggers visitors these days is the art students—mostly women—with their easels set up at nearly every house corner and street corner, on wharfs, in old boats, in lifts, in yards, along the beach—anywhere and everywhere you go—painters, painters, painters.' Journalists began to question the townspeople about their reactions to the artists, and their willingness to be used as models. One of those interviewed was the

town crier, reputedly the last of his kind in America: 'No sir, these artists don't get me to do no business with them: I don't have to depend on that kind of work, an' my eyes ain't good enough to sot there alookin' at nothin' for two an' three hours. Oh, they've tried to get me into all sorts of things— pictures an' plays an' musical concerts. But I guess, cryin's good enough for Mr Smith when there's anything to cry; an' I don't have to use no megaphone neither.' Another man interviewed was a local fisherman, who said that he had only posed once to artists and was very unhappy with the results: 'Of course I'm not much on looks now, but you ought to've seen me when they got through with me.' 'It was probably a futurist portrait of you they painted,' suggested the journalist.

There was no ebb in the tide of visitors to Provincetown in the following years. Neither did the vast numbers of tourists and amateur artists in the town put off serious writers and artists from continuing to go there. Among the distinguished writers who now came to be closely associated with the town were the critic Edmund Wilson, and the two

146 Scene from *The Game* by Louise Bryant, the first play presented in New York City by the Provincetown Players, with (from the left) Jack Reed, William Zorach, Martha Rythen, Kitty Karnell; stage design by Marguerite Zorach

Nobel prize-winners, Sinclair Lewis and John Dos Passos. Of the new artist settlers, there was the same strange mixture as before of traditionalists and modernists. Tensions between the two factions were heightened in 1921 when Hawthorne and his friends took control of the Provincetown Art Association, and virtually banned the modernists from exhibiting there. Eventually the latter forced the Association to allow them to have their own separate exhibitions.

The traditionalists within the colony in the 1920s included numerous veterans of European artist resorts. One was Max Böhm, who had stayed at Gloanec's in Pont-Aven in the eventful summer of 1888, and had also been a central figure in the artist colonies at Équihen and Étaples in Normandy. After returning for good to America in 1915, he had begun to feel restless and depressed. His daughter was later to describe what subsequently made him settle in

148 Commercial Street, Provincetown, 1983 (cf. fig. 141)

147 Front page of the Boston *Sunday Globe Magazine Section*, 27 August 1916

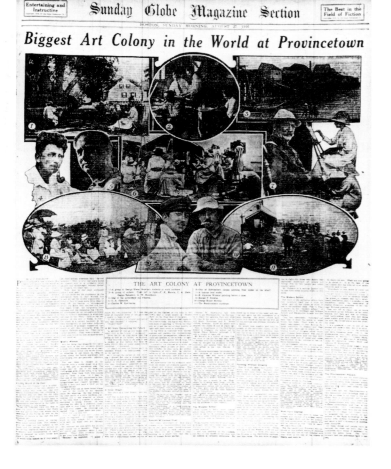

Provincetown: 'Father longed for broader horizons. He missed the easy-going days, the stimulation of conversation with artists and friends and the freedom of his former Bohemian life. He was told about the artist colony which existed in P-Town at the tip end of Cape Cod. There we went one summer. Many friends from abroad were already established in the quaint old village which had a sandy street, broad sidewalks and colourful fishermen reminding us of Équihen. It was the closest we could come to the life we had known before. Father was happy again. It was as if he had come home to a familiar and cherished place.' One of Böhm's friends from French days now residing in Provincetown was John Noble, who had spent much time in Brittany. Noble's life was later to be the subject of one of Irving Stone's historical novels, *The Passionate Journey*. According to this, when Noble arrived in Provincetown in 1917, 'his whole being filled with joy as he gazed out at sea: for Cape Cod was another Finistère'. In 1928 the marine painter and veteran of Barbizon, Grez, Concarneau, and St Ives, Frederick Waugh, came to spend the last years of his life in Provincetown. Like Böhm and Noble before him he felt happy to have come back to a place which so reminded him of his youth in France.

In the 1930s the abstract painter Hans Hoffman settled in the town, and opened up a highly influential school of abstract painting. In the subsequent decades Provincetown, like 'the American Barbison', East Hampton, developed into a major centre of Abstract Expressionism, attracting such painters as Helen Frankenthaler, Robert Motherwell, Franz Kline, Jackson Pollock, and Mark Rothko. The liveliest meeting-

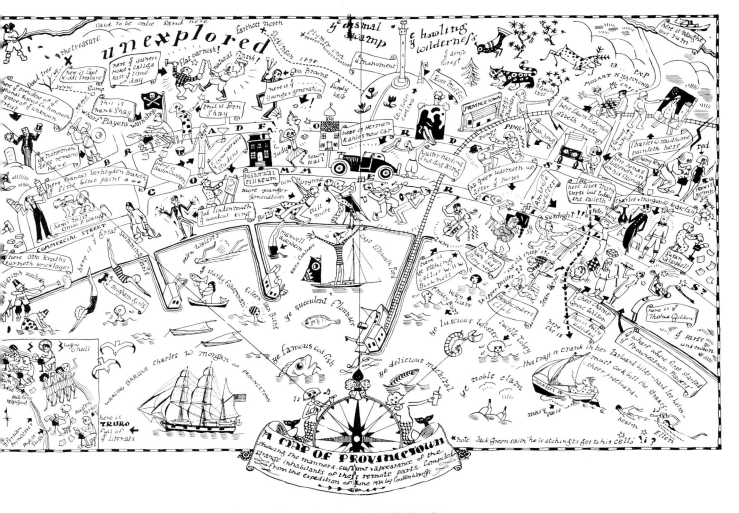

149 Map of Provincetown by Coulton Waugh (son of the marine painter Frederick Waugh), 1924

place in the town in this later period was the Atlantic or A-House. On a typical night here in the 1950s, one could have seen the writer Norman Mailer with sleeves rolled up looking for a fight, Jackson Pollock wildly dancing to jazz, and Kline drinking his way to his eventual death. Provincetown today still retains a lively character, and there is certainly no sign of abatement in the number of artists, writers, and tourists coming to the place. In the summer months the town's population swells from five to fifty-five thousand, and the traffic and crowds then make it difficult to walk in the streets. Perhaps in this respect the Provincetown of the 1980s is fundamentally not much different from what Barbizon must have been like in the 1880s. Yet in looking at present-day Provincetown, it is difficult to accept that its colony developed initially out of that same impulse which in the early years of the last century had led artists to wander through the forest of Fontainebleau in search of a world of primitive grandeur.

10
In Retrospect

'IN AFTER YEARS, according to the manners of our several countries, we affronted existing conditions and each in our way became very respectable dray-horses; but when met together, some whiff of keener air from the plains of Fontainebleau blew our way, and the coltish spirit of our youth was reawakened.'

When Will Hicock Low wrote these words he was already in his fifties and well established as a successful muralist working primarily in America. Memories of early days spent at Barbizon and Grez haunted him all his life, and of course provided him with much of the material for his *Chronicle of Friendships*. Advancing years made many other veterans of the nineteenth-century colonies view their youthful experiences in such places in a similarly romantic light. Accordingly they often came to find their present lives dull and even depressing. Many, like Low, saw their former Bohemian companions die off one by one, and the modern world advance in what was to them an ever more disturbing manner. The English painter George Clausen, who had joined Stanhope Forbes in Quimperlé in 1883 and had later become a well-known specialist in rural genre, wrote to Forbes in 1936. In this letter he bemoaned both the death of their mutual friend Adrian Stokes ('old Adrian, another link with old time gone') and the changes in the type of rural district which they had all so loved to paint: 'Now I don't think you could get that sort of atmosphere in the country—the "old-fashioned" country has passed away.'

Perhaps the saddest of Low's contemporaries were those who stayed on in the colonies where they had settled in their youth. Whether they did so through choice or 'snoozing', they frequently became lonely and embittered, with sometimes even their past illusions destroyed. It was often easier to maintain such illusions for those who had not been back to the colonies since their student days. Many of these artists acquired enormous reputations in later life, becoming prominent figures in the artistic establishment which they had once rebelled against. From their position of fame and wealth they could afford to indulge in harmless nostalgia about the simple Bohemian life of former days. Although certain artists such as Max Böhm and Frederick Waugh were able to recapture this life at a much later stage in their careers, generally age or success made this an impossibility. Thus the Grez veteran Sir John Lavery wrote: 'Many a time, tied down at Cromwell Place, I had longed for the freedom of the Bohemia I had known at first, and vainly hoped to recapture it one day. When a few years previously Hazel and I, after a terribly boring stay at the Riviera, had suddenly come upon a colony of artists at Saint-Paul du Var, vividly reminding me of earlier days, we decided to go and live there for a bit; but after the luxury we had grown accustomed to, Hazel found that she could not rough it. She never really had Bohemian tastes.'

The vision of a primitive world far removed from modern civilization led certain veterans of the colonies to become in later lives virtual recluses, as was, for instance, the case with many of Gauguin's followers. Others found themselves in the most exotic countries—places that had all the superficial characteristics of an earthly paradise and yet so often turned out to be delusive in their charms. Robert Louis Stevenson spent his last years in Samoa longing increasingly for the grey skies of his native Scotland; Gauguin died in

Tahiti, his body covered with syphilitic sores and his stomach lined with ulcers.

Today the fashion for joining an artist community in the country belongs safely to the past. Yet the rural nostalgia underlying the formation of these places in the nineteenth century is still as strong as ever. The ecology movement—which can almost be seen to have begun with the efforts of the Barbizon artists to prevent the deforestation of the Fontainebleau area—is rapidly gaining ground. The passing away or wilful destruction of old-fashioned rural traditions or monuments still causes enormous concern, and there remains a belief that the village community shows up the inhumanity of modern urban life. Even the peasant is still regarded in some circles as a noble being, and certain intellectuals, such as, for instance, the English writer and art critic John

Berger, have tried to integrate themselves into peasant communities.

The history of artist colonies illustrates the extent to which the sentimentality about rural life is based on an illusion. It also points to the difficulties of achieving a happy, harmonious integration between artists and countryfolk. Both worlds remained essentially separate, each maintaining preconceived notions about the other, and, moreover, presenting in their own ranks by no means a united front. In the case of the artists, personal differences proved much stronger than shared ideals, and often made life in the colonies unbearable. The smiling picture of rural Bohemia as depicted by Krøyer in *Hip, Hip, Hurrah!* simply provides the basis of another mythology, in this case one which serves to sustain glamorous visions of the past.

Notes on Sources

As well as listing the main sources on which this book is based, these notes are intended to assist the reader who wishes to read further about the subject. For this purpose I have tried to indicate wherever possible material available in English. The initials AAA refer to the Archives of American Art, whose central office is in Washington, DC.

1. The Academy of Nature

The only book up till now to be devoted to artist colonies is G. Wietek, *Deutsche Künstlerkolonien und Künstlerorte* (Munich, 1976). The distinction made in this between an 'artist colony' and an 'artist place' is a tenuous one; the chapters devoted to individual colonies in Germany, each written by a separate author, are varying in quality. A short and extremely poor introduction to artist colonies in Europe and America is included at the back of D.G. Seckler, *Provincetown Painters, 1890s to 1970s* (exhibition catalogue; Everton Museum of Art, Syracuse, New York, 1977). The most enjoyable and stimulating discussions of the formation and character of the French colonies are R.L. Stevenson, 'Fontainebleau: Village Communities of Painters', *Magazine of Art* (1884) and R.A.M. Stevenson, 'Grez', *Magazine of Art* (1893).

The general literature on European art of the late nineteenth century is in itself remarkably limited. R. Rosenblum and H.W. Janson, *Art of the Nineteenth Century: Painting and Sculpture* (London, 1984) is one of the few books to attempt some form of international perspective on the subject; F. Novotny, *Painting and Sculpture in Europe 1780–1880* (Harmondsworth, 1970) tries similarly, but hardly makes stimulating reading. J. Rewald, *The History of Impressionism* (4th, revised edition, London, 1980) and *Post-Impressionism: from Van Gogh to Gauguin* (New York, 1956; revised edition, London, 1978), are two of the most detailed general works in the art-historical literature on this period; yet they both fail to place the artists under discussion in the context of European art as a whole. The exhibition catalogue *Post-Impressionism* (Royal Academy, London, 1980), for all its lack of unity, at least treats Post-Impressionism as an international

phenomenon, and recognizes the importance of Bastien-Lepage to the art of this period.

The portrayal of peasant life in late nineteenth-century art is the subject of J. Thompson, *The Peasant in French Nineteenth-Century Art* (exhibition catalogue; Douglas Hyde Gallery, Trinity College, Dublin, 1980) and K. McConkey, *Peasantries: Nineteenth-Century French and British Pictures of Peasants and Field Workers* (exhibition catalogue; Polytechnic Art Gallery, Newcastle upon Tyne, 1981). For a more detailed account of the naturalistic tendencies in the art of this period see G. Weisberg, *The Realist Tradition: French Painting and Drawing 1830–1900* (exhibition catalogue; Cleveland, 1980). For an account of American painters in Europe at this time see M. Quick, *Expatriate Painters of the Late Nineteenth Century* (exhibition catalogue; Dayton Art Institute, Dayton, Ohio, 1976).

Tolstoy's writings on art are contained in L. Tolstoy, *What is Art?* and *Essays on Art* (trans. Aylmer Maude, London, 1929). Among the many books dealing with the experimental communities in Europe and America of the late nineteenth century mention should be made of W.H.F. Armytage, *Heavens Below: Utopian Experiments in England 1560–1960* (London, 1961) and M. Holloway, *Heavens on Earth, Utopian Communities in America 1680–1880* (second edition, New York, 1966). An interesting account of Whiteway, written by one of the colony's members, is N. Shaw, *Whiteway. A Colony in the Cotswolds* (London, 1935). The literature on the Arts and Crafts communities is also very extensive. A recent general introduction to the subject is L. Lambourne, *Utopian Craftsmen: the Arts and Crafts Movement from the Cotswolds to Chicago* (London, 1980). For Ashbee and Chipping Campden see F. Maccarthy, *The Simple Life: C.R. Ashbee in the Cotswolds* (London, 1981), which also includes a long bibliography relating to the Arts and Crafts movement as a whole.

For Millet see the notes to Chapter Two. Contemporary accounts of **Bastien-Lepage** include A. Theuriet, 'La Chanson du Jardinier', *Revue des Deux Mondes* (15 Nov. 1876), A. Theuriet, *Sous Bois, Impressions d'un Forestier* (Paris, 1878); L. de Fourcault, 'Jules Bastien-Lepage', *Gazette des Beaux-Arts* (Feb. 1885); L. de Fourcault, 'Exposition

des Oeuvres de Bastien-Lepage a l'Hôtel de Cluny', *Gazette des Beaux-Arts* (March 1885); A. Theuriet, *Jules Bastien-Lepage* (London, 1892), which includes essays on Bastien-Lepage by G. Clausen and W. Sickert; Prince Borojidar Karageorgovich, 'Personal Recollections of Bastien-Lepage', *Magazine of Art* (1890); and J. Cartwright, *Jules Bastien-Lepage* (London, 1894). For **Marie Bashkirtseff** see *Le Journal de Marie Bashkirtseff* (2 vols., Paris, 1887; English edition, London, 1890) and M. Blind, 'A Study of Marie Bashkirtseff', in A. Theuriet, *Jules Bastien-Lepage*, op. cit. The Musée de la Princerie de Verdun, France, has a collection of contemporary texts and documents relating to Bastien-Lepage. Howard Russell Butler's descriptions of Bastien-Lepage's works in the 1885 retrospective are in a letter to his sister dated 13 May 1885 in the AAA. After a long period of neglect Bastien-Lepage is at last beginning to receive more scholarly attention. See, for instance, Ph.D. thesis by W.S. Feldman, *The Life and Work of Jules Bastien-Lepage* (New York University, 1973) and K. McConkey, 'The Bouguereau of Naturalists. Bastien-Lepage and British Art', *Art History* 1, no. 3 (Sept. 1978).

2. The Bethlehem of Modern Painting

Among the earliest articles on Barbizon are A. de la Fizelière, 'Les Auberges Illustrées', *L'Illustration* (24 Dec. 1853); A. Pigeory, 'Barbizan: Notes et Souvenirs', *La Revue des Beaux-Arts* (1 Aug. 1854); and G.F., 'La Nouvelle Fête Patronale de Barbizon', *L'Illustration* (29 May 1858). Two of the most informative memoirs of Barbizon from the early 1850s are G. Gassies, *Le Vieux Barbizon, Souvenirs de Jeunesse d'un Peintre à Barbizon* (Paris, 1907) and A. Dubuisson, *Les Échos du Bois Sacré. Souvenirs d'un Peintre de Rome à Barbizon* (Paris, 1924). The general literature on the so-called **Barbizon School** of painters is very extensive, but largely unrewarding. The first writer to coin the term 'Barbizon School' was supposedly D.C. Thompson in his book *The Barbizon School* (London, 1902). Another early book on the subject is A. Hoeber, *The Barbizon Painters, being the Story of the Men of Thirty* (New York, 1915); this is interesting primarily for having been written by a former

veteran of the French painting colonies. More recent literature on the Barbizon School includes J. Bouret, *The Barbizon School and Nineteenth-Century French Landscape Painting* (London, 1973) and *Barbizon Revisited*, the catalogue of an exhibition held in San Francisco, Toledo, Cleveland, and Boston in 1962–3. Two most useful historical accounts of Barbizon are *Barbizon au Temps de Millet* (exhibition catalogue; Salle des Fêtes, Barbizon, 1975) and M.-T. Laforge, *Barbizon et l'École de Barbizon* (Paris, 1971; with English translation), which includes an extensive bibliography and potted biographies of many of the artists associated with Barbizon. G. Gassies and G. des Brulies, *Guide Artistique de Barbizon* (Paris, 1930) publishes the complete 'Plainte de Barbizon' of 1845 and contains a useful map showing where many of the Barbizon artists lived.

The standard contemporary biographies of **Théodore Rousseau** and **Jean François Millet** are by A. Sensier, who knew the two painters intimately: these are *Souvenirs sur Théodore Rousseau* (Paris, 1872) and *La Vie et l'Oeuvre de Jean François Millet* (Paris, 1881; English translation by Helena de Kray, London, 1881). Two of the most sympathetic contemporary accounts of Millet are by the American painters E. Wheelwright, 'Personal Recollections of Jean François Millet', *Atlantic Monthly* 38 (Sept. 1876) and Wyatt Eaton, 'Recollections of Jean François Millet', *Century Magazine* (May 1889). Another early account of Millet is by the English painter H. Naegely, *J.F. Millet and Rustic Art* (London, 1898). For a full bibliography of works on Millet up to 1976 see *Jean François Millet* (exhibition catalogue; Hayward Gallery, London, 1976). The best recent work on Rousseau is by N. Green, *Théodore Rousseau* (exhibition catalogue; Hazzlitt, Gooden and Fox, London, 1982).

The American painters working in Barbizon and the influence of the Barbizon School on American art are discussed in *American Art in the Barbizan Mood* (exhibition catalogue; National Collection of Fine Arts, Washington, DC, 1975). **Edward Simmons's** description of **William Babcock** in Barbizon is in E. Simmons, *From Seven to Seventy* (New York and London, 1922). For **William Morris Hunt** see *W.M. Hunt's Talks on Art*, compiled by Helen Knowlton (Boston, 1875) and H. Knowlton, *The Art-Life of William Morris Hunt* (Boston, 1894). For **Grigorescu** and **Andreescu** see G.S. Movileanu, *Grigorescu* (Bucharest, 1978; with summaries in French and English) and V. Varga, *Andreescu* (Bucharest, 1978).

For **Henri Murger** at Marlotte see R. Baldick, *The First Bohemian* (London, 1961). **Jules Breton's** recollections of Marlotte are contained in his memoirs *La Vie d'un Artiste* (Paris, 1890; English edition, London, 1891). The **Goncourts'** comments on Marlotte and Barbizon are to be found respectively in vols. 1 and 2 of *Journal Mémoires de le Vie Littéraire*, ed. R. Ricatte (Paris, 1956).

The principal account of Barbizon in the early 1870s, and of the move to Grez-sur-Loing in the second half of the decade is **Will Hicock Low's** highly entertaining *A Chronicle of Friendships* (New York, 1908); the same author's *A Painter's Progress* (New York, 1910) also includes a short discussion of Barbizon. For an account of Low's portrait of R.L. Stevenson at Barbizon see his *Concerning a Painting of R.L. Stevenson* (Bronx Valley Press, Bronxville, New York, 1924). For **László Paál** see B. Lazar, *Ladislas de Paal* (Paris, 1904). The sources for the life of Julian Alden Weir are discussed in the notes to Chapter Three. The writings of **R.L. Stevenson** on Barbizon and Grez are 'Forest Notes', *Cornhill Magazine* (1875–6; republished in *The Works of R.L.S.* vol. 4, 1896) and 'Fontainebleau: Village Communities of Painters', *Magazine of Art* (1884). R.L. Stevenson's letter to his mother describing Grez is quoted in Low's *Chronicle of Friendships*, p. 138. Recollections of R.L. Stevenson in this period are included in L. Osbourne's introduction to R.L. Stevenson, *The New Arabian Nights* vol. 1 (1882); L. Osbourne, *An Intimate Portrait of R.L.S.* (New York, 1924); I. Strong, *This Life I've Loved* (London, 1937); and B. Harrison, 'With Stevenson at Grez', *Century Magazine* (Dec. 1916). For R.L. Stevenson at Barbizon and Grez see also N. Sanchez, *The Life of Mrs R.L. Stevenson* (London and New York, 1920), which contains the young Isobel's description of life at Grez; C. Hamilton, *On the Trail of Stevenson* (London, 1916); and A.J. Darlyn, 'R.L.S. at Barbizon', *Chambers Journal* 7th series (July, 1917). The most recent biography of R.L. Stevenson is J. Calder, *R.L.S. A Life Study* (London, 1980), which has a bibliography. **R.A.M. Stevenson's** essay entitled 'Grez' was published in the *Magazine of Art* (1893). A biographical study of R.A.M. Stevenson is included in Denys Sutton's edition of Stevenson's *Velasquez* (London, 1962). For other artists in the Stevenson circle at Barbizon and Grez see 'The Late Frank O'Meara', *Scottish Art Review* vol. 1 (June 1888–May 1889); J. Campbell, *The Irish Impressionists: Irish Artists in France and Belgium, 1850–1914* (exhibition catalogue; National Gallery of Ireland, Dublin, 1984; and S. Johnston, *Theodore Robinson, 1852–1896* (exhibition catalogue; Baltimore Museum of Art, Baltimore, 1973). The history of Grez and the Hôtel Chevillon is the subject of F. Sadler, *L'Hôtel Chevillon et les Artistes de Grez-sur-Loing* (1938; published by *L'Informateur de Seine-et-Marne*). R.A.M. Stevenson devotes an article to 'William Stott of Oldham', *Studio* IV, no. 19 (October 1894). **Sir John Lavery's** *The Life of a Painter* (London, 1940), has a long section on Grez in the 1880s, and tells the story of Weldon Hawkins's *The Orphans*. For further information on Lavery at Grez, as well as on the stay here of **Sir James Guthrie, Alexander Reid**, and **Roderic O'Conor**, see J. Campbell, *The Irish Impressionists* (ed. cit.). For Birge and Alexander Harrison see the notes to Chapter Three.

For **Léon-Germain Pelouse** see *Exposition des Oeuvres de L.-G. Pelouse* (École National des Beaux-Arts, Paris, 1892). For Krøyer see notes to Chapter Three. Letters of his from Cernay-la-Ville dated 20 April to 22 May 1879 are in the archives of the Hirschsprung Collection, Copenhagen. The same collection has a drawing by Krøyer of R.A.M. Stevenson at Cernay, and an undated letter from Pelouse to Krøyer, in which mention is made of the Norwegian painter Kitty Kielland being at Cernay.

A short introduction in English to the **Scandinavian artists** working in France in the late nineteenth century is S. Sarajas-Korte, 'The Scandinavian Artists' Colony in France', in K. Varnadoe, *Northern Light: Realism and Symbolism in Scandinavian Painting 1880–1910* (exhibition catalogue; Brooklyn Museum of Art, New York, 1982). The contacts between Scandinavian and French art of this period are the subject of H. Usselmann, *Complexité et Importance des Contacts des Peintres Nordiques avec L'Impressionisme* (Ph.D. dissertation; University of Gothenburg, 1979), which has a section on the Scandinavians at Grez. The most detailed modern accounts of the Scandinavian community at Barbizon and Grez are in S. Strömbom, *Konstnärsförbundets historia* (Stockholm, 1945–60) and V. Loos, *Friluftmåleriets Genombrott i Svensk Konst 1860–1885* (Stockholm, 1945). For Norwegian artists in Paris and Grez see K. Berg, *Norgenkunst-Historie* vol. 5 (Oslo, 1981).

Christian Skredsvig's autobiographical novel *Møllerens Søhn* has a long description of Grez. For Skredsvig see also *Skredsvig* (exhibition catalogue; Modum Kunstforenig, Modum Blaafarvevaerk, 1978). For Krohg see notes to Chapter Four. **Clar Larsson's** autobiography, *Jag* (Stockholm, 1931), has a lengthy description of his time at Grez. Other writings by Larsson relating to Grez are in H. and S. Alfons, *Carl Larsson—Skildrad af honom själv* (Stockholm, 1977; German edition, Königstein im Taunus, 1977). For recent monographs in English on Larsson see *Larsson* (exhibition catalogue; Brooklyn Museum of Art, New York, 1982) and G. Cavalli-Björkman and others, *The World of Carl Larsson* (La Jolla, 1982). **Strindberg's** recollections of his stay at Grez were included in 'Carl Larsson. Ett Svenskt Porträtt med Fransk Bakgrund', *Ur Kalendern Svea* (Stockholm, 1884; reprinted Gothenburg, 1980). For his numerous letters from Grez see *August Strindbergs Brev*, ed. T. Eklund (Stockholm, 1948). For a biography of

Strindberg in English see E. Sprigge, *The Strange Life of August Strindberg* (London, 1949).

Two articles on Grez by the journalist **Spada** (J. Janzon), 'En Konstnärkoloni i Grez' (1883) and 'Jul i Grez' (1884), were included in Spada, *Svenska Pariser–Konstnärer i Hvardadslag* (Stockholm, 1913). **Georg Pauli's** memoirs of Grez were published in his *Pariserpojkarne* (Stockholm, 1926). This also includes a long description of **Frank O'Meare** and his unfortunate affair with Florence Lewis. For **William Blair Bruce** and **Caroline Benedicks** see G. Bonds, *William Blair Bruce, Caroline Benedicks och Brucebo* (M.A. dissertation; Stockholm Universitet Konstvetenskaplya Institutionem, 1977), which also publishes the diary kept by Caroline Benedicks while staying at Grez.

For **Delius** at Grez see L. Carley and R. Threlfalt, *Delius, A Life in Pictures* (Oxford, 1977) and L. Carley, 'Jelka Rosen Delius, Artist, Admirer and Friend of Rodin. The Correspondence, 1900–1914', *Nottingham French Studies* IX, nos. 1 and 2 (1970). The description of Jelka Rosen's garden as 'a select nudist camp' is from Sir John Lavery, *The Life of a Painter* (London, 1940).

The description of Barbizon in 1882 is from R. Whiteing, 'The American Student at the Beaux-Arts', *Century Magazine* 23 (Nov. 1881–Apr. 1882). There is a short section on Barbizon in the 1880s in E. Simmons, *From Seven to Seventy* (New York and London, 1922). **André Billy's** memoirs of Barbizon are in A. Billy, *Beaux Jours de Barbizon* (Paris, 1947).

3. A Second Arcadia

The opening lines of the chapter are from C. Swift, 'The Cry of the Chouette', one of a group of unpublished short stories by Swift among the Swift papers in the AAA.

Brittany's attraction for artists is the subject of Denise Delouche's extremely detailed *Peintres de la Bretagne: Découverte d'une Province* (Paris, 1977) and D. Elliott, *Brittany and the Concept of Primitivism in France during the Nineteenth Century* (M.A. dissertation; Courtauld Institute of Art, London University, 1973). For a dissenting, Marxist view of this subject see F. Orton and G. Pollock, 'Les Données Bretonnantes: La Prairie de Representation', *Art History* III, no. 3 (Sept. 1980).

The history of Pont-Aven before Gauguin's time has been scarcely studied. By far the most useful recent source on this subject is D. Sellin, *Americans in Brittany and Normandy, 1860–1910* (exhibition catalogue; Phoenix Art Museum, Phoenix, Arizona, 1982), which publishes numerous contemporary documents. See also D. Delouche, 'Pont-Aven

avant Gauguin', in the special issue devoted to Pont-Aven of the *Bulletin des Amis du Musée de Rennes* 2 (1978).

The writings of **Earl Shinn** (including those written under the pseudonyms 'L'Enfant Perdu', Edward Strahan, and G.W. Sheldon) include unpublished letters in the Cadbury Collection, Friends' Historical Library, Swarthmore College, Swarthmore, Pennsylvania; a series of articles entitled 'Rash Steps' published late in 1876 in the *Philadelphia Evening Bulletin* (extensively quoted in Sellin, op. cit.); 'Frederick Bridgman', *Harper's Monthly* (October 1981); and the sections on Bridgman in G. Sheldon, *American Painters* (London, 1879) and E. Strahan, *Great Modern Painters* (Paris, 1886). Another important contemporary source for Pont-Aven in the 1860s is B. Champney, *Sixty Years Memories of Art and Artists* (Woburn, Massachusetts, 1900).

For Douarnenez's development as a colony see J. Breton, *La Vie d'un Peintre*, op. cit.; A. Besnus, *Mes Relations d'Artiste* (Paris, 1898); and 'Les Peintres de Douarnenez', *Bretagne* (9 Mar. 1944).

For **Olin Warner's** letters from Paris during the Commune see the Olin Warner papers in the AAA. For Pont-Aven in the 1870s see the **Clement Swift, Julian Alden Weir, Thomas Hovenden,** and **Henry Mosler** papers in the AAA. Weir's letters from France, preserved in full typescript in the AAA, are published in part in D. Young, *The Life and Letters of J. Alden Weir* (New Haven, 1960). For **Julia Guillou** see L. Tual, *Mademoiselle Julia Guillou de Pont-Aven* (Concarneau, 1928). **Milne Ramsey's** daughter Ethel's impressions of Pont-Aven are in 'Ladies Didn't', an unpublished manuscript in the Frederick Ramsey Archive (quoted in Sellin, op. cit.). **Édouard Girardet's** description of Pont-Aven in around 1876 is partly published in R. Burnand, *L'Étonnante Histoire des Girardet. Artistes Suisses* (Neuchâtel, 1940). Hovenden's letter to Goupil and Co. describing the death of **Robery Wylie** is published in Sellin, op. cit. For the brothers **Bolton** and **Frank Jones** in Pont-Aven see the transcription of an interview with Francis Coate Jones in the De Witt McLellan Papers, AAA. For **William Lamb Picknell** at Pont-Aven see E.W. Emerson, 'An American Landscape Painter', *The Century Magazine* (May–Oct. 1901). Picknell's letter dscribing the painting of the *Road to Concarneau* is published in Sellin, op. cit. For **H. Blackburn** and **R. Caldecott** in Pont-Aven see H. Blackburn, 'Pont-Aven and Douarnenez', *The Magazine of Art* (1879); H. Blackburn, *Breton Folk, An Artistic Tour in Brittany* (London, 1880); and H. Blackburn, *Randolph Caldecott. A Personal Memoir of his Early Art Career* (London, 1886).

The artistic history of Concarneau is discussed in Camille de Montergon, *Histoire*

de Concarneau (Concarneau, 1953) and R. Klein, 'Concarneau, Ville de Peintres', *Les Cahiers de l'Iroise: Société d'Études de Brest et de Leon* XII (Apr.–June 1965). For the Americans in Concarneau see Sellin, op. cit. Letters by **P.S. Krøyer** from both Concarneau and Pont-Aven dating from 11 June to 2 Sept. 1879 are preserved in the archives of the Hirschsprung Collection, Copenhagen. Memoirs of Concarneau and Pont-Aven in the early 1880s include **Henry Jones Thaddeus,** *Recollections of a Court Painter* (London and New York, 1912); **Birge Harrison,** 'Quaint Artistic Haunts in Brittany, Pont-Aven and Concarneau', *Outing* XXIV (Apr. 1894); and **Edward Simmons,** *From Seven to Seventy* (New York and London, 1922). For **Alexander Harrison** see the T.A. Harrison papers in the archives of the Pennsylvania Academy of the Fine Arts, Philadelphia; C.L. Bourgmeyer, 'Alexander Harrison', *Fine Arts Journal* (Sept. 1913); Sir W. Rothenstein, *Men and Memories* (2 vols., London 1931-2); and the catalogue entry on *Castles in Spain* in D.B. Burke, *American Paintings in the Metropolitan Museum of Art* vol. III (1980).

For **Edwin Harris** in Pont-Aven see 'Mr Edwin Harris', *Edgbastonia* XIX, no. 218 (July 1899). **Stanhope Forbes's** letters from Brittany are in the Stanhope Forbes papers belonging to Monica Anthony and at present kept in the Newlyn Orion Gallery, Newlyn, Cornwall. Memoirs of Pont-Aven in 1883 by Forbes's future wife, **Elizabeth Armstrong,** are included in Mrs L. Birch, *Stanhope A. Forbes and Elizabeth Armstrong Forbes* (London, 1906). **Elmer Boyd Smith's** French diary is in the Boyd Smith papers in the AAA. **Arthur Hoeber's** description of Pont-Aven in 1884–5 is from his article, 'A Summer in Brittany', *The Monthly Illustrator* IV, no. 2 (1895).

A short introduction to **Finnish women painters** is *Taitelijattaria* (exhibition catalogue; Ateneumin Taidemuseo, Helsinki, 1981; text in Finnish and Swedish). For **Helene Schjerfbeck** see H. and E. Appelberg, *Helene Schjerfbeck. En Biografisk Konturteckning* (Helsinki, 1949; Finnish edition, Helsinki, 1949). For **Marianne Preindlsberger** and **Adrian Stokes** see H. Postlethwaite, 'Some Noted Women Painters', *Magazine of Art* (1895); 'The Work of Mrs Adrian Stokes', *Studio* XXIII (1901); W. Fred-Wien, 'Marianne und Adrian Stokes—Eine Malereher', *Kunst and Kunsthandwerk* IV (1901); and W. Meynell, 'Mr and Mrs Adrian Stokes', *The Art Journal* (1900). **Helena Westermark's** memoirs of Pont-Aven are included in *Trekonstarinnor* (Helsinki, 1937) and *Mina Levnadsminnen* (Helsinki, 1940). The Swedish journalist **Spada** (J. Janzon) also describes Pont-Aven at this time in his articles, 'Pont-Aven' and 'Med Konstnärer i Bretagne', included respectively in *Franska Provinserna* (Stockholm, 1913) and *Svenska Pariser-Konstnärer i Hvardaglslag* (Stockholm, 1913).

The most important source for Concarneau in the mid-1880s are the letters by **Howard Russell Butler** dating from 19 July to 11 October 1885, and preserved in the AAA. For a description of **'Shorty' Lasar** at the École des Beaux-Arts see J. Shirley-Fox, *An Art Student's Reminiscnces of Paris in the Eighties* (London, 1909).

The standard account of **Gauguin** and his followers is W. Jaworska, *Gauguin and the Pont-Aven School* (Boston, 1972); see also C. Chasse, *Gauguin et la Groupe de Pont-Aven* (Paris, 1921); D. Sutton, *Gauguin and the Pont-Aven Group* (exhibition catalogue; Tate Gallery, London, 1966); P. Tuarze, *Pont-Aven: Arts et Artistes* (Paris, 1973); and P. Tuarze, *Pont-Aven. Paradis des Arts* (Paris, 1977). Archibald Hartrick's memoirs of Gauguin are contained in his *A Painter's Pilgrimage through Fifty Years* (Cambridge, 1939). Gauguin's letters have been published in several different editions (including in English) of varying reliability. For a critical discussion of these and other works relating to Gauguin see the bibliography in J. Rewald, *Post-Impressionism: from Van Gogh to Gauguin* (ed. cit.).

For **Arthur Wesley Dow** see A.W. Johnson, *Arthur Wesley Dow, Historian, Artist, Teacher* (Ipswich Historical Society, Ipswich, Massachusetts, 1934); F. Moffat, 'The Breton Years of Arthur Wesley Dow', *Archives of American Art Journal* XV, no. 2 (1975); and F. Moffat, *Arthur Wesley Dow* (exhibition catalogue; National Collection of Fine Arts, Washington, DC, 1977). Dow's own writings on Brittany and Pont-Aven include 'Modern Brittany', *Ipswich Chronicle* (3 October 1885); 'Pont-Aven in Midsummer', *Ipswich Chronicle* (9 May 1886); and 'A Sad Dying', *Ipswich Chronicle* (13 November 1886). His letters, and those of his fiancée Millie Pearson, are in the A.W. Dow and Benjamin Tupper Newman Papers in the AAA, and the archives of the Ipswich Historical Society, Ipswich, Massachusetts.

Cecilia Beaux's letters are in the Beaux papers in the AAA; they are briefly discussed in E. Bailey, 'The Cecilia Beaux Papers', *Archives of American Art Journal* XIII, no. 4 (1973). Memoirs of her stay in Concarneau are included in his *Background with Figures* (Boston and New York, 1930).

Mortimer Menpès's description of Pont-Aven in the late 1880s is from his 'In the Days of My Youth', *Mainly About People* (8 July 1899). This was copied almost verbatim by his daughter Dorothy Menpès in *Brittany* (London, 1905). **Robert Henri**'s description of 'Guenn' at Concarneau is from a letter dated 18 Sept. 1889 in the Robert Henri papers, Yale University. **Signac**'s description of Pont-Aven in 1891 is quoted in J. Rewald. *Post-Impressionism* (ed. cit.). Pont-Aven in the 1890s is the setting of H.A. Vachell's popular novel *The Face of Clay* (1906), which bears a

dedication to Mlle Julia Guillou in which the author expresses his nostalgia for the grey skies of Brittany now that he is in sunny, distant California. Clive Bell wrote at length on Roderic O'Conor in *Old Friends, Personal Recollections* (London, 1956); see also D. Sutton, 'Roderic O'Conor. Little Known Member of the Pont-Aven Circle', *Studio* (Nov. 1960); J. Benington, *Roderic O'Conor* (M.A. thesis; Courtauld Institute of Art, London, 1982); and J. Campbell, *Irish Impressionists* (ed. cit.). Gauguin's fight at Concarneau in 1896 is the subject of R. Maurice, 'Autour de Gauguin, Sa Rixe à Concarneau avec les Marins Bretons', *Nouvelle Revue Bretonne* (1953). For **Charles Henry Fromuth** see his lengthy journals in the Library of Congress, Washington, DC (these are extensively quoted in Sellin, op. cit.).

For **Charles-François Cottet** and **Lucien Simon** see A. Cariou, 'Le Peintre Charles Cottet et al Bretagne', *Annales de Bretagne* (Sept. 1973) and *Lucien Simon* (exhibition catalogue; Musée des Beaux-Arts de Quimper, Quimper, 1981). For **Matthew Smith** in Pont-Aven see P. Hendy, *Matthew Smith* (London, 1944).

4. The Blue Hour

The best introduction to late nineteenth-century Scandinavian art in English is K. Varnadoe, *Northern Light: Realism and Symbolism in Scandinavian Painting 1880–1910* (exhibition catalogue; Brooklyn Museum of Art, New York, 1982). For French influences on Scandinavian art of this period see H. Usselmann, *Complexité et Importance des Contacts des Peintres Nordiques avec l'Impressionisme* (Ph.D. dissertation; University of Gothenburg, 1979). For Denmark see *Dansk Kunsthistorie* vol. 4 (Copenhagen, 1974). For Norway see *Norges Kunsthistorie* vol. 5 (Oslo, 1981) and M. Malamanger, *One Hundred Years of Norwegian Painting* (Oslo, 1980). For Sweden see S. Strömbom, *Konstnärsförbundets historia* (Stockholm, 1945–60), which is a history of the Swedish artists' union, and V. Loos, *Friluftsmaleriets Genombrott i Svensk Konst 1860–1885* (Stockholm, 1945). For Finland see S. Sarajas-Korte, *Suomen Varhaissymbolism i ja sen lähtet* (Helsinki, 1981; Swedish edition, Helsinki, 1981).

Fritz Thaulow's 'Plein-air Academy' at Modum is discussed in H. Usselmann, op. cit. For Fleskum see H. Aars, 'På Fleskum i Baerum 1886. Fra Sommenatter til Folkevisen', *Kunst og Kultur* 28 (1942); F. Bull, 'Christian Skredsvig og Fleskumkolonien', *Kunst og Kultur* 48, h. 2 (1965); and M. Lange, 'Fra den Hellige Lund til Fleskum, Kitty Kielland og den Nordiske Sommernatt', *Kunst og Kultur* 60, h. 2 (1977). For the Lake Racken colony see H. Sjöberg, *Konstnärskolonien vid Racken*

(Arvika, 1976). For the Åland colony see H. Rönnberg, *Konstnärskolonien på Åland 1886–1904*, the second volume of *Konstnärslivet i Slutet av 1800–talet* (Helsinki, 1938), and A. Reitala, *Victor Westerholm* (Helsinki, 1967).

The standard book on the Skagen colony is K. Madsen, *Skagens Malere og Skagens Museum* (Glydendal, 1929). The same author also wrote an article entitled 'Skagen' in the *American-Scandinavian Review* XIX (1931); this is the best introduction to the colony in English. **Alba Schwartz,** who grew up in Skagen in the 1880s and 1890s published *Skagen Før og Nu* (2 vols., Copenhagen, 1912–13), a badly written book full of mainly unreliable anecdotes; this has recently been reprinted (no date) but is only to be recommended for its extensive and rare photographs. Schwartz was a close friend of the Anchors and always gives their side of a particular story at the expense of Krøyer's. Madsen made an attempt to stop the publication of Schwartz's book.

More recent works on Skagen include K. Voss, 'Dansk Kunst på Skagen 1870–1920' in *Dansk Kunsthistorie* vol. 4 (1974) and *Skagensmalerne* (2 vols., Copenhagen, 1980), which contains many contemporary documents, including **Oscar Björck**'s account of his stays at Skagen. E. Mentze, *Skagens Guldalder. En Epoke i Dansk Malerkunst* (Copenhagen, 1967) has a résumé in English. Another introduction to the Skagen colony in English is in *Skagens Museum, Illustreert Katalog* (Copenhagen, 1981). P.I. Rockswold, *The Art Colony at Skagen. Its Contribution to Scandinavian Art* (Ph.D. dissertation; University of Minnesota, 1968) is the most substantial account in English, but is unreliable, excessively sentimental, and adds little to what can be found in K. Madsen, *Skagens Malere* (ed. cit.).

Christian Krohg's reminiscences of Krøyer and Skagen are to be found respectively in vols. 1 and 2 of his *Kampen for Tilværelsen* (Copenhagen, 1920). For Krohg see also Pola Gauguin, *Christian Krohg* (Oslo, 1932); O. Thue, *Christian Krohgs Portretter* (Oslo, 1971) and *Christian Krohg. Kunstnere Nasjonalgalleriet* IV (Oslo, 1958; with a very brief introduction in English by Oscar Thue).

The greater part of **P.S. Krøyer**'s enormous correspondence is divided between the archives of the Hirschsprung Collection, Copenhagen, and the Royal Library, Copenhagen. Alexander Harrison's letters to Krøyer are in the former. The only biography of Krøyer is E. Mentze, *P.S. Krøyer. Kunstner af Stort Format—med Brændte Vinger* (Copenhagen, 1969); for a short account of the artist in English see D.L. Paul, 'P.S. Krøyer, Painter of L'Heure Bleue', *Apollo* CXIII, no. 227 (January 1981). For the affair between Krøyer's wife and Hugo Alfvén see H. Alfvén, *Minnen*, ed. V. Nyberg (Stockholm, 1972).

Hanna Rönnberg's reminiscences of Skagen are to be found in the first volume of her *Konstnarslivet i Slutet av 1880—talet* (Helsinki, 1931). Another contemporary account of Skagen is in L. Tuxen, *En Malern Arbedje Gennem Tredsinstyve Aar Fortalt af Hamselv* (Oslo, 1928).

For **J.-F. Willumsen** see Jaworska, *Gauguin and the Pont-Aven School* (ed. cit.). For an account of the Skagen Museum in 1980 see the Museum's own publication *Mennesker og Kunst på Skagen* (Copenhagen, 1982).

5. In the Nest of the Gentry

Three general introductions in English to Russian art are G. Hamilton, *The Art and Architecture of Russia* (Harmondsworth, 1954); T. Rice, *The Arts of Russia* (London, 1962); and R. Auty (ed.), *An Introduction to Russian Art and Architecture* (Cambridge, 1980). For a more detailed account of late nineteenth- and early twentieth-century Russian art see C. Gray *The Great Experiment: Russian Art, 1863—1922* (London, 1962), which includes a lengthy discussion of Abramtsevo.

The main work in English on Abramtsevo is J. Bowlt, 'Two Russian Maecenases: Savva Mamontov and Princess Tanisheva', *Apollo* 98 (Dec. 1973). The longest account of Abramtsevo is D. Kogan's rather lightweight *Mamontovskiy Kruzhok* (Moscow, 1970). A more reliable and less sentimental book on Mamontov and his circle is M. Kopschitzer, *Savva Mamontov* (Moscow, 1972). Other works on Abramtsevo include *Katalog v'stavki. Posvyashshennoi 100-letiu. Abramtsevskogo kydoozhestvennogo kruzhka* (exhibition catalogue; Abramtsevo, 1979) and N.M. Beloglasova, *Abramtsevo* (Moscow, 1981), which has many other colour photographs of the place and a short text in English.

There are numerous letters and memoirs relating to Abramtsevo. Unfortunately, non-Russian scholars are generally not allowed access to the unpublished material. Moreover what has been published has often been handled in a very selective way. Published letters and memoirs of relevance to Abramtsevo include: N. Moleva, *Konstantin Korovin. Zhisn' i tvocestvo. Pisma, dokument' vospominaniya* (Moscow, 1963); N.V. Polenova, *Abramtsevo, Vospominaniya* (Moscow, 1922); E. Sakharova, *Vasily Dmitniyevich Polenov. Pisma, dnevniki, vospominaniya* (Moscow–Leningrad, 1950); V. Samkov and I. Silberstein, *Konstantin Korovin vospominaet* (Moscow, 1971); V. Samkov and I. Silberstein, *Valentin Serov v vospominanigakh, dnevnikakh, i pereliske sovremennikov* (2 vols., Leningrad, 1971); N. Simonvich-Yefimova, *Vospominanij o Valentine Aleksandroviche Serove* (Leningrad, 1964); and N. Sokolova, *V. Serov, Perliska 1884–1911* (Moscow, 1937).

Important works on **I. Repin, V. Vasnetzov, V. Polenov, K. Korovin, V. Serov** and **M. Vrubel** include I. Grabar, *Repin. Torn Pervyy* (Moscow, 1937); Lobanov, *Victor Vasnetzov v Mockve* (Moscow, 1961); D. Kogan, *Vasily Polenov* (Moscow, n.d.); D. Kogan, *Konstantin Korovin* (Moscow, 1964); I. Grabar, *Valentin Aleksandrovich Serov. Zhisn' i tvocestvo, 1865–1911* (Moscow, 1965); and D. Kogan, *Mikhail Vrubel* (Moscow, 1980). Two recent studies on Repin and Vrubel in English are F. Parker, *Russia on Canvas. Ilya Repin* (London, 1980) and R. Reeder, 'Mikhail Vrubel: A Russian Interpreter of Fin-de-Siècle Art', *The Slavonic and East European Review* 54 (July 1976).

6. Blood and Soil

Two excellent cultural histories of Germany in the late nineteenth century and early twentieth centuries are G. Mosse, *The Crisis of German Ideology: Intellectual Origins of the Third Reich* (London, 1966) and F. Stern, *The Politics of Cultured Despair: a Study in the Rise of Germanic Ideology* (Berkeley and Los Angeles, 1961). The latter includes a detailed study of **Julius Langbehn** and of his *Rembrandt als Erzieher* (most recent edition, Berlin, 1944).

For a brief account of German painting in the late nineteenth century see the German section of *Post-Impressionism* (exhibition catalogue; Royal Academy, London, 1980). For an account of art in Munich in the late nineteenth century, with particular emphasis on the American painters in the city, see M. Quick, *Munich and American Realism in the Nineteenth Century* (exhibition catalogue; E.B. Crocker Art Gallery, Sacramento, California, 1978).

The German artist colonies are the subject of G. Wietek, *Deutsche Künstlerkolonien und Künstlerorte* (Munich, 1976). For the colony at Dachau see J. Kalckreuth, 'Dachau das alte Malernest', *Bayerland* 56 (1954); M. Gruber, 'Kunst und Kunstler im Landkries Dachau', *Bayerland* 56 (1954); C. Thiemann, *Erinnerungen einer Dachauer Maler, Beiträge zur Geschichte Dachaus als Künstlerort* (Dachau, 1966); and O. Thiemann, 'Stoedtner Malerinnen in Dachau', *Amperland* 6 (1970).

The recent literature on Worpswede and its artists is enormous; in the village itself there are two publishing houses dealing exclusively with publications relating to the place. Few of these works, however, have much scholarly value. The most useful general introduction to Worpswede is *Worpswede: Eine Deutsche Künstlerkolonie um 1900* (exhibition catalogue; Bremen, 1980). For a sentimental, anecdotal account of the colony see S. Weltge-Wertman, *Die Erste Maler in Worpswede* (Worpswede, 1979); this is an improved version of her M.A. thesis, *An Historical Investigation of the Artists' Colony, Worpswede at the Turn of the Century* (Goddard College, 1975). For **Fritz Mackensen** see B. Kauffmann, *Fritz Mackensen, Monographie einer Landschaftskunstverein* (exhibition catalogue; Landesmuseum, Hanover, n.d.). The standard books on **Heinrich Vogeler** and **Otto Modersohn** are H.W. Petzet, *Von Worpswede nach Moskau—Heinrich Vogeler* (Cologne, 1972) and C. Modersohn, *Otto Modersohn, 1865–1943* (Hamburg, 1977). Books on **Paula Modersohn-Becker** appear at regular intervals; for one in English see G. Perry, *Paula Modersohn-Becker* (London, 1979).

At the Haus im Schluh in Worpswede there are archives devoted to the Worpswede artists. They contain typescripts of letters by **Fritz Overbeck, Fritz Mackensen, Hans am Ende,** and **Otto Modersohn,** as well as numerous contemporary articles and pamphlets. The complete letters of Modersohn are kept in the museum devoted to him at nearby Fischerhude. However, they have not been made freely available to scholars, and have only been published in an infuriatingly condensed form in several publications, including C. Modersohn, op. cit. Paula Modersohn-Becker's letters and diaries have all been brought together in G. Busch, *Paula Modersohn-Becker in Briefen und Tagebüchern* (Frankfurt, 1979). Many years after her death a number of her friends got together to produce *Paula Modersohn-Becker, Ein Buch der Freundschaft,* introduction by R. Hetsch (Berlin, 1932). Other important sources on Worpswede include R.M. Rilke, *Worpswede* (Leipzig, 1903; abridged edition, Bremen, 1970); G. Pauli, *Erinnerungen aus Sieben Jahrzehnten* (Tübingen, 1936); and H. Vogeler, *Erinnerungen* (Berlin, 1952). Two of the earliest articles on Worpswede were F. Overbeck, 'Ein Brief aus Worpswede', *Die Kunst für Alle* vol. 11 (Munich, 1895–6) and P. Schultze-Naumberg, 'Die Worpswede', *Die Kunst für Alle* vol. 12 (Munich, 1896–7). Two later articles on Worpswede of considerable interest are K. Krummacher, 'Worpswede und seine Bedeutung', *Heimathote* 21 (10 Oct. 1926) and K. Krummacher, 'Worpswede und das Teuffelsmoor', *Der Wanderer* (the Sunday supplement of *Der Weser Zeitung*) nos. 18/20/21. Fritz Mackensen's 'Das Weltdorf Worpswede', which included uncomplimentary comments on Vogeler's Communism, first appeared in the *Nationalsozialistischer Gaudienst* (Osthanover, Lüneburg, 1 Nov. 1938); it was reprinted, omitting the mention of Vogeler, in the *Niedersachsischer Heimatkalender* (1947). Copies of these and Krummacher's articles can be seen in the Haus in Schluh archives.

7. The Rákóczi March

The main introduction in English to Hungarian art from the late nineteenth century onwards is L. Németh, *Modern Art in Hungary* (Budapest, 1969). See also D. Patsky, *Hungarian Drawings and Watercolours* (Budapest, 1961); *Collection of the Hungarian National Gallery* (Budapest, 1976); and A. Kampis, *The History of Art in Hungary* (London and Wellingborough, 1966). For a short introduction to late nineteenth-century Hungarian art see also *L'Art 1900 en Hongrie* (exhibition catalogue; Petit Palais, Paris, 1976–7). The standard work on this subject is L. Németh (ed.), *Magyar Művészet 1890–1919*, the sixth volume of *A Magyarországi Művészet Története* (Budapest, 1981).

An excellent account of Hungarian artists in Munich is K. Lyka, *Magyar Művészélet Münchenben* (Budapest, 1951; reprinted Budapest, 1982). For the colony at Szolnok see *A Szolnoki Festőiskola* (exhibition catalogue; Hungarian National Gallery, Budapest, 1975; text also in German); *A Szolnoki Művésztelep Jubiláris Kiállítása, 1902–1944* (exhibition catalogue; Damjanich Museum, Szolnok, 1977); M. Egri, *A Szolnoki Művésztelep* (Budapest, 1977); and *Austellung der Szolnoker-Künstlerkolonie 1902–1944* (exhibition catalogue; Collegium Hungaricum das Ungarische Kulturinstitut in Wien, Vienna, 1982). For the artists in Hódmezővásárhely see L. Németh, *Modern Art in Hungary* (ed. cit.). and J. Dömötör, *Városról, Művészetről* (Hódmezővásárhely, 1975.)

The only material in English on Nagybánya is in L. Németh, *Modern Art in Hungary* (ed. cit.) and A. Kampis, *The History of Art in Hungary* (ed. cit.). The exhibition catalogue *A Nagybánya Művésztelep* (Hungarian National Gallery, Budapest, 1976) includes a very short summary in French. The standard work on Nagybánya is I. Réti, *A Nagybányai Művésztelep* (Budapest, 1954), the longest and most detailed book devoted to any artist colony; for a recent account see O. Mezei, *Nagybánya, A Hazai Szabadiskolák Múltjából* (Budapest, 1983). For **Simon Hollósy** see L. Németh, *Hollósy Simon és Kora Művészete* (Budapest, 1956) and R. Șorban, *Simon Hollósy (Corbul) 1857–1918 Întemeietorul Coloniei de Arta de la Baia Mare* (Centenar Muzeal Orădean, 1972). An account of Hollósy's Huszt commission is given in J. Murádin, 'Hollósy Simon: A Huszti Vár', *Művészettörténeti ertesíto* XXVIII, no. 2, (1979). For **Károly Ferenczy** see the biography written by his painter son, Valér, *Ferenczy Károly* (Budapest, 1934). Two more recent books on Ferenczy are I. Genthon, *Ferenczy Károly* (Budapest, 1963; reprinted Budapest, 1979), which deals largely with Ferenczy's art, and J. Murádin, *A Ferenczy Család Erdélyben* (Bucharest, 1981), which contains a detailed biographical study of him and other members

of his family. For a history of Nagybánya in its Romanian period see N. Lăptoiu, 'Date Privind Coloniași Scuola de Pictură de la Baia Mare in Perioada Interbelică, *Anuarul Marmația* IV (Baia Mare, 1978). Raoul Șorban is shortly to bring out a detailed study of the Nagybánya colony from its beginnings to recent times.

8. From Breton to Briton

For an excellent short account of British reactions to French art in the late nineteenth century see A. Gruetzner, 'Two Reactions to French Painting in Britain' in *Post-Impressionism* (exhibition catalogue; Royal Academy, London, 1980). For a history of the formation of the New English Art Club see W. Laidley, *The Origin and First Two Years of the New English Art Club* (London, 1907). For Bastien-Lepage and British art see K. McConkey, 'The Bouguereau of Naturalists. Bastien-Lepage and British Art', *Art History* I, no. 3 (Sept. 1978). The artist colony at Manresa Road is the subject of 'A Colony of Artists', *Scottish Art Review* II (June–Dec. 1889). Short accounts of all Britain's artist colonies are included in M. Jacobs and M. Warner, *Phaidon Companion to Art and Artists in the British Isles* (Oxford, 1980), which also has a bibliography featuring all the main publications on these colonies.

The main source for the Newlyn colony is the **Stanhope Forbes** papers in the collection of Ms Monica Anthony, currently kept in the Newlyn Orion Gallery, Newlyn. These include not only letters by Stanhope Forbes from 1877 onwards, but also letters by **Elizabeth Armstrong**, Forbes's aunt Alice, models, and friends of Forbes such as George Clausen; in addition there are diaries by Forbes from 1918 to 1940, Valentine cards, innumerable press cuttings, transcripts of lectures (such as those given at the Penzance Library on 24 July 1935 and at the Passmore Edwards Gallery on 9 June 1939), the odd lock of hair, and even a tooth. Other writings of Forbes include 'A Newlyn Retrospect', *The Cornish Magazine* I (1898) and *Cornwall from a Painter's Point of View*, Annual Report of the Royal Cornwall Polytechnic Society for 1900 (Falmouth, 1903). For a biography of Stanhope Forbes see Mrs L. Birch, *Stanhope A. Forbes and Elizabeth Stanhope Forbes* (London, 1906).

Another important unpublished source for the Newlyn artists are the letters by **Frank Bourdillon** in the collection of his daughter, Mrs Claudine Baber. The earliest important article on the Newlyn artists was A. Meynell, 'Newlyn', *Art Journal* (1889). For a highly entertaining account of the Newlyn artists see F. Richards, 'Newlyn as a Sketching Ground', *Studio* V (1895). The main scholarly account of the Newlyn artists is C. Fox and F. Greenacre,

Artists of the Newlyn School (Newlyn, 1979), which refers in its footnotes to all the early articles to have appeared on Newlyn.

The only accounts of the St. Ives colony in the nineteenth century are the very brief ones included in J.H. Matthews, *A History of the Parishes of St. Ives, Lelant, Towednack and Zennor in the County of Cornwall* (London, 1892) and H.H. Robinson, 'St. Ives as an Art Centre', in W. Badcock, *Historical Sketch of St. Ives and District* (London, 1896).

Edward Simmons's memoirs of St. Ives are contained in his *From Seven to Seventy* (New York and London, 1922). **Howard Russell Butler** described St. Ives in his letter to his family in the AAA dating from 2 Aug. 1886 to 18 Sept. 1887. **Helene Schjerfbeck's** letters from St. Ives are quoted in H. and E. Appelberg, *Helene Schjerfbeck. En Biografisk Konturteckning* (Helsinki, 1949). For **Anders Zorn** see G. Boëthius, *Zorn. His Life and Work* (London, 1954) and H. Brummer, *Zorn. Svensk Målare i Världen* (Stockholm, 1975). Zorn's recollections of St. Ives are included in his autobiography, which is in the process of being published (by Hans Brummer) after a fifty-year interdict; I am grateful to Hans Brummer for showing me the work at proof stage. Letters from Emma Zorn to Hugo Geber and Elin Lamm describing St. Ives are in the archives of the Zorn Museum, Mora, Sweden.

Louis Grier's description of the St. Ives Arts Club is in his 'A Painter's Club', *Studio* V (1895). For **Frederick Waugh** at St. Ives see G. Havens, *Frederick J. Waugh, American Marine Painter* (Orono, Maine, 1969); the Waugh papers in the AAA contain descriptions of his stay in St. Ives not included in Haven's book. **Alexander Harrison's** letter of 20 Sept. 1899 from the Treganna Castle Hotel, St. Ives, is in the archives of the Pennsylvania Academy of the Fine Arts, Philadelphia.

For an account of the later history of St. Ives see *Cornwall 1945–1955* (exhibition catalogue; New Art Centre, London, 1977); P. Davies, *St. Ives Years: Essays on the Growth of an Artistic Phenomenon* (Wimborne, 1984); T. Cross, *Painting the Warmth of the Sun: St. Ives Artists 1939–1975* (Alison Hodge and The Lutterworth Press, Penzance and London, 1984); and *St. Ives 1939–1964: Twenty-Five Years of Painting, Sculpture, and Pottery* (exhibition catalogue; Tate Gallery, London, 1985).

9. Victorians in the Modern World

Champney's letter from Boston is quoted in D. Sellin, *Americans in Brittany and Normandy, 1860–1910* (exhibition catalogue; Phoenix Art Museum, Phoenix, Arizona, 1982). Low's description of his return to America is in *A*

Chronicle of Friendships (New York, 1910). His Chicago lecture of 1910 was published in *A Painter's Progress* (New York, 1910).

For an account of late nineteenth-century American art see W. Gerdts, *American Impressionism* (exhibition catalogue; Henry Art Gallery, University of Washington, Seattle, 1980). A. Parry, *Garrets and Pretenders* (New York, 1960) gives a detailed history of artist and writer communities in America. For a short history of the American open-air painting schools see K.A. Marlin, 'Painting on the Straw-Hat Circuit', *Portfolio* (July/August 1981).

For **William Morris Hunt** in Magnolia see H. Knowlton, *The Art-Life of William Morris Hunt* (Boston, 1899) and *William Morris Hunt and his Summer Art School at Magnolia, Massachusetts* (exhibition catalogue; Essex Institute, Salem, Massachusetts, 1981). For Gloucester see J. O'Gorman, *This Other Gloucester* (Boston, 1976) and J. O'Gorman, *Portrait of a Place. Some American Landscape Painters of Gloucester* (Gloucester, 1973). Kenyon's description of Annisquam is contained in a letter to Tupper Newman in the Tupper Newman papers in the AAA.

For artists on Long Island in the late-nineteenth century see C.B. Todd, 'The American Barbison', *Lippincott's Magazine* (Apr. 1883); *East Hampton. The American Barbison, 1850–1900* (exhibition catalogue; East Hampton, New York, 1969); and R. Pisano, *The Students of William Merrit Chase* (exhibition catalogue; Heckscher Museum, Huntington, New York, 1973).

The Connecticut artist colonies are discussed at length in *Connecticut and American Impressionism* (exhibition catalogue; William Benton Museum of Art, University of Connecticut, Storrs, 1980). For Woodstock, see *Woodstock. An American Art Colony, 1902–1977* (exhibition catalogue;

Vassar College Art Gallery, 1977), which also contains an essay entitled 'The Art Colonial Movement' and an account of experimental artist and writer communities in America such as the MacDowell Colony and Yaddo. There are numerous books on the Taos colony; the most recent are P. Broder, *Taos: A Painter's Dream* (Boston, 1980) and M.C. Nelson, *The Legendary Artists of Taos* (New York, 1980).

General works on Provincetown and its painters include N. Smith, *Provincetown Book* (Brockton, Massachusetts, 1922); N. Smith, *Provincetown, A Book about the Artists* (Provincetown, 1927); Provincetown Art Association, *The Provincetown Guide Book* (Provincetown, 1931); M.H. Vorse, *Time and the Town, a Provincetown Chronicle* (New York, 1942); R. Moffett, *Art in Narrow Streets. The First Thirty-Three Years of the Provincetown Art Association, 1914–1947* (Falmouth, Massachusetts, 1964); and D.G. Seckler, *Provincetown Painters* (exhibition catalogue; Everton Museum of Art, Syracuse, New York, 1977). For a history of Days Lumberyard Studios see *Days Lumberyard Studios* (exhibition catalogue; Provincetown Art Association and Museum, Provincetown, 1978). For an account of the Beachcombers see T. Robinson, *The Beachcombers* (Provincetown, 1947); documents relating to the Beachcombers (including much salacious poetry and correspondence) are in the AAA. For the most detailed account of the Provincetown Players see H. Deutsch and S. Hanau, *The Provincetown. A Story of the Theatre* (New York, 1931). Reminiscences of Provincetown are included in S. Glaspell, *The Road to the Temple* (London, 1926) and H. Hapgood, *A Victorian in the Modern World* (Washington, DC, 1939).

Extensive papers relating to **Charles Hawthorne** are in the AAA. See also his

Hawthorne on Painting (New York, 1960); E. MacCausland, *Charles Hawthorne. An American Figure Painter* (New York, 1947); J. Hawthorne, *Hawthorne Retrospective* (exhibition catalgue; Chrysler Art Museum of Provincetown, Massachusetts, 1961); and *The Paintings of C. Hawthorne* (exhibition catalogue; University of Connecticut Museum of Art, Storrs, Connecticut, 1968). **Edwin Dickinson's** papers are also in the AAA. See also J. Drobkin, *Edwin Dickinson: Draftsman/Painter* (exhibition catalogue; National Academy of Design, New York, 1982). For **Charles Demuth** see E. Farnham, *Charles Demuth: Behind a Laughing Mask* (Norman, Oklahoma, 1971). For **Marsden Hartley** see E. McCausland, *Marsden Hartley* (Minneapolis, 1952). **William Zorach's** description of his stay in Provincetown and relationship with Eugene O'Neill is in his *Art is My Life* (Cleveland, Ohio, 1967). See also D. Hooper, *William Zorach: Paintings, Watercolors and Drawings, 1911–1922* (exhibition catalogue; Brooklyn Museum, New York, 1969) and R. Tarbell, *Marguerite Zorach: The Early Years, 1908–1920* (exhibition catalogue; National Collection of Fine Arts, Washington, DC, 1974). For **Max Böhm** see the Böhm papers in the AAA. For **John Noble** see I. Stone, *The Passionate Journey* (London, 1950). For **Frederick Waugh** see G. Havens, *Frederick J. Waugh. American Marine Painter* (Orono, Maine, 1969).

For an account of Provincetown and East Hampton in their days as centres of abstract painting see D. Ashton, *The New York School: A Cultural Reckoning* (New York, 1971); R. Motherwell, 'Provincetown and Days Lumberyard: A Memoir' in *Days Lumberyard Studios* (ed. cit.); and *Seventeen Abstract Artists of East Hampton: the Pollock Years, 1946–1956* (exhibition catalogue; Parrish Art Museum, Southampton, New York, 1980).

Index

ACKNOWLEDGEMENTS

The publishers have endeavoured to credit all known persons holding copyright or reproduction rights for illustrations in this book, and wish to thank all the public, private and commercial owners and institutions concerned, and the photographers and librarians, especially Professor Anne Crookshank, Dr L. Czigany, Kati Evans, Gordon Roberton, John Wall and Elizabeth Williams.

The works of István Réti (fig. 4) and Émile Bernard (figs. 58, 59) are © DACS 1985.

Figs. 89, 93: courtesy of Professor John E. Bowlt, The Institute of Modern Russian Culture at Blue Lagoon, Texas; figs. 12, 14, 28: by kind permission of Roger Karampournis; fig. 147: courtesy of Boston Public Library; figs. 119–21, 125, 137 (Reg Watkiss—Newlyn Art Gallery) and frontispiece (Private Collection): courtesy of Bristol Museum and Art Gallery; figs, 4, 106, 107, 110–15: courtesy of the Hungarian National Gallery; fig. 63: Albright-Knox Art Gallery, Buffalo, New York, General Purchase Funds, 1946; fig. 10: collection of The Art Institute of Chicago, Henry Field Memorial Collection; fig. 44: Detroit Institute of Arts, Gift of Mr and Mrs Harold O. Love; fig. 6: courtesy of Aimo Reitala; plate 1: Layton Art Collection, Milwaukee Art Museum; fig. 7: The Metropolitan Museum of Art, Wolfe Fund, 1897—Catharine Lorillard Wolfe Collection; fig. 139: courtesy of Lyme Historical Society; fig. 39: Arch. Phot. Paris/S.P.A.D.E.M.; fig. 59: Giraudon; figs. 17, 58: cliché des Musées Nationaux; figs. 31, 33, 35: photo N.D. Roger-Viollet; figs. 34, 65: Collection Viollet; fig. 136: Reg Watkiss, courtesy of Penzance Town Council; figs. 54 (Temple Fund Purchase), 62 (Gift of Henry S. Drinker): Pennsylvania Academy of the Fine Arts; fig. 45: Phoenix Art Museum, Museum Purchase with funds provided by COMPAS and a friend of the Museum; fig. 141: photo Irving Rosenthal; fig. 142: courtesy of the Provincetown Art Association and Museum: fig. 148: photo Peter Macara; fig. 134: by kind permission of the Saint Ives Arts Club; figs. 75, 77, 78, 86, plates 2, 4: Hans Petersen, courtesy of Herluf Stockholms Forlag; fig. 140: courtesy of the Parrish Art Museum, Southampton, NY; figs. 22, 24: courtesy of Institutionen för Konstvetenskap, Stockholm; fig. 21: Prins Eugens Waldemarsudde; figs. 124 (courtesy of Andrew Lanyon), 122, 123, 126, 129 (all courtesy of the Royal Institution of Cornwall): County Museum, Truro; fig. 138: courtesy of Andrew Lanyon; figs. 8 (Museum purchase through the gift of William Wilson Corcoran, 1981), 36, 46 (both Museum purchase, 1899): in the collection of the Corcoran Gallery of Art; fig. 57: courtesy of the National Gallery of Art, Washington, DC; figs. 42, 145 (photo Geoffrey Clements): courtesy of the National Museum of American Art; figs. 3, 94, 95, 96, 99, 100, 101, 102 (photo Hans Müller-Brauel), 103, plate 8: courtesy of Worpsweder Verlag; fig. 23: G. Leindgren.